TIM ROLLINS AND K.O.S.

A HISTORY

after breakfast and the Highwood,
and back by river, that will show
his paces.'

'I will, sir kfast he came and
fitted me wit particular in letting
out and takin s not broad enough
then he brou for my back; d went for another,
which fitted slowly, then a trot,
then a cante on the common he
gave me a lig and we had a splen-
did gallop.

'Ho, ho! r pulled me up, 'you
would like to nk.'

As we cam we met the Squire
and Mrs Gore d, and John jumped
off.

'Well, Joh

'First-rate is as fleet as a deer,
and has a fine st touch of the rein
will guide hi he common we met
one of those d over with baskets,
rugs, and su any horses will not
pass those ca a good look at it, and
then went o as could be. They
were shootin ood, and a gun went
off close by; looked, but did not

right or left. I just hel
y him, and it's my opin
r ill-used while he was y
ell,' said the Squire, 'I

r day I was brought u
my mother's counsel a
ried to do exactly what h
as a very good rider, an
hen we came home the
de up.

dear,' she said, 'how do y
ctly what John said,' he
ever wished to mount.

u like Ebony?' said sh

bony.'

call him Blackbird, li

far handsomer than old
said, 'he is really quite
good-tempered face an
hat do you say to calling
auty – why, yes, I think
like it shall be his name,
n went into the stable,

mast sen a good sensible
name ething, not like Marc
Pega oth laughed, and Jam
'If it ack the past, I shou
name never saw two horse
alike

'T ohn, 'didn't you kno
farm s the mother of them
I ore, and so poor Rob R
was y brother! I did not
that bled. It seems that
have hey never know eac
after

Jo of me: he used to m
man oth as a lady's hair,
wou l; of course I did not
stan ed more and more t
wha wanted me to do. I gr
fond tle and kind, he see
kno and when he cleaned
knew the ticklish places; w
brus carefully over my ey
they r stirred up any ill-tem

Ja boy, was just as gen
plea ught myself well off
was in the yard, but he h
little ne.

favourite with im the run of the
Park; he some ting on the estate,
or carried one hen they rode out
with their fat tle, and could be
trusted with a gs. The cob was a
strong, well-m rse, and we some-
times had a l k, but of course I
could not be with Ginger, who
stood in the sa

stead rse who has worked
years there, a bit in my
and b ow, I am not complai
I kno mean to say that for
horse irits who has been
some re he can fling up hi
and op away at full spe
roun snort to his compan
say i bit more liberty to d
like. ave had less exerci
usua e and spring, that wh
has se, I really could n
quie emed as if I must j
danc good shake I know
have the first; but he was
good

'S e would say; 'wait a
we'll soon get the tickle
your e were out of the vil
wou a spanking trot, ar
bring re, only clear of the
as h rses, when not enou
cise h, when it is only p
som em, but our John d
he k irits. Still, he had
ways d by the tone of his
the was very serious an

CHAPTER VI
LIBERTY

happy in my new place
hat I missed, it must not
ed; all who had to do wi
ht airy stable and the b
ant? Why, liberty! For thr
d had all the liberty I c
r week, month after mo
I must stand up in a sta
am wanted, and then

my un d and wrenched my n
open, on the halter and th
into m ged me along by the
anothe is was the first expe
I had a all force; they did no
me a c y wanted. I was high
and ha d was very wild, no
and ga ty of trouble, but t
was d stall day after day in
of hav ted and pined and w
to get , it's bad enough wh
have a y of coaxing, but the
nothi

'T ster, Mr Ryder, who I
could und, and could have
anythi given up all the hard
the tr her experienced ma
he on e. His son was a stron
bold nson, and he used to
that h rse that could throw
There n as there was in his
but o e, a hard eye, a hard e
and I hat he wanted was t
all the ust make me into a
humb e-flesh. "Horse-flesh
that is t,' and Ginger stamp
foot a m made her angry.

his voice, and
hing else, for I

we had our lib
ne Sundays in
went out on
T.

be turned out
d. The grass w
eet, and the fre
gallop, to lie d
e the sweet gra
ng, as we stood
nut tree.

oon became gr
, good-temperee
h everyone, and
used to ride hi
s with him and

rses that stood
cob, used for ri
was an old brov
work now, but

has been all so differe
had any one, horse or m
cared to please; for in th
mother as soon as I wa
er young colts: none of t
none of them. There w
k after me, and talk to
at. The man that had th
word in my life. I do no
hat he did not care for
t we had plenty to eat

an through our field a
ng through would fling
ver hit, but one fine you
and I should think it
care for them, but of
we settled it in our mir

r good fun in the free
d chasing each other rou
ding still under the shad
breaking in, that was
me to catch me, and
one corner of the field,
other caught me by th
hardly draw my breath;

ONE day w anding alone in
the shad alk; she wanted
to know breaking in,
and I told her.

'Well,' said sh ging up I might
have been of as g but now I don't
believe I ever sha

'Why not?' I sa

And a man has not begun to live until he can rise above
the narrow confines of his own individual concerns
to the broader concerns of all humanity.

MARTIN LUTHER KING, JR.

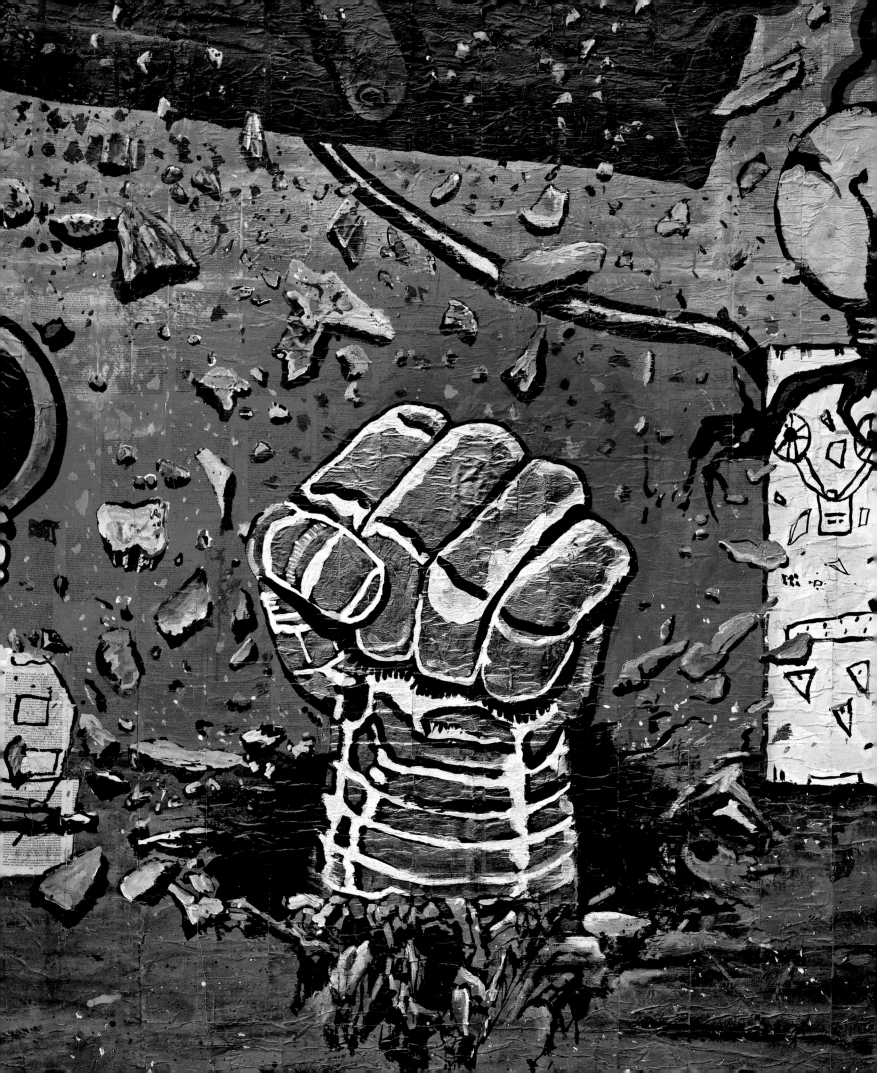

Today we are going to make art,
and we are also going to make history.

TIM ROLLINS

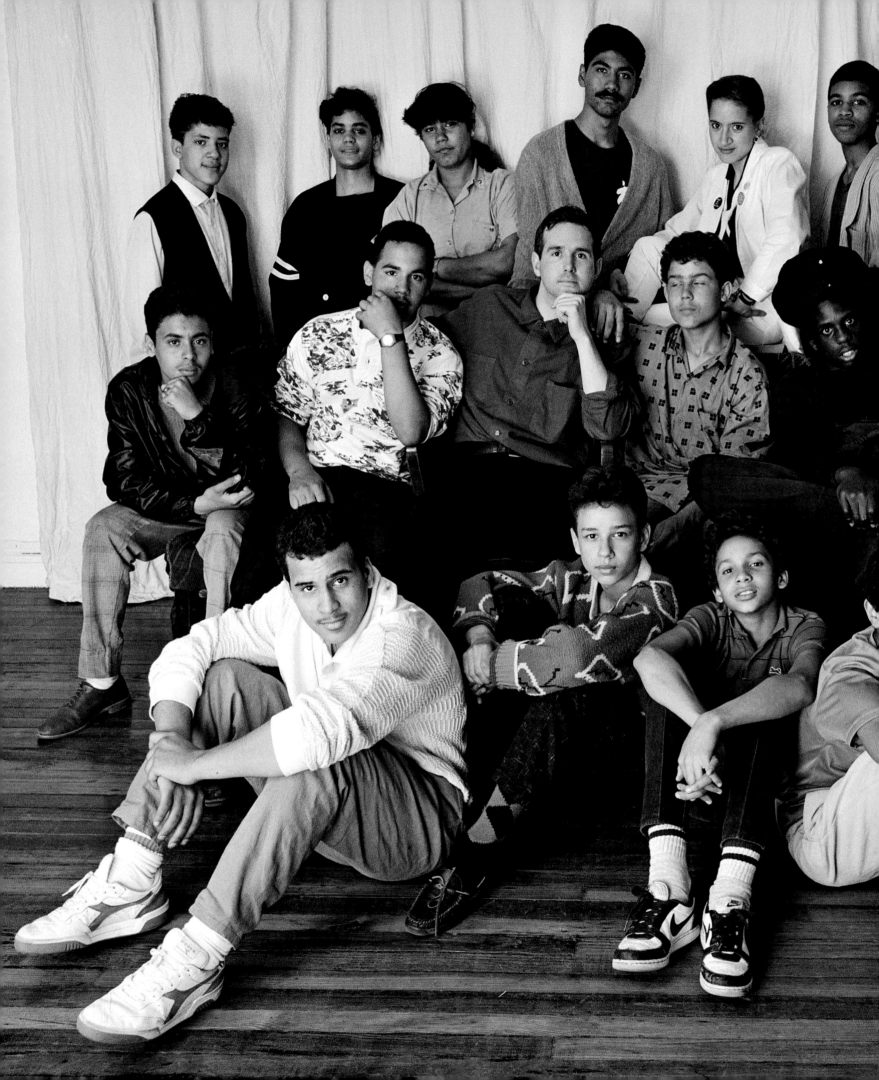

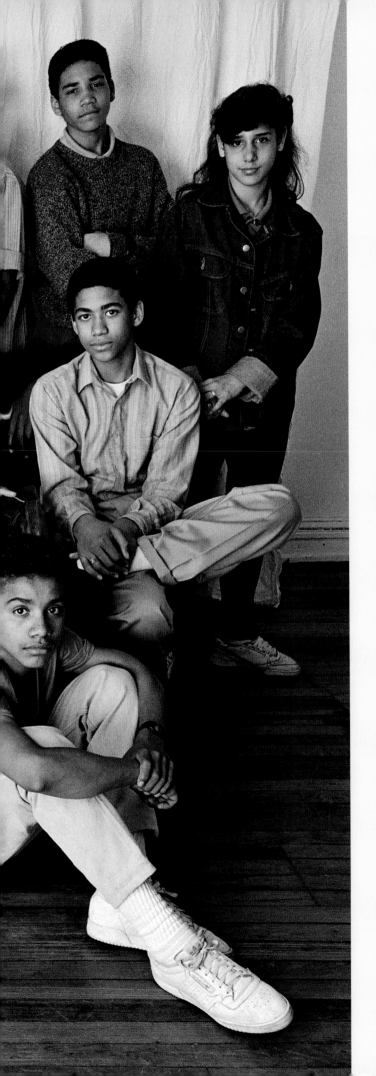

TIM ROLLINS AND K.O.S.

A HISTORY

Edited by Ian Berry

with essays by
Julie Ault, Susan Cahan, David Deitcher,
Felix Gonzalez-Torres, Eleanor Heartney,
Lawrence Rinder, James Romaine,
and a dialogue with Tim Rollins
by Ian Berry

THE FRANCES YOUNG TANG TEACHING MUSEUM
AND ART GALLERY, SKIDMORE COLLEGE
SARATOGA SPRINGS, NEW YORK

MIT PRESS
CAMBRIDGE, MASSACHUSETTS / LONDON, ENGLAND

This publication accompanies the exhibition
Tim Rollins and K.O.S.: A History
Ian Berry, Curator

The Frances Young Tang Teaching Museum
and Art Gallery
Skidmore College
Saratoga Springs, New York
February 28–August 23, 2009

Institute of Contemporary Art
University of Pennsylvania
Philadelphia, Pennsylvania
September 11–December 6, 2009

Frye Art Museum
Seattle, Washington
January 23–May 31, 2010

Published in 2009 by The Frances Young Tang
Teaching Museum and Art Gallery
at Skidmore College

The Frances Young Tang Teaching Museum
and Art Gallery
Skidmore College
815 North Broadway
Saratoga Springs, New York 12866
T 518 580 8080
F 518 580 5069
www.skidmore.edu/tang

Editor: Ian Berry
Designer: Bethany Johns
Printed and bound in Italy by Conti Tipocolor

© 2009 The Frances Young Tang Teaching Museum
and Art Gallery at Skidmore College

Front cover and title page © Lisa Kahane, NYC

Back cover:
AMERIKA I (AFTER FRANZ KAFKA), 1984–85 (detail)
Oil paint stick, acrylic, china marker, and pencil
on book pages on rag paper mounted on canvas
71 1/2 x 177 inches
The JPMorgan Chase Art Collection

ISBN 978-0-262-01355-0

MIT Press books may be purchased at special quantity
discounts for business or sales promotional use. For
information, please email special_sales@mitpress.mit.edu
or write to Special Sales Department, The MIT Press,
55 Hayward Street, Cambridge, MA 02142.

Library of Congress Cataloging-in-Publication Data

Tim Rollins and K.O.S. : a history / edited by Ian Berry;
with essays by Julie Ault, Susan Cahan, David Deitcher ...
[et al.] and a conversation with Tim Rollins by Ian Berry.
 p. cm.
Issued in connection with an exhibition held Feb. 28–
Aug. 23, 2009, Frances Young Tang Teaching Museum
and Art Gallery at Skidmore College, Saratoga
Springs, New York, Sept. 11–Dec. 6, 2009, Institute
of Contemporary Art, University of Pennsylvania,
Philadelphia, Pennsylvania, and Jan. 23–May 31, 2010,
Frye Art Museum, Seattle, Washington.
Includes bibliographical references.
ISBN 978-0-262-01355-0 (alk. paper)
1. Rollins, Tim, 1955- –Exhibitions. 2. K.O.S. (Group of
artists)–Exhibitions. 3. Mixed media painting–United
States–Exhibitions. 4. Group work in art–United
States–Exhibitions. I. Rollins, Tim, 1955- II. Berry,
Ian, 1971- III. Ault, Julie. IV. Cahan, Susan. V. Deitcher,
David. VI. Frances Young Tang Teaching Museum and
Art Gallery. VII. University of Pennsylvania. Institute
of Contemporary Art. VIII. Charles and Emma Frye
Art Museum.
ND237.R715A4 2009
709.73'07474748–dc22

 2009037795

CONTENTS

Our paintings are us, and we're showing ourselves to people like an open book.

ANNETTE ROSADO

Children's Storefront Workshop, Harlem,
New York, c. 2000

"A big problem with the traditional school is that it places the student in a constant state of preparation. […] I begin with a different premise. Instead of constantly training kids to "become" artists, why not take on the job of encouraging them to be artists now?"
TIM ROLLINS

TIM ROLLINS, 1988

TIM

SEPTEMBER 1973. This is how I remember it: It was the first day of school at University of Maine at Augusta. Petrified, I entered the pre-fab art department building, on the edge of campus. There he was, with pale, translucent skin, piercing dark eyes, and shoulder-length black hair. He wore black-and-white polka-dot platform shoes, jeans, a white shirt, and a black suit coat adorned with glittering thrift store pins. And he was coming my way, a big bag of candy in his hand. "Would you like a Tootsie Pop?" *Would I?* Tootsie Pops were my favorite, and he had all the flavors. I reached in and chose several. He later confided the candy was a strategy to smooth the way for making friends, which had been difficult for him in high school. It certainly worked in my case: I was smitten. Tim was eighteen, and I was fifteen. I had left high school after only two years, under the pretext of studying art, an option not offered at Winthrop High. He took me under his wing, and our lifelong friendship began.

MAY 1974. Tim steered me into the art department library, which I had never visited. We sat at a round table looking at the volumes he selected—Gregory Battcock's *The New Art*, Lucy Lippard's *Six Years*. They seemed intriguing enough, but required that I read, which was something I didn't much do. Then he showed me *the book*, the one that inspired him so and changed his life—Germano Celant's *Arte Povera*. I didn't really understand what I saw, but the force of Tim's enthusiasm made me try. In my memory's eye the book consists solely of grainy black-and-white photos that cover the pages edge to edge. One image in particular rocked my world: a line drawn underwater with an electric current—was it neon? I could not fathom how that worked, but found it thrilling and poetic. Tim had opened the door to a larger world than I knew existed.

1973–1975. Tim was an overachiever (Still is.), relentlessly curious and critical, well read, confident, articulate, and fearless. His knowledge of contemporary art and theory surpassed that of our teachers. He became the star student of the department, his every move attracting school-wide attention and debate. He got a woman who looked like his mother to iron clothes in front of an audience for hours as part of his performance series about his family's working class conditions. He and another student, my cousin George, stole some dirt from the yard of the governor's mansion one night, and sent him a ransom note demanding he pay $10,000 for its safe return. To fulfill a sculpture assignment

he wrapped metal bands around a set of trees, creating a horizontal plane in the woods behind the art building, and provoking an ad-hoc protest from a couple students who worried he was harming the trees. For a self-portrait assignment he meticulously rendered his eyes but obscured the lower part of his face with a bandit-style bandana. Tim once mounted posters of suggestive images around campus advertising a flick called *Blue Movie*, and then screened a brief super-8 monochromatic film showing a completely blue screen. That conceptual trick really pissed off the jocks who had lined up outside the auditorium in rowdy anticipation of a porno movie and booed during the screening. It was exhilarating and frightening. Tim, always courting interaction, was elated.

Back then I was an underachiever, working at Sampson's supermarket as a cashier and taking classes in Augusta to escape my home town of Winthrop, where I had turned to hanging out with an older crowd of mostly male hippie bikers. I didn't read anything other than *Cosmopolitan* and felt profoundly insecure. I had lucked into the program at the university and more importantly, the group of friends who cohered there. I had no idea, however, what kind of art I wanted to make, although for over a year I saved every cash register receipt from my shifts at the supermarket, in hopes of eventually "doing something with them." I struggled with the assignments. Yet through all my tentative and unformed efforts, Tim acted as though everything I did showed seeds of brilliance. My first dose of wholehearted encouragement! Tim had a gift for recognizing a creative glimmer in others before they felt it themselves.

JUNE 1975. We finished the program. Tim had a plan: he would get accepted to School of Visual Arts (SVA), to study with Joseph Kosuth, procure scholarships and loans, move to New York, and become a practicing, and eventually, famous artist—which is what he did. I had no plan—no desire, money, or support to continue school, only a resolute aim to leave Maine and move to a city in another state.

FALL 1975. Tim was cut out for New York. Ever curious and ravenous for culture, he absorbed all the city could offer. He had done his research and went directly to the legendary places of contemporary art. He even rented a room in the Chelsea Hotel for a period, despite it taking so much of his budget. He was determined to live his vision and he seemed to relish

every minute of it. He flourished at SVA and soon began working for Kosuth as well as in the school library. He attended every exhibition, performance, panel, and event he could. Tim's letters enthusiastically detailed his diverse experiences and all that he was seeing. One day I received a package containing documentation of a piece he had made called *Student Work*. A transparent plastic envelope held a time card indicating the hours Tim punched in for courses, student activities, and studio time at SVA in a given period. He annotated inconsistencies on the card, for instance when the punch clock malfunctioned, forcing him to register the time by hand. The oaktag timecard in its clear plastic sleeve is wrapped in tracing paper, which is signed, titled, stamped, and dated, and carries an explanation of all the piece's content as well.

Tim's mother Charlotte had said, "New York is for mutants," and we definitely fit the bill, at least in the environment of rural Maine. I realized New York was inevitable, but initially chose Washington, DC, home of Yolanda Hawkins, a friend and fellow student at Augusta, where I worked at a dry cleaners by day, in a take-out joint by night, as an occasional usher at the Kennedy Center, and pursued little else.

SEPTEMBER 1976. Tim found a big cheap apartment for us and I moved to Manhattan, along with Yolanda. I worked at Baskin Robbins (my all-time-favorite job), and then as a telephone operator. My artistic, cultural, social, and political education continued thanks to Tim and his new friends, assisted by New York City.

Tim frequently brought cultural work to my attention. We shared and savored the music of James Brown, Betty Wright, Rufus and Chaka Kahn, Esther Phillips, Labelle, Steve Reich, Frederick Rzewski, Martha Reeves, and X-Ray Spex; the art of Alexander Rodchenko, Jannis Kounellis, Nancy Spero, and Odilon Redon; the poems of Vladimir Mayakovsky; the designs of Enzo Mari; the writings of Wilhelm Reich, and Lucy Lippard; the films of George Romero, and Pier Paolo Pasolini, and much more.

OCTOBER 1978. We were on a plane; I don't recall where we were headed. Tim was looking at an art catalogue and critiquing: "Oh my god, look at that!" Then, "This one's not so great." I asked him how he knew some artworks were good and some not. He lit up at the opportunity. "Well, let's take a look." We went through the catalogue page by page. He didn't say a word, and asked me to

tell him what I thought. Silence. I was tongue-tied. He waited. "Go on, just take a look and say what you think." More silence. I was so nervous. "What about this one here?" I took a chance. "Well, I like it but I don't know why." Tim was expressionless. I went on, "This one doesn't do anything for me," "This seems kind of great," and so on. Tim was soon smiling. "See, you *do* know what works and what doesn't." So our opinions were in synch, but only after this demonstration did he steer the conversation toward what factors codetermine the processes of evaluating art, and what problems emerge within those dynamics. Always teaching.

FALL 1979. We were talking in the kitchen after work and Tim announced everyone was ready to start the collaborative group we had long imagined assembling and begin to work together. "Everyone" meant Patrick Brennan, his fellow student and friend from NYU—as well as Marybeth Nelson, Beth Jaker, Peter Szypula, and Hannah Aldefer—his close friends from Kosuth's class, who had also become my friends. We identified some other possible participants, including Yolanda Hawkins, and Marek Pakulski, the bass player for the Fleshtones. I remember feeling excited about formalizing a group from this circle, while not really knowing what it might accomplish or become. That enterprise became Group Material, to which I belonged for seventeen years. Although we all created it, and those who joined later helped develop it as well, Tim proved a primary force in Group Material until he left late in 1987 to focus on his work with K.O.S.

Tim is a born teacher, and I became his earliest unofficial student. He understands what it means to feel underdeveloped and yearning, and he fashions methods to counter those conditions. His buoyant attention draws forth latent capacities. He propels people to grow, and to learn how to trust themselves. He nourishes by example. He catalyzes. He prods. He cajoles. And he continually signposts potential paths for discovery, action, and agency.

For Tim, art inherently involves teaching and learning, the symbiotic passions at the core of his being. For Tim, art is a social practice—a collaboration with history and with people in the present. His disposition—already apparent at eighteen—comes across thirty five years later through the testament of practice: in bodies of work produced collaboratively, in the group structures he has catalyzed, and in the individuals transformed by their connection with Tim, forever changed by their joint actions.

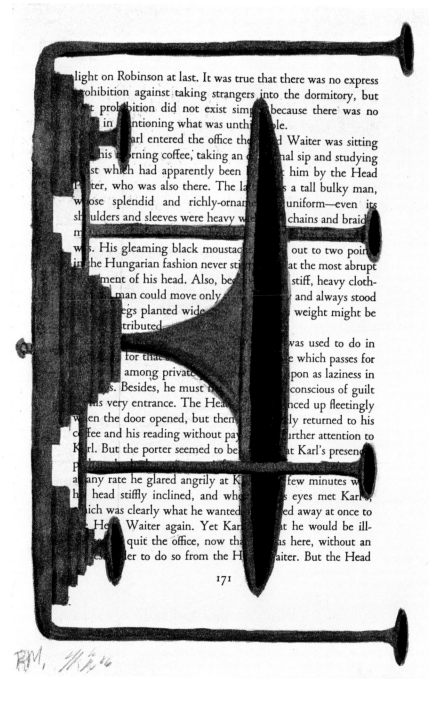

light on Robinson at last. It was true that there was no express prohibition against taking strangers into the dormitory, but t prohibition did not exist simply because there was no in entioning what was unthi ble.

arl entered the office th d Waiter was sitting his orning coffee, taking an d nal sip and studying st which had apparently been him by the Head ter, who was also there. The la s a tall bulky man, w ose splendid and richly-ornam uniform—even its sh ulders and sleeves were heavy w chains and braid m

w s. His gleaming black moustac out to two poin in the Hungarian fashion never st at the most abrupt ment of his head. Also, be stiff, heavy cloth- man could move only y and always stood gs planted wide weight might be tributed

was used to do in for tha e which passes for among privat pon as laziness in s. Besides, he must conscious of guilt is very entrance. The Hea need up fleetingly w en the door opened, but then ly returned to his c ffee and his reading without pay urther attention to K rl. But the porter seemed to be at Karl's presenc P a ny rate he glared angrily at K few minutes w h head stiffly inclined, and whe s eyes met Karl ich was clearly what he wanted ed away at once to He Waiter again. Yet Kar t he would be ill- quit the office, now tha as here, without an der to do so from the H aiter. But the Head

171

Study for AMERIKA (AFTER FRANZ KAFKA), 1985–86
Watercolor on book page
8 x 5 ¹/₂ inches
Private collection

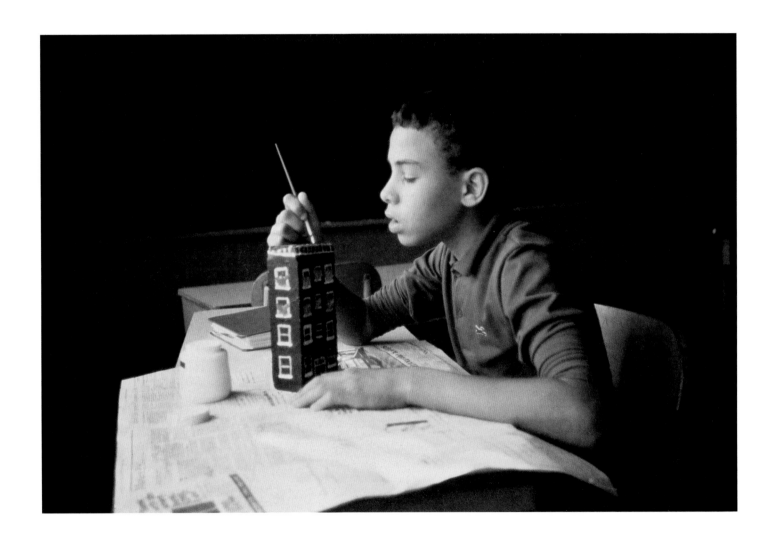

Roberto Ramirez, working in classroom at I.S. 52, 1982

(facing page)
UNTITLED (BRICKS), 1982–83
Tempera, acrylic on found brick
Approx. 8 x 3 ¹/₂ x 2 ¹/₂ inches
Courtesy of Brooke Alexander, New York

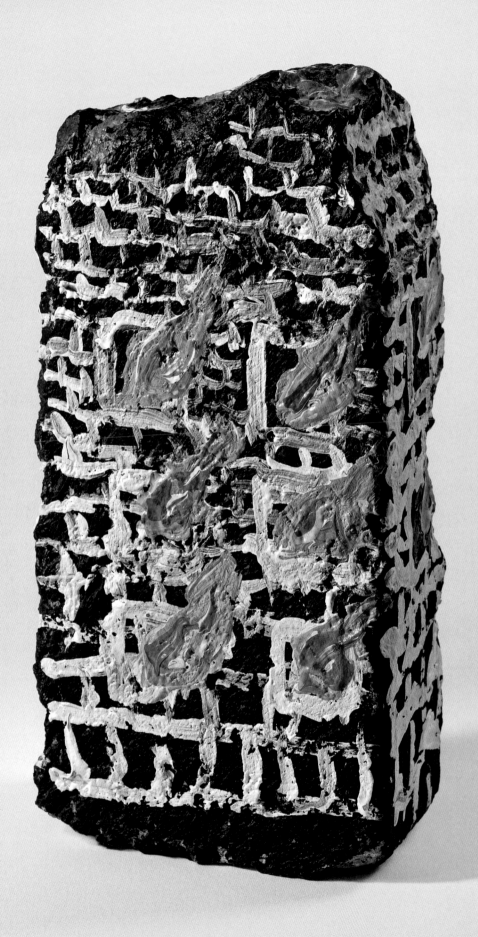

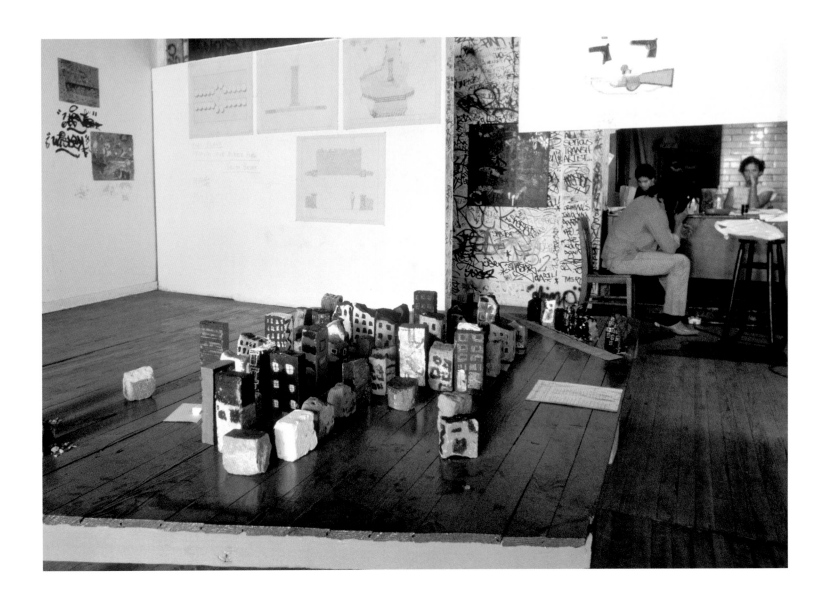

Installation view, Fashion Moda,
Bronx, New York, 1984
© Lisa Kahane, NYC

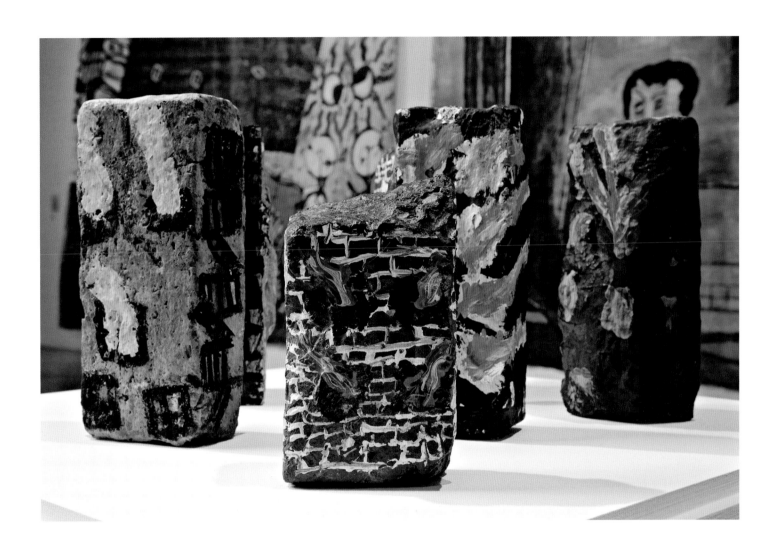

UNTITLED (BRICKS), 1982–83
Tempera, acrylic on found brick
Approx. 8 x 3 ¹/₂ x 2 ¹/₂ inches each
Collection of Peter Stern, courtesy of the artists and
Lehmann Maupin Gallery, New York; Courtesy of
Brooke Alexander; Collection of David Deitcher;
Collection of the artists
Installation view, ICA Philadelphia, 2009

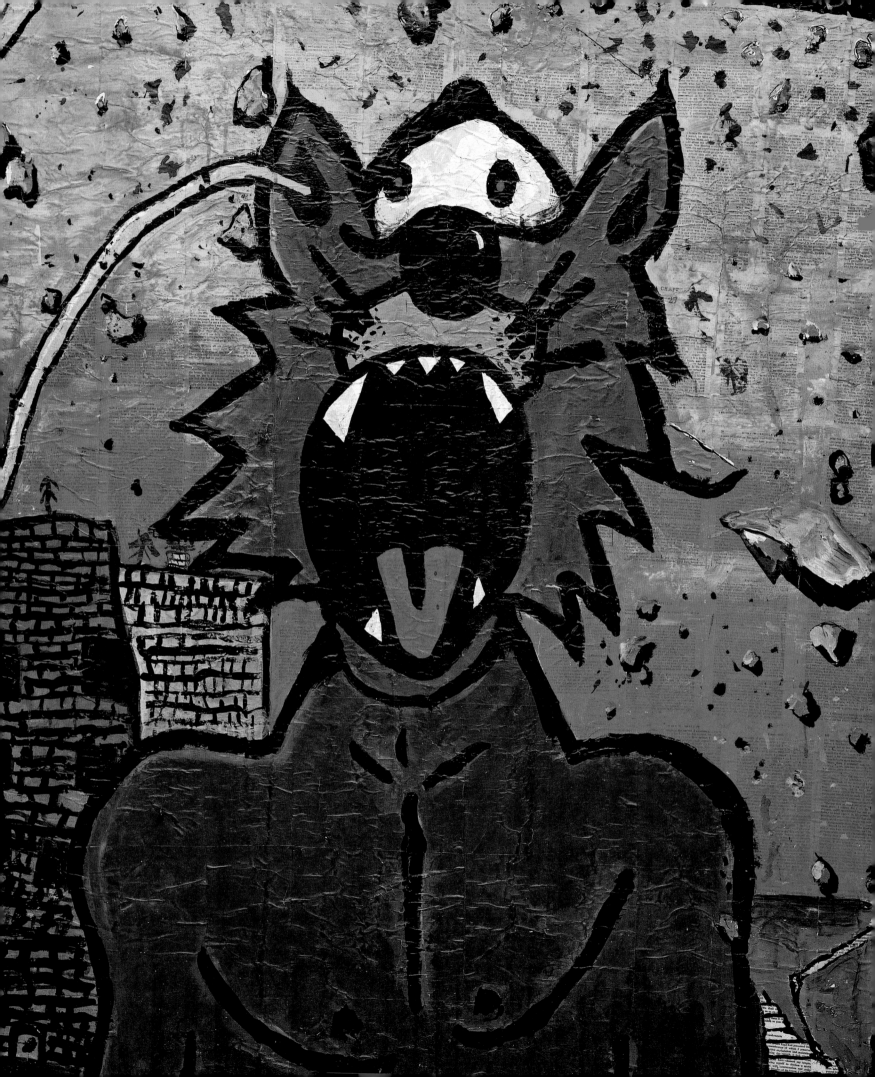

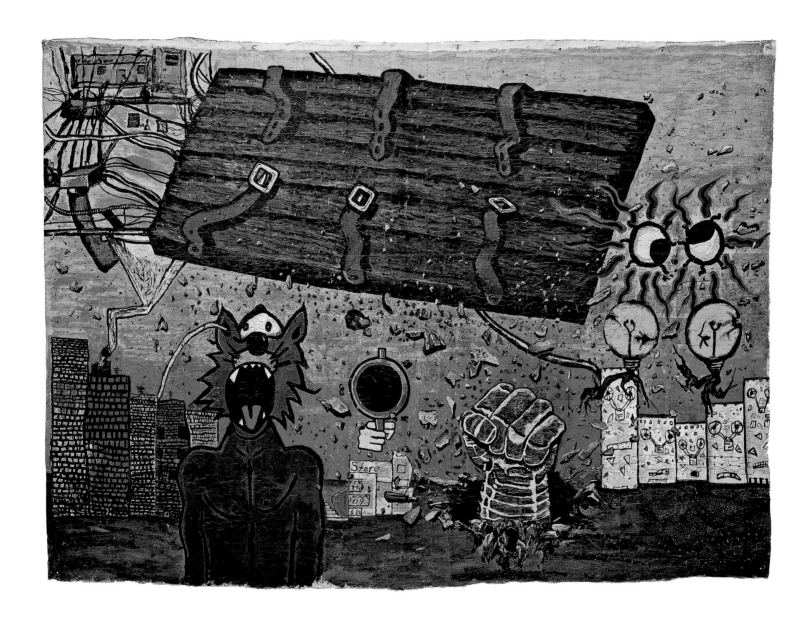

This page, detail facing:
FRANKENSTEIN (AFTER MARY SHELLEY), 1983
Acrylic on book pages mounted on canvas
Irregular, approx. 113 ³/₄ x 158 ¹/₄ inches
Courtesy of the artists, Galerie Eva Presenhuber, Zurich,
and Galleria Raucci/Santamaria, Naples

Facing page, detail on overleaf:
DRACULA (AFTER BRAM STOKER), 1983
Acrylic on book pages mounted on canvas
Irregular, approx. 108 x 144 inches
Collection of the artists

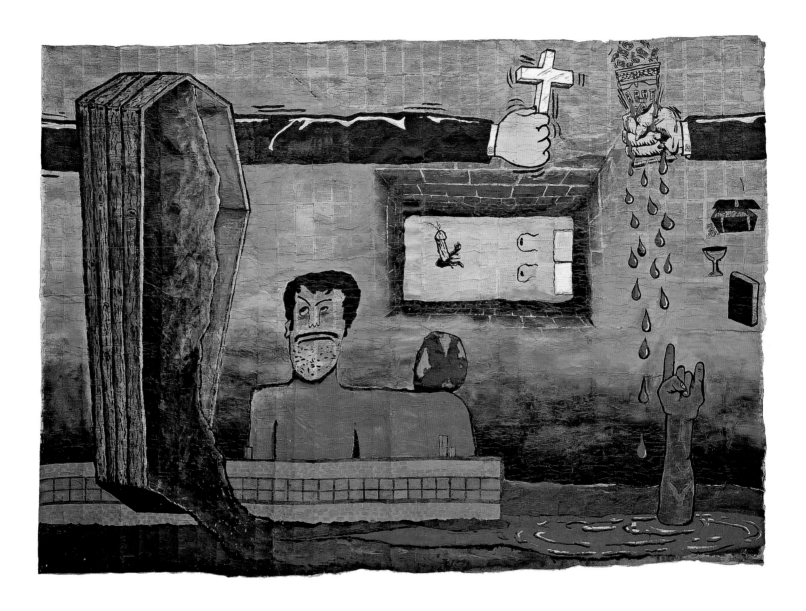

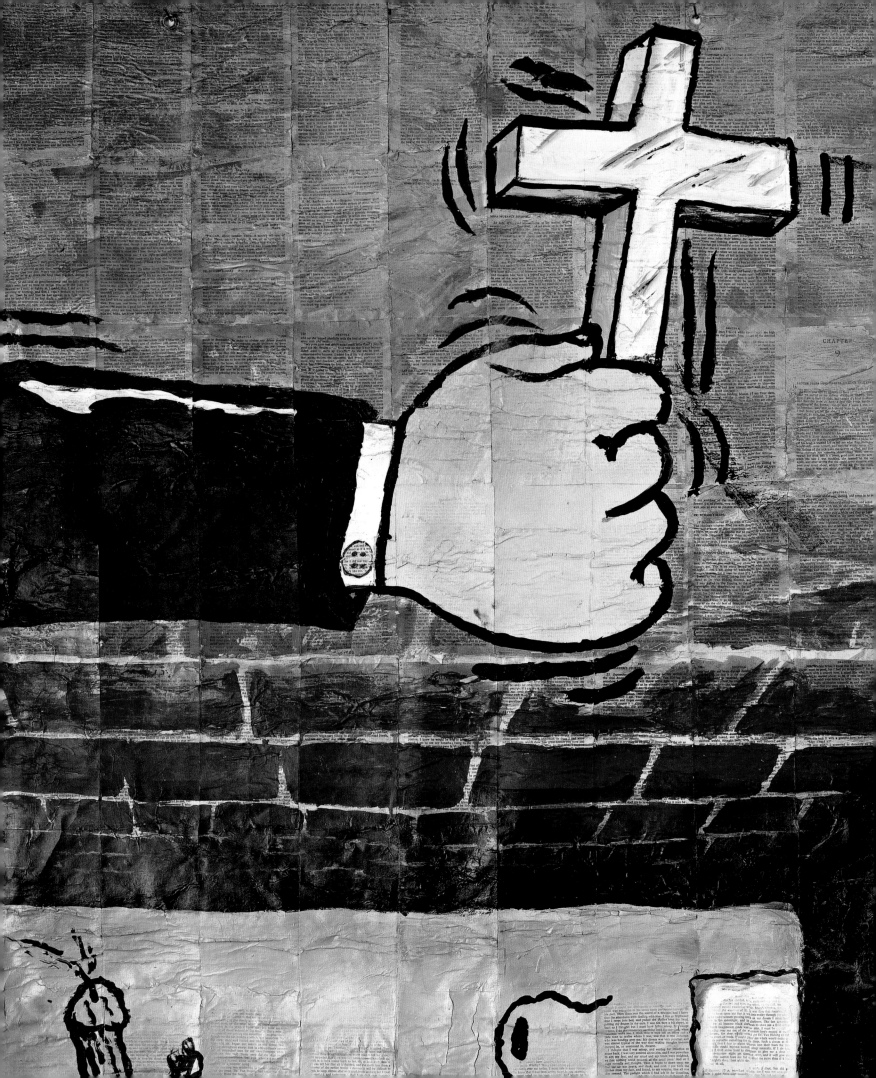

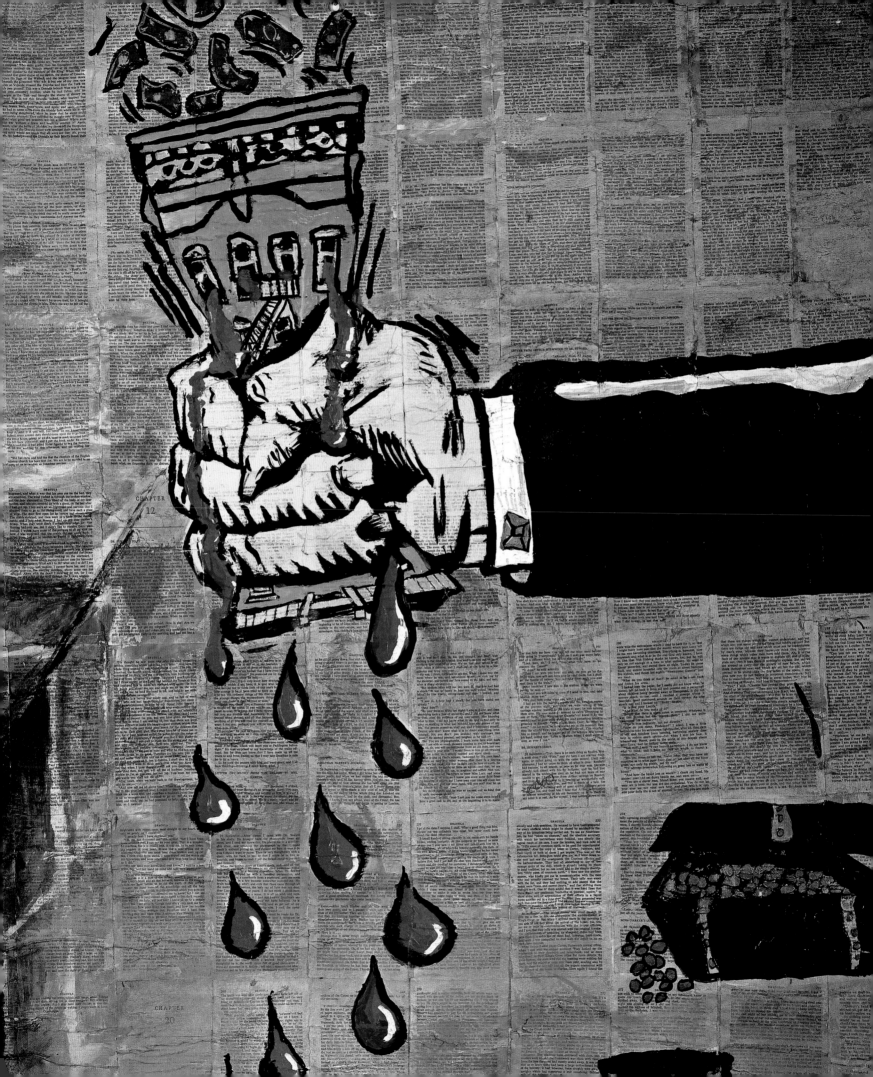

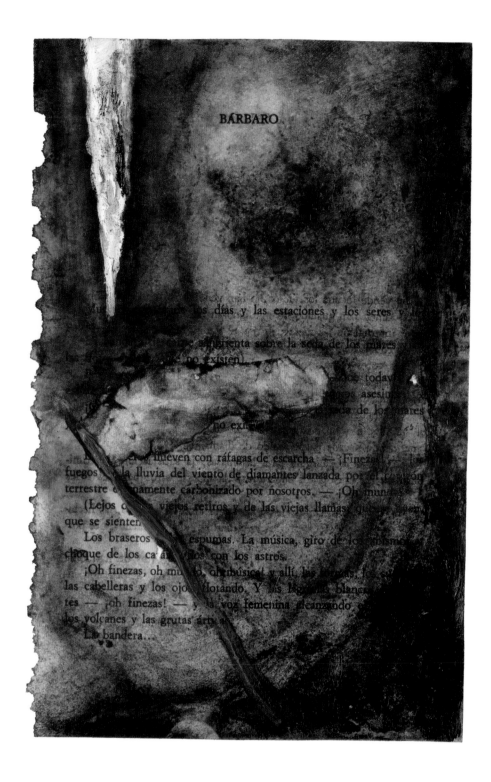

BÁRBARO (AFTER RIMBAUD), 1983
Acrylic on book page
5 7/8 x 3 3/4 inches
Jersey City Museum, New Jersey
Gift of Benjamin J. Dineen III, 2003

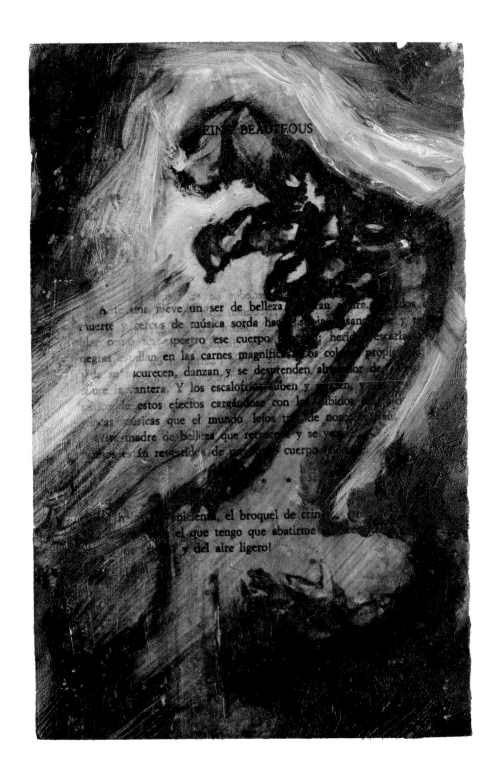

BEING BEAUTEOUS (AFTER RIMBAUD), 1983
Acrylic on book page
5 7/8 x 3 3/4 inches
Jersey City Museum, New Jersey
Gift of Benjamin J. Dineen III, 2003

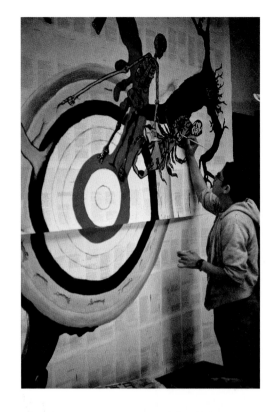

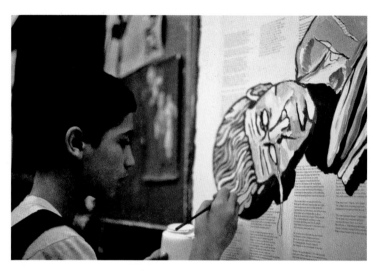

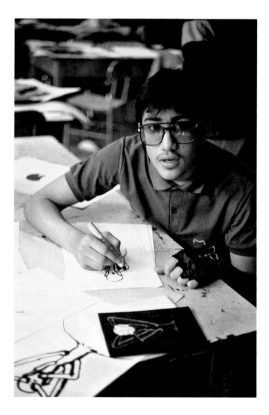

Making THE INFERNO (AFTER DANTE ALIGHIERI), 1983–84
top left: Robert Delgado
bottom left: Roberto Ramirez
bottom right: Adalberto Badillo

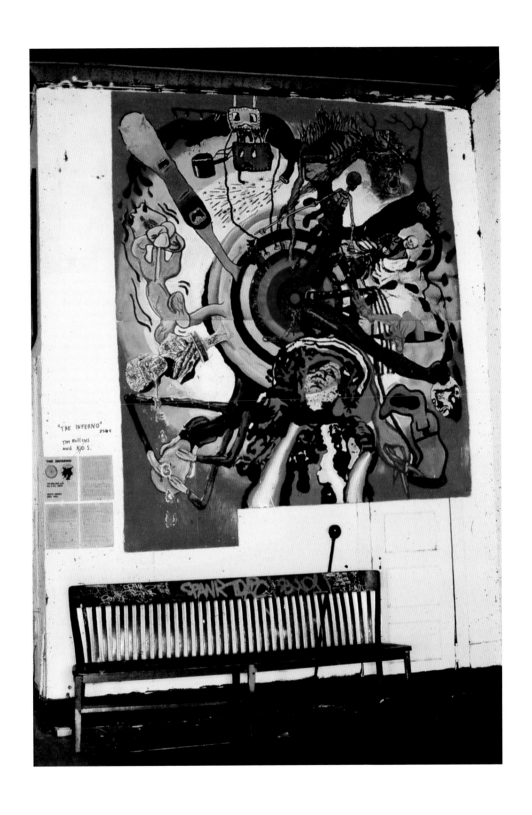

Installation view, Fashion Moda,
Bronx, New York, 1986

THE INFERNO

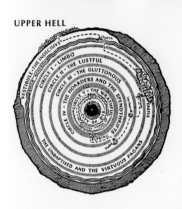

UPPER HELL

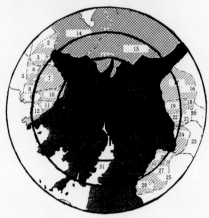

Bombed area (Nagasaki City)

Area regarded as including A-bomb
victims as of 1 October 1974

Area regarded as including A-bomb
victims as of 18 September 1976

× Hypocenter

——— Present city limits of Nagasaki

——— City, town, and village limits as of
9 August 1945

TIM ROLLINS with the K.O.S. CREW

SOUTH BRONX 1983 - 1984

THE METHOD : I am an artist who works as a regular schoolteacher in a
public junior high school in the South Bronx. In my studio I work with
about 70 adolescents who've been categorized as learning-disabled or
emotionally handicapped. The kids and I have been making art together for
about three years now.

In the process of producing art for a large public audience, we are
forced to struggle with issues often ignored in school : problems of learn-
ing what actually interests and involves us, problems of representing
ourselves directly and with honesty , problems of the political and economic
factors that determine our lives. While the art objects we make are vital,
the learning process that culminates in these objects is far more important.
We use art as a means to knowledge of the complex forces that support or
undermine our society and our future. In addition, we're attempting to
prove that the ghetto of the art world must begin to recognize the value
and importance of things that an excluded yet vast segment of the
American people have to say, even if they are just kids or non-artists.

Lately we've been painting on books. Our method works something like
this : I select a piece of literature that I believe speaks to issues that
the kids might relate to and be interested in. I read with the kids,
defining unfamiliar vocabulary or paraphrasing while I go along. While
I read, many of the kids "jam" - that's what we call making literally
hundreds of small drawings. The drawings do not illustrate what is being
read; the object is to relate the content of the book to what we know,
feel or sense in our everyday lives. After we've made stacks of drawings,
we begin to edit, reducing the number of pictures to a small amount of
images that seem the most true and exciting. Transparencies are made of
these small selections. Using an overhead projector on a moving cart,
we compose and draft the large piece. Each kid then gets to paint his or
her own enlarged drawing on a ground of pages torn from the book that
provided the inspiration for the art. In this way the book becomes a
literal and metaphorical foundation for our new (our own) form and content
and method. The book is transformed from something we're supposed to
consume into an artwork with immediate, relevant and concrete social uses
for us today.

ABOUT THE INFERNO :

Our newest painting, THE INFERNO, is the culmination of over a
year of study, planning and making. The beginnings of this work can
be traced back to one our our first collaborative artworks, HYPOCENTER:
SOUTH BRONX, first shown at Ronald Feldman Fine Arts' "The Atomic Salon"
exhibition a few years ago. In the center of this piece was a super-
imposition of two maps : one of the target area of Hiroshima in 1945 and
the other of Prospect Ave., the neighborhood in which we live and work
today.

It was after Hypocenter when the kids and I began working with and
on books. I had never read Dante (he being of those authors strictly
and automatically assigned in my high school lit. classes.) It was
through the films and writings of a man named Pier Paolo Pasolini (a
major guide of mine) that a modern appreciation seemed possible.

Several pages into one of the many editions of The Inferno I first
investigated, I found Scott-Giles' great diagrams of Dante's System of
Hell. The placement of the nine rings immediately reminded me of those
defense department maps of Hiroshima from our work before. I showed
both maps, both systems of destruction, to the kids and the work took off !

Guide to THE INFERNO (AFTER DANTE ALIGHIERI), 1983–84
Courtesy of Fashion Moda Archive, Fales Library and
Special Collections, Elmer Holmes Bobst Library,
New York University

To reinterpret a work of the magnitude of Dante's , we needed the help of art history, not to ransack it for quotations, but to find the older struggles that produced the older pictures, gaining encouragement from these great images for the enormous struggles our generations face in the Present. Instead of leaving the painting as an intellectual puzzle for the historians and the art critics, here's a direct, select list of the stuff we looked at : Delacroix's The Bark of Dante, Grunewald's Isenheim Altarpiece and drawings, Dr. Seuss' Lorax and new Butter Battle Book, Puyol's revolutionary poster illustrations from the Spanish Civil War, Frida Kahlo's What the Water Gave Me, stills from Pasolini's Canterbury Tales and Salo, Leonardo's studies of facial expressions for The Battle of Anghiari and his St. Jerome, Jasper Johns' Target with Body Parts, Otto Dix's war etchings, Botticelli's drawings for the Divine Comedy, Dore's Divine Comedy, photos of victims from Hiroshima and Nagasaki, Gericault's Raft of the Medusa, Munch's The Scream, Jack Kirby's new Captain Victory comic book series, the Blake watercolors of the Comedy, the package art from a big box of Tide laundry detergent and last, but maybe most important, the huge painting on the front of the Hellhole ride at Coney Island.

We want to turn these images into active forms of freedom against those other very active forces who would bring an end to human history and culture as we know it if they are left without our resistance.

Tim Rollins
1984

STATEMENTS (references to images starting from multi-armed ghost moving
 clockwise)

VESTIBULE : The Undecided
 This painting is for the people who don't want to see or hear or say what's going on. They just sit and worry and do nothing.
- Adalberto Badillo

CIRCLE I : Limbo
 Aristotle must be having a nervous breakdown by now.
- Harvey Moore

CIRCLE II: The Lustful
 This is the new story of Francesca and Paolo. Sex turns into a mutant.
- Jose Carlos

CIRCLE III: The Gluttonous
 It seems like most of the world's leaders don't want to serve. They just want to eat.
- Steven Hernandez

CIRCLE IV: The Hoarders and the Spendthrifts
 The machines have power and they take the people's money and blood, then they buy ammunition with it, then they figure out a way to get the people they made poor to fight their battles for them.
- Roberto Ramirez

CIRCLE VI.: The Heretics
 A nuclear war would be like picking up the whole world and throwing it into a tomb of fire.
 (note: Circle VI and V are not in sequence - Cesar Ruiz
 on the painting.)

CIRCLE V : The Wrathful
 You have got to be full of burning hate to start a big war. Sometimes you can see it on people's faces. I bit a lot from Leonardo when I made this picture.
- Luis Feliciano

CITY OF DIS
 Intense are the crimes of all. Even in their homes, one can see the flames of crime shoot out, as if to engulf homes with fire. Their buildings are not strong enough to conceal their past.
- Ms Dolores Royal
studio co-teacher

CIRCLE VII : Circle of Violence

1. The River of Blood
 Everything will be washed in blood, but nothing will ever get clean.
- Eric Ramirez

2. The Wood of the Suicides
 There was only one Jesus. I don't want to die for other peoples' sins.
- Anthony Cruz

3. The Old Man of Crete
 Human civilization could turn from gold to clay in an instant.
- Adalberto Badillo

4. Geryon
 People with honest faces lots of times have the bodies of scorpions.
- Armando Perez

VIII : MALABOLGIA (Fraud Simple):

1. Whip and Excrement
 No matter what, being the victim is humiliating.
- Anthony Dixon

2. Talking Feet
 The burning feet poke out of the hole of death. They tell us warnings.
- Nestor Ortiz

3. The Hypocrite
 The Hypocrite wears a cloak of gold to cover the heavy lead he hides inside.
- Felix Cepero

4. Arm with the Head of Saint
 Even the heads of the saints have been blown off. They are still trying to talk to us.
- Jesus Ruiz

CIRCLE IX : Circle of Traitors and Lucifer

 The face of Lucifer isn't a fake monster. It could be the face of a kid who got burned alive in a place called Hiroshima.
- Roy Rogers

BACKGROUND :

 If that bomb goes off, the Earth will glow in rings. The universe will never be the same.
- Kevin Smalls

Canto XVII

...is described; to whom while
...harry them both down to the
...a little further along the edge of
...scenes of sinners contained in this com-
...have done violence to Art; and then
...they both descend, seated on the back of

...with the deadly ...ing,
...rains, breaks throu... ...enced walls
...ed spears, and ...th... ...il h
... Thus ...e ...by ...ld ...address'd,
...that he should...e ...sho...
...seiz...d ...itnes...

...le of Fraud a... ...,
...pa... exposed on ...
...sho... his bestial t...
...le of a just man's
... ...s outward ...
...wo ...aggy cla...
...back an...
...te ...oter with n...
...more
...th of state
...wove,
...nnis loom.

As oft-timesull ...
Stands part in ... p...;
Or as where ... th...rato
The beaver ...od ... wa...
So on the rim ...ng, Grc... ...
Sat perch'd the ...nd o...
Glancing, his ...noud...
With sting like scorpio...
"Now ...need... ...lay m...
...t ...s to ...a... ...east,the

The ...at, ...y, ...the ...o... ...uward
We shaped, ...ll ...etter th...
And ...urn ng ...ar... ...an...
Proceeded. So ...e ...se to...
...little further ...ne ...ne ey...
...ily of e...t... ...ed on
...ar to the ...s...
...at to this ...
...all this ...
...en th...
...their re...
...arly, ...atin as...
...air of ...a...ong ...hu...
...ar ...he extra...
...even ...eir le...
... As ...e eyes ...
...e ...apo... ...
...ch ...eing h...

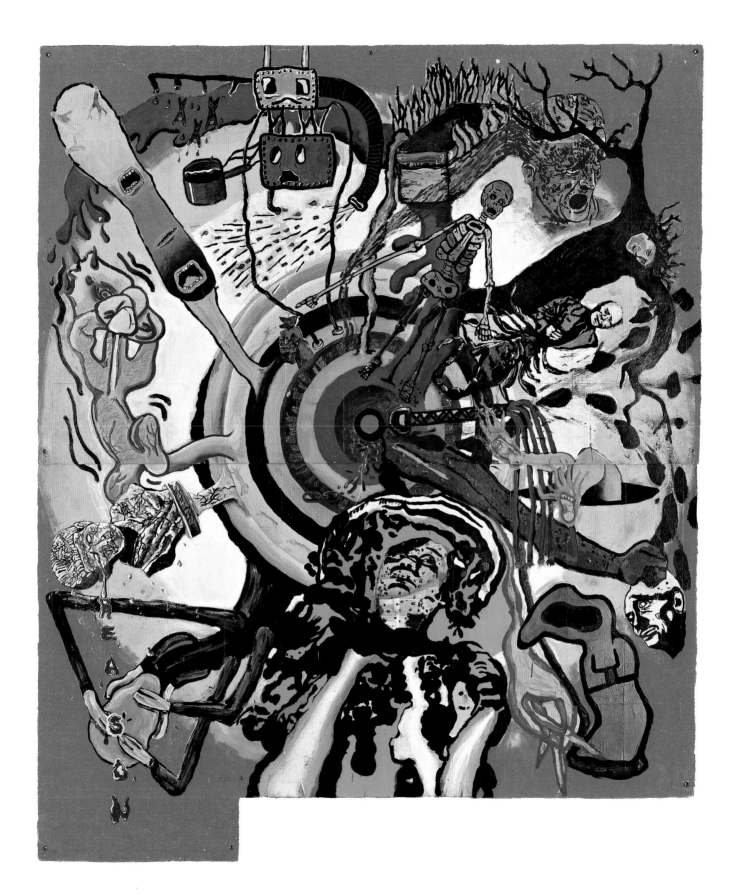

This page, detail facing:
THE INFERNO (AFTER DANTE ALIGHIERI), 1983–84
Acrylic on book pages mounted on paper
120 3/4 x 108 inches
Collection of John Ahearn

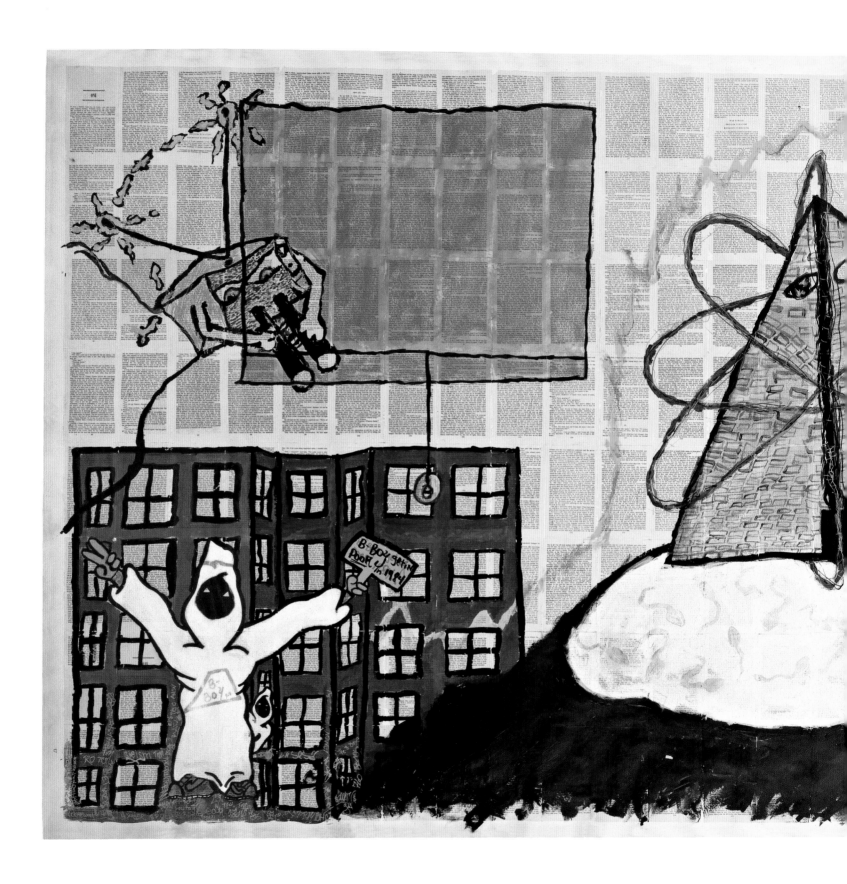

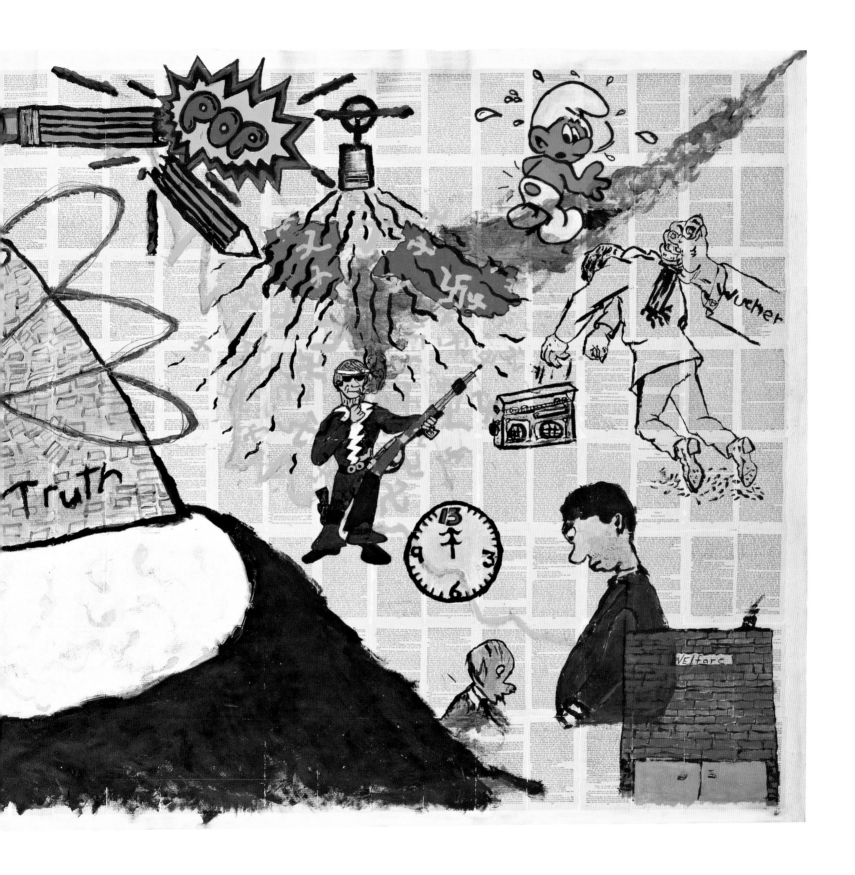

IGNORANCE IS STRENGTH (AFTER GEORGE ORWELL), 1984
Acrylic on book pages mounted on linen
57 x 124 inches
Collection of Barry and Arlene Hockfield

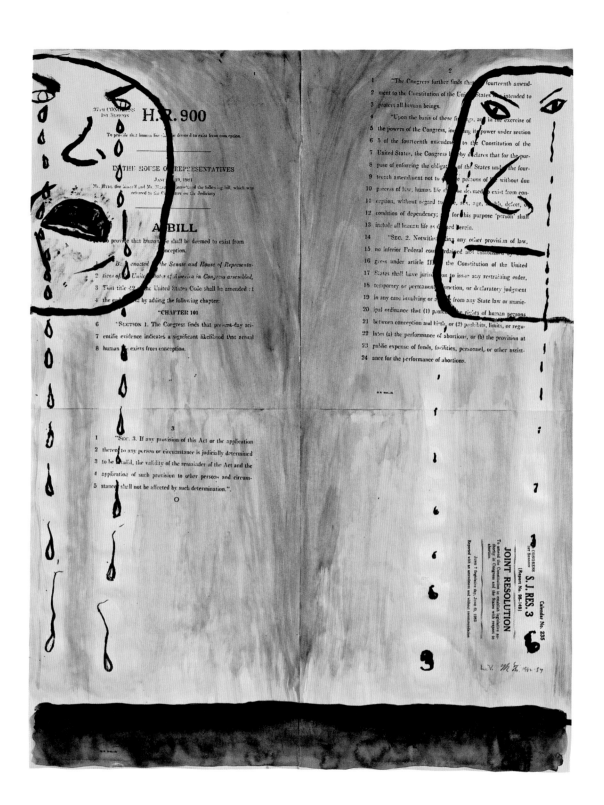

ANGRY FATHER AND MOTHER, 1982–84
Watercolor on anti–abortion legislation
21 5/8 x 16 7/8 inches
Collection of Alice Zoloto–Kosmin

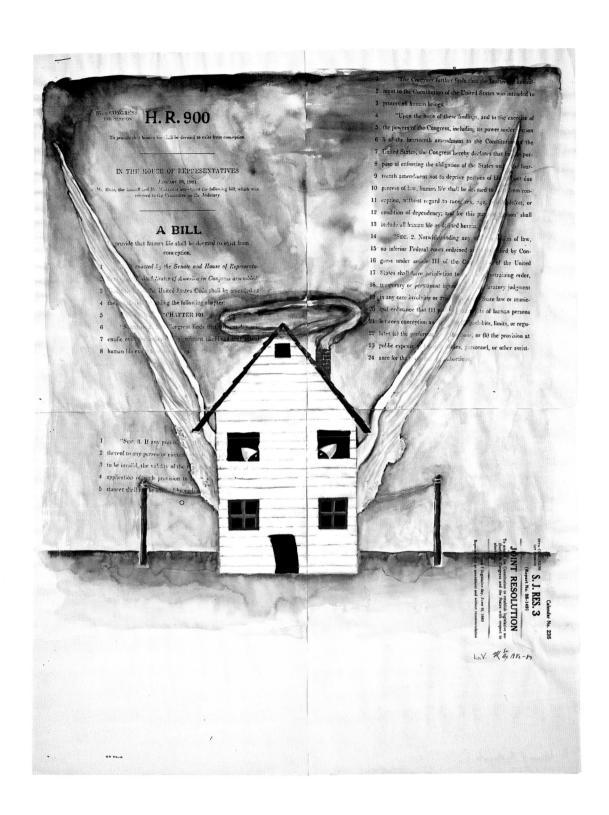

HOUSE OF THE ANGEL, 1982–84
Watercolor on anti–abortion legislation
21 5/8 x 16 7/8 inches
Collection of Alice Zoloto–Kosmin

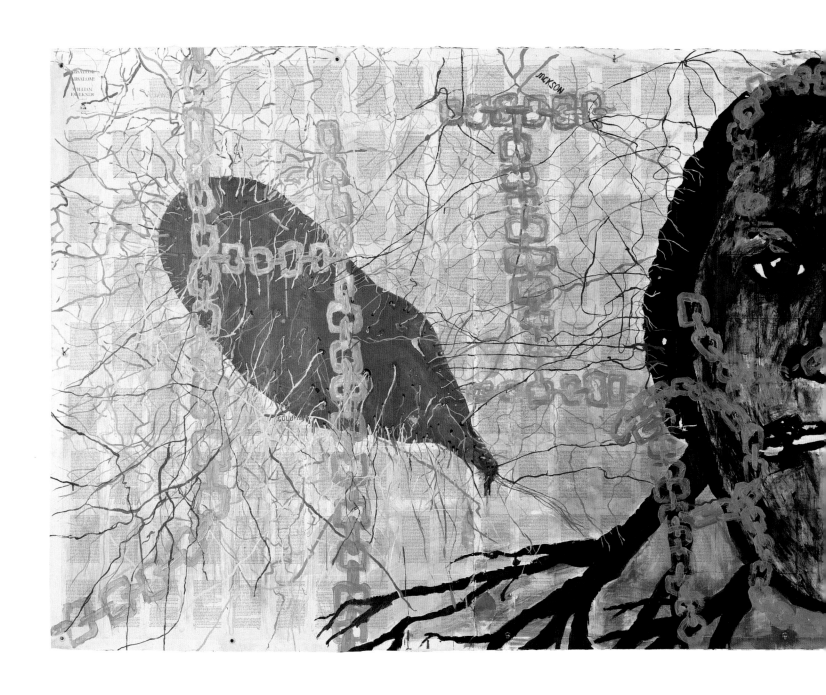

ABSALOM, ABSALOM! (AFTER WILLIAM FAULKNER),
1983–85
Rope, oil and acrylic on book pages mounted on paper
60 x 180 inches
Emanuel Hoffmann Foundation, on permanent loan
to the Kunstsammlung Basel

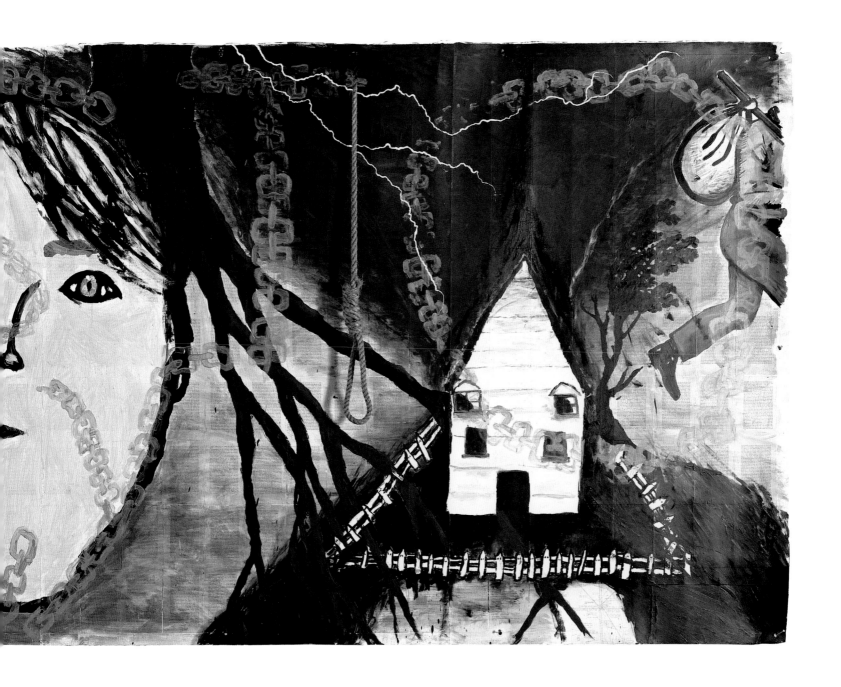

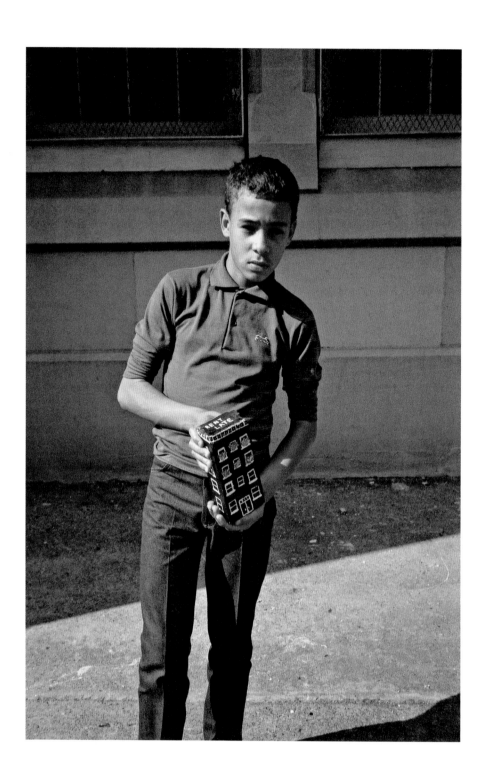

Roberto Ramirez, outside I.S. 52, 1982

JAMES ROMAINE

MAKING HISTORY

Setting a Fire in the Bronx

"Today we are going to make art and we are also going to make history."[1] With this declaration, artist, activist, and educator Tim Rollins introduced himself to a group of sixth-grade special-education students at Intermediate School 52 in the South Bronx. Of course, Rollins could not have predicted that some of these students, including Jose Carlos, Felix Cepero, Adalberto Badillo, Richard Lulo, Joel Nieves, Jose Padilla, Roberto Ramirez, Roy Rogers, Jesus Ruiz, and Jose Ruiz, would join him in founding one of the most celebrated and controversial artistic collaborations of the past half-century.

In August 1981, Rollins met Arthur Albert, a crisis intervention teacher at I.S. 52, at a Learning to Read Through the Arts workshop held at Community Elementary School 4 in the South Bronx. Albert asked Rollins to come to I.S. 52, and after meeting with Principal George Gallego, he agreed to a two-week visit to design a program that a yet to-be-hired, full-time teacher would implement. At the end of his first day, he accepted Principal Gallego's invitation to stay on as an "appointed temporary per diem" teacher. After two years, Rollins earned his teaching license and would remain at I.S. 52 until 1987.

When Rollins first saw the South Bronx, he believed he had arrived at "hell on earth."[2] He recalls stepping off the subway at Longwood Avenue to the smell of burning garbage: "You could smell the neighborhood before you could see it."[3] Rollins walked the four-and-a-half blocks to the school through a decimated landscape of burnt-out buildings and vacant lots strewn with trash and urban rubble, roamed by packs of wild dogs, with the remains of Santeria animal sacrifices in front of crack houses. He also saw mothers walking their children to school. Although shocked by this material and social desolation, Rollins was "too naive to turn around and go back to the East Village."[4]

As Rollins arrived, Principal Gallego excitedly called out, "I won, I won; pay up!"[5] He had wagered with some of the other teachers that Rollins would in fact show up. Designed in the early twentieth century by famed school architect Charles B. J. Snyder, I.S. 52 stood in disrepair. Rollins recalls he had been assigned Room 318 as a special privilege, because it had a sink– but with no plumbing underneath; the water drained into a bucket, to be emptied in the bathroom across the hall. This bathroom had no toilet paper so students could not use it to clog and overflow the toilets. This combination of physical dilapidation and lack of student discipline made I.S. 52 a pandemonium that mirrored the worst conditions of the South Bronx at that time.

Although located on the third floor, the art room had no natural light. The windows, all broken out, had been boarded over.[6] "Every square inch of the room was covered in graffiti,"[7] Rollins recalled. "Even the ceiling, which was about fifteen feet high, was covered in graffiti. . . . It was like a hip-hop Sistine Chapel."[8] Principal Gallego explained that the students had taped markers to wooden poles and drawn on the ceiling. Rollins was impressed with the ingenuity of this creative destruction and felt he could direct it into constructive artistic and educational activities.[9]

Such a paradox of artistic creativity combined with physical destruction echoed across the South Bronx: "The Bronx was on fire in two ways at once. It was literally being destroyed by arson and there was the explosion of the hip-hop movement.... So it was a horrific time and a fantastic time to be in the South Bronx."[10]

Of the works Rollins and his students created at I.S. 52, *Untitled (Bricks)* may best exemplify art making as a strategy of creatively transforming their environment. This project began with an assignment to reclaim an object from an abandoned lot across the street from the school and imagine it as something else. Roberto Ramirez, from the beginning one of the creative leaders in Rollins's class, painted a brick to look like a burning building. Inspired, Rollins and the other students collected more bricks and painted each of them. The first set of approximately fifty bricks sold out in one day at a benefit for Colab at Artists Space, after which Rollins and his students created a second set, exhibited at the Hostos Art Gallery of the Bronx's Hostos Community College, and at the State University of New York at Old Westbury.

Rollins described *Untitled (Bricks)* as portraits of resilience and resurrection: "Each brick was like the student [who made it], solid, a little chipped, a little damaged, taken out of its rightful place, but it is beautiful and survives. . . . We were broke but not broken.... One is a physical or material state; the other is a psychological or spiritual state."[11] Relating this distinction to experiences of his own youth, he added, "Growing up in Pittsfield, Maine, my mom would say, 'We aren't poor, we just don't have a lot of money.' It's not about how much you have, it's how you look at yourself and how you look at what you do have." This distinction between being broke and being broken resembled the contrast between Rollins and his students' inherited environment (what they were given) and the inherent potential they perceived

within each brick and, by extension, each of themselves. Making the art became a process of transforming their experiences by revealing their capacity to remake their own destiny.

When asked to elaborate on what he meant by "making history," Rollins explained:

It is about surviving, not just physically but spiritually. It is about doing something or making something that extends or survives beyond the maker, beyond you, and has an impact on the world. To believe that you can make history, when you are young, when you are a minority, when you are working, or non-working class, when you don't have the best educational opportunities, when you are voiceless in society, takes a particular sort of faith and courage. Where we came from, where I came from in Maine and where my kids have come from in the South Bronx, just surviving is "making history." So many others, in the same situations, have not survived, physically, psychologically, socially, or spiritually. K.O.S and I weren't going to accept history as something given to us. We were making our own history out of something that wasn't given to us.[12]

Rollins and K.O.S. have developed a collective structure that gives purpose and direction to their personal development and allows for expression of their full creative selves. Their notion of "making history" has been realized in a process of art making as a proactive form of history painting. This practice manifests itself through art objects, which can be seen as vehicles for *creating a more beautiful life and a more beautiful world.*

The Purposeful Artist

Rollins's conception of "making history" was forged and tested during his youth in rural Maine. He adapted his experiences at home, in school, and at church into a philosophy of survival and a sense of artistic purpose profoundly shaped by the Rev. Dr. Martin Luther King, Jr.'s ethos of personal transformation and social change. Reading King, Rollins developed a cognizance of himself as a self-reliant and creative individual with social and spiritual purpose.

Timothy William Rollins, born June 10, 1955, is the eldest child of Carlton Leroy Rollins and Charlotte Imogene Rollins, née Hussey. Until departing for the University of Maine at Augusta in 1973, Rollins lived with his brother Ronnie Lee and sisters Carline Marie and Cindy Sue in Pittsfield, a working-class town in rural Maine with a 1960 population of approximately 4000.[13] Although Pittsfield and the South Bronx initially seem to have greater dissimilarities than commonalities—one rural and white, the

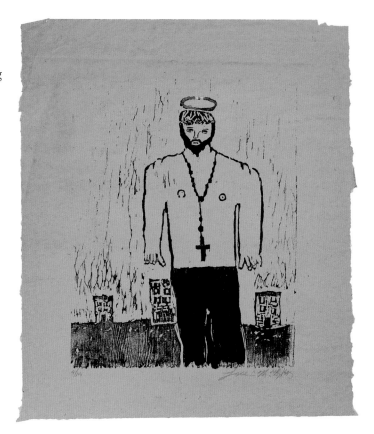

JESUS RETURNS TO THE SOUTH BRONX, 1983
Woodcut and watercolor on kraft paper
20 x 17 inches
Collection of the artists

other urban and African American and Latino—both were close-knit, even insular, communities struggling economically. The youth of Pittsfield and the South Bronx faced comparable challenges of geographic and cultural isolation, low expectations, and limited economic opportunities.

Rollins was fortunate to have teachers who mentored him and encouraged his artistic interests. Aside from church, he primarily explored his artistic interests in school, where his success contrasted sharply with the tensions he encountered at home. He recalls, "I was the kid who always stayed after school to avoid going home. I was in so many groups and clubs, anything to avoid home."[14] Carlton Rollins, a functioning alcoholic, worked in a series of non-unionized factory jobs at Northeast Shoe Company, Dexter Shoe Company, and the Ethan Allen furniture workshop. Even when his father was at home, Rollins always felt an emotional, psychological, and spiritual distance between them. Rollins's mother Charlotte, a loving protector, held the family together despite limited resources through pragmatic ingenuity and sheer tenacity. Although she did not finish high school, she worked as a hospital secretary. "She can make something out of nothing, over and over and over again," Rollins said. "She has an amazing resourcefulness.... I know that I got that from her."[15]

As a boy, Rollins read avidly; he collected *Classics Illustrated* comic books, including Lewis Carroll's *Alice in Wonderland,*

Stephen Crane's *The Red Badge of Courage*, Homer's *Iliad*, Herman Melville's *Moby-Dick*, and Mark Twain's *Huckleberry Finn*, books he and K.O.S. would later engage in their art. By the sixth or seventh grade, Rollins expanded his literary interests to include Martin Luther King, becoming what he called an "amateur King scholar."[16] The expressions of purpose, faith, love, hope, joy, and beauty he found in King's writings and personal example instilled in him ideals for pursuing a personally meaningful, socially consequential, and spiritually fulfilling life.

Rollins's philosophy of survival incorporated the capacity to adapt to and transform adverse situations, as well as a recognition of artistic resolve. A formative influence on Rollins was King's sermon "The Three Dimensions of a Complete Life" in which the civil rights leader proposed that the measure of a person consists of sense of self-purpose, commitment to community, and faith in God. Embracing this, Rollins developed a philosophy of "The Three Dimensions of a Complete Artist," one who had self-determination, was motivated by an ethos of service to others, and ultimately participated in the spiritual redemption of the universe.

As he began to develop his consciousness of himself as an artist, Rollins became interested in the visual artist's potential to help create what King called a "beloved community," an ethical and righteous society defined not merely by the absence of oppression and prejudice but by the presence of love and reconciliation.[17] For Rollins, this meant establishing an artistic practice that not only transcended personal and social limitations but also transformed those impediments into attachments. This faith in the creative power of love and community has motivated and sustained Rollins's collaboration with K.O.S.

"I don't believe that people are determined by their environment," Rollins has said. "If that were true, I would be working in the woods of Pittsfield, Maine."[18] Rollins found in King both motivation and method to redirect his destiny. In his essay "Transformed Nonconformist," King wrote, "Nonconformity is creative when it is controlled and directed by a transformed life and is constructive when it embraces a new mental outlook. . . . Human salvation lies in the hands of the creatively maladjusted."[19] As Rollins stepped into Room 318 at I.S. 52, he intuited that he and his students, by any measure maladjusted nonconformists, would "make history."

Art as Knowledge

Discovering that few of his students could read or write at their grade level and believing it "criminal" to encourage their artistic interests when they could not spell "artistic," Rollins developed a pedagogy that connected their creative abilities with educational exercises.[20] Inspired by his teenage students' creative potential as much as distressed by their illiteracy, Rollins developed a program of reading texts from classic literature and responding to them in works of art. "I would tell my students, 'This is special ed. You are special and you *are* going to be educated.'"[21]

For Rollins, activity directs theory. Rejecting determinist methods of both political action and teaching, which force experiences to conform to abstractions, he turned to pedagogies rooted in his own background as a student. At I.S. 52, Rollins found two principles most applicable: the notion of the self-reliant individual and the adaptability of theory to actuality, precepts he drew from King's ethos of "creative maladjustment."[22] As he began formulating the practices that developed into his artistic strategies with K.O.S., Rollins increasingly turned to authors such as Ralph Waldo Emerson, Henry David Thoreau, and John Dewey.

As a young person in Pittsfield, Maine, Rollins read Emerson's "Self-Reliance" and Thoreau's "Civil Disobedience," texts that articulate the dialectic between the individual and society through the recognition that people are by nature social beings, but that society continually imposes itself on their autonomy. In "Self-Reliance," Emerson plainly states, "Society everywhere is in conspiracy against the manhood of every one of its members.... The virtue in most request is conformity. Self-reliance is its aversion.... Whoso would be a man must be a nonconformist."[23] Thoreau further develops this notion of resistance, describing how, within any social framework, the independent person continuously struggles to transform and transgress the structure. While Thoreau focused on the self-preservation of personhood, Rollins, like King, believed that this struggle meant not only the survival of the individual but also ultimately the salvation of the society.

Rollins's method unites these pragmatist influences: "What I got from Emerson was the notion of...coming up with your own vision of the universe and putting it out there as opposed to taking it as received information."[24] And, speaking of Thoreau, he said, "I have always thought that art, at its best, was a form of civil disobedience. We are not going to take it the way that it was given to us. We have the audacity to have a vision for something new."[25] As Rollins and his students began combining educational exercises and artistic creation, they developed a pedagogy that was nonconformist in its rejection of the received structures of I.S. 52, and adaptive in transforming their South Bronx experiences into haunting works of art.

Rollins and K.O.S. have explored the interaction between the individual and society in several of their works. They created one of the earliest examples, *Frankenstein (after Mary Shelley)*, at I.S. 52 in 1983. A principal theme of Shelley's novel, identity formation, is conversely illustrated by the devolution of Dr. Victor Frankenstein from a creative and brilliant scientist into a self-destructive individual, and the evolution of his creature, who never receives a name, from an accumulation of dead body parts

into a person desiring to know himself and have relationships with others. As the creature becomes increasingly self-aware and desirous of human contact, he also becomes conscious that others perceive and reject him as a hideous monster.

Rollins and his students channeled their own rage into the creation of a work that visually manifested their self-perception, as well as their recognition of the perception of others, of their own "monstrosity." Toward the lower left of *Frankenstein (after Mary Shelley)* Jose Padilla painted a werewolf creature meant as a self-portrait. The machinery at the upper left is by Michael John Gonzalez, the operating table by Adalberto Badillo, one of the best students in the class, the gun by Alberto Rivera, and the eyes by Roy Rogers, one of the class leaders. The identical twins Jesus and Jose Ruiz, who delighted in confounding their teachers by pretending to be each other, created the image's light bulbs. John Mendoza, whose family had been burned out of their apartment three times by arsonists, drew the computers and also the store. Joel Nieves, inspired by the character Galactus from the Silver Surfer comics, produced the fist, that seems to break through the bottom of the painting. Although not classified as learning disabled, Nieves joined Rollins's class because of his artistic interests.

Although influenced by Jane Addams, Robert Coles, Ivan Illich, and Paulo Freire, Rollins's main pedagogical point of reference was the American pragmatist John Dewey. He adapted and combined three of Dewey's principal theories—education as a medium of democracy, "learning by doing," and art as an experience—into a practice that Dewey probably could not have anticipated. This pedagogy distinguished between "teaching" as a process of giving students information to take in and "educating" as a process of creating situations and experiences that drew learning and knowledge out from them. Rollins said:

> As an educator, you do not give students anything; you can only be a resource. You take what the students already know and expand upon that, as opposed to dumping a truck load of new stuff on them that has no particular relevance to the student's lives…. Educators draw, they make a mark; they draw out, they discern what the students have and challenge them to develop that into an ability. I've never met a person in my life who doesn't have a gift. The educator has the power to make something that is there manifest and material.[26]

Rollins adapted Dewey's concept of "learning by doing" into a strategy of "educating by art making," a collaborative process among Rollins, his students, and their material. Rather than reading books as received knowledge, Rollins and K.O.S. responsively paint directly upon their texts, creating something new that actualizes their learning experience. As it mirrors the dialogical struggle between the individual and the environment, the work of art becomes a transgressive form of knowledge that both exists in the world and has the capacity to transform it.

As it produces in material form the lasting and transforming impact of the educational experience, the work of art becomes a catalyst for a creative knowledge awaiting realization in future action outside the classroom.

At I.S. 52, Rollins and his students evolved a collaborative strategy that combined educational exercises in reading and writing with the production of works of art. He or one of the students would read aloud from the selected text while the other students would responsively sketch with pencils on Xerox paper, the best materials that Rollins could "liberate" from the office; the students would sign and number their sketches.[27] Other reading and writing assignments, such as journaling, would center on developing a collective analysis of the text's historic meaning and modern relevance. After a period of collecting sketches and developing various visual motifs, the group would identify collectively the most successful drawings. Sometimes these selected drawings would initiate a new cycle of responsive sketching. After arriving at visual motifs that satisfied them, designs that would "take the text and visual motif to a level beyond even what we could have initially imagined," Rollins and his students would unbind the book pages and attach them in a grid on a canvas.[28] Often using an overhead projector, a method they still employ, they would transfer the selected motifs onto the book pages.

Amerika I (after Franz Kafka), one of the last works created at I.S. 52, provides evidence of their success. In Franz Kafka's unfinished novel, a young immigrant boy named Karl Rossmann escapes the designs of his family and friends who mean to control and exploit him, finally joining a utopian traveling troupe, the Nature Theatre of Oklahoma, whose motto is "Everyone is welcome," where two rows of figures blowing golden trumpets greet him. Rollins and K.O.S., following their method of developing imagery through cycles of sketching and re-sketching in response to the text, focused on the motif of the golden horn as a visual emblem of their own creative voice. In the catalogue for their exhibition of the *Amerika* series at the Dia Art Foundation, Rollins recounts how he and more than one hundred students worked on drawings of golden horns.[29] Most looked like fairly realistic renderings of instruments until Gregorio Torres, who had been truant for a week, arrived back at school with an assortment of the most unusual and strange horns. Fired up, students competed with each other to create the most unconventional horns. The group selected the best forty of these drawings to transpose onto the larger work.

Amerika I (after Franz Kafka) culminates Rollins and K.O.S.'s first stage of development. Relying on a diversity of sources, including comic books, graffiti, horror movie posters, and modernist expressionism, *Frankenstein (after Mary Shelley)* and *Ignorance is Strength (after George Orwell)* evidenced an abject-

expressionist aesthetic of struggle. Even though *Amerika I (after Franz Kafka)* contains embedded references to Matthias Grünewald, Marcel Duchamp, and Joseph Beuys, it demonstrates how Rollins and K.O.S. had developed an aesthetic uniquely their own, which graphically realized the ethos of community out of which it grew. Furthermore, Rollins and K.O.S. were increasingly creating their own visions rather than responding to received experiences. This evolution in tactic from holding up a mirror to injustice to creating an instrument of beauty proved significant, perhaps even more consequential than the discovery of painting on book pages.

Everyone is Welcome

Although Rollins continued working at I.S. 52 until 1987, the methodological and practical maturation of his partnership with his collaborators became increasingly limited by the school's schedule and institutional parameters. With as many as forty students per class period, in a school day composed of eight forty-five-minute periods, it was impossible for Rollins to give attention to every student. While some students stood out for their creativity, artistic talent, or misbehavior, others disappeared in the crazed, over-crowded classrooms designed for fifteen students. As their collaboration evolved, Rollins and his most dedicated students would meet during their lunch period and after school hours to make their art.

In 1984, Rollins and K.O.S. matched an $8000 grant from the National Endowment for the Arts and opened the Art and Knowledge Workshop at 965 Longwood Avenue, two blocks from I.S. 52. This studio was a spacious former gymnasium on the third floor of a school converted into a community center. At the end of each school day, from three p. m. until seven p. m. or later, sometimes even past midnight and often on weekends, Rollins and K.O.S. members would meet at the workshop; homework would be done, and art would be made. In this studio, Rollins could give more individual attention to a self-selecting group of young artists. Having escaped I.S. 52's overflowing classrooms, Rollins and K.O.S. now had the physical and psychological space to become a genuine team. This renewed optimism, self-confidence, and sense of accomplishment are evident in the aesthetic lightness of the new series of works they began to produce.

By 1984, Rollins and K.O.S.'s artistic strategy of painting on book pages had matured into the method they continue to employ. They began to create works such as *The Whiteness of the Whale (after Herman Melville)*, overlaying appropriated texts with minimalist-influenced imagery, both abstract and representational, at once more accessible and more veiled in their meanings. While Rollins has insisted that K.O.S. initiated this shift and that it reflected their changing conceptions of themselves from social victims to self-directing individuals, some critics have speculated that Rollins orchestrated these changes in order to make their work more marketable. Rollins countered that, in fact, abjection had greater commercial appeal:

We were never intentionally abject. That was something we had to work through about ourselves and our own self-image in works like *The Inferno (after Dante Alighieri)*, *Dracula (after Bram Stoker)*, and *Frankenstein (after Mary Shelley)*.

Studies for AMERIKA–A REFUGE
(AFTER FRANZ KAFKA), 1991
Watercolor on book pages
16 x 13 inches each
Private Collection

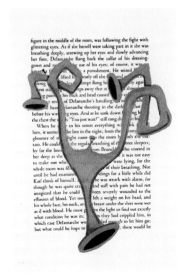

…. The abject was what was expected of us. We were either supposed to represent African American and Latino clichés or be doing paintings about our constant and irredeemable suffering. Both are quite tired, boring, superficial, simplistic…. What was not expected of us was something beautiful and explosive. That beauty was what the kids most wanted to make. Beauty was not given to us. We had to make our own beautiful art and our own beautiful lives…[30]

The move to their studio on Longwood Avenue, where they stayed until 1989, had been, in part, financed by the sale of *Amerika I (after Franz Kafka)*. The exhibition of their work in galleries required Rollins and his collaborators to name themselves officially. Initially their work appeared as "Tim Rollins (and 15 kids from the South Bronx)." In a 1983 group show at the Barbara Gladstone Gallery, *The State of the Art: The New Social Commentary*, they adopted the name "Tim Rollins and Kids of Survival." Rollins recalls holding a competition with a twenty-dollar prize for the student who came up with the best name. The group especially liked the name "K.O.S." because it sounded a bit like "chaos" and had a similar linguistic structure to super-hero groups in comic books.

The name "Tim Rollins and K.O.S." reflects a transparency that the group has always maintained about the structure of their collaboration. Rollins and K.O.S. have not shied away from employing the successes and imperfections of their collaboration as a case study in the opportunities and challenges of collaborative creative action as a model of democracy. The intentional ambiguity of "Tim Rollins *and* K.O.S." asserts both their unity and distinction. Rollins's name is privileged as the individual responsible for organizing and directing the group. Being collectively known as K.O.S. gives the group a balance of identity and flexibility, allowing individual members to join and leave at their choosing. Nevertheless, the structure of their name and relationship favors Rollins, who by virtue of giving or withholding his support of any particular member or project always retains the power position.

Rollins and K.O.S.'s collaboration recognizes that in a democracy specific individuals have to assume leadership roles as well as allow themselves to be held accountable. As in any democracy, the question of how we measure equality becomes paramount. Should all members gain equally from the collaboration regardless of input, or should their gain reflect the degree and quality of that input? The tension contrasts the ideals with the realities of democracy. Within the organizational framework of this collaboration, all members of K.O.S. can cultivate and practice their individual interests and abilities in service of the collective goal. From the very genesis of the collaboration, K.O.S. members have participated in every conceptual and creative dimension of their art. The work of art is deemed "finished" when each contributor is satisfied with his or her own design and the group collectively decides it is ready for public exhibition. Although, as in any democracy, not all members share equal power and influence in every situation, the structure of their collaboration aims for mutual and reciprocal exchange and division of work according to each member's abilities.

Several of the texts Rollins and K.O.S. have used in their art, including Franz Kafka's *Amerika* and George Orwell's *Animal Farm*, raise issues relevant to the contradictions between the idealism of Rollins's Dewey-and-King-inspired pedagogy and the complexities of its practice. *Amerika* follows a literary formula that recurs in many of the texts used by Rollins and K.O.S., in which the protagonist experiences a series of adventures and misfortunes, triumphing through the capacity to both accept and adapt to the situation. Rossmann's search for identity and a sense of belonging culminates in his being greeted by theater members dressed as angels blowing golden horns. Since the novel remained unfinished at Kafka's death, the reader may imagine if Rossmann will realize his utopian dreams or have them broken. Rollins and K.O.S. found in the motto of "Everyone is welcome" and the Nature Theater of Oklahoma's seemingly non-hierarchical collaboration an optimistic, if not idealistic, model of democracy.

Orwell's *Animal Farm* presents a satirical allegory of the corruption of power and revolution through the manipulation of ideology. When the animals of Manor Farm rebel against their human oppressors, they establish a new social order in which "all animals are equal." As the pigs, particularly a Berkshire boar named Napoleon, assume increasing power, they amend this slogan to "all animals are equal, but some animals are more equal than others." Orwell's novel explores the benefits and disadvantages of the concentration of power in one person and opens questions about the relationship of leadership to society.

The comparison of *Amerika* and *Animal Farm* highlights a key distinction between collaboration and collectivism. In the collectivism described in *Animal Farm*, individuals are absorbed into a single social identity, which is inevitably controlled by one or a small group of dominant figures. The vision of collaboration in *Amerika* is one where each individual is celebrated while working together. In practice, Rollins and K.O.S.'s project has elements of both collectivism and collaboration. As they test the poetics and politics of their collaboration as a model of democracy, the reality of their own collaboration falls somewhere between Kafka's invitation and Orwell's retort.

The impetus to work on *Animal Farm* came from George Garces, who joined K.O.S. in 1985. Rollins met Garces and his friend Nelson Ricardo (Rick) Savinon at a summer workshop at Lehman College. Rollins invited them to meet K.O.S., and Savinon recalls the atmosphere in the studio as "structured chaos."[31] They became two of K.O.S.'s most active members. Garces, who habitually drew comical caricatures of people he

saw, asked, "Can we make something that shows how well we can draw?"[32] Neither Garces nor Rollins had any training in caricature or knowledge of its history; together with the entire K.O.S. team, they began to research the satirical work of artists such as Goya, Grandville, Daumier, and Heartfield. The group visited the print collections of the New York Public Library and the Museum of Modern Art to study firsthand the ideas and techniques of nineteenth- and twentieth-century political caricatures. As they began to draw their own zoomorphic caricatures of modern political leaders, they researched the personal and political lives of each of their subjects as well as the modern history of the countries they represented. The results included works such as *From the Animal Farm: Jesse Helms (after George Orwell)* by Garces, which depicts the then-North Carolina senator as a bulldog, that remain among their most celebrated.

Testing Survival

By 1985, K.O.S. comprised a mix of young artists who had worked with Rollins at I.S. 52 and new members from the outside, including Angel Abreu, Wilson Acosta, Jose Burgos, Richard Cruz, Luis Feliciano, George Garces, Angel Hernandez, Nelson Montes, Jorge Luis Muniz, Jose Parissi, Carlos Rivera, Annette Rosado, Jesus Ruiz, Jose Ruiz, and Rick Savinon. Having participated in group shows at Fashion Moda, Ronald Feldman Fine Arts, Barbara Gladstone Gallery, Artists Space, and Sarah Lawrence College, Rollins and K.O.S. had their first solo exhibition at the Hostos Art Gallery, Hostos Community College, Bronx, NY, in 1985. That same year, they were included in the Whitney Museum of American Art's Biennial as part of the Group Material-curated project *Americana*. In 1986, they began to be represented by Jay Gorney Modern Art. By 1989, Rollins and K.O.S. had appeared on the cover of *Artforum* and participated in group exhibitions at P.S.1 in Long Island City; Documenta in Kassel, Germany; New York's Museum of Modern Art; and the Venice Biennale.

In 1989 they moved to a spacious third-floor warehouse studio in the American Banknote Company Building on Barretto Street, in the South Bronx's Hunts Point section. Their exhibition at the Dia Art Foundation, which ran October 13, 1989–June 17, 1990, brought together works based on Kafka's *Amerika*, and Franz Schubert's 1827 song cycle *Winterreisse*, as well as several other studies and small works. The exhibition received generally positive reviews. In the *New York Times*, Roberta Smith wrote, "In every case, the image is a kind of radiant grillwork, a golden gate of overlapping, intertwining trumpets, each more eccentric, more wildly mutated and suggestive than its neighbor."[33] Amei Wallach, in *New York Newsday*, called it a "graduation of sorts." She quoted Rollins saying, "This show is our vindication."[34] Although it may not have seemed like a meteoric rise, the fact

that Rollins and K.O.S. went, in less than a decade, from that boarded-up special-ed classroom to the center of the art world made history. The years between their exhibition at Dia and their exodus from the Barretto Street studio, 1989 to 1993, marked the high point of their collaboration, by which the group is remembered and measured.

Each level of success for Rollins and K.O.S. brought new questions about their future, even some reviewers who lauded the Dia exhibition speculated about what lay ahead. Hilton Kramer largely praised the Dia exhibition but wondered if it had been part of a 1980s phenomenon of overrated art that could collapse under its own weight.[35] Roberta Smith, who had been an advocate of Rollins and K.O.S. since their emergence in 1982, voiced widely held questions, writing, "The example of Mr. Rollins and K.O.S. is so unusual that it's hard to know what to expect next. They can't make 'Amerika' paintings forever and nothing else they have done…has mustered quite the same emotional and visual density."[36]

These questions reflected and contributed to a growing tension between the New York art press and Rollins and K.O.S., who have intentionally cultivated contradictions to challenge generalizations about them. Rollins had always considered himself an outsider in the art world and felt they were often exploited by a system that projected its own prejudices, guilts, and restrictions onto the collaborative. He maintains that the group's defiance of social boundaries of age, education, economic class, race, and religion exposes to the art world aspects of itself it would prefer to leave unaddressed. Rick Savinon, somewhat defiantly, echoed this sentiment:

> We have always made a lot of people in the art world uncomfortable, but that says more about them than it does about us. We are just doing what we love to do. We make art because we want to make art and we want to be together as a group. We make art, first of all, for ourselves and for each other.[37]

The continuing undercurrent of conflict between the collaborative and their critics surfaced with a piece in *New York* magazine by Mark Lasswell entitled "True Colors." Combining the accusations of two expelled K.O.S. members with art-world rumors, Lasswell depicted Rollins and K.O.S.'s relationship disparagingly.[38] Although almost every aspect of Lasswell's article has been challenged and it has never been cited as a trustworthy source in any scholarly examination of Rollins and K.O.S., it provided sufficient reason for those inclined to doubt the project to dismiss it all together.[39]

Suddenly and shockingly, real-world calamity overtook Rollins and K.O.S.'s art-world successes and problems. On Sunday, February 14, 1993, Valentine's Day, fifteen-year-old K.O.S. member

Christopher Hernandez was one of six people murdered in an apartment on Prospect Avenue in the South Bronx.[40] The crime made newspapers not only across the country but around the world, furthering an image of the South Bronx as bedlam. It eventually emerged that the murders were not drug-related, as initially reported, but violent revenge for a family insult. The killers had used Hernandez, a neighbor in the building, as a decoy to gain entry to the apartment, then murdered him after he had witnessed the other killings.

Christopher Hernandez had first come to the studio along with his older brother Juan. When Juan stopped working with K.O.S., Christopher continued to show up, even though he was too young to join K.O.S., whose minimum age Rollins had set at thirteen. Because of his enthusiasm for art, and at the request of his widowed mother, Rollins admitted Hernandez at age eleven. The principal creator of *From the Earth to the Moon (after Jules Verne)*, he became one of the central creative contributors to the group.

The senseless nature of Hernandez's murder tested the very premise of Rollins and K.O.S.'s conception of survival. His absence left a discernible vacancy in the group's creative dynamics and artistic production. The drawings and paintings they produced in 1993, including *Oedipus Rex (after Sophocles)*, *Nation and Race (after Adolf Hitler)*, and *Death and Transfiguration (after Richard Strauss)*, number among their thematically darkest works.

The tragedy was followed by a collapse in the market for Rollins and K.O.S.'s art. Rollins described its impact: "We lost everything, the art market crashed, I could hardly get up in the morning, I drank myself to sleep at night, there were no ideas coming, we got evicted from our beautiful studio [on Barretto Street], taking only what we could carry."[41] Sorting through material in the studio, Jorge Abreu found a portfolio marked "CH," containing previously unknown drawings by Hernandez, inspired by Aristophanes's comedies *The Frogs*, *The Birds*, and *The Clouds*. Rollins noted:

> [They] were the most buoyant, delicate, luminous, joyous, transparent drawings of frogs. Jorge said, "Look, we can use these to get Christopher back." At first, I said, "What do you mean? We can't bring Christopher back." But Jorge was right; that is what we did.[42]

Practicing their own philosophy of survival, Rollins and K.O.S. transformed the sketches inspired by the three plays into some of their most innocently lyrical and shamelessly beautiful paintings. Aristophanes's *The Frogs* is literally a story of a journey to hell and back. Dionysus, despairing over the state of Athens, determines to bring back the poet Euripides from the dead. The frogs appear only tangentially in the play; as Dionysus crosses the Acherusian lake, they chant back and forth to him, often ending their chorus with the refrain "Brekekekex, koax, koax, koax, koax, koax." Rollins described *The Frogs (after Aristophanes)* as a response to Christopher Hernandez's murder:

> Our best work is not about suffering; our best art is about survival. The appeal of the work is its beauty. There is hope and joy there. How can people from the poorest congressional district in America make this? How can a group who has had one of its members brutally and senselessly murdered find this much joy and beauty? It's like Aristophanes and *The Frogs*, the frogs are in hell but they still have a song to sing, and if they don't sing they will swell up and die.[43]

Works like *The Frogs (after Aristophanes)* as well as *The Psalms, Invisible Man (after Ralph Ellison)*, *I See the Promised Land (after Martin Luther King, Jr.)*, *Incidents in the Life of a Slave Girl (after Harriet Jacobs)*, and *A Midsummer Night's Dream (after William Shakespeare)*, all made in the years immediately following Hernandez's murder and the discovery of his portfolio, are some of the most colorful and thematically optimistic in Rollins and K.O.S.'s oeuvre. Their renewed belief in their creative capacity to transform adversity into evolution and affect their own destiny shows in Rollins and K.O.S.'s survival as a collaborative. In 1993, Robert Branch, Emanuel Carvajal, and Daniel Castillo joined continuing members Angel Abreu, Jorge Abreu, Carlos Rivera, and Rick Savinon in reestablishing K.O.S. With the exception of Rivera, all of these men are current members, the longest continuing core of K.O.S., having worked together for fifteen years.

In 1994 Rollins and K.O.S. opened a new space on 26th Street in New York's Chelsea neighborhood, an area that since has become the center of the New York contemporary art world. An image of Martin Luther King posted on the door signifies, according to Rollins, "what is going on in our studio. It is a cipher for the freedom and creativity that King was talking about as the 'beloved community.'"[44]

King's "beloved community" defined a state of personal fulfillment, social unity, and spiritual renewal, the summation and realization of "The Three Dimensions of a Complete Life." In his 1957 essay, "Facing the Challenge of a New Age," King described the ultimate goal of his strategy of creative nonviolent action: "We have before us the glorious opportunity to inject a new dimension of love into the veins of our civilization…. [And] the end is reconciliation; the end is redemption; the end is the creation of the beloved community."[45] While King argued that such a goal would not be achieved without unified effort,

collective sacrifice, and, above all, personal suffering, he also believed that this endeavor was guided and supported by an undeniable and victorious spiritual power.

King's prophetic proposal of "the beloved community" provided Rollins not only with philosophic inspiration but also practical application. As an artist, Rollins understood how creative action could bring together disparate materials and forms into a harmonious whole. King equipped Rollins to see the artist's activity as something more than the creation of visual pleasure. In what Rollins has called a "King aesthetic," he and K.O.S. have developed an artistic strategy of bringing discordant elements into a whole that finds fruition not only in the formal structure of the art object but in the collaborative method employed in its creation. They have demonstrated that survival had become, more than a philosophy, a form of action guided by faith.

1. Tim Rollins, interview with author, June 27 2006.
2. Ibid.
3. Ibid.
4. Ibid. For further reading on the state of the South Bronx in 1981, see *The Bronx* by Evelyn Gonzalez, *Devastation/Resurrection: The South Bronx* by Robert Jensen, and *South Bronx Rising: The Rise, Fall, and Resurrection of an American City* by Jill Jones, *When the Bronx Burned* by John Finucane. Two books with photographs of the South Bronx are *In the South Bronx of America* by Mel Rosenthal and *Do Not Give Way To Evil: Photographs of the South Bronx, 1979–1987* by Lisa Kahane.
5. Ibid.
6. Tim Rollins remembers that it took two years to have the windows replaced. Tim Rollins, interview with author, June 27 2006.
7. Tim Rollins, interview with author, June 27 2006.
8. Ibid.
9. Ibid.
10. Ibid.
11. Tim Rollins, interview with author, April 18 2008.
12. Tim Rollins, interview with author, June 27 2006.
13. Sanger Mills Cook, *Pittsfield on the Sebasticook*, (Bangor, Maine: Furbush-Roberts Printing Co., Inc., 1966), 189.
14. Tim Rollins, interview with author, June 8 2005.
15. Ibid.
16. Tim Rollins, interview with author, January 5 2005.

17. Martin Luther King, Jr., "An Experiment in Love," in *A Testament of Hope: The Essential Writings and Speeches of Martin Luther King Jr.*, ed. James M. Washington (San Francisco: Harper Collins), p.18.
18. Tim Rollins, interview with author, June 24 2008.
19. Martin Luther King Jr., "Transformed Nonconformist," in *Strength to Love*, 23–24.
20. Tim Rollins, interview with author, June 27 2006.
21. Tim Rollins, interview with author, August 9 2006.
22. Martin Luther King jr., "Transformed Nonconformist," *Strength to Love*, 24.
23. Ralph Waldo Emerson, "Self-Reliance" *The Collected Works of Ralph Waldo Emerson* Joseph Slater ed. (Cambridge: The Belknap Press of Harvard University Press, 1979), 2:29.
24. Tim Rollins, interview with author, August 9 2006.
25. Ibid.
26. Tim Rollins, interview with author, August 10 2006.
27. Tim Rollins, interview with author, June 24 2008.
28. Ibid.
29. Tim Rollins, "Notes on Amerika I–XII" in *Amerika: Tim Rollins and K.O.S.*, Gary Garrels ed. (New York: Dia Art Foundation), 68–70
30. Tim Rollins, interview with author, January 5 2005.
31. Nelson Ricardo Savinon, interview with author, April 28 2009.
32. George Garces, interview with author, June 9 2009.
33. Roberta Smith, "'Amerika' by Tim Rollins and K.O.S."

New York Times, November 3 1989.
34. Amei Wallach, "Survival Art, 101" in *New York Newsday*, October 30 1989, 9.
35. Hilton Kramer, "South Bronx Children's Art at Dia: Buoyant, Cheerful, Well Executed," *The New York Observer*, (6 November 1989): 1, 25.
36. Roberta Smith, "'Amerika' by Tim Rollins and K.O.S." *New York Times*, November 3 1989.
37. Nelson Ricardo Savinon, interview with author, May 5, 2009. Italics his.
38. Mark Lasswell, "True Colors," *New York Magazine*, (29 July 1991): 30–38.
39. David Hershkovits. "The Kids Are Alright," *Paper*, (September 1991): 18–19.
40. Robert D. McFadden. "Police Search For Motive In 6 Slayings" *New York Times*. (February 16, 1993): pg. B.1
41. Susan Mansfield, "Painting the Pain," *The Scotsman*, (October 16, 2001): 8.
42. Tim Rollins, interview with author, August 2 2005.
43. Ibid.
44. Tim Rollins, interview with author, January 5 2005.
45. Martin Luther King jr., "Facing the Challenge of a New Age" in *A Testament of Hope*, 135–141.

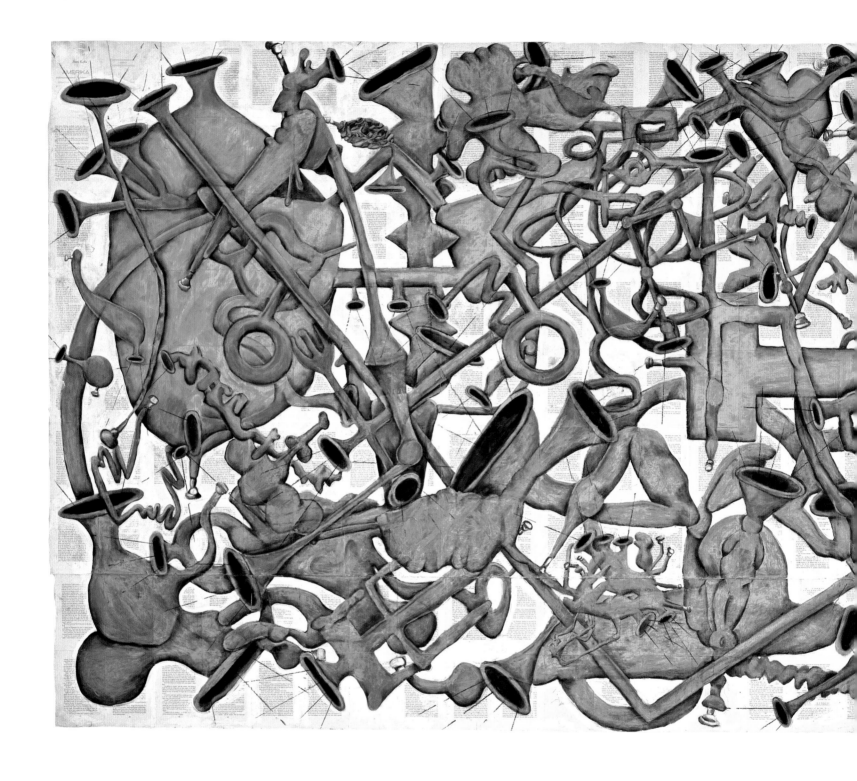

"…you all have your own taste and you have different voices. If you could be a golden instrument,
if you could play a song of your freedom and dignity and your future and everything you feel about *Amerika*
and this country, what would your horn look like?"

TIM ROLLINS

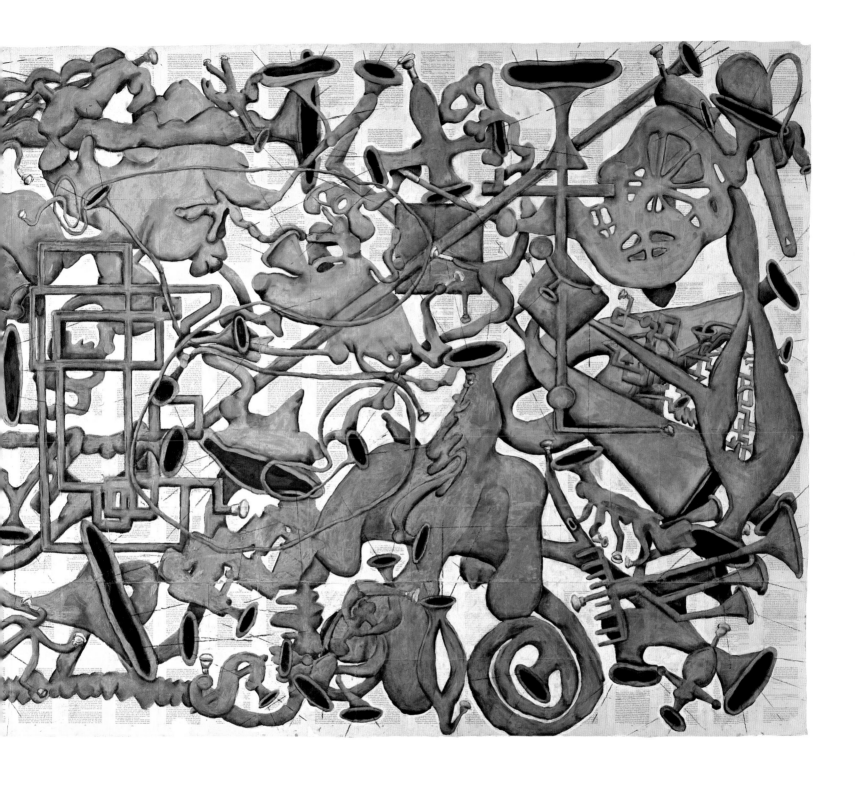

AMERIKA I (AFTER FRANZ KAFKA), 1984–85
Oil paint stick, acrylic, china marker, and pencil
on book pages on rag paper mounted on canvas
71 $^1/_2$ x 177 inches
The JPMorgan Chase Art Collection

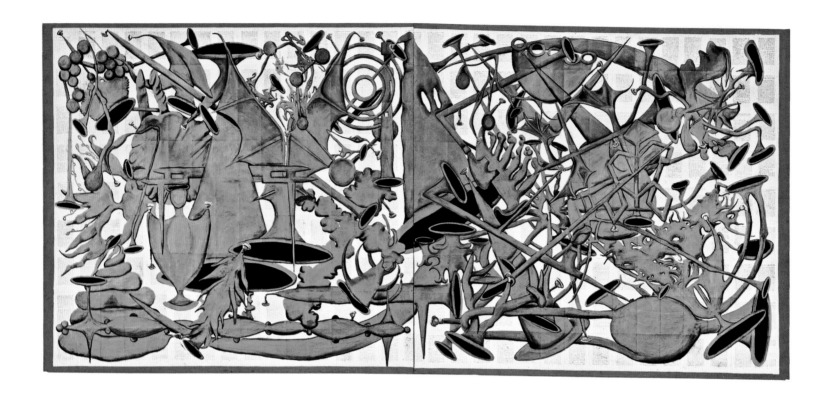

AMERIKA III (AFTER FRANZ KAFKA), 1985–86
Oil paint stick, china marker, and pencil on
book pages mounted on linen
74 x 164 ³/₄ inches
Collection of Camille O. Hoffmann

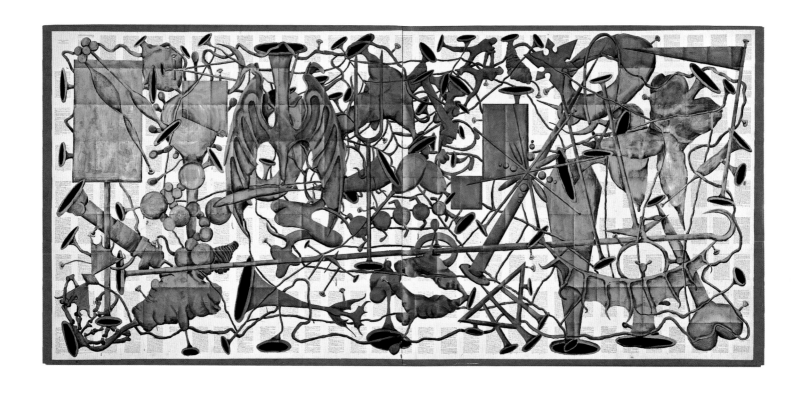

AMERIKA IV (AFTER FRANZ KAFKA), 1986
Lacquer, oil paint stick, and pencil on
book pages mounted on linen
72 x 180 inches
Collection of Virginia Wright and Clay Rolader

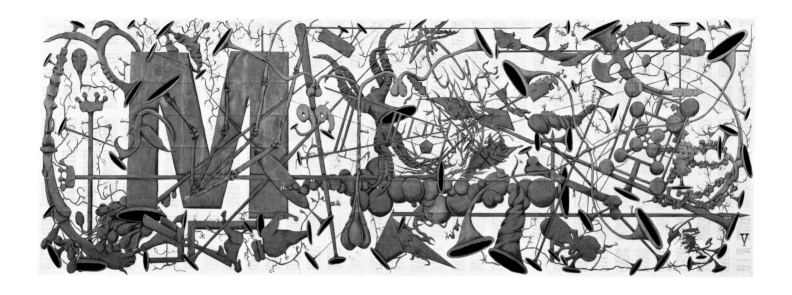

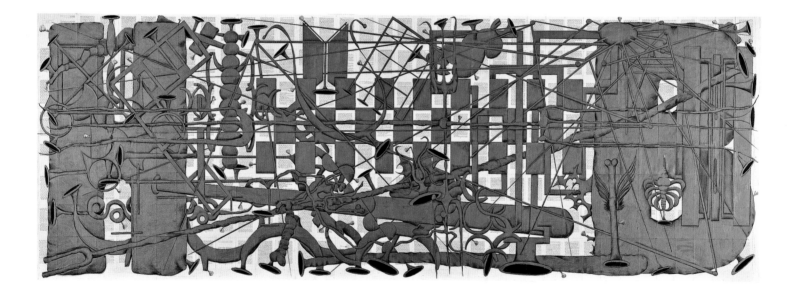

Top:
AMERIKA V (AFTER FRANZ KAFKA), 1985–86
Watercolor, charcoal, acrylic, and
book pages mounted on linen
66 x 186 inches
Collection of Andrew Ong, New York

Bottom:
AMERIKA VI (AFTER FRANZ KAFKA), 1986–87
Watercolor, charcoal, acrylic, and
book pages mounted on linen
66 x 186 inches
Private Collection, courtesy of Thomas Ammann
Fine Art, Zurich

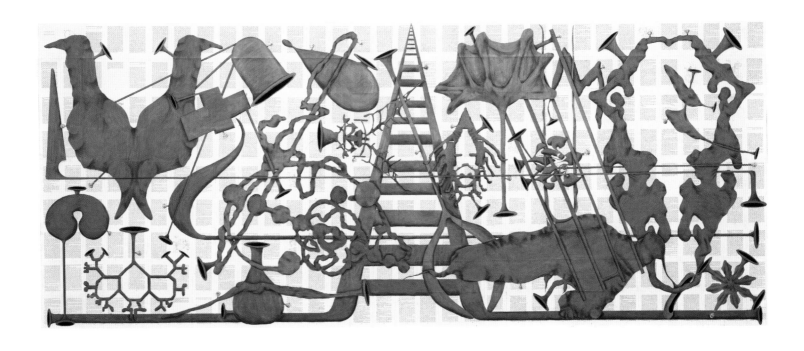

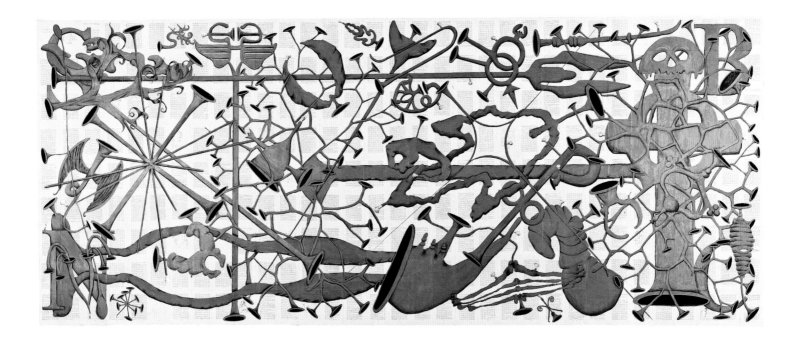

Top:
AMERIKA VIII (AFTER FRANZ KAFKA), 1986–87
Watercolor, charcoal, synthetic polymer paint,
and pencil on book pages mounted on linen
69 ¼ x 168 inches
The Museum of Modern Art, New York
Jerry I. Speyer Fund and Robert and
Meryl Meltzer Fund, 1988

Bottom:
AMERIKA IX (AFTER FRANZ KAFKA), 1987
Watercolor, charcoal, acrylic, and pencil on
book pages mounted on linen
64 x 168 inches
Mint Museum of Art, Charlotte, North Carolina
Gift of the artists and Knight Gallery, Spirit Square Arts
Center, with support of the North Carolina Arts Council

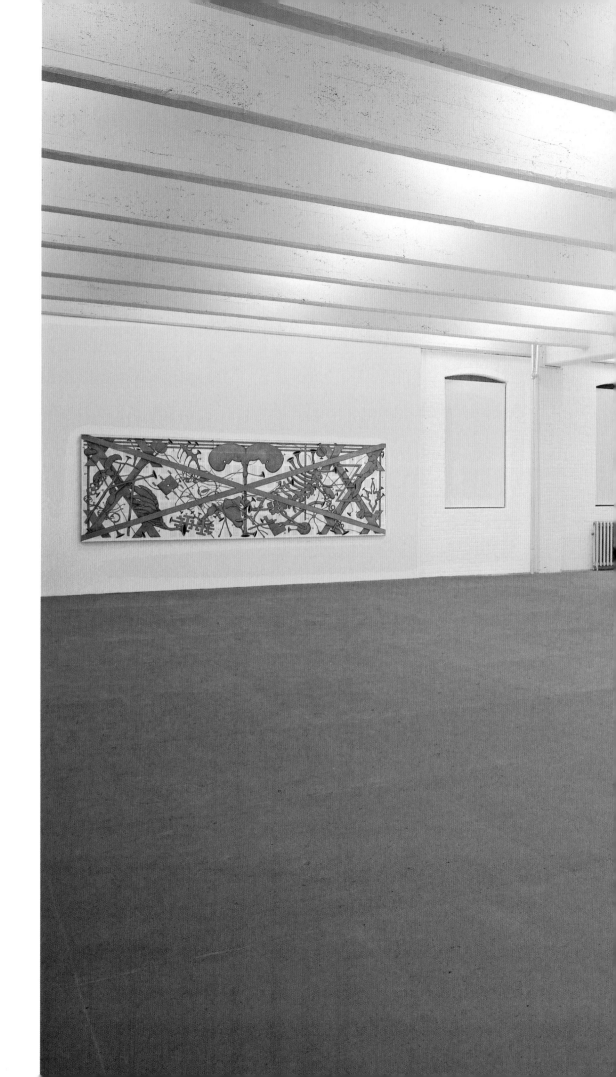

Installation view, Dia Art Foundation,
New York, 1990

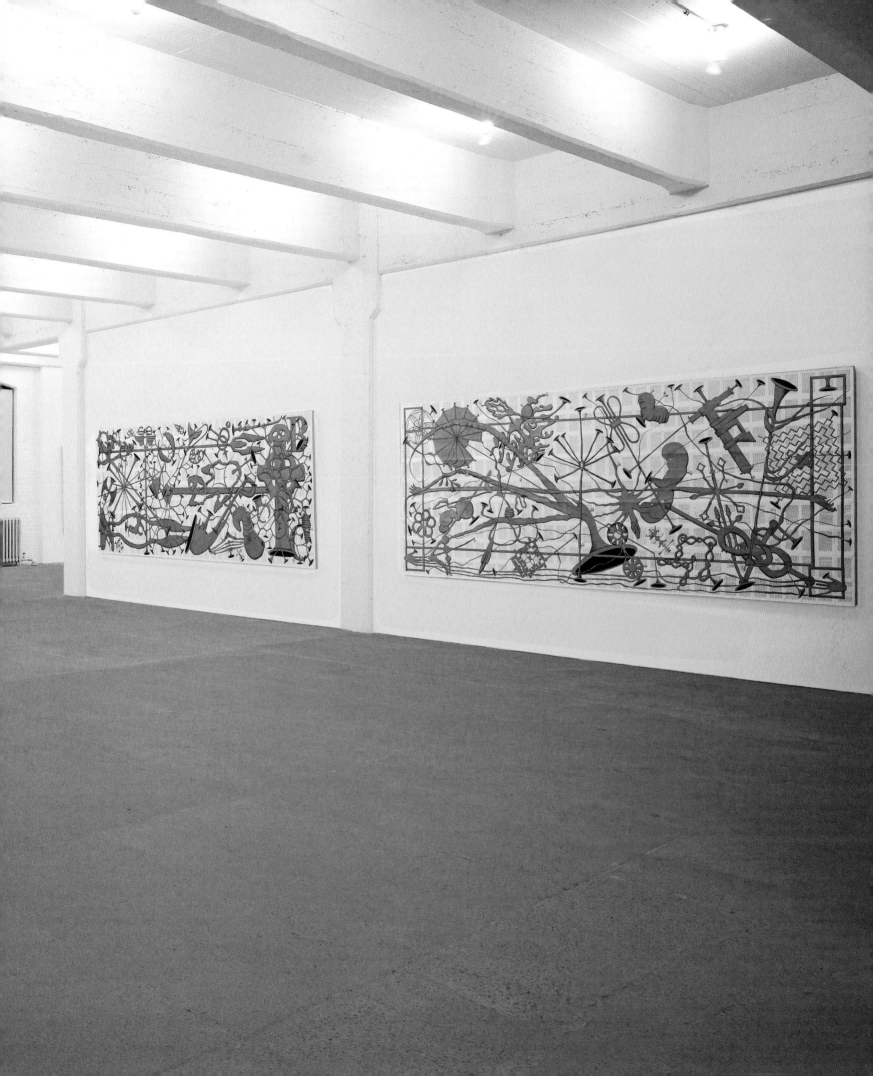

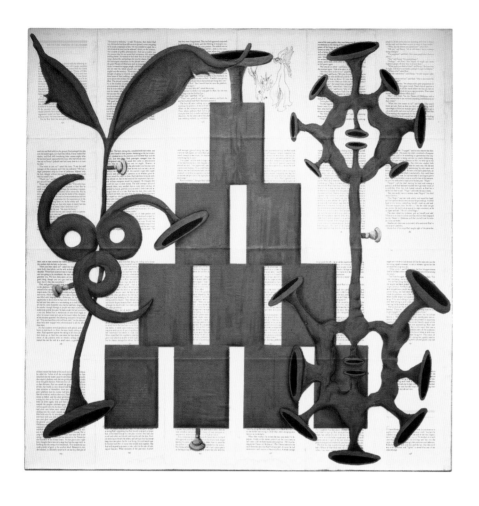

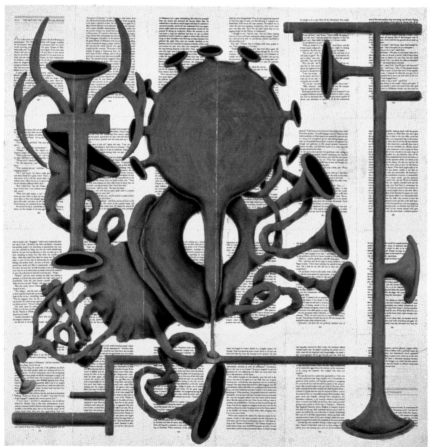

Top:
THE NATURE THEATRE OF OKLAHOMA
(AFTER FRANZ KAFKA), 1988
Watercolor on book pages mounted on linen
32 x 32 inches
Estate of Henry Feiwel, courtesy of
Fleisher/Ollman Gallery

Bottom:
THE NATURE THEATRE OF OKLAHOMA III
(AFTER FRANZ KAFKA), 1985–86
Oil and china marker on book pages mounted on linen
32 x 32 inches
The Carol and Arthur Goldberg Collection

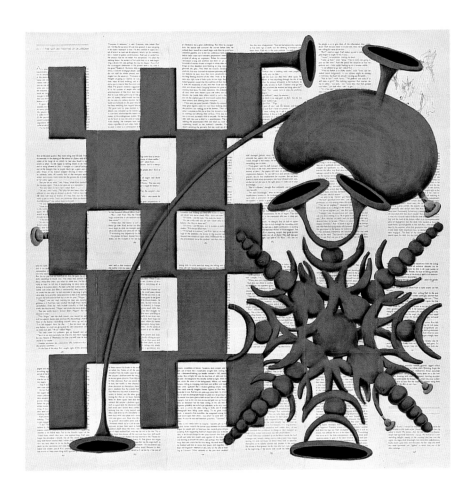

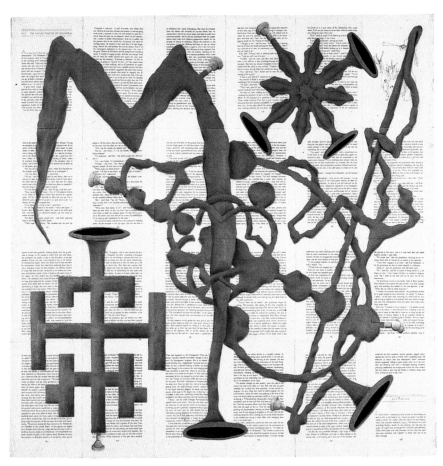

Top:
THE NATURE THEATRE OF OKLAHOMA XIII
(AFTER FRANZ KAFKA), 1986
Watercolor on book pages mounted on linen
32 x 32 inches
The JPMorgan Chase Art Collection

Bottom:
THE NATURE THEATRE OF OKLAHOMA (M)
(AFTER FRANZ KAFKA), 1987
Watercolor and charcoal on book pages
mounted on linen
32 x 32 inches
Private Collection

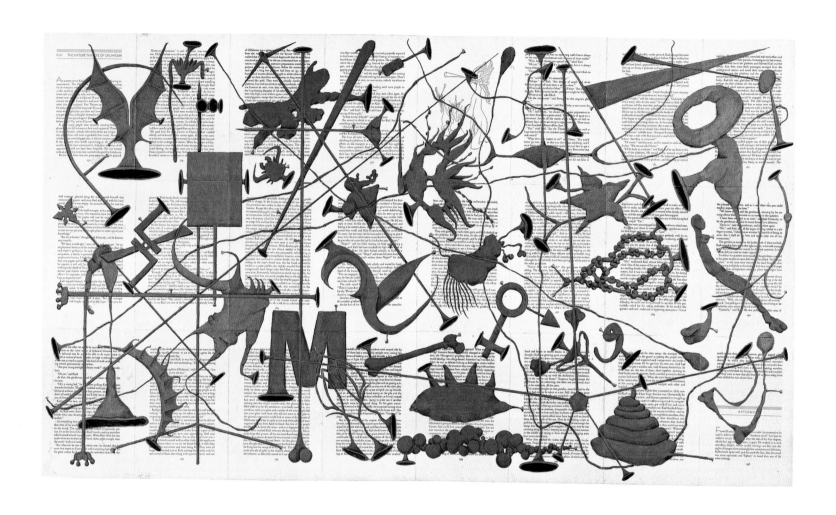

THE NATURE THEATRE OF OKLAHOMA X
(AFTER FRANZ KAFKA), 1986
Watercolor on book pages mounted on linen
24 x 42 ¹/₂ inches
Private Collection

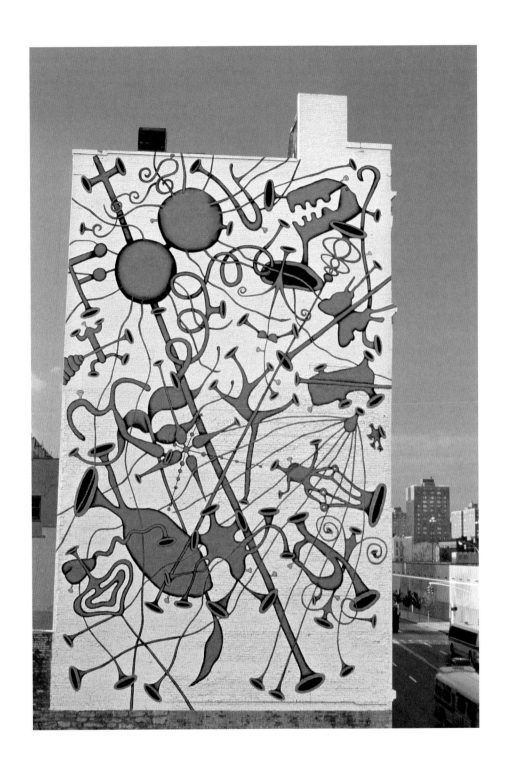

AMERIKA—FOR THE PEOPLE OF BATHGATE
(AFTER FRANZ KAFKA),
completed October 6, 1988 (destroyed c. 1992)
Mural on masonry wall
660 x 432 inches
Central Elementary School #4, Bathgate Avenue,
Bronx, New York
Co–sponsored by Public Art Fund, Inc. and the Port
Authority of New York & New Jersey in cooperation
with C.E.S. 4 and the Board of Education

ow she was. And then she
ow she used to come home
ecause she had lost a job

t remember which—had
was working, and the
actually a Negro, she
me crying, this time

n coming to our
etimes and find
sand questions.
round in our
at least for
e were just

Welfare
elped.
When
was
ry

give us packages of meat, sacks of potatoes and fruit, and
cans of all kinds of things, our mother obviously hated to
accept. We really couldn't understand. What I later under-
stood was that my mother was making a desperate effort to
preserve her pride—and ours.

Pride was just about all we had to preserve, for by 1934,
we really began to suffer. This was about the worst depres-
sion year, and no one we knew had enough to eat or live
on. Some old family friends visited us now and then. At
first they brought food. Though it was charity, my mother
took it.

Wilfred was working to help. My mother was working,
when she could find any kind of job. In Lansing, there was a
bakery where, for a nickel, a couple of us children would
buy a tall flour sack of day-old bread and cookies, and then
walk the two miles back out into the country to our house.
Our mother knew, I guess, dozens of ways to cook things
with bread and out of bread. Stewed tomatoes with bread,
maybe that would be a meal. Something like French toast,
if we had any eggs. Bread pudding, sometimes with raisins
in it. If we got hold of some hamburger, it came to the
table more bread than meat. The cookies that were always in
the sack with the bread, we just gobbled down straight.

But there were times when there wasn't even a nickel and
we would be so hungry we were dizzy. My mother would
boil a big pot of dandelion greens, and we would eat that.
I remember that some small-minded neighbor put it out, and
children would tease us, that we ate "fried grass." Some-
times, if we were lucky, we would have oatmeal or corn-
mush three times a day. Or mush in the morning and
read at night.

ert and I were grown up enough to quit fighting long

Then, about in late 1934, I would guess, something began
to happen. Some kind of psychological deterioration hit our
family circle and began to eat away our pride. Perhaps it was
the constant tangible evidence that we were destitute. We had
known other families who had gone on relief. We had known
without anyone in our home ever expressing it that we had
felt prouder not to be at the depot where the free food was
passed out. And, now, we were among them. At school, the
"on relief" finger suddenly was pointed at us, too, and some-
times it was said aloud.

It seemed that everything to eat in our house was stamped
Not To Be Sold. All Welfare food bore this stamp to keep the
recipients from selling it. It's a wonder we didn't come to
think of Not To Be Sold as a brand name.

Sometimes, instead of going home from school, I walked
the two miles up the road into Lansing. I began drifting from
store to store, hanging around outside where things like apples
were displayed in boxes and barrels and baskets, and I would
watch my chance and steal me a treat. You know what a
treat was to me? Anything!

Or I began to drop in about dinnertime at the home of some
family that we knew. I knew that they knew exactly why I
was there, but they never embarrassed me by letting on. They
would invite me to stay for supper, and I would stuff myself.

Especially, I liked to drop in and visit at the Gohannas'
home. They were nice, older people, and great churchgoers.
I had watched them lead the jumping and shouting when my
father preached. They had, living with them—they were rais-
ing him—a nephew whom everyone called "Big Boy," and
he and I got along fine. Also living with the Gohannas was
old Mrs. Adcock, who went with them to church. She was

there—it became incre...
kening. That was when...
me away from home. Th...
going to be at the Gohannas...
d Big Boy and Mrs. Adcock...
d me, and would like to have...

didn't want to leave Wilfred.
y big brother. I didn't want
second mother. Or Philbert;
a feeling of brotherly union.
s weak with his hernia condi-
as his big brother who looked
Wilfred. And I had nothing,
e, Wesley, and Robert.
lf more and more, she grad-
us. And less responsible. The
an to be more unkempt. And

hor giving way. It was some-
get your hands on, yet you
a sensing that something bad
r ones leaned more and more
of Wilfred and Hilda, who

he Gohannas' home, at least
remember that when I left
other said one thing: "Don't

s, at the Gohannas'. Big Boy
and we hit it off nicely. He
od brothers. The Gohannas'
Boy and I attended church
ed Holy Rollers now. The
ped even higher and shouted
ad known. They sang at the
back and forth and cried
ourines and chanted. It was
als and "ha'nts" seeming to
finally we all came out of

ock loved to go fishing, and

Boy and I would go along. I had changed
sing's West Junior High School. It was
he Negro community, and a few white
g Boy didn't mix much with any of
didn't either. And when we went
liked the idea of just sitting and
the cork under the water—or
when we fished that way. I
smarter way to get the fish—
t it might be.
with some other men who,
som... Big Boy with them hunt-
ing r... aliber rifle; my mother
had sa... take it with me. The
old men... y that they had al-
ways use... a rabbit, and the
rabbit gets... somehow instinc-
tively run in... ter past the very
spot where he... old men would
just sit and wai... bbit to come
back, then get th... g about it,
and finally I thoug... from them
and Big Boy and I... ured that
the rabbit, returning,

It worked like magic... abbits
before they got one. The... e of
the old men ever figured... ves
exclaiming what a sure sho...
All I had done was to improv...
the beginning of a very importan...
time you find someone more successfu...
cially when you're both engaged in the sam...
know they're doing something that you aren't.

I would return home to visit fairly often. Sometim...
Boy and one or another, or both, of the Gohannas' wou...
go with me—sometimes not. I would be glad when some...
of them did go, because it made the ordeal easier.

Soon the state people were making plans to take over all
of my mother's children. She talked to herself nearly all of
the time now, and there was a crowd of new white people
entering the picture—always asking questions. They would
even visit me at the Gohannas'. They would ask me questions
out on the porch, or sitting out in their cars.

Eventually my mother suffered a complete breakdown, and
the court orders were finally signed. They took her to the
State Mental Hospital at Kalamazoo.

It was seventy-some miles from Lansing, about an hour
and a half on the bus. A Judge McClellan in Lansing had
authority over me and all of my brothers and sisters. We were
"state children," court wards; he had the full say-so over us.
A white man in charge of a black man's children! Nothing
but legal, modern slavery—however kindly intentioned.

My mother remained in the same hospital at Kalamazoo
for about twenty-six years. Later, when I was still growing
up in Michigan, I would go to visit her every so often.
Nothing that I can imagine could have moved me as deeply
as seeing her pitiful state. In 1963, we got my mother out
of the hospital, and she now lives there in Lansing with
Philbert and his family.

It was so much worse than if it had been a physical
sickness, for which a cause might be known, medicine given,
a cure effected. Every time I visited her, when finally they
led her—a case, a number—back inside from where we
had been sitting together, I felt worse.

My last visit, when I knew I would never come to see her
again—there—was in 1952. I was twenty-seven. My brother
Philbert had told me that on his last visit, she had recognized
him somewhat. "In spots," he said.

But she didn't recognize me at all.

She stared at me. She didn't know who I was.

Her mind, when I tried to talk, to reach her, was some-
where else. I asked, "Mama, do you know what day it is?"

She said, staring, "All the people have gone."

I can't describe how I felt. The woman who had brought
me into the world, and nursed me, and advised me, and
chastised me, and loved me, didn't know me. It was as if I
was trying to walk up the side of a hill of feathers. I looked
her. I listened to her "talk." But there was nothing I
ld do.

ruly believe that if ever a state social agency destroyed
a family, it destroyed ours. We wanted and tried to stay
together. Our home didn't have to be destroyed. But the
Welfare, the courts, and their doctor, gave us the one-two-
three punch. And ours was not the only case of this kind.

I knew I wouldn't be back to see my mother again because

This page, detail facing:

BY ANY MEANS NECESSARY: NIGHTMARE
(AFTER MALCOLM X), 1986
Black gesso on book pages mounted on linen
21 x 28 inches
Whitney Museum of American Art, New York
Gift of Barbara and Eugene Schwartz, 93.148

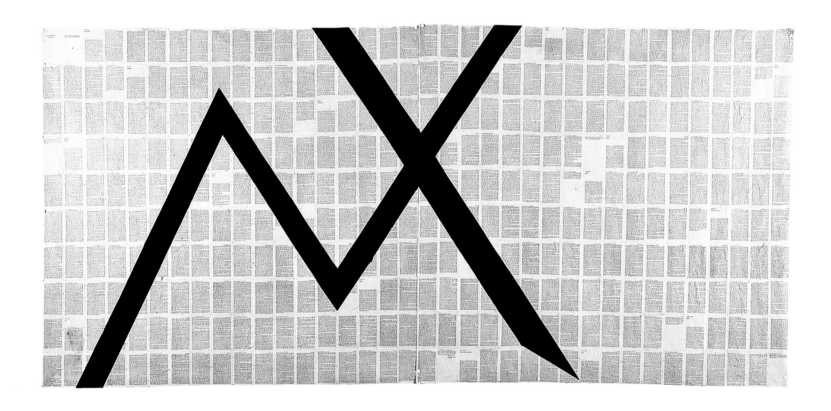

BY ANY MEANS NECESSARY (AFTER MALCOLM X), 1986
Acrylic and black gesso on book pages
88 x 128 inches
The Studio Museum in Harlem, New York
Gift of the Artists

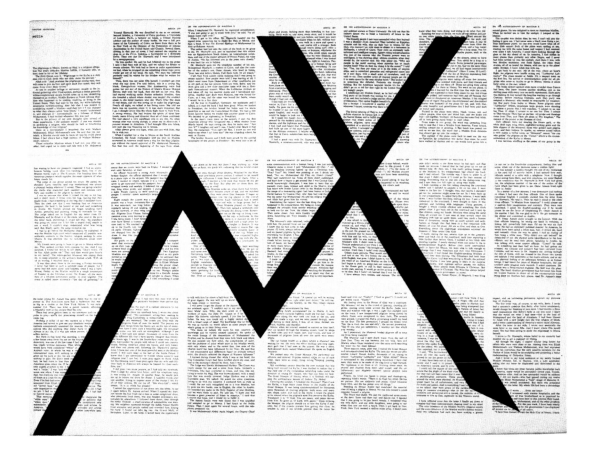

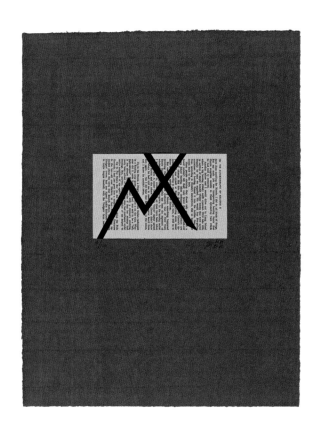

Top:
BY ANY MEANS NECESSARY: MECCA
(AFTER MALCOLM X), 1985–87
Black gesso on book pages mounted on canvas
21 x 28 inches
Toledo Museum of Art, Toledo, Ohio
Gift of Dr. and Mrs. Julius H. Jacobson,
by exchange, 2006

Bottom:
BY ANY MEANS NECESSARY (AFTER MALCOLM X), 1985–86
Silkscreen on book page mounted on red
Fabriano Roma paper
Image: 4 1/8 x 6 7/8 inches
Sheet: 18 1/2 x 14 1/4 inches
Museum of Fine Arts, Boston, Massachusetts
Gift of the Barbara Krakow Gallery in memory
of Helen Isaacs Mazur, 1988.551

"There is a passage in the book where Melville talks about the color white and how horrible it is,
how evil it is, about the whale and the whale's presence. You always think about black as being the color of evil—
this was the complete opposite. We kept looking at Turner's stormy skies when we made this.
It looks like a nuclear flash to me—an explosion."
NELSON RICARDO SAVINON

Facing page:
THE WHITENESS OF THE WHALE II
(AFTER HERMAN MELVILLE), 1991
Acrylic on book pages mounted on linen
90 x 68 inches
Fisher Landau Center for Art, Long Island City,
New York

This page:
THE WHITENESS OF THE WHALE
(AFTER HERMAN MELVILLE), 1985–86
Acrylic on book page mounted on linen
8 x 5 1/2 inches
Private Collection

Facing page:
THE WHITENESS OF THE WHALE
(AFTER HERMAN MELVILLE), 1985–87
Matte acrylic on book pages mounted on linen
147 1/$_2$ x 135 inches
Private Collection
Courtesy of Thomas Ammann Fine Art, Zurich

This page:
THE WHITENESS OF THE WHALE—THE CASTAWAY
(AFTER HERMAN MELVILLE), 1990
Acrylic on book pages mounted on linen
90 x 68 inches
Private Collection

WHITE ALICE (AFTER LEWIS CARROLL), 1984–87
Acrylic on book pages mounted on canvas

BLUE ALICE II (AFTER LEWIS CARROLL), 1990
Acrylic on book pages mounted on linen
104 x 156 inches
Private Collection

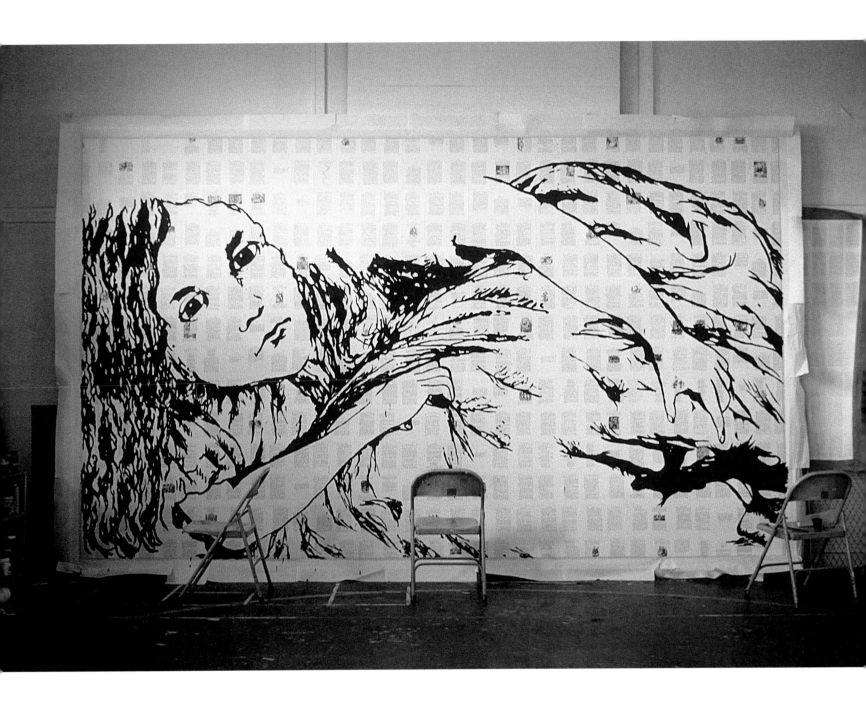

Studio view of ALICE (AFTER LEWIS CARROLL)
in progress, South Bronx, New York, 1987
© Lisa Kahane, NYC

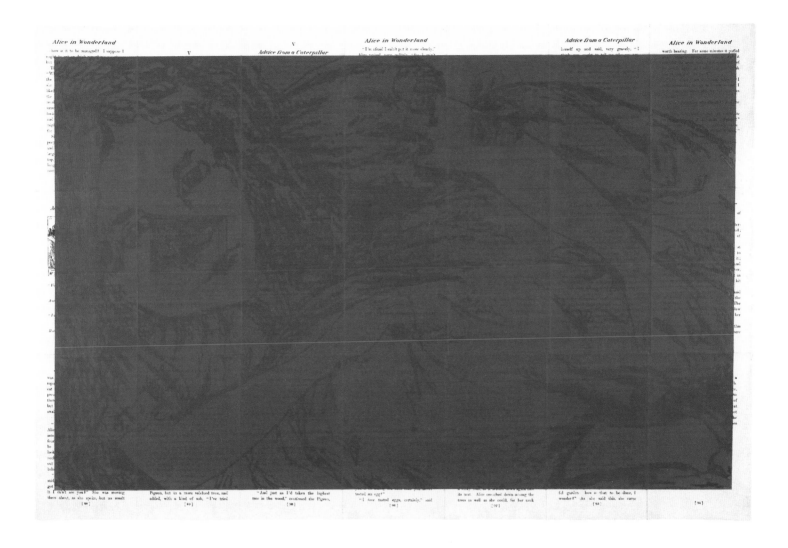

"The Red Alice means both anger and blood to me. This is funny, because red is also the color of love—like valentines. The Red Alice is a young girl who is so angry and in pain that she has had it and might jump out of the painting and fight back. The Red Alice is angry because of all the girls who are raped and hurt and killed because they are girls."

ANNETTE ROSADO

Facing page, top:
WHITE ALICE III (AFTER LEWIS CARROLL), 1992
Acrylic on book pages mounted on canvas
27 x 40 inches
Private Collection

Bottom:
DARK GRAY ALICE (AFTER LEWIS CARROLL), 1990
Acrylic on book pages mounted on linen
24 x 36 ¹/₂ inches
Indianapolis Museum of Art, Indianapolis, Indiana
Gift of Mr. Steve Russell

This page:
RED ALICE II (AFTER LEWIS CARROLL), 1990
Acrylic on book pages mounted on linen
24 x 36 inches
Private Collection

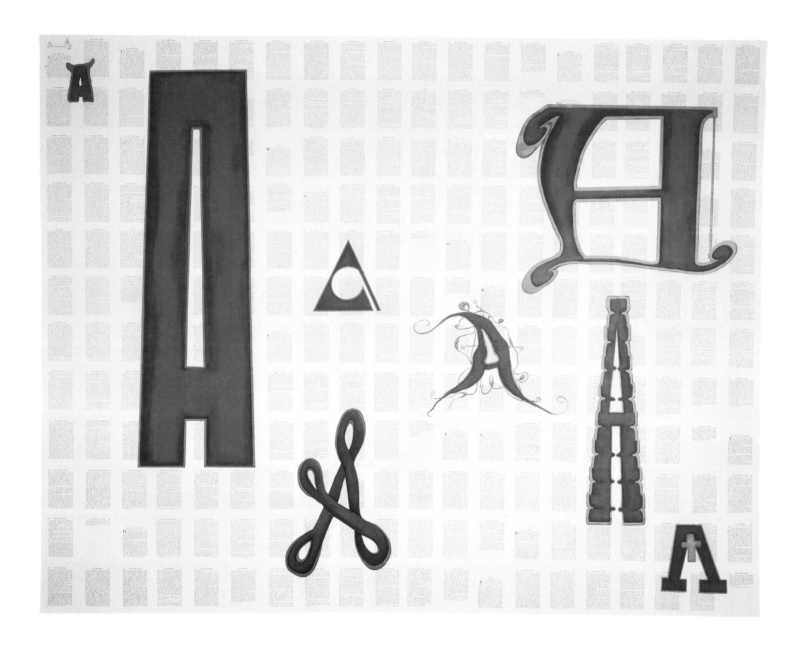

THE SCARLET LETTER I
(AFTER NATHANIEL HAWTHORNE), 1988
Acrylic and watercolor on book pages mounted on linen
108 x 140 inches
Private Collection, courtesy of Thomas Ammann
Fine Art, Zurich

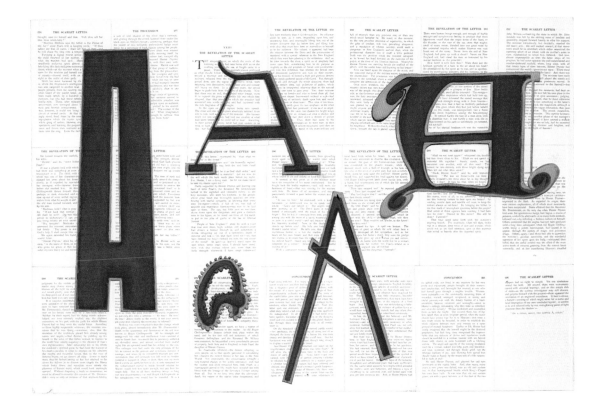

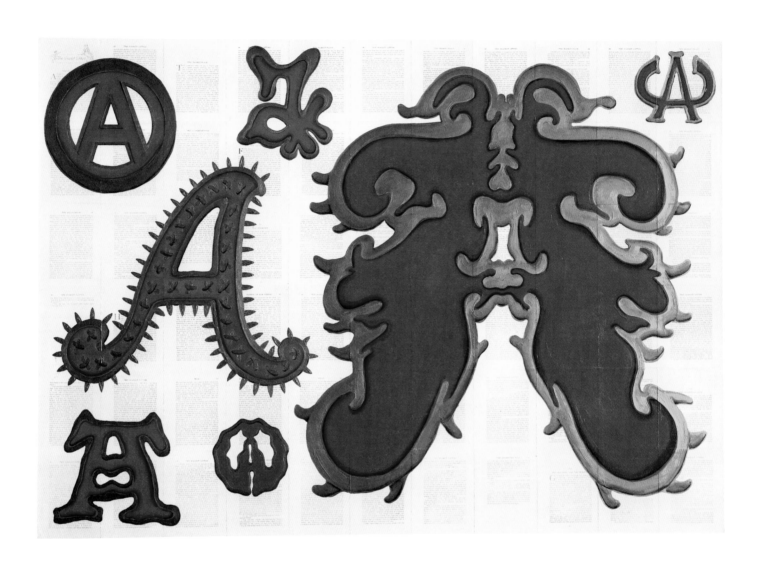

This page, detail facing:
THE SCARLET LETTER—THE PRISON DOOR
(AFTER NATHANIEL HAWTHORNE), 1992–93
Acrylic on book pages mounted on linen
54 $^1/_8$ x 77 $^1/_4$ inches
Mildred Lane Kemper Art Museum,
Washington University in St. Louis, Missouri
University Purchase, Bixby Fund, 1993

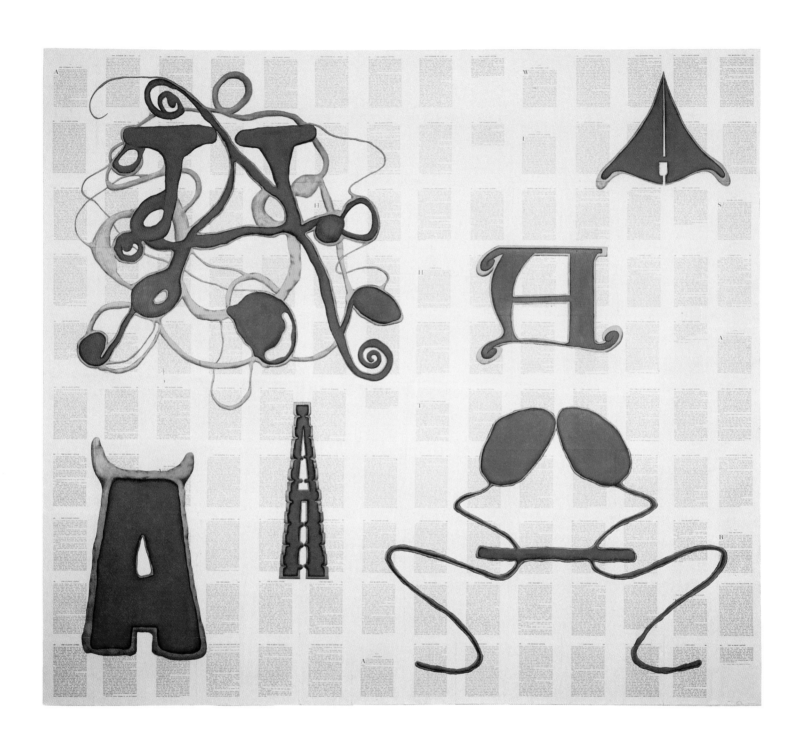

THE SCARLET LETTER—THE INTERIOR OF A HEART I
(AFTER NATHANIEL HAWTHORNE), 1987–88
Acrylic and watercolor on book pages mounted on linen
90 x 102 inches
Collection of Alison and Marc Feldman

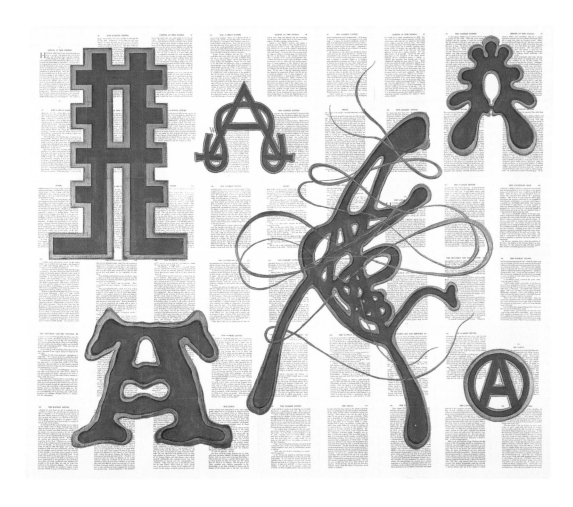

HESTER AT HER NEEDLE
(AFTER NATHANIEL HAWTHORNE), 1992
Acrylic on book pages mounted on linen
52 x 62 inches
Private Collection

This page:
THE RED BADGE OF COURAGE I
(AFTER STEPHEN CRANE), 1985–86
Oil on book pages mounted on linen
80 x 142 inches
Private Collection

Facing page, top:
THE RED BADGE OF COURAGE II
(AFTER STEPHEN CRANE), 1986
Oil on book pages mounted on linen
21 x 36 inches
Private Collection

Bottom:
THE RED BADGE OF COURAGE XII
(AFTER STEPHEN CRANE), 1986–87
Oil, acrylic, pastel, and vellum
on book pages mounted on linen
72 x 132 inches
Private Collection, courtesy of Thomas Ammann
Fine Art, Zurich

inched teeth shone
ny heads surged to
pale sea of smoke.
quently shouted and
e cries, but the regi-
silence. Perhaps, at
ecalled the fact that
diggers, and it made

They were breath-
e ground and thrust-
of the enemy. They
espairing savageness

not to budge what-
arrows of scorn that
heart had generated
atred. It was clear
olute revenge wa
ody lying, tor

This wa
the offic
ater
gs of
erin
n th
nd
con
eproach

The regiment bled extravagantly. Gr
bundles of blue began to drop. The
sergeant of the youth's company was shot
the cheeks. Its supports being injured
hung afar down, disclosing in the wide
his mouth a pulsing mass of blood a
And with it all he made attempts to
In his endeavor there was a d
as if he conceived that
make him well.

The youth saw
His strength seem
ran swiftly, casting

Others fell dow
panions. Some
away, but many
impossible shapes.

The youth looked
saw a vehement young ma powder smeared and
rowzled, whom he knew to be him. The lieu-
nant, also, was unscathed in his position at the
He had continued to curse, but it was now
the air of a man who was using his last box
oaths.

For the fire of the regiment had be
wane and drip. The robust voice
strangely from the thin r
rapidly weak.

CHAPTER XXIII

THE colonel came running along back of the
line. There were other officers following him.
"We must charge 'm!" they shouted. "We must
charge 'm!" they cried with resentful voices, as
if anticipating a rebellion against this plan by the
men.

The youth, upon hearing the shouts, began to
study the distance between him and the enemy.
He made vague calculations. He saw that to be
firm soldiers they must go forward. It would be
death to stay in the present place, and with all
the circumstances to go backward would exalt
too many others. Their hope was to push the
galling foes away from the fence.

He expected that his companions, weary and
stiffened, would have to be driven to this assault,
but as he turned toward them he perceived with
a certain surprise that they were giving quick
and unqualified expressions of assent. There was
an ominous, clanging overture to the charge
217

when the shafts of
rifle barrels. At
the soldiers spra
There was new
movement of the
faded and jaded
pear like a parox
that comes before
scampered in insan
achieve a sudden
fluid should leave
spairing rush by t
and tattered blue,
a sapphire sky, tov
smoke, from behin
rifles of enemies.

The youth kept
He was waving h
the while shrieking
on those that did
seemed that the m
selves on the dar
again grown sudde
unselfishness. Fro
toward them, it loc
succeed in making
on the grass betw
the fence. But the

OF COURAGE

among them was the
he youth saw had been
s of the last formidable
is man fighting a last
one whose legs are
wa a ghastly battle.
of death, but set
desperate
he
un
way

made it seem that his
and he fought a grim
souls fastened greedily
advance of the scam-
cheers, leaped at the
lost was in his eyes as

nt over the obstruction
sprang at the flag as a
led at it and, wrench-
red brilliancy with a
en as the color bearer,
a final throe and, stiff-
d his dead face to the
blood upon the grass

THE RED BAD

At the place of succes
clamorings of cheers. Th
bellowed in an ecstasy. W
as if they considered their li
away. What hats and caps w
they often slung high in the air.

At one part of the line four men
swooped upon, and they now sat as
Some blue men were about them in
curious circle. The soldiers had tr
birds, and there was an examinati
fast questions was in the air.

One of the prisoners was nursi
wound in the foot. He cuddled
but he looked up from it often to
astonishing utter abandon straigh
his captors. He consigned them to
he called upon the pestilential w
gods. And with it all he was
from recognition of the finer point
duct of prisoners of war. It was as
clod had trod upon his toe and he conce
be his privilege, his duty, to use deep,
oaths.

Another, who was a boy in years, too
plight with great calmness and apparent go
nature. He conversed with the men in blue
studying their faces with his bright and keen

THE RED BADGE OF COURAGE

s. They spoke of battles and conditions
here was an acute interest in all their faces dur-
ing this exchange of view points. It seemed a
great satisfaction to hear voices from where all
had been darkness and speculation.

third captive sat with a morose counte-
He preserved a stoical and cold attitude.
nces he made one reply without varia
t' hell!"

the four was always silent and,
most part, kept his face turned in un
directions. From the views the youth
seemed to be in a state of absolute
ame was upon him, and with
ret that he was, perhaps, no more
ed in the ranks of his fellows. The
nd detect no expression that would
him to believe that the other was giving
ought to his narrowed future, the pictured
ons, perhaps, and starvations and bru'
, liable to the imagination. All to
was shame for captivity and regret for
to antagonize.

After the men had celebrated su
settled down behind the old rail fe
opposite side to the one from w
had been driven. A few shot
distant marks.

THE RED BA

There was some
nestled in it and reste
support the flag. Hi
fied, holding his trea
him there. They sat
ated each other.

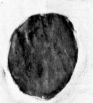

ual machines of re-
where he had pro-
d to marshal all his
before him clearly.
nt he was enabled
ctator fashion and

A specter of reproach came to him. There
loomed the dogging memory of the tattered
soldier—he who, gored by bullets and faint for
blood, had fretted concerning an imagined wound
in another; he who had loaned his last of strength
and intellect for the tall soldier; he who, blind
with weariness and pain, had been deserted in

THE RED BADGE OF COURAGE

"Oh, if a man should come up an' ask me
say we got a dum good lickin'."

"Lickin'—in yer eye! We ain't licked, sonny.
We're goin' down here aways, swing aroun', an'
come in behint 'em."

"Oh, hush, with your comin' in behint 'em.
I've seen all 'a that I wanta. Don't tell me about

THE RED BAD

at a distance. And at
open to some new ways
look back upon the b
earlier gospels and
gleeful when he dis
them.

With this con

This page, detail facing:
THE RED BADGE OF COURAGE IV
(AFTER STEPHEN CRANE), 1986
Oil on book pages mounted on linen
21 x 36 inches
The Carol and Arthur Goldberg Collection

THE RED BADGE OF COURAGE
(AFTER STEPHEN CRANE), 1992
Acrylic, watercolor, and tempera on book page
11 x 8 ³/₄ inches
Private Collection

at last going there would be a
battle, an liged to labor to
make rance an omen
that s of the earth.
 f vague and
 and fire. In
 d imagined
 s. But awake
 es of the past.
 hought-images
 on of the world's
 wars, but it, he
 nd had disappeared

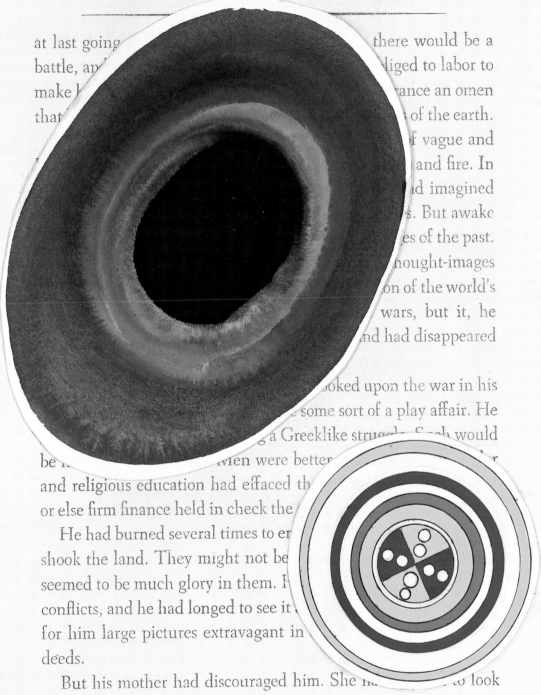

 oked upon the war in his
 some sort of a play affair. He
 a Greeklike struggle. Such would
be Men were better
and religious education had effaced th
or else firm finance held in check the

 He had burned several times to er
shook the land. They might not be
seemed to be much glory in them. F
conflicts, and he had longed to see it
for him large pictures extravagant in
deeds.

 But his mother had discouraged him. She ha to look

THE RED BADGE OF COURAGE
(AFTER STEPHEN CRANE), 1992
Acrylic, tempera, and watercolor on rag paper
on book pages mounted on linen
66 x 92 inches
Private Collection

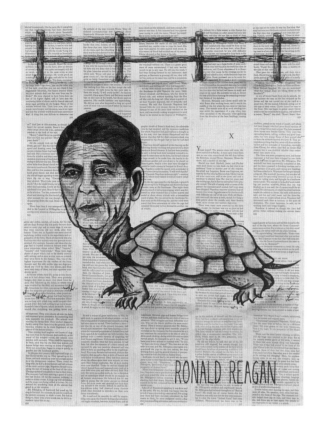

RONALD REAGAN

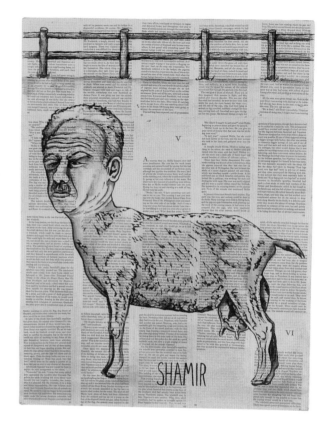

SHAMIR

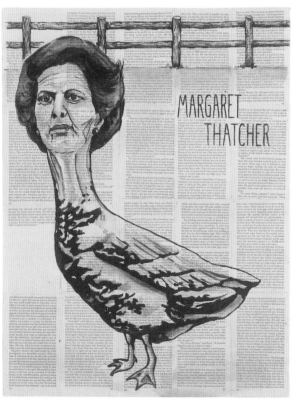

MARGARET THATCHER

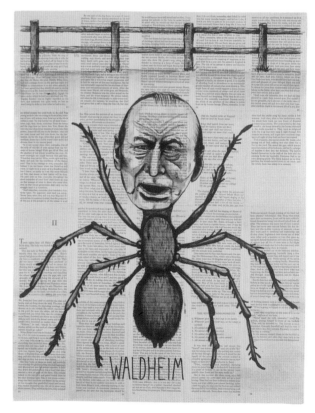

WALDHEIM

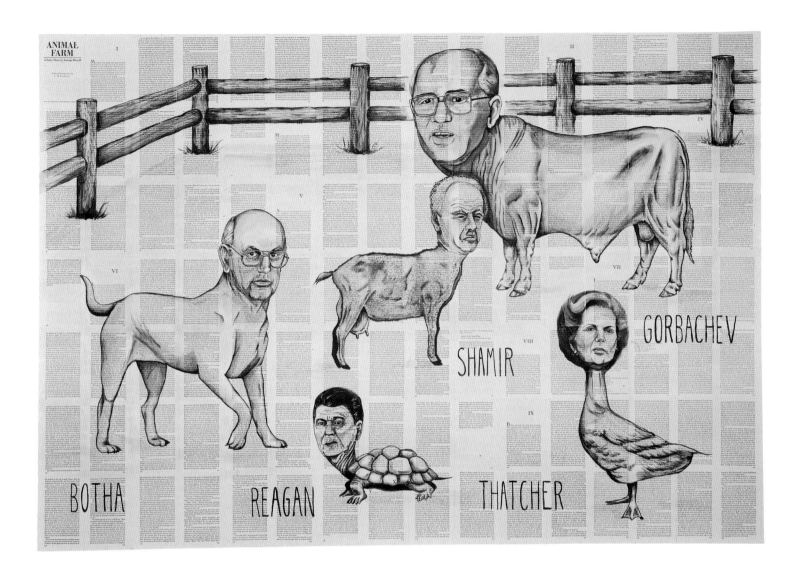

Facing page, top left:
FROM THE ANIMAL FARM: RONALD REAGAN
(AFTER GEORGE ORWELL), 1984–87
Acrylic and wash on book pages
26 x 20 inches
Private Collection

Top right:
FROM THE ANIMAL FARM: YITZHAK SHAMIR
(AFTER GEORGE ORWELL), 1984–87
Acrylic and wash on book pages
26 x 20 inches
Private Collection

Bottom left:
FROM THE ANIMAL FARM: MARGARET THATCHER
(AFTER GEORGE ORWELL), 1984–87
Acrylic and wash on book pages
26 x 20 inches
Collection of Peter Fleissig

Bottom right:
FROM THE ANIMAL FARM: KURT WALDHEIM
(AFTER GEORGE ORWELL), 1984–87
Acrylic and wash on book pages
26 x 20 inches
Collection of Susan and Michael Hort

This page:
FROM THE ANIMAL FARM I
(AFTER GEORGE ORWELL), 1985–88
Acrylic on book pages mounted on linen
55 x 80 inches
Private Collection

"If you open up a K.O.S. member's notebook they are always covered with little doodles and funny pictures in the margins. This painting comes from that. Taking pictures we would make when we were supposed to be paying attention in class, and turning that into a political statement."
ROBERT BRANCH

FROM THE ANIMAL FARM: JESSE HELMS
(AFTER GEORGE ORWELL), 1987
Graphite and acrylic on book pages
mounted on canvas
55 7/8 x 80 1/8 inches
Courtesy of the artists and
Galerie Eva Presenhuber, Zurich

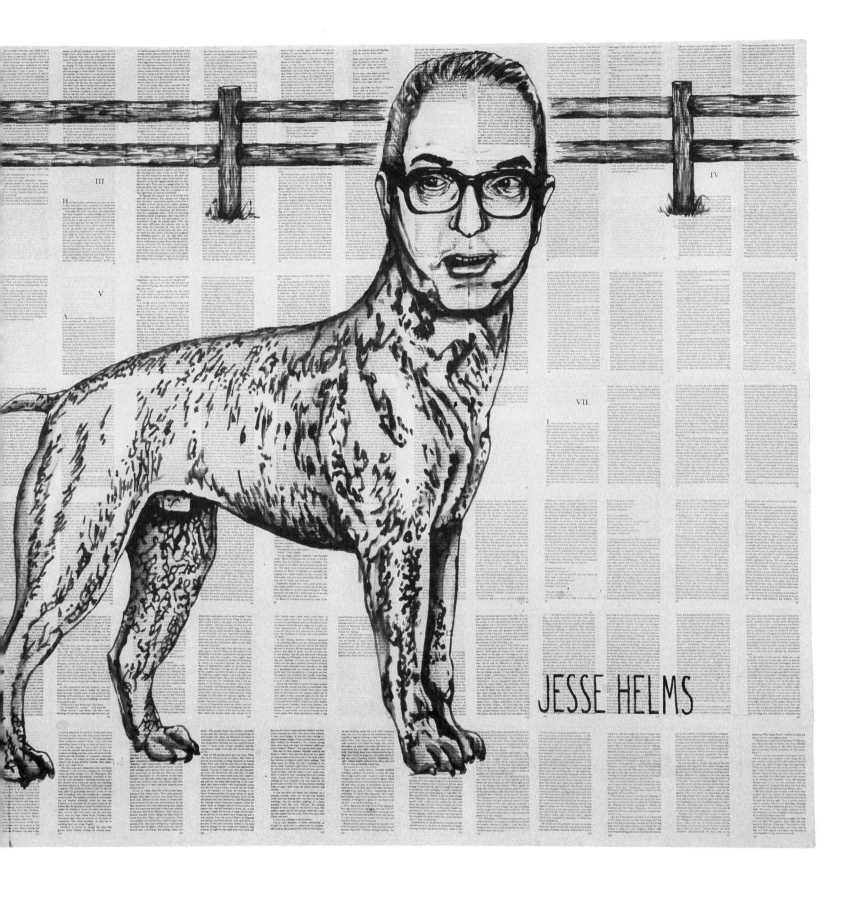

JESSE HELMS

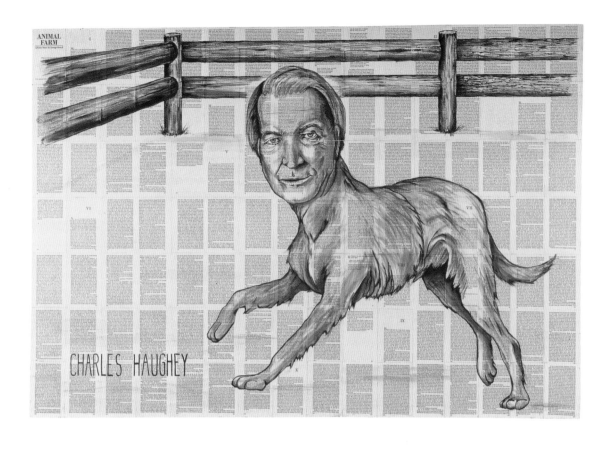

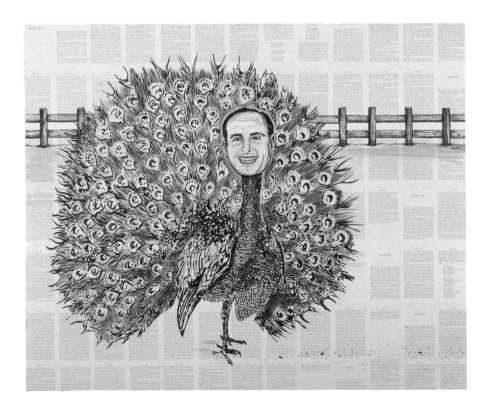

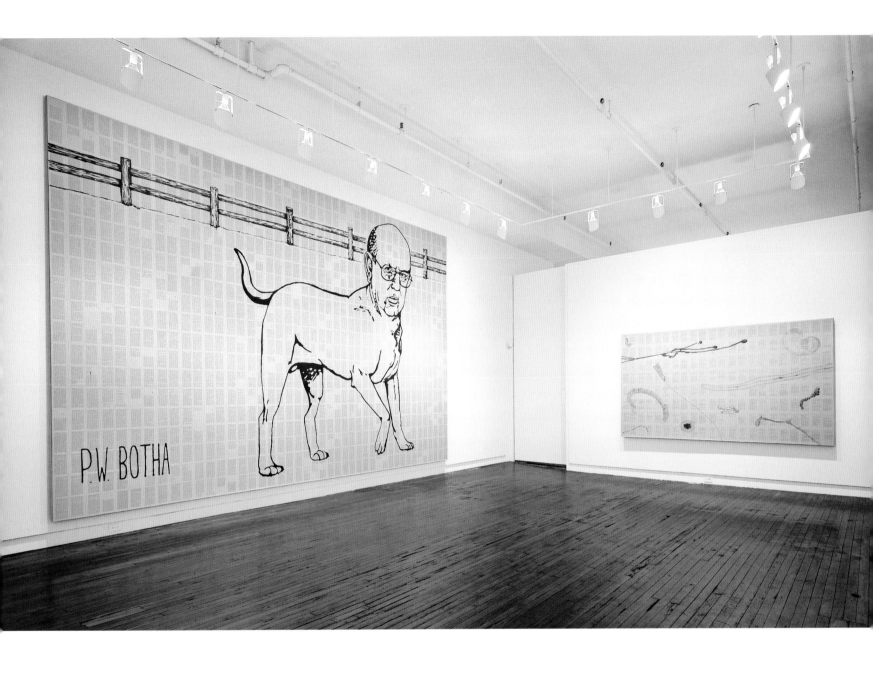

"Our Botha needs to be big, because he's over as a leader maybe,
but the system behind him is still big like a monster…"
CARLOS RIVERA

Facing page, top:
FROM THE ANIMAL FARM: CHARLES HAUGHEY
(AFTER GEORGE ORWELL), 1984–87
Acrylic on book pages mounted on linen
56 x 80 inches
Private Collection

Bottom:
FROM THE ANIMAL FARM: BERLUSCONI
(AFTER GEORGE ORWELL), 2002
Acrylic and pencil on book pages mounted on canvas
48 x 60 inches
Courtesy of Galleria Raucci/Santamaria, Naples

This page:
Installation view, Jay Gorney Modern Art,
New York, May 1989

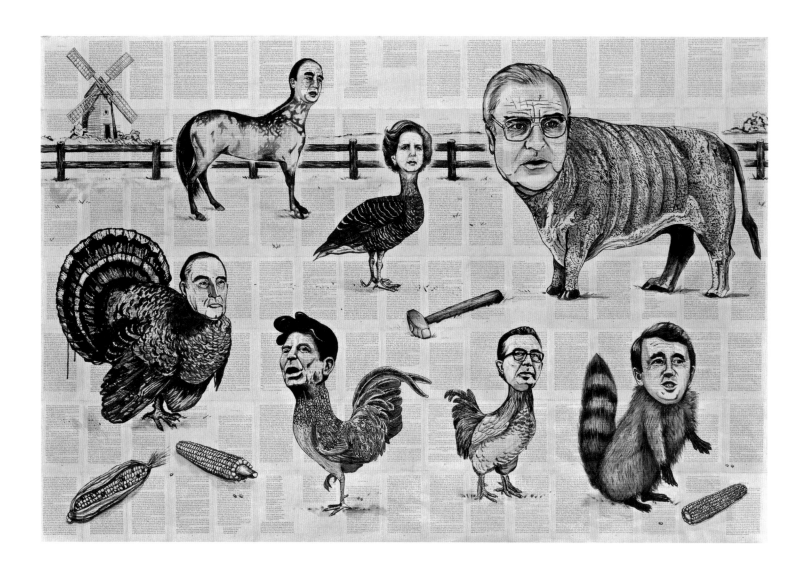

FROM THE ANIMAL FARM: G7, 1989–92
Acrylic on book pages mounted on canvas
54 x 80 inches
Tate, London, Lent from a Private Collection, 2000

Facing page, top:
FROM THE ANIMAL FARM: NEW WORLD ORDER, 1989–92
Acrylic on book pages mounted on canvas
48 x 72 inches
Tate, London, Lent from a Private Collection, 2000

Bottom:
FROM THE ANIMAL FARM: BIG THREE, 1989–92
Acrylic on book pages mounted on canvas
54 x 80 inches
Tate, London, Lent from a Private Collection, 2000

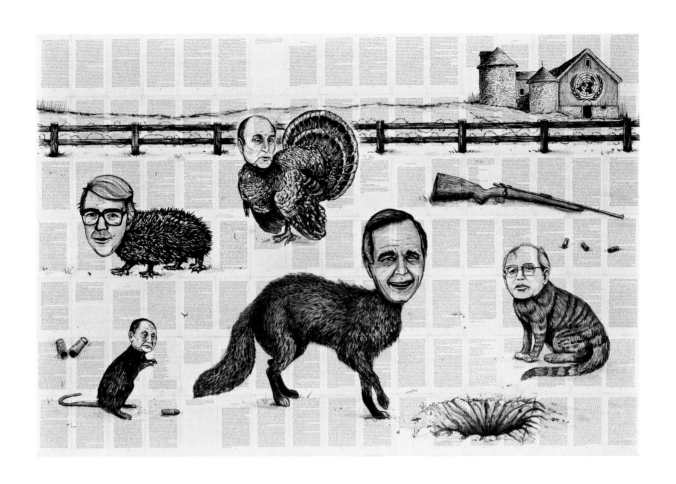

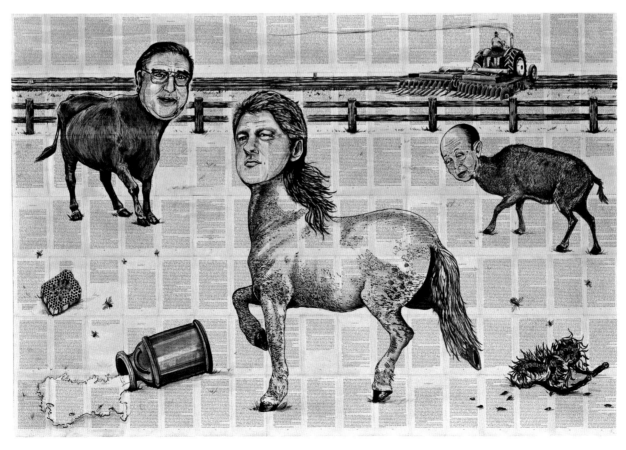

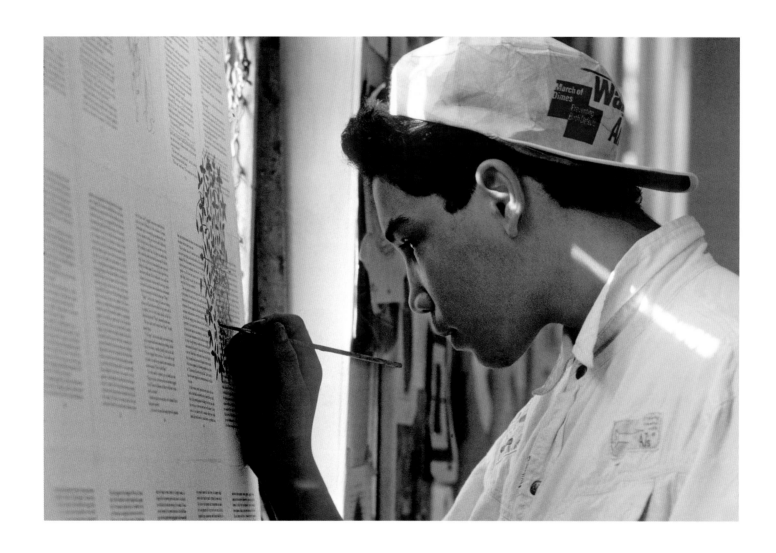

Nelson Ricardo Savinon working on
AMERIKA (AFTER FRANZ KAFKA)
South Bronx, New York, 1987
© Lisa Kahane, NYC

LAWRENCE RINDER

LIBERATION

It was the early 1980s. I was working as a freelance lecturer for the Museum of Modern Art, giving talks on modern and contemporary art at high schools and junior high schools throughout New York City. Fresh out of college, I approached my task by lecturing the students on topics such as the phenomenology of Minimalism and the significance of Cézanne's *passage*. It didn't take long, however, for me to modify this strategy. My epiphany came at a high school in the Bronx when a student stood on his chair and cried out "Boring!"

I don't recall how I first learned of Tim Rollin and K.O.S., whether by seeing their work, reading about them, or (as I prefer to remember it) by chance assignment through my MoMA duties. In any case, during this period I found myself in Rollins's classroom, talking about art with his unusually attentive students. They were just beginning their reading of Kafka's *Amerika*. The students showed me some of their works in progress and explained the process of developing individual visual responses to the text, painted directly on the pages of the book. I was struck by Rollins's choice of texts. The books he was reading with these kids were not hip or particularly "multicultural," but drawn from the canon of Western literature. I was also impressed by Rollins's choice of media. He didn't have them work in photography (the de rigueur medium of that moment), but in old-fashioned painting.

And yet, despite the throwback approach, Rollins accomplished with his students something I saw very little of in any of the many other schools I had visited. The kids were engaged. However imbued with white-maledom it may have been, his choice of books engaged potent, universal themes and inculcated a higher degree of cultural fluency, helping them get a foot in the door of the dominant culture. Through this strategy of criticism through complicity, Rollins's work aligned itself with that of the more avant-garde artists downtown. Since theorists such as Jean Baudrillard had shown that there was no "outside" to the dominant hegemony, artists looked for ways to insert modes of resistance into the status quo, borrowing the language and tools of capitalism and patriarchy in order to reveal or provoke internal fractures. While most such work operated within the field of mass media, Rollins chose a less fashionable but no less important arena: that of high culture. This practice embedded a paradox. Rollins used the texts of the literary canon and materials that signified upper-class taste and power—such as linen grounds and real gold paint—in a pedagogical approach unlike that of the common academic, drawing on the radical theories of Paolo Freire, and aimed ultimately not exclusively at knowledge (as the title of his Art and Knowledge Workshop might suggest) but at liberation.

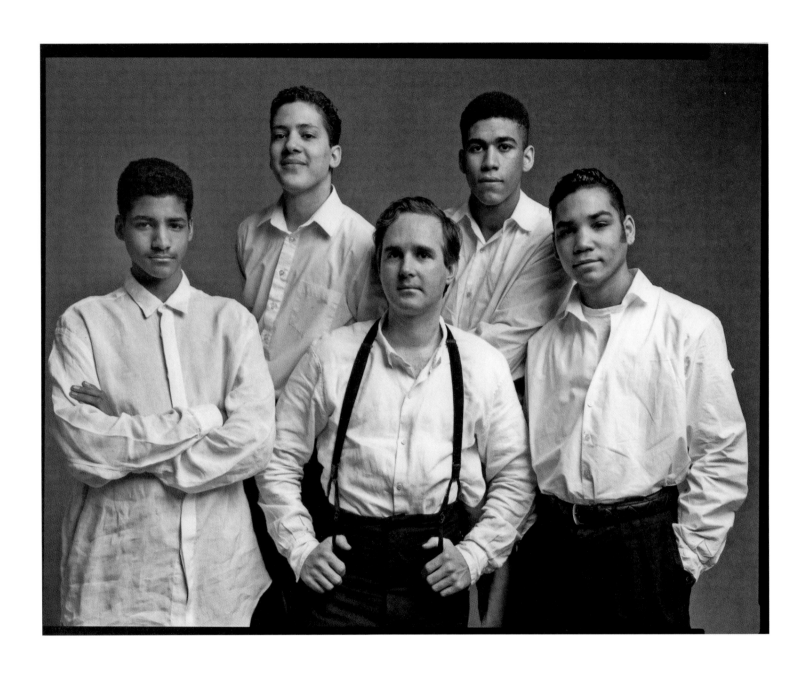

From left to right:
Victor Llanos, Carlos Rivera, Tim Rollins, Angel Abreu,
and Nelson Ricardo Savinon, 1992

SUSAN CAHAN

THE WONDER YEARS

Three young men in ties and jackets greeted me in the galleries of the Dia Center for the Arts in the fall of 1989.[1] They shook my hand, looked me in the eye, and calmly and assertively talked about their work, thirteen paintings from a series inspired by Franz Kafka's *Amerika* and a piece based on Franz Schubert's *Winterreise*. They seemed a little nervous and looked as if they might have borrowed their jackets from older relatives or their teacher, Tim Rollins. But they struck me as poised and articulate, smart and clear as they led me through the cool white galleries hung with works that *The New York Times*'s art critic Roberta Smith would refer to as "precocious masterpieces."[2]

A documentary film made about the group and shot mostly in the K.O.S. studio offers a different view.[3] The kids appear equally aware of their self-presentation, but in a way more typical of teenagers. The guys rag on each other and goof in front of the camera. We see their street smarts and sense of humor. We also see their tenuous connection to the education system. Carlos skips school and lies to Tim about it. Tim sees right though him and reminds him that he's twenty years old and has to graduate before twenty-one or the system will kick him out. The newest member of the group, Victor, is repeating ninth grade for the third time. He's a wisecracking goofball who rarely shows up for school and, when he does, usually just walks the halls. When I interviewed Tim for this essay, he told me that the guys back then acted like "knuckleheads."[4] Watching the film I see exactly what he means. Despite having sold their art work to museums and collectors all over the world, they blithely disregard institutional authority. Shrewd but uncooperative, they appear to have little faith in the value of schooling.

Even if schoolwork had been their priority, their school did not foster success. The art room where Tim started working with the kids in the early 1980s had few supplies, a sink that barely worked, and windows that didn't open, covered with plywood, which in turn was covered with graffiti. Located in the poorest congressional district in the country, the school suffered the highest incidence of violence against teachers. And violence was rampant in the students' lives. According to Rick, "It's so hard every day just to survive in the Bronx. You know, all the time your friend's getting shot or you're with your friend—you're not even associated with him—and you get shot. And then there's all

these temptations…. I can make two thousand a week just by pressing a little button advising someone upstairs that the cops are coming…."[5]

For Rick, Victor, Carlos, and the others, the American truism that education paves a pathway to success was a banal cliché. Even their most committed teachers saw little hope for their students, except maybe the occasional "breakthrough." As educational theorist Peter McLaren has written:

> We claim to live in a meritocracy where social salvation is supposedly achieved through initiative, regardless of sex, religion or family background. That all sounds fine on the surface, but in reality, it's simply hollow rhetoric. Research has shown that one of the greatest predictors of academic success is socio-economic status. In other words, while we profess to believe in equal opportunity for rich and poor alike, the fact remains that an individual's social class and race at birth have a greater influence on social class later in life than do any other factors— including intelligence and merit.[6]

How do we reconcile these contradictory images of Tim Rollins and K.O.S., the poised young artists and the doomed "inner city" youths? How did Tim and his students navigate back and forth across the class barriers that separated the South Bronx from the elite echelons of the art world? How did they develop and maintain an authentic voice without being romanticized or patronized as "outsiders"? How did they "win" and actually change the rules of the system of which they became a part?

Tim's process as an educator was rooted in the critical philosophies of educational theorists Paulo Freire, Robert Coles, and John Dewey. Freire's work in literacy education in Latin America was particularly relevant, modeling and promoting the idea that all people have the potential to act upon and transform their world in order to move toward new possibilities and fulfillment in their lives. According to Freire, there is no such thing as neutral education. What he calls dehumanizing education is designed to maintain the status quo and help the privileged retain their status; it not only keeps the world as it is, but also trains oppressed groups to *accept* the world as it is. Liberatory

education, however, is a transformative process that develops critical consciousness[7] and enables learners to recognize connections between their individual problems and the social contexts in which these problems are produced. For both Freire and Rollins, education has the potential to "provoke recognition of the world, not as a 'given' world, but as a world dynamically 'in the making.'"[8]

The image of the South Bronx of the late 1970s and early '80s is infamously etched in popular memory as an inversion of the American dream. Once a middle class enclave, the area had been disrupted by the building of the Cross Bronx Expressway in 1963, which cut through the community and dispersed many of its residents. The nearness of apartment buildings to the expressway led to a drop in real estate values. Rent control laws that limited landlords' revenues provided further disincentives to maintain the buildings. In the 1970s, fires became commonplace, some the accidental result of decaying electrical systems, but many set by landlords scrambling to salvage some of their investment through insurance payments. This, combined with white flight, led to a fifty-seven percent drop in the South Bronx's population from 1970 to 1980.[9] The resulting landscape has often been compared to Beirut in the late 1970s or Dresden after World War II, a bombed-out no man's land. The government absurdly attempted to brighten the situation by applying decals of potted flowers to windows sealed up with cinder blocks.[10]

The work of Tim Rollins and K.O.S. grew out of members' own experiences, so it is not surprising that their earliest paintings took inspiration from the gothic horror novels *Frankenstein* and *Dracula*, two stories that investigate existence hovering between life and death. The group made its first publicly exhibited sculptures from found bricks, salvaged from the ubiquitous rubble that littered their neighborhood and painted to look like the flaming buildings from which they had come.[11] Each brick became a synecdoche of a larger decaying ruin.

Tim himself grew up in the rural community of Pittsfield, Maine, and attended the University of Maine at Augusta for two years before coming to New York. An avid art student and reader, after devouring the essay "Art After Philosophy" by Joseph Kosuth, he tracked down the author and enrolled in the School of Visual Arts to study under him. To earn money, Rollins worked at the SVA visual arts library and was then hired by Kosuth to organize the artist's own library of five thousand volumes. Kosuth would often ask him to stay for dinner and meet the art luminaries who came to visit. Rollins became a participant/observer in Kosuth's circle of elite theoreticians and artists. "That was my education," says Rollins. These experiences account not only for his bond with the printed word, but also, in part, for his belief that anybody can enter the art system.

After completing his BFA at the School of Visual Arts he entered the graduate program of the School of Education at New York University. At NYU he studied Marxist philosophy with political theorist Bertell Ollman and film historian Jay Leyda. He sat in on classes with art historians Kirk Varnedoe, John Pope Hennessy, and Robert Rosenblum. He listened to lectures by literary theorist Roland Barthes and philosophers Michel Foucault, Gilles Deleuze and Félix Guattari, and Julia Kristeva.

In 1981, Rollins came to I.S. 52 in the South Bronx after discovering that he had a gift for working with kids written off by the system as emotionally disabled, intellectually handicapped, or just plain uneducable. During his last year at NYU he student-taught at P.S. 3, an elementary school in the West Village founded in 1971 by parents looking for an educational alternative, dedicated to student-centered teaching methods and open classrooms. Tim's placement with a special education group proved a pivotal experience. He electrified the students and amazed the teachers with his charismatic command of attention in the classroom and a pragmatism that led him to overcome obstacles with creative solutions that defied convention. He had found his milieu.

Rollins never finished his MA, but with his BFA became one of several instructors in a program called Learning to Read Through the Arts. From 1980 to 1982 he traveled to schools throughout New York City, lugging art supplies and slide projectors for short-term stints as a visiting artist/teacher. On the day in 1981 that he arrived at I.S. 52, assigned to a special needs class, he was surprised, entertained, and horrified to find that the students had managed to write graffiti on the ceiling of the art room. They had devised an ingenious method of taping charcoal to the end of the long pole meant for operating the windows, a technique that reminded Tim of the one used by the bedridden Henri Matisse at the end of his life. Yes, it was vandalism, but executed with imagination and skill.

To that first class Tim brought a ream of copier paper and some nice drawing pencils. Deviating from the program's official lesson plan, he put Grandmaster Flash and Afrika Bambaataa on his boom box, slammed down the stack of paper, and said, "You've got forty-five minutes to make the best damn drawing you've ever made in your life and you're doing it now." The students rose to the challenge.

Rollins's ability to establish order and instill discipline in students deemed beyond reach was quickly recognized by I.S. 52's Crisis Intervention teacher Arthur Albert. He spoke to principal George Gallego, who within days hired Rollins on a permanent basis. He accepted the offer but only with conditions: Art would become a major subject, and Tim would see the kids every day. He would offer a multidisciplinary curriculum that used art as a means to knowledge and included reading, writing, literature, art history, and music. "I felt it was unethical," he says, "to make art when they couldn't even spell the word art." Each project would generate its own curriculum. For instance, one student's desire to make a painting of the universe led to the

reading of Jules Verne's *From the Earth to the Moon*, the study of astronomy, and an introduction to Charles and Ray Eames's classic film, *Powers of Ten*.

Child psychiatrist Robert Coles provided inspiration for using art within a holistic vision of human development. In the 1960s and '70s Coles wrote the great series of books *Children of Crisis*, which chronicled and analyzed children's political and moral lives in situations of change and stress. A white man from New England, Coles studied the effects of poverty, privilege, and racism on children of all races in the United States, using drawing as a means to help them express the truth about their lives, especially when they could not express it verbally. According to Coles, art is a good medium for those who find it easier to "do" than to "talk."[12] Coles's "children of crisis" were Tim's "kids of survival."

The later work of Tim Rollins and K.O.S. was made with the finest archival materials, but they made their early works using whatever they could find at little or no cost, including the sheet metal that had fallen off the covered windows of vacant buildings. As the group began to jell, Tim noticed that even the kids who couldn't read could memorize every word and grunt of a hip hop song. Tim began to create homemade books on tape to animate their art projects. He intuited that literary classics would resonate with his students' depth of experience, their frequent encounters with danger and death, and their vitality. When Tim made these recordings, he focused on inspirational passages. In class he'd show the students the book, play the tape or read aloud, and ask them to draw whatever came into their minds. Eventually, the kids started looking at the books themselves, taking them home, and soon, reading aloud to each other.[13] Tim put his students into dialogue with the greats, but the group never worked with a book that Tim knew well. This allowed for reciprocity in the student/teacher relationship and kept the creative process open, since Tim deciphered the texts as a member of the group.

The story of the first book-page works presents an object lesson in the pragmatic creativity that marks K.O.S.'s work. Tim had always loved books, and his love only increased when he worked in the libraries at SVA and Kosuth's studio. One day he brought a first edition of George Orwell's *1984* to school to share with the students. Oblivious to its value, one of the kids started drawing on its pages. After Tim recovered from his initial fury, the group realized that this transgression was actually a breakthrough. They discovered that painting on book pages offered an ideal methodology for executing their artistic vision, complete with all of its metaphorical associations with knowledge, authority, voice, and cultural consumption as a form of cultural production. Their subsequent paintings would each embody an intertextual relationship between a canonical cultural object and its pragmatic use in understanding and re-envisioning the present.

The earliest pieces almost obliterate the text with paint, using the book pages more as inspiration and canvas than as communicative or signifying element in the composition. In the painting *Frankenstein (after Mary Shelley)* (1983), one has to look hard to see the text and, even then, it's difficult to read the words. This technique suggests the possible influence of Jasper Johns's paintings of flags and targets, made with encaustic on newspaper and similarly hard to read. But there is a lack of precision in the group's aesthetic choices. For example, the painting includes pages from both Mary Shelley's classic novel and Bram Stoker's *Dracula* (the subject of another work). The potential of the text as canvas is only partially realized. Moreover, the figures in the work are stylized and cartoon-like, qualities typical of the work of talented kids who haven't had much training.

Later works integrate the book pages as significant visual and conceptual elements, with *Winterreise (after Franz Schubert)* (1988–89) standing as one of their aesthetic triumphs. In this work the visual relationship between the paint and the text—in this case a musical score—is rendered in exquisite equilibrium. The paintings create an analogue to the song cycle's narrative, in which a young poet faces rejection by his beloved and finds his sorrow mirrored in the inexorable onset of winter. *Winterreise (after Franz Schubert)* is a series of twelve canvases covered with sheet music, each corresponding to one of twelve songs. The canvases are painted edge to edge with mixtures of white paint and tiny flakes of mica. The first canvas covers the score with a thin translucent layer that leaves the notes almost perfectly visible. In each subsequent canvas, the paint layer grows more and more opaque, until, in the last two canvases, the dense coating completely

HYPOCENTER SOUTH BRONX, 1982 (detail)
Tempera on paper
18 x 24 inches
Courtesy of the artist

whites out the music. The penultimate canvas renders the entire text illegible; the final canvas takes this heaviness even one step further into an impenetrable field of blinding whiteness.[14]

One vital aspect of the humanizing educational process that Tim advanced consisted of countering dominant social expectations regarding students like his through the public exhibition of their art. While still working with Learning to Read Through the Arts, Tim had exhibited works that a group of his students made in response to the Atlanta child murders of 1979–1981. The drawings were shown in an exhibition organized by Group Material[15] and cited in a review by critic Lucy Lippard in *The Village Voice*. Group Material's philosophy of cultural democracy and exhibition practice as a form of public dialogue made possible the acceptance of Rollins's students' work as legitimate artistic expression in a public setting, not dismissed or patronized as "children's art."

At I.S. 52 Tim continued to release his students' work into the art system. In 1983 the kids sold their burning bricks for $5 apiece at Colab's A. More Store, a temporary shop that offered artists' multiples during the Christmas holiday season. Shortly thereafter Rollins received a call from art dealer Ronald Feldman about a show called *The Atomic Salon*, organized with *The Village Voice* and its art critic Carrie Rickey to coincide with a nuclear disarmament demonstration in New York City. Feldman wanted suggestions for young artists to include in the show.[16] Tim surprised the dealer by suggesting his own students, then thirteen and fourteen years old. To Rollins's own surprise, Feldman agreed. The group submitted *Hypocenter: South Bronx*, premised on the idea that the hypocenter of a nuclear blast would fall at Prospect Avenue, the subway stop nearest their school. The piece consisted of nineteen drawings hung on the wall in the shape of a mushroom cloud, and depicting targets, war planes, burning bodies, and charred flesh. Most of the reviews cited the work as among the most powerful in the show.

Other early pieces, the *Frankenstein* and *Dracula* paintings, shown at Brooke Alexander and Barbara Gladstone Gallery, celebrated abjection. This "expressionist" phase would quickly give way to their first major series to receive widespread acclaim, the *Amerika* paintings. *Amerika I (After Franz Kafka)* appeared in the 1985 group show *Social Studies* at Barbara Gladstone, along with works by Eric Fischl, Jenny Holzer, Mike Glier, Leon Golub, Nancy Spero, and others. The painting sold to Chase Manhattan Bank for $5000 and the group went pro.

The alternative arts movement of the 1970s and the proliferation of collaborative exhibition practices in the 1980s created a context for recognizing and showcasing the work of Tim Rollins and K.O.S. as art. The movement had emerged in the wake of 1960s social activism that demanded more democratic concepts of cultural value. Newly available government arts funding supported the growth of an art sector not beholden to wealthy patrons. Less restrictive art venues, especially artist-run galleries, made space for more diverse and socially-engaged art.[17]

Tim's first contact with the alternative arts movement came just after his arrival in New York in 1975. His mentor Joseph Kosuth had belonged to the conceptual art group Art & Language and when Tim arrived, was the editor of the group's influential but short-lived publication, *The Fox*. By 1977 Rollins himself had become involved with Artists Meeting for Cultural Change, a group formed to protest an exhibition at the Whitney Museum of American Art celebrating the Bicentennial of the American Revolution. Culled exclusively from the limited collection of Mr. and Mrs. John D. Rockefeller III, the exhibition included no artists of color and only one woman. Rollins participated in the production of *an anti-catalogue*, a low-budget publication containing critical essays and documents opposing the use of arts institutions to serve the interests of the rich.

By the late 1970s a new generation of artists began establishing a second wave of artist collectives and artist-run organizations. Collaborative Projects (Colab), one of the first, consisted of about forty artists who raised money, shared equipment, and organized exhibitions.[18] The epicenters of activity among young artists moved from SoHo and Tribeca, which had been overtaken by the affluent, to the East Village and the South Bronx. Ideas of community were pursued by John Ahearn and Rigoberto Torres, who cast plaster portraits of South Bronx residents, taking molds of their sitters outdoors on the sidewalk. In 1978 Stefan Eins and Joe Lewis opened Fashion Moda in a South Bronx storefront space. There the downtown and uptown art worlds met, including graffiti writers, hip-hop musicians, break dancers and other artists.[19] Fashion Moda also organized projects in public places such as vacant lots and abandoned buildings. A new style of art show emerged: "non-curated, densely packed shows on oddball themes, including art by children and the anonymous...."[20] The scene was celebratory and critical, and it reinvented the idea of the art exhibition, fueled by political ideals, artistic ambition, and communalism undeterred by lack of resources.

In 1979 Tim helped found Group Material, a collaborative group whose artistic medium was exhibition practice, which they viewed not only as a vehicle for the display of objects, but as a means of building community. In a 1983 statement, the group defined itself in ambitious terms:

Group Material was founded as a constructive response to the unsatisfactory ways in which art has been conceived, produced, distributed and taught in American society.... While most art institutions separate art from the world, neutralizing any abrasive forms and contents, Group Material accentuates the cutting edge of art. We want our work and the work of others to take a role in a broader cultural activism.... In our exhibitions Group Material

reveals the multiplicity of meanings that surround any vital social issue. Our project is clear. We invite everyone to question the entire culture we have taken for granted.[21]

From 1980 to 1981, Group Material operated a space in the East Village, believing it important to establish a physical presence in order to gain legitimacy and recognition.[22] Group Material's ideological positioning strategy informed Tim's work with K.O.S. Like Group Material, Tim wanted K.O.S. to stake a claim in the center, not the periphery. In a prescient statement about their work made in 1983, Tim said, "I think my greatest success is that I've pulled kids into the realm of production, where they make real things that other people see…. [T]he work I do with my kids is almost always shown in a real art gallery, mainly alternative spaces…so far."[23]

Tim Rollins and K.O.S. were not the only young artists to make it big in the 1980s. The most visible were graffiti artists, among them Lady Pink, who started her career at sixteen while still a student in high school, and Jean-Michel Basquiat, who began as a graffiti writer and became an art star by age twenty.[24] But beyond its use of text, the work of Tim Rollins and K.O.S. had little in common with graffiti art. The group's works were increasingly influenced by the artists they studied with Tim, including the conceptual art of Hanne Darboven, Sol LeWitt, and Kosuth; the monochromatic paintings of Ad Reinhardt and Robert Ryman; and the politically engaged work of Joseph Beuys, Margaret Harrison, and Conrad Atkinson.

Of particular influence was Atkinson, a conceptual artist and activist who also showed at Ronald Feldman's gallery. During the late 1960s and early '70s many "political" artists turned their backs on dominant cultural values, but Atkinson continued to see the history of high art and the institutional art world as vital sites. He especially identified with the history of socially engaged literary texts and wanted to see them mined on the main stage of art. In a 1985 interview, he expressed the need to employ a broad range of activities to rebuild the torn social fabric, including the kind of intellectual discourse that can happen through cultural institutions.[25] "You have to occupy the ruling hegemonic spaces as well as popular areas. Otherwise you render yourself invisible," he would later say.[26]

The art world's increasing recognition of "community-based" art aided the acceptance of Tim Rollins and K.O.S. by mainstream institutions. The work of Tim Rollins and K.O.S. has often been classified among artistic practices that emerged in the 1980s and proliferated in the 1990s, variously referred to as "service work," "project work," or "new genre public art." These terms describe process-oriented art that involves "community" participation and often limits the authorial role of the artist.[27] Such work uses art as a means to engage groups of people, often those who do not identify themselves as artists, and is sometimes described as disrupting the conventional social relationships in the art system.

The fashion for this type of art paved the way for Tim Rollins and K.O.S.'s acceptance into the art world, even though their work didn't really fit this category. First and foremost, Tim was not engaged for a short-term project or exhibition to "collaborate" with a "community group" on a temporary basis. The group's projects did not serve as a metaphor for cultural democracy, but an actual rethinking of definitions of cultural participation. The relationships among the members of the group were sustained and continue to this day. Much "community-based" art is more concerned with process than product and, as Michael Brenson has written, "is intended to lead away from the object into the lives of real people, real neighborhoods."[28] Not only did Tim Rollins and K.O.S. reject the glorification of poverty and "difference" as signs of social or artistic authenticity; they also embraced the "thing-ness" of art, the joy of making beautiful and lasting things that embody the mind, strength, character, and presence of their makers. Referring to the group's painting, Tim says, "Call it a commodity if you want, but honey, this is a commodity that has spirit."

Much "community-based" art aspires to the condition of unalienated collective labor and attempts to critique capitalism either by remaining outside the art market or taking social and economic relations as its subject matter. By contrast, Tim Rollins and K.O.S. jumped into the market enthusiastically. In 1986, after the show at Barbara Gladstone from which Chase Manhattan Bank had purchased *Amerika I,* dealer Jay Gorney offered an exhibition at his gallery on East 10th Street, then part of the red hot East Village art scene. Gorney paired *Amerika II* and works based on the *The Red Badge of Courage* and *Alice in Wonderland* with photographs from *The Ballad of Sexual Dependency* by Nan Goldin. Not expecting to sell a thing, Tim was stunned to learn that mega-collector Charles Saatchi had purchased their work.

On occasion, Tim has been vilified for what appears to some as missionary work or exploitation, and the group's market success has only exacerbated these accusations. But selling their work enabled K.O.S. to fulfill the pragmatic need to make a living. They matched a grant from the National Endowment for the Arts to open their Art and Knowledge Workshop with $8000 of the money they earned, set up a college fund, and provided them-selves stipends.[29] Whatever scorn one might have for the inequi-ties produced by the capitalist system, earning money is practical and legitimized the group's work. Tim says, "It was this bizarre—and I'm sorry but this is the reality—it was this kind of bizarre affirmation of everything that we had been doing." This is the essential dialectical tension in Tim Rollins and K.O.S.'s work: in order to pursue a Marxist-driven vision of social liberation, the group had to "win" in the capitalist system.

Tim Rollins and K.O.S. were firmly grounded in the art world, but Tim also belonged to a community of New York City

arts educators who shared his critical understanding of education as having the potential either to reproduce existing social relations or intervene in and transform them. The concept of art and art education as instruments of social change informed a subculture of educators in the 1980s, including Artists/Teachers Concerned, with whom Tim Rollins and K.O.S. showed in 1989 at the gallery Minor Injury.[30] Artists/Teachers Concerned comprised thoughtful, good-hearted, politically aware individuals, but their work with their students tended to be predictable and underdeveloped. They promoted art activities in which students depicted social problems, such as homelessness and pollution, or expressed positive messages, as in murals that read, "We can make a difference!"

Several things distinguished Tim Rollins and K.O.S.. They not only penetrated the art market, they developed a high level of artistic sophistication. They took frequent field trips to research their painting projects, to the Museum of Modern Art, for example, where they looked at Rothko and Reinhardt and the Russian Constructivists. They were often dogged by security guards who bristled at their age and skin color; nonetheless MoMA became a second home to them.

When art prices declined in the early 1990s, Tim Rollins and K.O.S.'s market sagged. The infrastructure that supported their artistic development was then further battered by the assault on cultural democracy, whose main target became the National Endowment for the Arts. But the group itself endured. The work had matured. Its process of creation, formal elegance, and poignant content defied categorization and so disrupted both aesthetic and social categories. Tim's teacher Kosuth, it seems, ended up offering Tim more than simple entrée into a community of art intellectuals. His own art modeled an approach for Rollins, a drive to continually recreate the idea of art as a characteristic of art itself. As Kosuth has described: "…[T]he work of art is essentially a play within the meaning system of art. As that 'play' receives its meaning from the system, that system is—potentially—altered by the difference of that particular play."[31]

Tim Rollins and K.O.S. have integrated process and product into a practice that defied assumptions about who is eligible for recognition as an artist. The members of the group formed bonds and alliances across lines of age, class, and ethnicity. In retrospect, the refusal of Carlos, Victor, Rick, and the others to remain complacent provided a necessary condition for change and for the model they developed, a harbinger of a more democratic, liberal (in its true meaning), and just America.

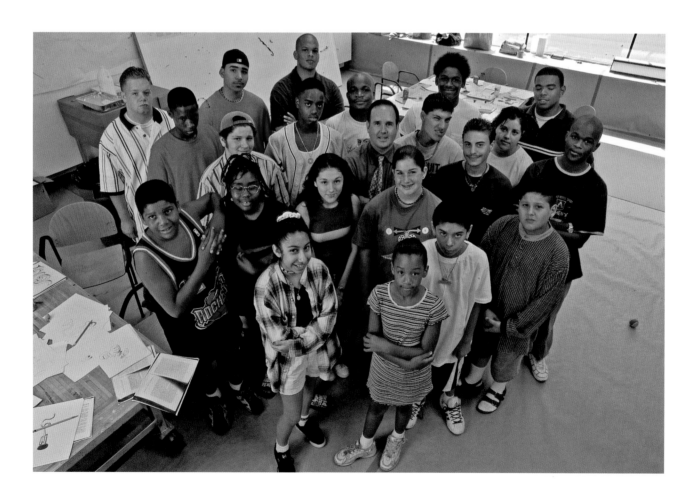

1. The exhibition was *Tim Rollins and K.O.S.: Amerika*, at the Dia Center for the Arts, New York, October 13, 1989–June 17, 1990.

2. Roberta Smith, "Review/Art; 'Amerika' by Tim Rollins and K.O.S.", *The New York Times*, November 3, 1989, C33.

3. *Kids of Survival: The Art and Life of Tim Rollins and K.O.S.*, a film by Dayna Goldfine and Dan Geller (1996).

4. Unless otherwise specified, all quotations by Tim Rollins are from an interview with the author recorded on December 9, 2008.

5. Victor Llamos, quoted in *Kids of Survival: The Art and Life of Tim Rollins and K.O.S.*

6. Peter McLaren, *Life in Schools: An Introduction to Critical Pedagogy in the Foundations of Education* (New York and London: Longman, 1989), 151.

7. Freire called this *conscientização*.

8. Paulo Freire, *The Politics of Education*, trans. Donaldo Macedo (Granby, MA: Bergin & Garvey, 1985), 106.

9. http://www.demographia.com/db-sbrx-txt.htm, March 9, 2009.

10. For a discussion of representations and perceptions of the South Bronx, see Katherine Simpson, "Media Images of the Urban Landscape: the South Bronx in Film," *Centro Journal* 14, no. 2 (Fall 2002): 99–113.

11. Rollins has stated that these early works reflected his paternalist imposition of his own liberal agenda. See "Tim Rollins Talks to David Deitcher," *Artforum* 40, no. 8 (April 2003): 79.

12. See especially Robert Coles, *Children of Crisis: A Study of Courage and Fear* (Boston and Toronto: Little, Brown, 1967).

13. In the course of writing this essay, I asked Tim how well the kids learned to read. He responded with just a handful of their accomplishments. One just completed graduate school at Columbia; another graduated from Stanford and is teaching at Berkeley. A third got a full undergraduate scholarship at Bard College and is getting his masters in art education at Lehman College.

14. The influence of Glenn Ligon's work may be seen in this piece in its play of textual legibility and illegibility.

15. *Atlanta*, at Group Material's space on East 13th Street, 1981.

16. *The Atomic Salon*, Ronald Feldman Gallery, June 9–July 2, 1982. The show was mounted in conjunction with a special *Village Voice* issue on nuclear disarmament, which published images of the art in the exhibition.

17. The Kitchen, founded in 1971, showed video art, a medium ignored by museums at the time. 112 Workshop/112 Greene Street, founded in 1970, provided a place for conceptual works that responded to the physical and social conditions of its site. AIR, founded in 1972, was a women's cooperative gallery. Many other organizations, including El Museo del Barrio, Kenkeleba House, El Taller Boricua, and Basement Workshop showcased works by artists of color who had been shut out or included as tokens in the major museums.

18. Their most celebrated project was *The Times Square Show*, mounted in June 1980.

19. *Tim Rollins & K.O.S, 1983-1985* featured works based on *Amerika* by Franz Kafka, *Absalom, Absalom!* by William Faulkner, *The Autobiography of Malcolm X*, and *The Wild Boys* by William Burroughs, January 25–February 26, 1986.

20. Alan Moore and Mark Miller, eds. *ABC No Rio Dinero: The Story of a Lower East Side Art Gallery* (New York: ABC No Rio, 1985), 3.

21. Group Material, "Statement," reprinted in *ABC No Rio Dinero*, 22.

22. Following this phase the group continued with a changing roster of members until 1996.

23. "Art, Ideology and Education: Who's Teaching What to Whom and Why?" Excerpts from a panel on Art, Ideology and Education, PADD Second Sunday Forum, Franklin Furnace, November 14, 1983. Printed in *Upfront: A Publication of Political Art Documentation/Distribution* #05 (February 1983) and reprinted in *ABC No Rio Dinero*, p. 25.

24. Fab Five Freddy and Charlie Ahearn parodied the rapacious hunger for young South Bronx artists among downtown art aficionados in their 1983 film *Wildstyle*.

25. Charlotte Townsend-Gault, "Conrad Atkinson," *Parachute*, No. 38 (March/April/May 1985): 20–24.

26. "Conrad Atkinson's Tactical Art: An Interview by Penelope Shackelford," *Art Papers* 19, no. 1 (January/February 1995): 26.

27. For discussions of this type of work see the 1994 lecture by Andrea Fraser and Helmut Draxler, "How to Provide an Artistic Service," in *Museum Highlights: The Writings of Andrea Fraser*, ed. Alexander Alberro (Cambridge: MIT Press, 2005) and Miwon Kwon, *One Place After Another: Site-Specific Art and Locational Identity* (Cambridge: MIT Press, 2002).

28. Michael Brenson, "Healing in Time," in *Culture in Action* (Seattle: Bay Press, 1995), 21.

29. Artist Jenny Holzer also contributed toward this match.

30. *Out of the Classroom: Social Education Through Art* ran at Minor Injury in Brooklyn, New York, March 3–April 2, 1989.

31. Joseph Kosuth, "Exemplar," in *Felix Gonzalez-Torres* (Los Angeles: Museum of Contemporary Art, 1994), 54. Emphasis in the original.

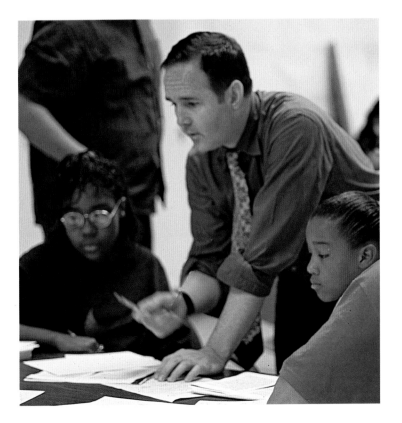

This page and facing:
Workshop, Grand Arts, Kansas City, Missouri, 1998

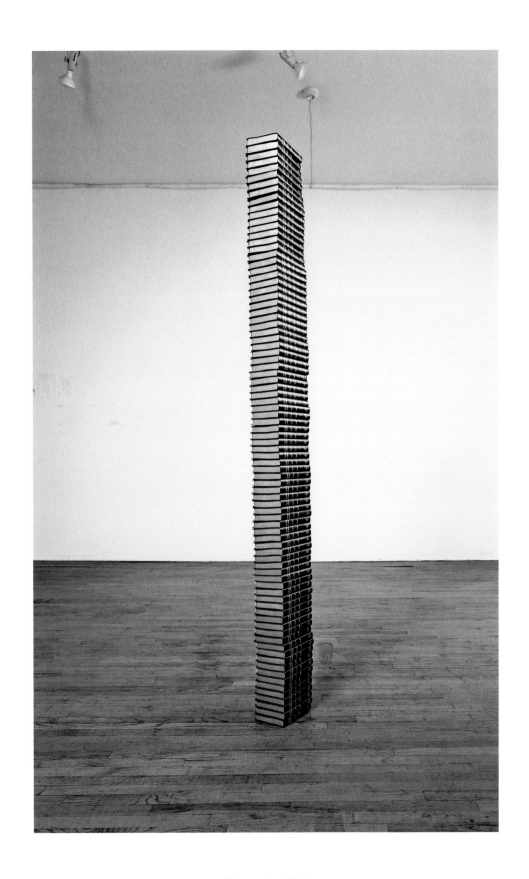

This page, detail facing:
THE HOLY BIBLE, 1987
Books, steel
114 ¹/₂ x 8 x 5 ⁵/8 inches
Private Collection, courtesy of Thomas Ammann
Fine Art, Zurich

RAY BRADBURY

Fahrenheit 451

F-451—FAHRENHEIT 451 (AFTER RAY BRADBURY), 1985–87
Acrylic and ashes on book pages mounted on linen
52 x 104 inches
Private Collection

F-451—MACBETH ACT 1 (AFTER RAY BRADBURY), 1988–89
Acrylic and ashes on book pages mounted on linen
38 x 14 inches
Private Collection

F-451—MEIN KAMPF (AFTER RAY BRADBURY), 1988
Acrylic and ashes on book pages mounted on linen
120 x 44 inches
Private Collection

like the fire the next year. The fire, which consumed what the plague could not touch, defied all the application of remedies; the fire-engines were broken, the buckets thrown away, and the power of man was baffled and brought to an end. So the plague defied all medicines; the very physicians were seized with it, with their preservatives in their mouths; and men went about prescribing to others and telling them what to do, till the tokens were upon them, and they dropped down dead, destroyed by that very enemy they directed others to oppose. This was the case of several physicians, even some of them the most eminent, and of several of the most skilful surgeons. Abundance of quacks too died, who had the folly to trust to their own medicines, which they must needs be conscious to themselves were good for nothing, and who rather ought, like other sorts of thieves, to have run away, sensible of their guilt, from the justice that they could not but expect should punish them as they knew they had deserved.

Not that it is any derogation from the labour or application of the physicians to say they fell in the common calamity; nor is it so intended by me; it rather is to their praise that they ventured their lives so far as even to lose them in the service of mankind. They endeavoured to do good, and to save the lives of others. But we were not to expect that the physicians could stop God's judgment, or prevent a distemper eminently armed from heaven from executing the errand it was sent about.

Doubtless, the physicians assisted many by their skill, and by their presence and applications, to the saving of their lives and restoring their health. But it is not lessening their character or their skill, to say they could not cure those that had the tokens upon them, or those who were mortally infected before

This page:
A JOURNAL OF THE PLAGUE YEAR
(AFTER DANIEL DEFOE), 1988
Animal blood with graphite underdrawing
on book page
6 7/8 x 5 inches
Museum of Fine Arts, Boston, Massachusetts
Gift of the Barbara Krakow Gallery in memory
of John Larrabee, 1989.290

Facing page:
A JOURNAL OF THE PLAGUE YEAR
(AFTER DANIEL DEFOE), 1987–88
Animal blood on book pages mounted on linen
97 x 85 inches
Private Collection

ABRACADABRABRACADABRABRACAD
ABRACADABRABRACADABRABRACA
ABRACADABRABRACADABRABRAC
ABRACADABRABRACADABRABRA
ABRACADABRABRACADABRABR
ABRACADABRABRACADABRAB
ABRACADABRABRACADABRA
ABRACADABRABRACADABR
ABRACADABRABRACADAB
ABRACADABRABRACADA
ABRACADABRABRACAD
ABRACADABRABRACA
ABRACADABRABRAC
ABRACADABRABRA
ABRACADABRABR
ABRACADABRAB
ABRACADABRA
ABRACADABR
ABRACADAB
ABRACADA
ABRACAD
ABRACA
ABRAC
ABRA
ABR
AB
A

RA AABRACADABRA ABRAC

A JOURNAL OF THE PLAGUE YEAR (AFTER DANIEL DEFOE), 1988
Animal blood on book pages mounted on linen
7 x 53 inches
Private Collection
Installation view, Galeria La Maquina Espanola, Madrid, Spain, 1988

"It's like when your father does something bad to you. It's just like the apple that sticks in the back of Gregor. It doesn't fall out, it stays stuck in your back and soon becomes part of you, like it's stuck in there forever."

CARLOS RIVERA

THE METAMORPHOSIS (AFTER FRANZ KAFKA), 1988–89
Apple and book pages mounted on linen
36 x 64 inches
Wadsworth Atheneum Museum of Art,
Hartford, Connecticut
The Ella Gallup Sumner and
Mary Catlin Sumner Collection Fund

the family to forget as soon as possible the catastrophe which had overwhelmed the business and thrown them all into a state of complete despair. And so he had set to work with unusual ardor and almost overnight had become a commercial traveler instead of a little clerk, with of course much greater chances of earning money, and his success was immediately translated into good round coin which he could lay on the table for his amazed and happy family. These had been fine times, and they had never recurred, at least not with the same sense of glory, although later on Gregor had earned so much money that he was able to meet the expenses of the whole household and did so. They had simply got used to it, both the family and Gregor; the money was gratefully accepted and gladly given, but there was no special uprush of warm feeling. With his sister alone had he remained intimate, and it was a secret plan of his that she, who loved music, unlike himself, and could play movingly on the violin, should be sent next year to study at the Conservatorium, despite the great expense that would entail, which must be made up in some other way. During his brief visits home the Conservatorium was often mentioned in the talks he had with his sister, but always merely as a beautiful dream which could never come true, and his parents discouraged even these innocent references to it; yet Gregor had made up his mind firmly about it and meant to announce the fact with due solemnity on Christmas Day.

Such were the thoughts, completely futile in his present condition, that went through his head as he stood clinging upright to the door and listening. Sometimes out of sheer *weariness he had to give up listening* and let his head *fall negligently* _____ but he

always had to pull himself together again at once, for even the slight sound his head made was audible next door and brought all conversation to a stop. "What can he be doing now?" his father would say after a while, obviously turning towards the door, and only then would the interrupted conversation gradually be set going again.

Gregor was now informed as amply as he could wish —for his father tended to repeat himself in his explanations, partly because it was a long time since he had handled such matters and partly because his mother could not always grasp things at once—that a certain amount of investments, a very small amount it was true, had survived the wreck of their fortunes and had even increased a little because the dividends had not been touched meanwhile. And besides that, the money Gregor brought home every month—he had kept only a few dollars for himself—had never been quite used up and now amounted to a small capital sum. Behind the door Gregor nodded his head eagerly, rejoiced at this evidence of unexpected thrift and foresight. True, he could really have paid off some more of his father's debts to the chief with this extra money, and so brought much nearer the day on which he could quit his job, but doubtless it was better the way his father had arranged it.

Yet this capital was by no means sufficient to let the family live on the interest of it; for one year, perhaps, or at the most two, they could live on the principal, that was all. It was simply a sum that ought not to be touched and should be kept for a rainy day; money for living expenses would have to be earned. Now his father was still hale enough but an old man, and he had done no work for the past five years and could not be expected

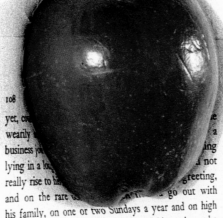

Gregor was still lying there
as quiet, perhaps that was a
oorbell rang. The servant girl
her kitchen, and Grete would
was his father. "What's been
rst words; Grete's face must
Grete answered in a muffled
er head on his breast: "Mother
s better now. Gregor's broken
ected," said his father, "just
, but you women would never
egor that his father had taken
of Grete's all too brief state-
at Gregor had been guilty of
ore Gregor must now try to
ce he had neither time nor
And so he fled to the door
rouched against it, to let his
ame in from the hall that his
ion of getting back into his
it it was not necessary to drive
ly the door were opened he

yet, co_____e
wearily _____a
business jo_____ng
lying in a kn_____ not
really rise to hi_____greeting,
and on the rare _____ go out with
his family, on one or two Sundays a year and on high
holidays, walked between Gregor and his mother, who
were slow walkers anyhow, even more slowly than they
did, muffled in his old greatcoat, shuffling laboriously
forward with the help of his crook-handled stick which
he set down most cautiously at every step and, when-
ever he wanted to say anything, nearly always came to
a full stop and gathered his escort around him? Now
he was standing there in fine shape; dressed in a smart
blue uniform with gold buttons, such as bank messen-
gers wear; his strong double chin bulged over the stiff
high collar of his jacket; from under his bushy eye-
brows his black eyes darted fresh and penetrating
glances; his onetime tangled white hair had been combed
flat on either side of a shining and carefully exact part-
ing. He pitched his cap, which bore a gold monogram,
probably the badge of some bank, in a wide sweep
across the whole room on to a sofa and with the tail-
___ f his jacket thrown back, his hands in his trouser
_____ towards Gregor.

before his father, stopping when he stopped and scut-
tling forward again when his father made any kind of
move. In this way they circled the room several times
without anything decisive happening, indeed the whole
operation did not even look like a pursuit because it
was carried out so slowly. And so Gregor did not leave
the floor, for he feared that his father might take as a
piece of peculiar wickedness any excursion of his over
the walls or the ceiling. All the same, he could not stay
this course much longer, for while his father took one
step he had to carry out a whole series of movements.
He was already beginning to feel breathless, just as in
his former life his lungs had not been very dependable.
As he was staggering along, trying to keep his eyes open; in his
energy on running, hardly keeping his eyes open; in his
dazed state never even thinking of any other escape
than simply going forward; and having almost forgot-
ten that the walls were free to him, which in this room
were well provided with finely carved pieces of furni-
ture full of knobs and crevices—suddenly something
lightly flung landed close behind him and rolled before
him. It was an apple; a second apple followed imme-
diately; Gregor came to a stop in alarm; there was no
point in running on, for his father was determined to
bombard him. He had filled his pockets with fruit from
the dish on the sideboard and was now shying apple
after apple, without taking particularly good aim for the
moment. The small red apples rolled about the floor

Facing page:
THE METAMORPHOSIS
(AFTER FRANZ KAFKA),
1988–89 (detail)
Private Collection

This page:
THE METAMORPHOSIS IV
(AFTER FRANZ KAFKA), 1989–90
Apple and book pages mounted on canvas
22 x 18 inches
Courtesy of Rhona Hoffman Gallery, Chicago, Illinois

"I like 'Der Leierman' because, well, it's a little like "Courage." Here is this guy at the end of his rope and he meets the hurdy-gurdy dude, this weirdo playing the hurdy-gurdy over and over with no one around who wants to listen. He's standing in the snow barefoot with this empty tin cup, but still, he's living. His existence offers hope. He doesn't care what other people think about him."

NELSON RICARDO SAVINON

This page, details on overleaf:
WINTERREISE (SONGS XX—XXIV)
(AFTER FRANZ SCHUBERT), 1988
Acrylic and mica on music pages mounted
on linen
12 works, 12 x 9 inches each;
approx. 12 x 119 inches overall
Collection of Ruth and William Ehrlich, New York
Installation view, Tang Museum, Skidmore College,
Saratoga Springs, New York, 2009

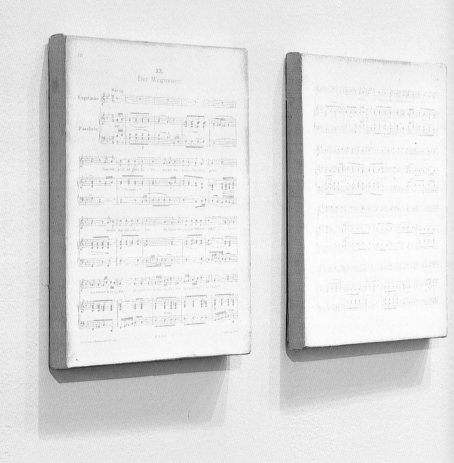

XX.
Der Wegweiser.

Stich und Druck von Breitkopf & Härtel in Leipzig.

F. S. 899.

Ausgegeben 1895.

F. S. 899.

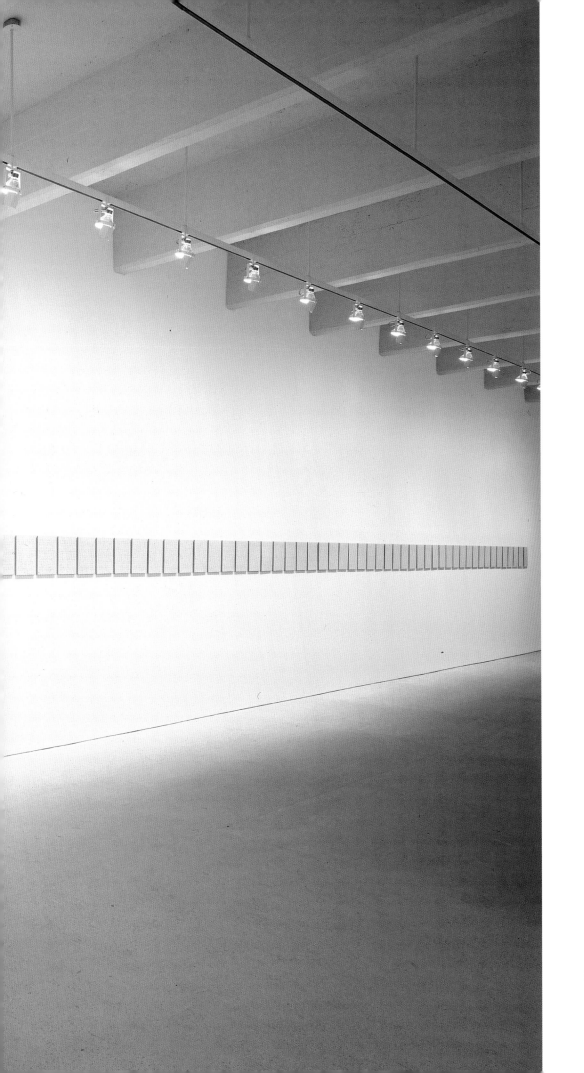

WINTERREISE (AFTER FRANZ SCHUBERT), 1988–89
Acrylic and mica on music pages mounted on linen
Seventy works, 12 x 9 inches each;
overall 12 inches x 58 feet
Installation view, Dia Art Foundation, New York, 1990

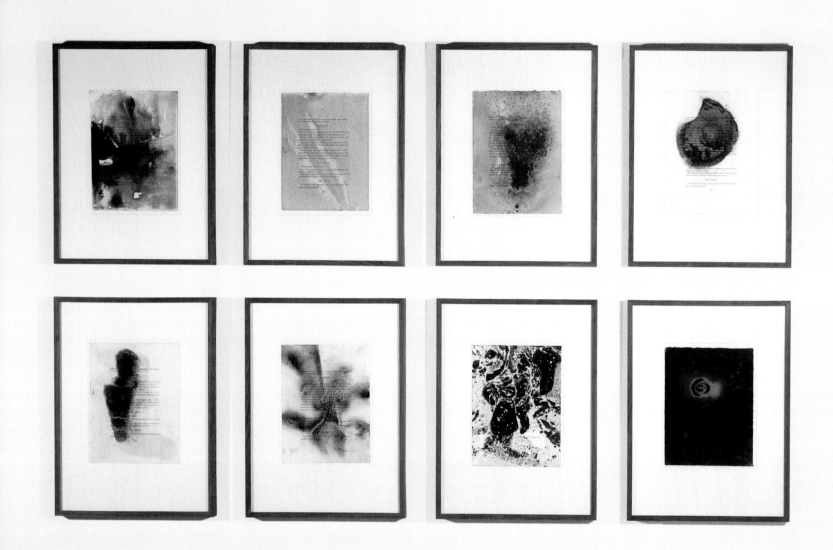

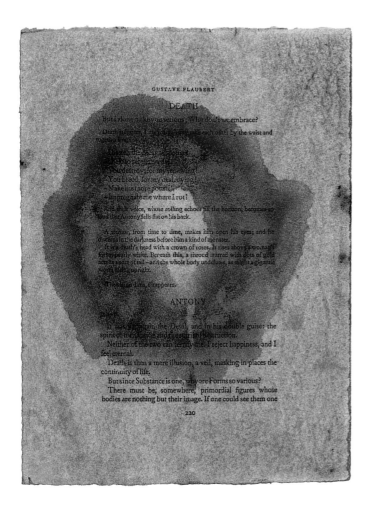

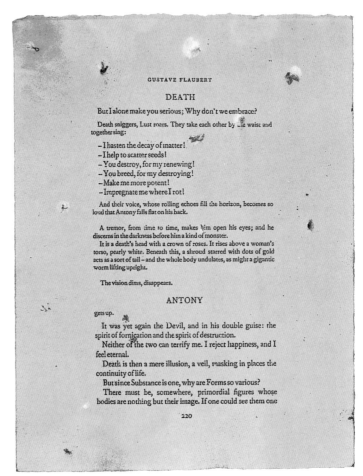

"Antony isn't only asking, what is the purpose of all this the Devil's showing him now?
He's asking, what is the meaning of all the temptation he has had to experience and suffer?
What is the purpose of *his* temptation?"

GEORGE GARCES

Facing page:
THE TEMPTATION OF SAINT ANTONY—THE CAINITES
(AFTER GUSTAVE FLAUBERT), 1991
Powdered pigment, India ink, alcohol, watercolor,
turpentine, and water on xerograph mounted
on rag paper
11 x 8 ¹/₂ inches each
Private Collection

This page, left:
THE TEMPTATION OF SAINT ANTONY—SIMON
(AFTER GUSTAVE FLAUBERT), 1990
Alcohol, powdered pigment, and acrylic on xerograph
mounted on rag paper
11 x 8 ¹/₂ inches
Private Collection

Right:
THE TEMPTATION OF SAINT ANTONY— TERTULLIAN
(AFTER GUSTAVE FLAUBERT), 1989–1990
Watercolor and acrylic on xerograph mounted
on rag paper
11 x 8 ¹/₂ inches
Private Collection

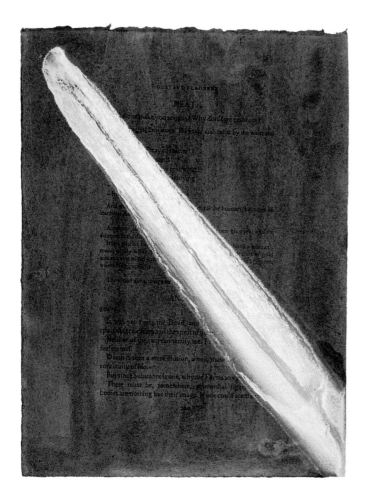

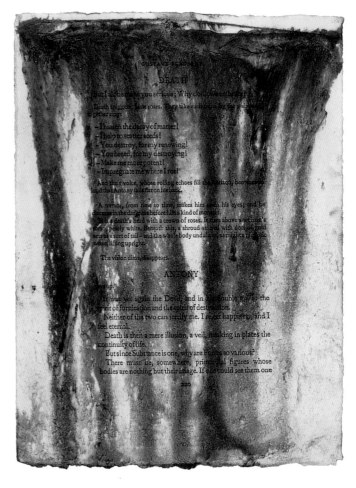

THE TEMPTATION OF SAINT ANTONY—APPOLONIUS
(AFTER GUSTAVE FLAUBERT), 1990
Powdered pigment, alcohol, acrylic, and tempera on
xerograph mounted on rag paper
11 x 8 ¹/₂ inches
Private collection

THE TEMPTATION OF SAINT ANTONY—
THE GYMNOSOPHIST (AFTER GUSTAVE FLAUBERT), 1990
Powdered pigment, ink, egg white, and watercolor on
xerograph mounted on rag paper
11 x 8 ¹/₂ inches
Kunstsammlung Basel, Kupferstichkabinett
Gift of the artists and Jay Gorney Gallery

Facing page:
THE TEMPTATION OF SAINT ANTONY—ISIS
(AFTER GUSTAVE FLAUBERT), 1990
Gouache, powdered pigment, and alcohol on xerograph
mounted on rag paper
11 x 8 ¹/₂ inches
Kunstsammlung Basel, Kupferstichkabinett
Gift of the artists and Jay Gorney Gallery

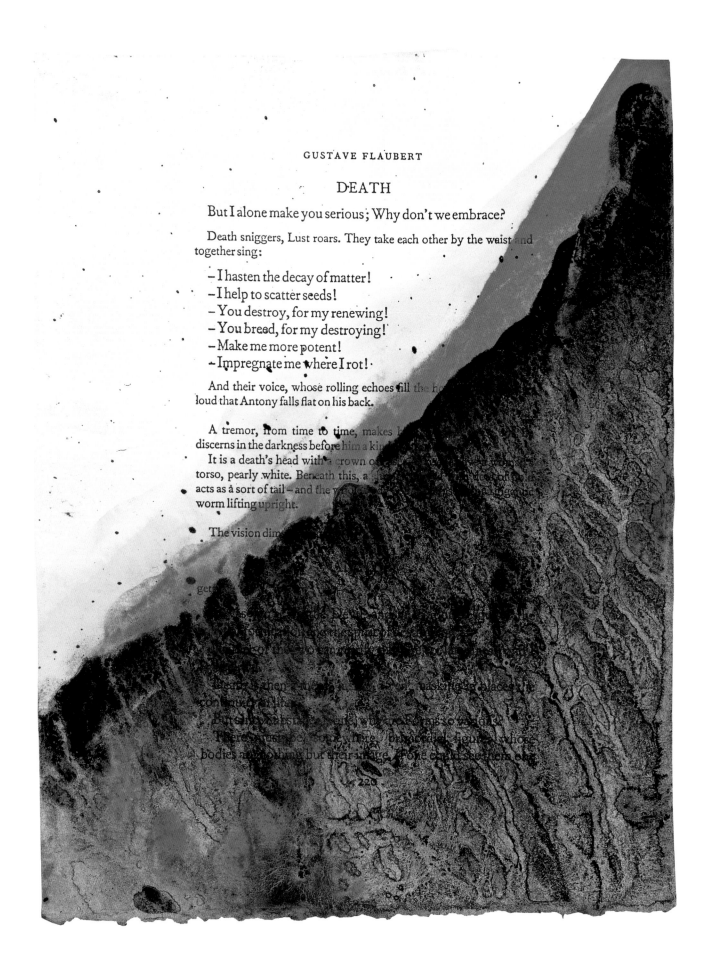

DEATH

But I alone make you serious; Why don't we embrace?

Death sniggers, Lust roars. They take each other by the waist and together sing:

– I hasten the decay of matter!
– I help to scatter seeds!
– You destroy, for my renewing!
– You breed, for my destroying!
– Make me more potent!
– Impregnate me where I rot!

And their voice, whose rolling echoes fill the h
loud that Antony falls flat on his back.

A tremor, from time to time, makes
discerns in the darkness before him a ki
It is a death's head with a crown o
torso, pearly white. Beneath this, a
acts as a sort of tail – and the
worm lifting upright.

The vision dim

get

Beauty when
conquering life
But in
Pare
bodies

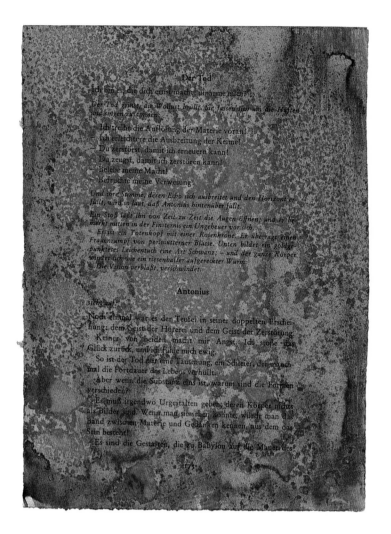
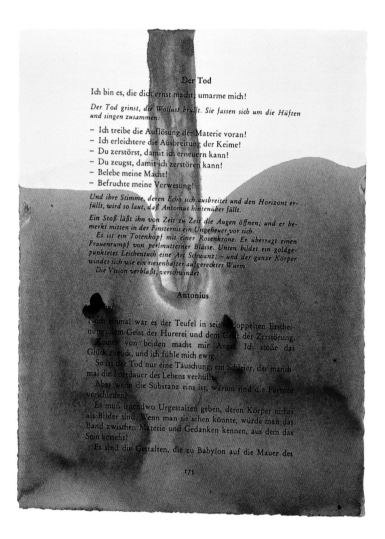

THE TEMPTATION OF SAINT ANTONY—DER TOD
(AFTER GUSTAVE FLAUBERT), 1990 (details)
Animal blood, alcohol, and water on xerograph
mounted on rag paper
From a set of twelve works, each 11 ¼ x 8 inches
Private Collection

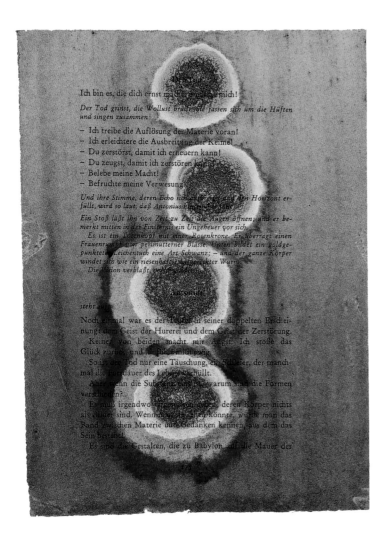

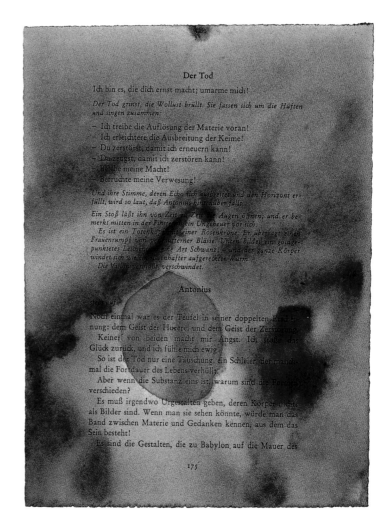

"In the past, things that were considered demons, the things that terrified people the most,
were things around that were imagined to be evil. Like the beasts of the sea—
sharks, jellyfish, manta rays. They can cause people harm, but I think people are afraid of them
because of the way they look. They are so different from us that we can't see them as cute—
only as demons. The same thing with cells and organisms and blood and stuff in our own bodies.
They are a part of us, but they seem so alien."

GEORGE GARCES

"Our monsters don't look like monsters.
They look like stains, or sick planets, or sick cells…"

CARLOS RIVERA

Der Tod

Ich bin es, die dich ernst macht; umarme mich!

Der Tod grinst, die Wollust brüllt. Sie fassen sich um die Hüften und singen zusammen:

– Ich treibe die Auflösung der Materie voran!
– Ich erleichtere die Ausbreitung der Keime!
– Du zerstörst, damit ich erneuern kann!
– Du zeugst, damit ich zerstören kann!
– Belebe meine Macht!
– Befruchte meine Verwesung!

Und ihre Stimme, deren Echo sich ausbreitet und den Horizont erfüllt, wird so laut, daß Antonius hintenüber fällt.

Ein Stoß läßt ihn von Zeit zu Zeit die Augen öffnen; und er bemerkt mitten in der Finsternis ein Ungeheuer vor sich.

Es ist ein Totenkopf mit einer Rosenkrone. Er überragt einen Frauenrumpf von perlmutterner Blässe. Unten bildet ein goldgepunktetes Leichentuch eine Art Schwanz; – und der ganze Körper windet sich wie ein riesenhafter aufgereckter Wurm.

Die Vision verblaßt, verschwindet.

Antonius

steht auf:

Noch einmal war es der Teufel in seiner doppelten Erscheinung: dem Geist der Hurerei und dem Geist der Zerstörung.

Keiner von beiden macht mir Angst. Ich stoße das Glück zurück, und ich fühle mich ewig.

So ist der Tod nur eine Täuschung, ein Schleier, der manchmal die Fortdauer des Lebens verhüllt.

Aber wenn die Substanz eins ist, warum sind die Formen verschieden?

Es muß irgendwo Urgestalten geben, deren Körper nichts als Bilder sind. Wenn man sie sehen könnte, würde man das Band zwischen Materie und Gedanken kennen, aus dem das Sein besteht!

Es sind die Gestalten, die zu Babylon auf die Mauer des

175

This page, detail facing:
THE TEMPTATION OF SAINT ANTONY—DER TOD II
(AFTER GUSTAVE FLAUBERT), 1990
Animal blood, alcohol, and water on xerograph
mounted on rag paper
Twelve works; 11 ¼ x 8 inches each
Marieluise Hessel Collection, Hessel Museum of Art,
Bard College, Annandale-on-Hudson, New York

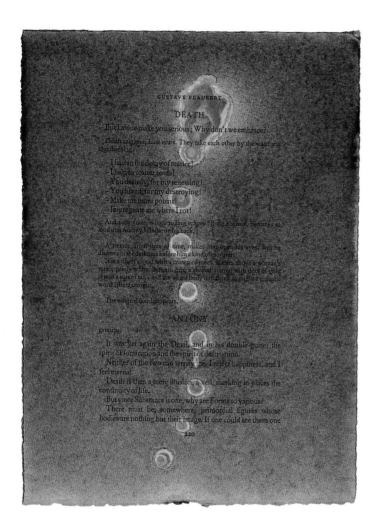
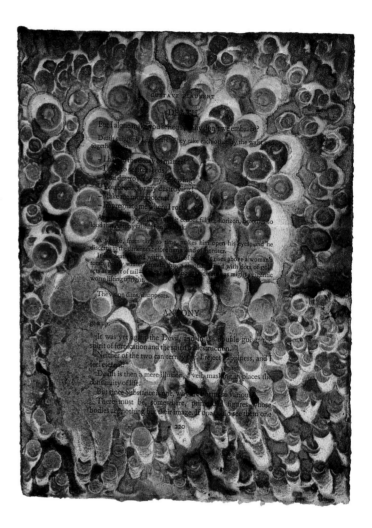

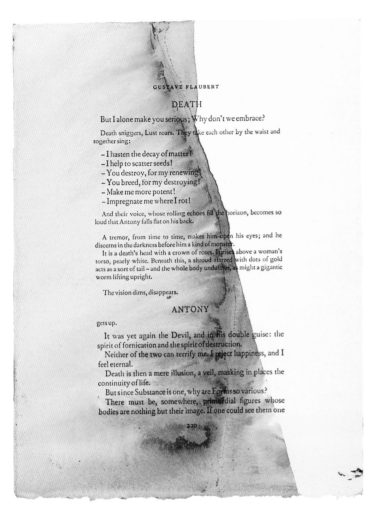

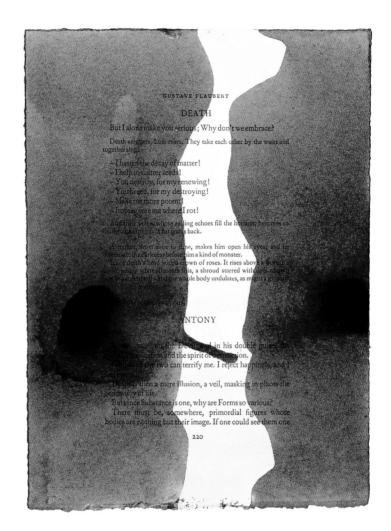

Overleaf:
THE TEMPTATION OF SAINT ANTONY—THE MARCOSIANS
(AFTER GUSTAVE FLAUBERT), 1990 (details)
Animal blood, water, and alcohol on xerograph
mounted on rag paper
From a set of eighteen works, 11 x 8 ¹/₂ inches each
Kunstsammlung Basel, Kupferstichkabinett

GUSTAVE FLAUBERT

DEATH

But I alone make you serious. Why don't we embrace?

Death sniggers, Lust roars. They take each other by the waist and together sing:

— I hasten the decay of matter.
— I help to scatter seed.
— You destroy, for my renewal!
— You breed, for my destroying!
— Make me more potent!
— Impregnate me with your rot!

And their voices, whose rolling echoes fill the horizon, becomes so loud that Antony falls flat on his back.

A tremor, from time to time, makes him open his eyes; and discovers in the darkness before him a kind of monster.

It is a death's head with a crown of roses. It rises above a woman's torso, nacre white. Beneath this, a shroud starred with dots of gold acts as a sort of tail — and the whole body undulates, as might a gigantic worm lifting upright.

The vision dims, disappears.

ANTONY

gets up.

It was yet again, the Devil, and in his double guise: spirit of fornication and spirit of destruction.

Neither of the two alarms me. I reject happiness, and I feel eternal.

Death is thus only an illusion, a veil, masking in places the continuity of life.

But since substance is one, why do forms appear so various?

There must be, somewhere, primordial figures whose bodies are merely images. If one could see them one

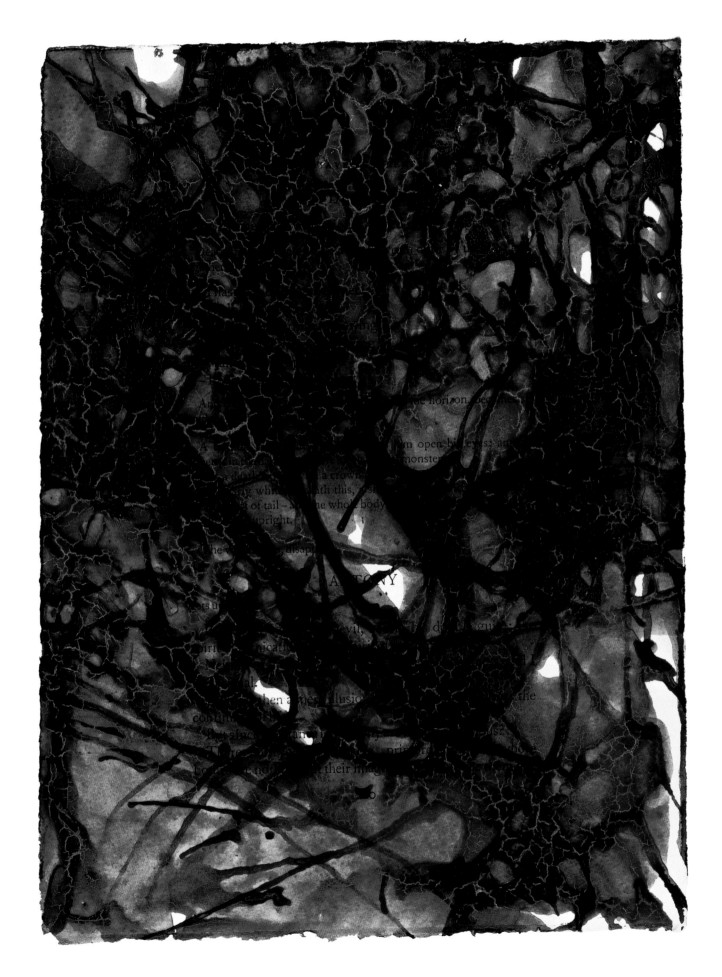

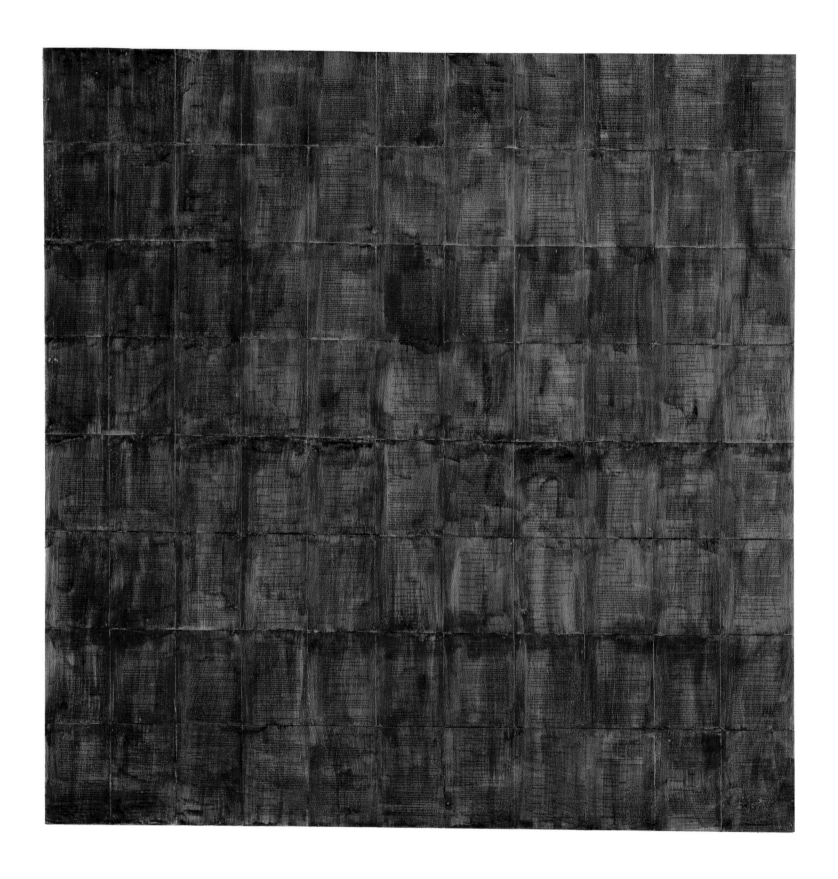

THE TEMPTATION OF SAINT ANTONY—OCEAN AND SUN
(AFTER GUSTAVE FLAUBERT), 1992
Animal blood and matte medium on book pages
mounted on linen
Two works, 44 x 72 inches together
Private Collection

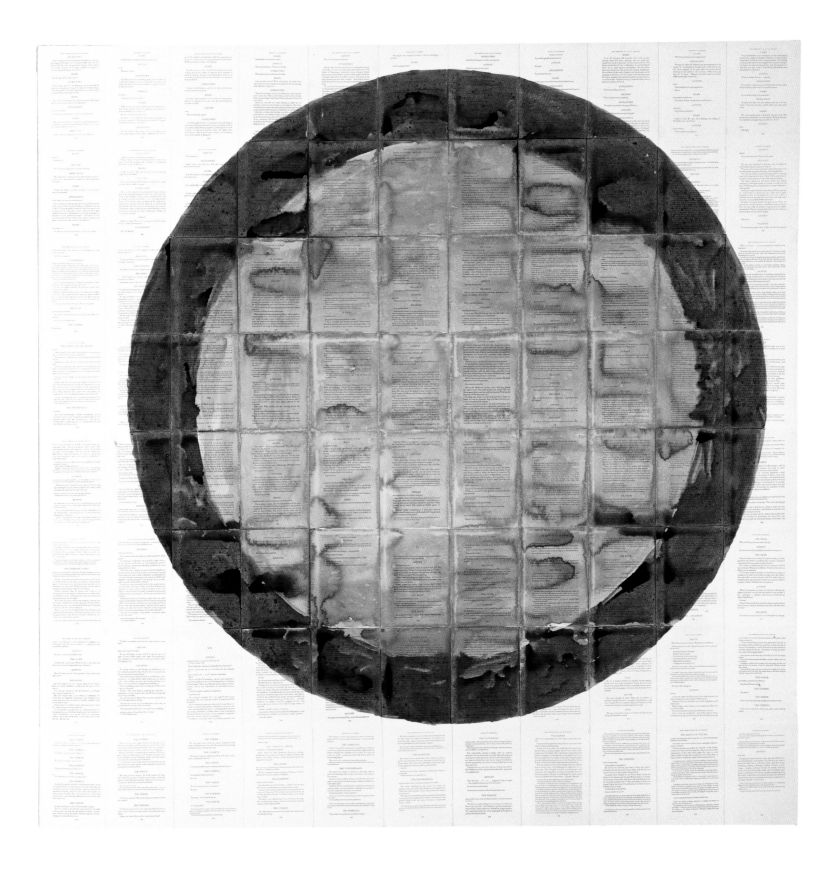

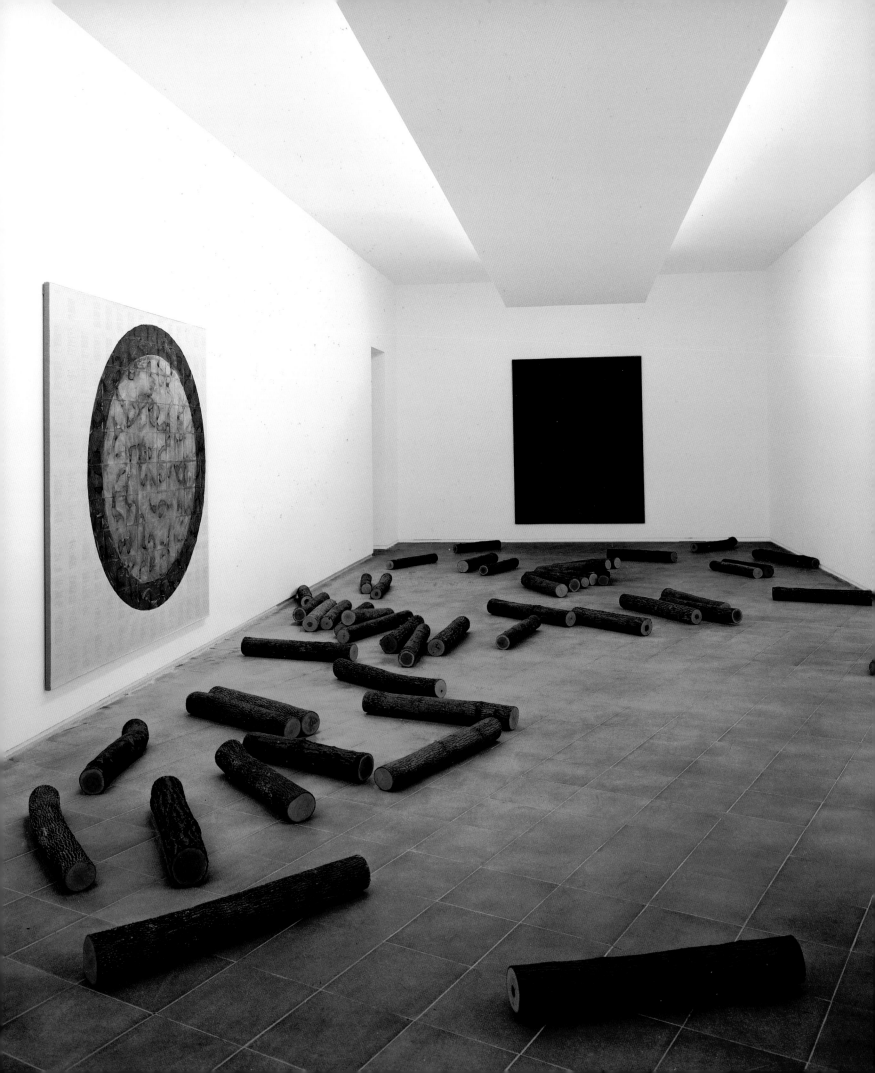

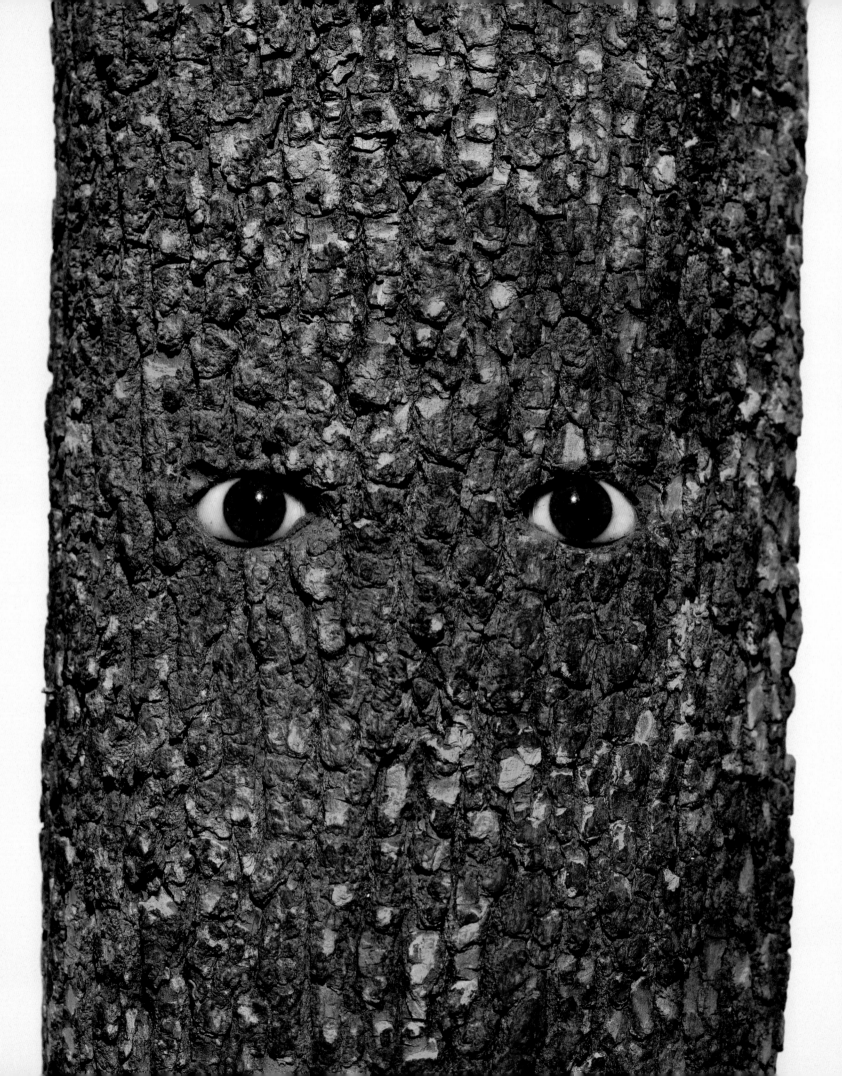

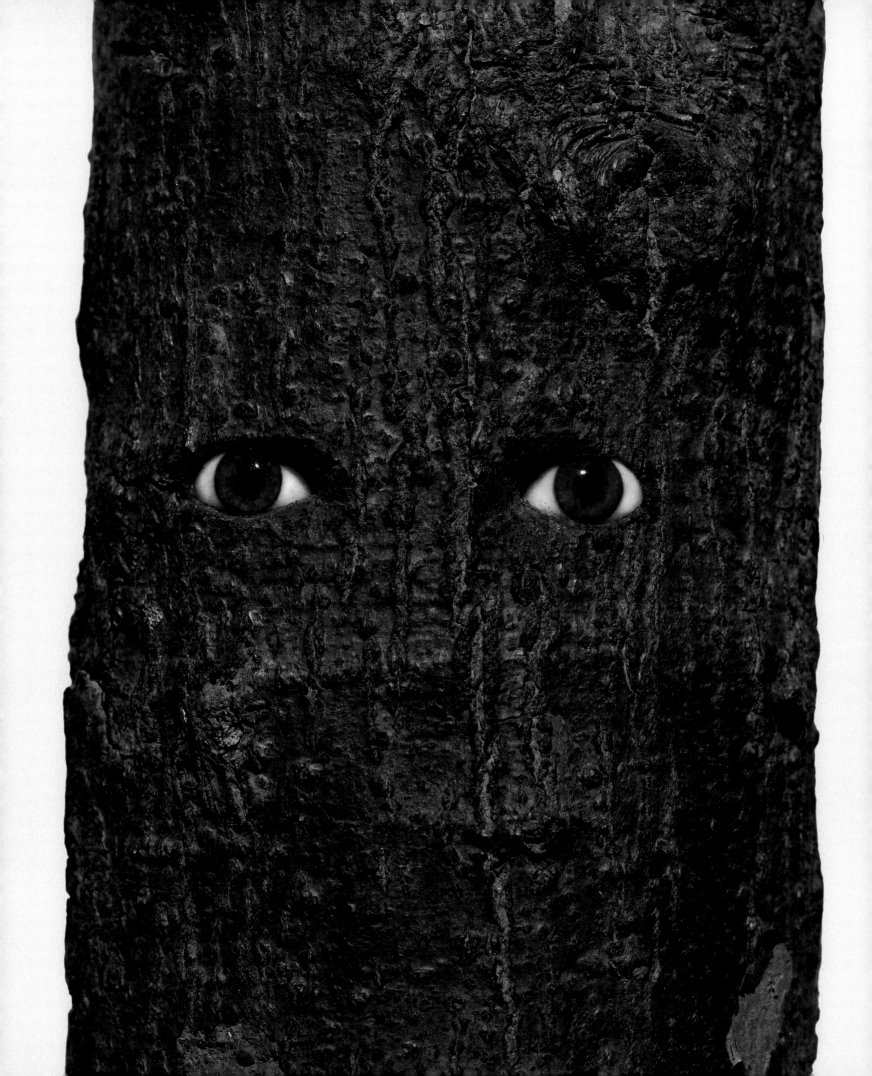

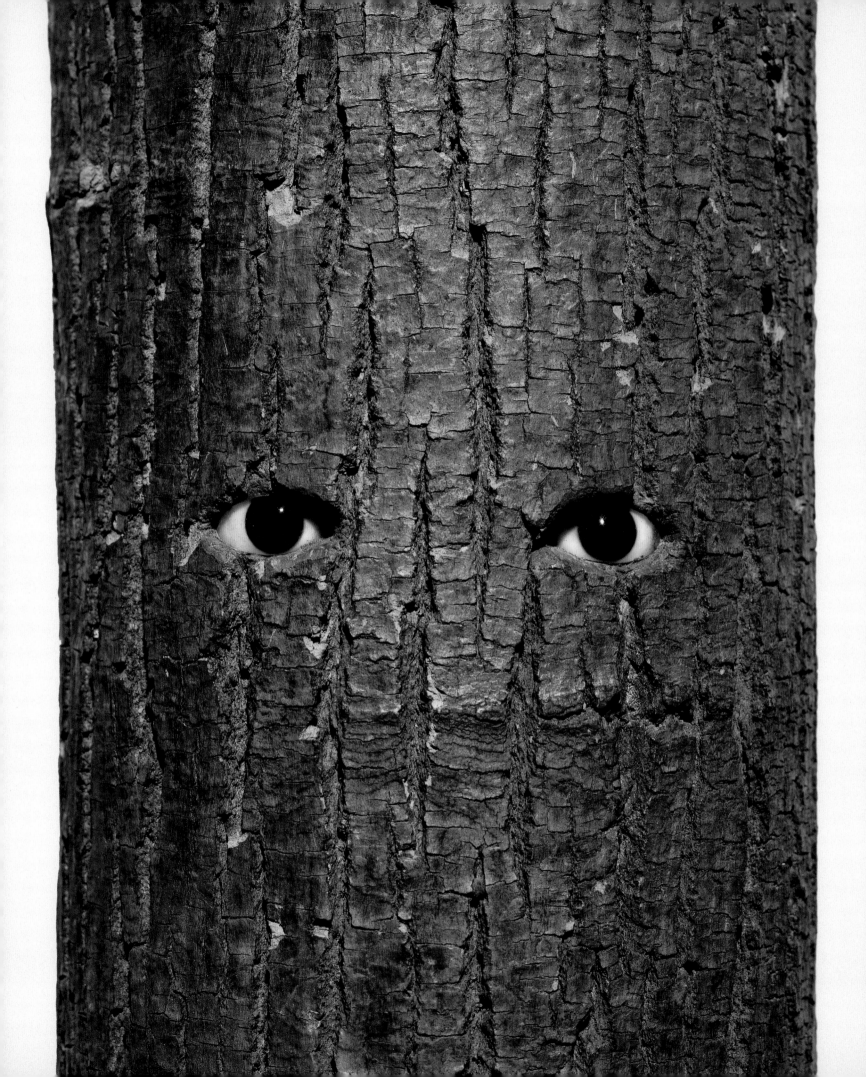

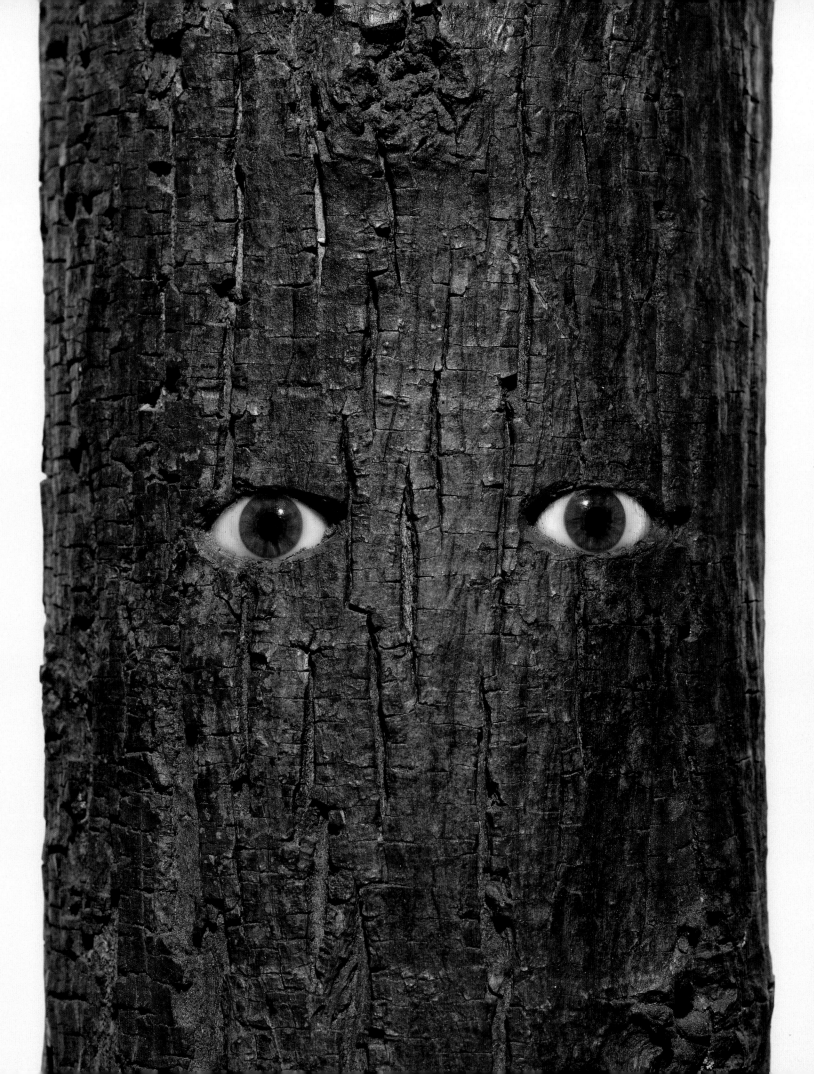

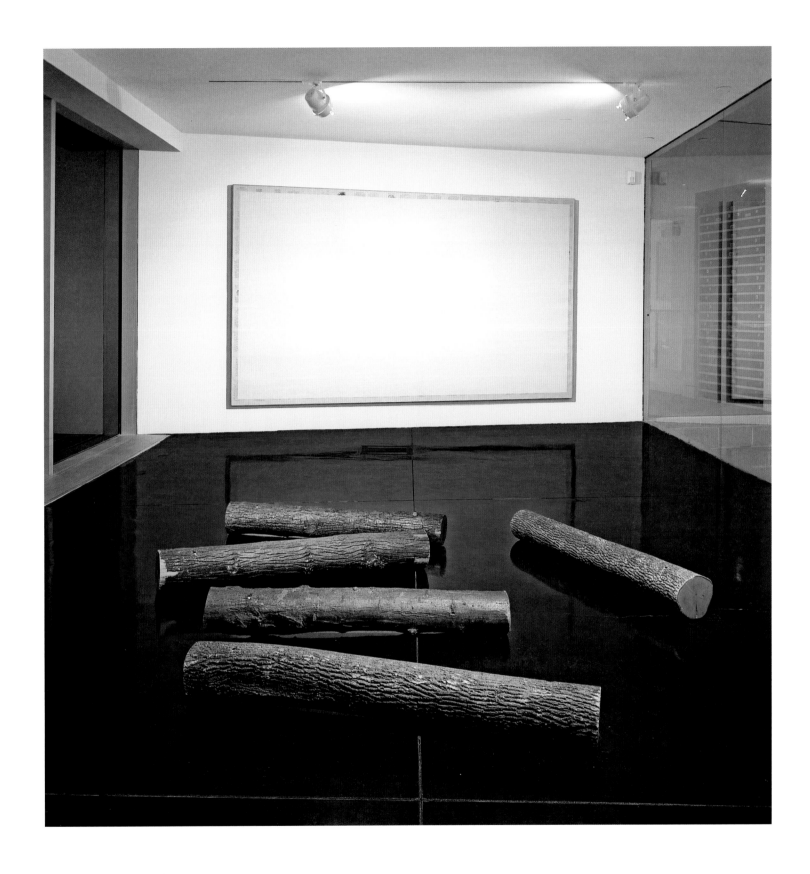

Facing page:
PINOCCHIO (AFTER CARLO COLLODI), 1991 (detail)
Wood, plastic, wax, tung oil
Irregular, approx. 42 $^4/_5$ x 5 $^4/_5$ x 5 $^4/_5$ inches each
Courtesy of AMP Gallery, Athens

This page:
Installation view, The Frances Young Tang Teaching
Museum and Art Gallery at Skidmore College,
Saratoga Springs, New York, 2009

Installation view, Jay Gorney Modern Art,
New York, 1989

"I was thinking that when you first look at the Black Beauty, it looks like the text is in jail. But it could be that you're not outside looking in, but you're inside looking out. You are the one in jail."

RICHARD CRUZ

BLACK BEAUTY—LIBERTY (AFTER ANNA SEWELL), 1987
Matte acrylic on book pages on canvas
23 1/8 x 23 1/8 inches
Courtesy of Galleria Raucci/Santamaria, Naples and
Galerie Eva Presenhuber, Zurich

BLACK BEAUTY III (AFTER ANNA SEWELL), 1988–90
Acrylic and mica on book pages mounted on linen
72 x 70 inches
Private Collection

"In the X-Men comics, there is a mentor and these mutant kids who have special powers,
but they are rejected by society because society can't understand them—or is afraid of their powers.
So these pieces became a kind of self-portrait for us."

GEORGE GARCES

This page, details on overleaf
X-MEN 1968 (AFTER MARVEL COMICS), 1990
Comic book pages and acrylic mounted on linen
76 ¹/₄ x 194 inches
Straus Family Collection

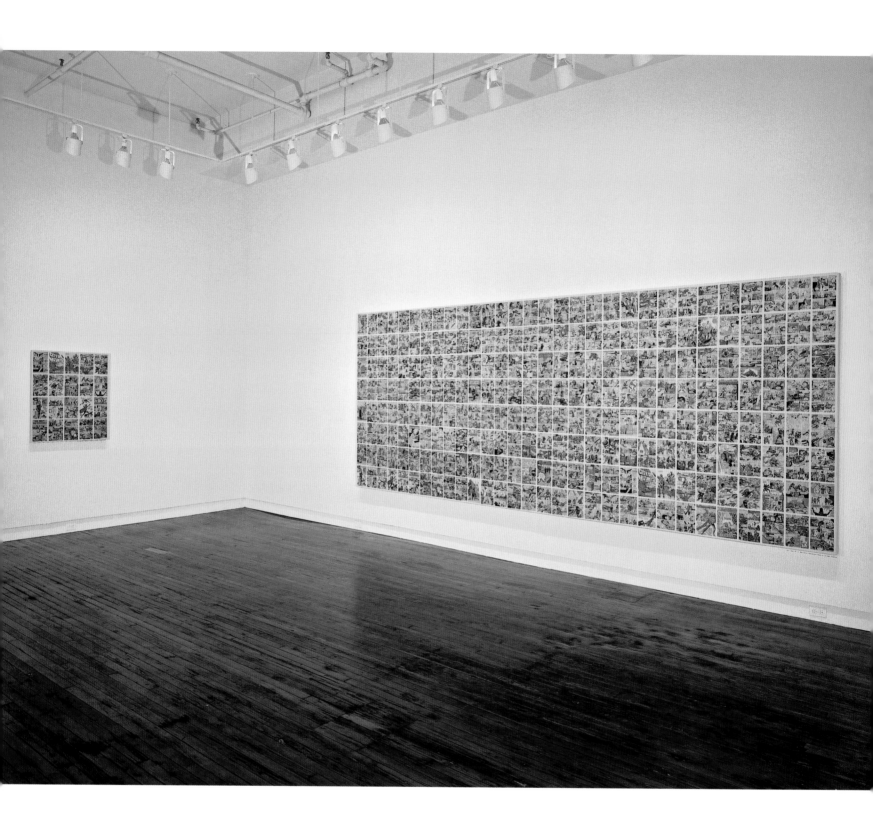

Installation view, Jay Gorney Modern Art,
New York, 1990

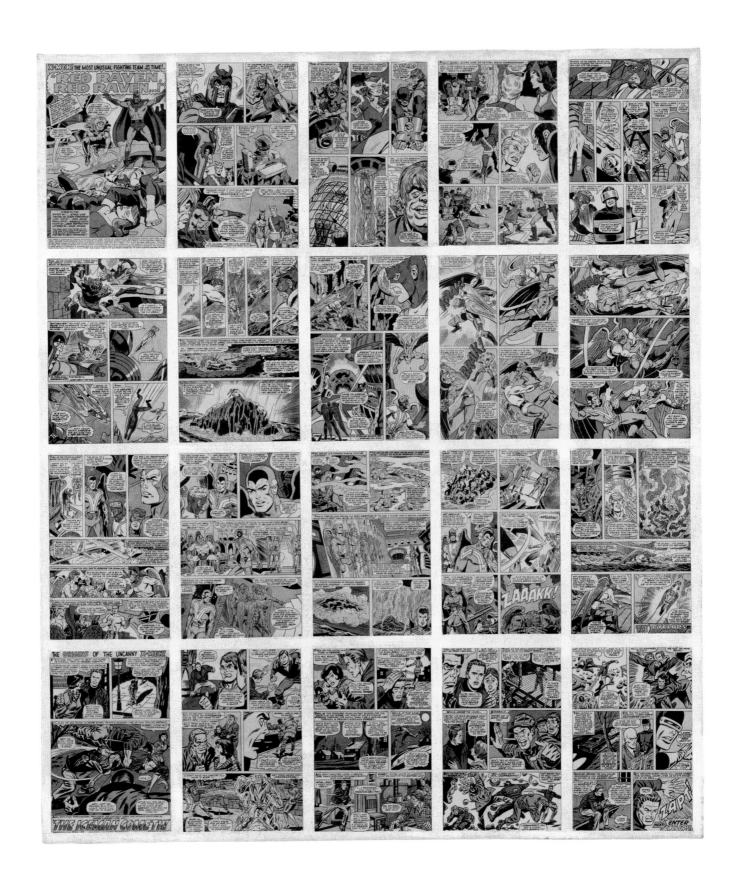

X–MEN '68—RED RAVEN, RED RAVEN!
(AFTER MARVEL COMICS), 1991–92
Comic book pages and acrylic mounted on linen
38 $\frac{1}{4}$ x 33 $\frac{1}{8}$
Private Collection, Oslo

"I had a dream. I said, 'Which would look good, mirror or glass?'
…I found a piece of mirror in the floor. I just picked it up—this is the dream I had—
I picked it up and brought it over here and I said,
'Look Tim.' I stuck it on the painting and said, 'Look Tim, it shines.'
And he said, 'Oh, Chris, look, it shines really good.'
…A good painting makes everything."
CHRISTOPHER HERNANDEZ

FROM EARTH TO THE MOON
(AFTER JULES VERNE), 1991–92
Acrylic, glass, and mirror fragments on linen
120 1/8 x 96 1/8 inches
Hirshhorn Museum and Sculpture Garden,
Smithsonian Institution, Washington, D.C.
Gift of the Artists in Memory of
Christopher Hernandez, 1992

FELIX GONZALEZ-TORRES
STATEMENT (1989)

I guess Tim was fed up with the bureaucracy and red-tape of our inner-city public educational system. This pushed him to have a group of his students come after class to do some artwork, to read, and to have discussions—something that might look very simple, but considering the possibilities and situation of the South Bronx, the Kids of Survival are impressive.

It's humorous when people argue that Tim ought to be teaching those kids about their own culture. There is some guilt-trip in that argument. It is redundant. Those kids get their own "Newyorican" culture every day, the moment they wake up. Culture can not be imported. (And, after all, "Goya" products are available in any marqueta.)

The collaborative process that leads to the creation of the work—for example, the paintings based on *Animal Farm*—is very significant. It is through those discussions that Tim brings important knowledge to the group, knowledge that contextual- izes the place of those kids in history and in the world in general. It is okay to live in the ghetto, but to be the ghetto is dreadful.

Anyway, I always like writing on the pages of the book when I read. It makes me feel that I have done some real reading. When I first saw one of the K.O.S. paintings, I thought, "Gee! some people can really push an idea and make something meaningful and beautiful out of it." At the same time it looked fun to make.

I wish I had a teacher like Tim.

THE SILVER SURFER (AFTER MARVEL COMICS), 2001
Ink on comic book page
10 x 6 ½ inches
Collection of the artists

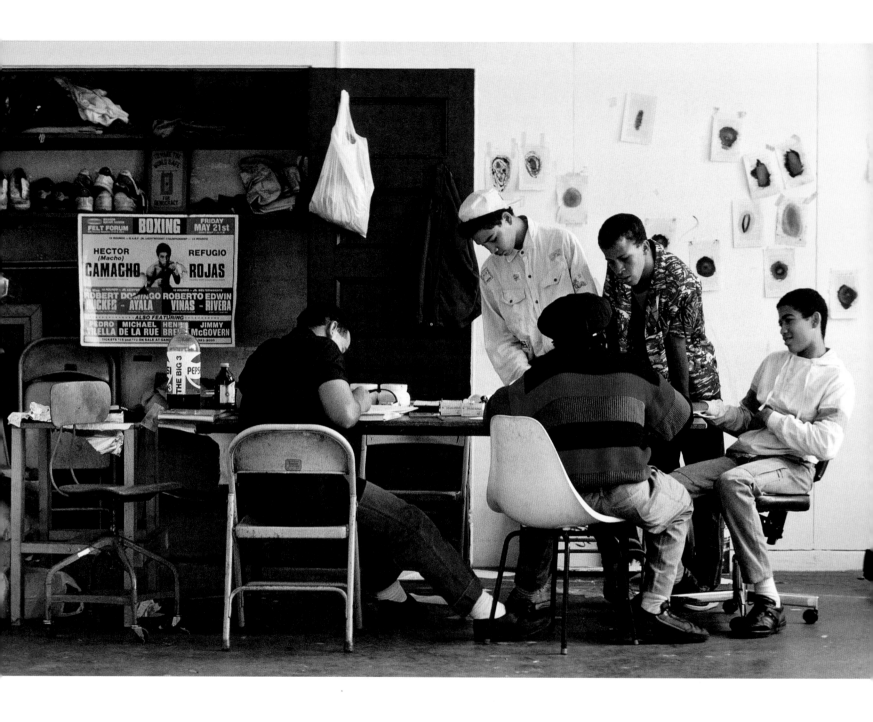

K.O.S. members in the studio, South Bronx,
New York, 1987
© Lisa Kahane, NYC

DAVID DEITCHER
THE OTHER WAY

In a 1996 video documentary about Tim Rollins and his student-collaborators, the Kids of Survival (K.O.S.), Rollins dramatically and succinctly describes the group's process: "We begin by cutting up the text. We vandalize it, but we also honor it; and we end up making it our own."[1] While some might disagree that the process begins with "cutting up the text" (as opposed, for example, to reading it first while the kids improvise), few would contradict Rollins's characterization of the group's unique relationship to the texts that they read, discuss, draw, paint, and otherwise "make their own."[2]

Rollins made a similar point concerning the art world's supposed "opening up" to women and people of color during the 1980s. "I don't think of it as an 'opening up,'" he said. "No one did us a favor. We just broke in. Not everyone banged on the palace doors; many went through the back door. We walked in, pretended we were servants, and decided to stay for a while."[3] Embedded within both "breaking in" and going "through the back door" is an abiding belief in the efficacy of art, in combination with radical pedagogy, to empower underprivileged youth. This compelling as well as uplifting understanding emerged, as it were, organically from the group's creative process and has informed most critical analyses not only of the Art and Knowledge Workshop's mission, but also of the impressive works Rollins and K.O.S. have produced. In what follows, I intend to pull back somewhat from that understanding to consider some of the other ways in which important works by the group relate to the times, culture, and politics in which they created them.

Here is how Rollins has described the process that, beginning in 1986, led to the group's monumental paintings based on Stephen Crane's *The Red Badge of Courage*: "What I asked the Kids to do," he reports, "was to paint a wound as if it was a self-portrait—but not a realistic-looking wound. It's a wound of everything that your people have survived in the past, and that you as an individual are surviving in the present, and what you're going to have to survive in the future."[4] In the video documentary, these words follow upon the Kids' recital of brief passages from the book (for example, "He had dwelt in the strange land of squalling upheavals and had come forth . . ."). Together, the sequence demonstrates how the Kids identified with Crane's novel, which Rollins encouraged them to read as allegory. "It's not about a war in the 1860s," he maintains, "it's really about the civil war that rages within every individual who chooses to fight

life as it is." Despite Rollins's inclination to allegorize Crane's narrative, the Kids may well have identified with the struggles of its protagonist, Henry Fleming, who survives the horrors of the Civil War and ultimately acquires in the process an appreciation for the power of solidarity, of "pulling together as a group" ("There was a consciousness always of his comrades about him. . . . It was a mysterious fraternity born of the smoke and danger of death"). The special-ed students who became Rollins's early collaborators knew a great deal about hardship and confronting discouraging odds, having been raised amid the poverty, privation, and random violence of the South Bronx during the early years of the Reagan era—to say nothing of the individual learning disabilities that sometimes added to their burden.

Most of them would have ranged in age between seven and nine in 1980, when then-presidential candidate Ronald Reagan staged an early photo-op standing amid the rubble of a vacant lot on Charlotte Street in the South Bronx. Photo-documentation of the event shows the so-called great communicator holding a mike in his right hand and a script in his left, as the press record his every word and gesture. On that day, Reagan appeared oblivious to (or deliberately to exploit) the presence directly behind him of a giant word ("DECAY"), which the guerrilla-artist John Fekner had stenciled in huge letters on the brick wall of a neighboring building. Reagan stood amid flattened junk and bricks—the remains of the demolished buildings that once stood there. Two years later, Rollins and his students removed bricks from just such desolate lots, taking them back to their classroom where they conceived the first of many impressive poetic condensations: they painted each brick to resemble a burning tenement building like the ones from which each had fallen.

For the *Red Badge* paintings, the Kids painted their "wounds" on paper and applied them to a meticulous grid of book pages that they mounted, as in all their ambitious paintings since 1984, on stretched Belgian linen. The result was a monumental, all-over composition spotted with the colorful designs—blobs of color ranging from biomorphic to geometric, suggesting raw vulnerability, or shield-like medallions suggesting self-protection. But to this observer, the "wounds" always conjured the Kaposi Sarcoma lesions that then disfigured the faces and bodies of people with AIDS. Identifying these paintings with the AIDS crisis helps bridge the conceptual gap that separated the underprivileged residents of the South Bronx from their more affluent

counterparts in the downtown art world. For as AIDS activists argued throughout the late 1980s and early 1990s, this blood-borne, sexually transmitted epidemic cut across socioeconomic lines, establishing common ground between the lives of middle-class, mostly white gay men and those of the differently disenfranchised people of color who constituted the epidemic's other principal risk group.

The *Red Badge* paintings also bring to mind Ross Bleckner's contemporaneous black paintings of the mid-1980s (themselves among the earliest artists' responses to AIDS) in which sickly greenish strokes of paint that share space with ornamental embellishments and funerary iconography such as wreaths and urns reminded some of K.S. lesions.

No less susceptible to the inspirational reading of the group's project, other works from the mid-to-late 1980s referred more directly to the health emergency. Beginning in 1988, the group addressed head-on the epidemic, its public policy implications, and its framing iconography in a series of works based on their reading of Daniel Defoe's 1722 novel *A Journal of the Plague Year*. Considering that the South Bronx was likely the most impoverished congressional district in the U.S., beset, moreover, with one of the nation's highest rates of HIV infection, and that at least one K.O.S. member learned that his mother was HIV-positive and feared that he might be too, the group determined to pull together and address the crisis to understand its actual causes, to combat the mystification, panic, and prejudice surrounding AIDS, and to provide a symbolic means of managing its terrible emotional toll. British critic Marko Daniel has identified a number of parallels between Defoe's fictional account of the Great Plague in seventeenth-century London and "prevalent public attitudes [during the 1980s] towards AIDS." Daniel notes,

for example, the unreliability of data as "residents who have been infected…are not yet showing symptoms," an observation not from Defoe but in fact from *The New York Times*. Daniel also quotes directly from Defoe regarding the use of symbols in seventeenth-century Europe to ward off infection. "Papers tied up with so many Knots, and certain Words, or Figures written on them, as particularly the Word Abracadabra, form'd in Triangle or Pyramid."[5]

Centered on an expansive grid of book pages, the *Plague Year* paintings feature an inverted pyramid of lettering (its typeface derived from a Roman tomb) that repeatedly spells "ABRACADABRA," the cabalistic word that, as Defoe noted, was thought to have magical powers to keep the Plague at bay, especially when inscribed in blood in the form of a triangle or pyramid. Encountering that word writ large in lamb's blood on a ground composed of pages from Defoe's book had a starkly different effect in the late twentieth century, when it read as a caustic metaphor for not only the widespread governmental refusal to address the epidemic scientifically and humanely, but also the toxic mystifications of religious fundamentalists such as Jerry Falwell, who declared AIDS God's punishment of gay men; and the Roman Catholic Church's opposition to the use of condoms to prevent HIV transmission. "The sign *Abracadara* does nothing," writes Daniel, "to fight, heal or prevent the spread of a disease. It identifies victims and 'marks' them, stigmatizes them."[6]

Indeed, the inverted pyramid employed by Rollins and K.O.S. refers to the ultimate stigmatizing "mark" of gay men: the inverted pink triangle that the Nazis used to brand homosexuals in and out of the concentration camps to which thousands of them were sent. Rollins and K.O.S. also responded to *Plague Year*

AMERIKA VII, 1986–87
Watercolor, charcoal, acrylic, and pencil on book pages mounted on linen
64 x 168 inches
Philadelphia Museum of Art, purchased with funds contributed by Marion Stroud Swingle, Mr. and Mrs. David Pincus, Mr. and Mrs. Harvey Gushner, and Mr. and Mrs. Leonard Korman

in 1988 with an edition of small works in which they again used lamb's blood to paint an inverted triangle on single pages from Defoe's book. The resulting works therefore evoked the blood-borne nature of the virus, the Nazi's use of an inverted pink triangle to brand homosexuals, and also the reversal and rehabilitation of that Nazi emblem by gay liberationists, culminating in the 1986 Silence=Death Project's black poster with its bright pink pyramid—now pointing upwards—over the equation "Silence=Death," an image that became the galvanizing emblem of the AIDS activist movement.

These were not the only times when Rollins and K.O.S. used animal blood as an ingredient for creating works of art to respond topically to a literary classic. They also used it to powerful effect in paintings and prints based on Flaubert's *The Temptation of Saint Antony*, as they had in an early work based on Shakespeare's *Macbeth*. Such sensitivity to the symbolic as well as material properties of organic substances relates such projects to the groundbreaking works of the Italian Arte Povera movement; it also brings to mind Group Material's *Timeline: Chronicle of US Intervention in Central and Latin America* (1984) in which the artist's collective (in which Rollins then still participated) installed quantities of coffee and tobacco leaves, a reference to Arte Povera that also underscored precisely what was at stake in such American meddling in the affairs of other sovereign nations.

The celebrated "golden horn" paintings from the *Amerika* series, inspired by Franz Kafka's novel, also harbor discreet and direct references to AIDS and to the violence it unleashed against those it affected most directly. The upper left corner of *Amerika VII* (1986–87) is dominated by a satellite-like form that represents the morphology of HIV, derived from an illustration on the front page *of The New York Times Science Times* section of March 3, 1987. The painting also includes a depiction of Louise Bourgeois's phallic *Janus* sculptures, and depictions of coiled lengths of spiky thorns borrowed from Grünewald's *Isenheim Altarpiece*. Painted during the spring of 1987, *Amerika VII* corresponded with the formation of ACT UP/New York—that is, with the crystallization of the AIDS activist movement, and in retrospect implies Rollins's personal solidarity with that movement. Such solidarity would have been complexly determined. In addition to the anger that he shared with virtually everyone he knew about the government's failure to address the health crisis, to say nothing of the politics, prejudice, and injustice that informed it, Rollins was deeply concerned about the well being of his youthful collaborators. And as a man who had sex with men, he would also have been susceptible to the terror and anxiety regarding his own health.[7]

The paintings that Rollins and K.O.S. executed in response to George Orwell's *Animal Farm* assume central importance within any consideration of the political and artistic implications of the group's project. They worked together to learn about world leaders and about national and international politics, ultimately demonstrating their determination and entitlement to speak truth to power. Rollins says that the *Animal Farm* paintings have given people "a hard time" because of the propagandistic logic of identifying politicians and heads of state with so many barnyard animals. That said, this zoomorphic brand of caricature has illustrious roots that date back beyond even such eighteenth- and nineteenth-century exemplars as Thomas Rowlandson, J. J. Grandville, and Honoré Daumier. The first major *Animal Farm* painting gathers together Israel's Yitzhak Shamir (a goat), South Africa's Pieter Willem Botha (a rottweiler), Russian President Mikhail Gorbachev (a bull), British Prime Minister Margaret Thatcher (a goose), and Ronald Reagan (a turtle). While one might debate who more deserves comparison with a rottweiler, Botha or Shamir, Thatcher's head atop the body of a goose, or Reagan's on a turtle leaves little mystery. Thatcher's goose handily satirizes her absurd, faux upper-class British arrogance and hauteur, while the portrayal of Reagan as a turtle relates more directly to politics. When in 1987 members of ACT UP/NY installed *Let the Record Show*, in the Broadway window of the New Museum of Contemporary Art, their design featured a photomural of the Nuremburg Trials as backdrop to cutout photographic portrait-busts of six "AIDS criminals," their notoriously AIDS-phobic and homophobic words inscribed before them in tombstone-like panels. This motley crew included Jesse Helms, Cory Servaas (of the Presidential AIDS Commission), an anonymous surgeon, Jerry Falwell, and William F. Buckley; only Reagan's marker remained blank—blank because the president couldn't bring himself to come out of his turtle's shell, even to pronounce the word "AIDS," until the death of Rock Hudson in 1985 made his continued silence about the health emergency politically untenable.

In 1992, Rollins and K.O.S. executed a gigantic (fifty-foot long), commissioned *Animal Farm* painting teeming with zoomorphically caricatured world leaders. A compositional tour de force, the work depicts the heads of state isolated by power not only from their constituents, but also, curiously, from each other. Creating this monumental work clearly entailed a great deal of research, enabling Rollins and the Kids to learn more about geography and world leaders than most people. Nevertheless, to this observer the most forceful *Animal Farm* works have always been the large-scale paintings focusing on one figure, such as the memorable portrayal of then-Senator Jesse Helms as a pit-bull who fiercely, if absurdly, stands his barnyard ground. Clearly the use of zoomorphic caricature was well suited both to the Kids and their mentor, helping them realize a variety of pedagogical and artistic goals. From another perspective, however, these works also bring to mind the uncompromisingly straightforward *Portraits of Power* that Leon Golub painted throughout the 1970s. The decidedly modest scale of Golub's easel paintings, as well as

his stylistic distortions, effectively de-monumentalized, in some cases humanized, and in many more instances satirized such larger-than-life, often heartless players on the world stage as Henry Kissinger, Richard Nixon, Nelson Rockefeller, Francisco Franco, Fidel Castro, and Mao Zedong. Given that during the 1980s Golub's powerful paintings of menacing interrogators, mercenaries, and other bullies became highly visible, Rollins likely shared with the Kids his familiarity with them.

Painted in 1999, *Invisible Man (after Ralph Ellison)* is another one of the group's elegant poetic visualizations of a classic, and in this case African-American, novel. Two towering white sans-seraph letters, "I" and "M," dominate the painting, left and right. Each is composed of the cutout book-page ground under a thin wash of translucent white paint. Positive and negative fuse as the letters "I" and "M" are shaped by the black-painted surface that surrounds them. The group took full advantage of the fact that, when pronounced out loud, those two letters approximate the historically charged phrase "I am a man," and the many photographs that show it being carried by sanitation workers during the tumultuous 1968 Memphis Sanitation strike. Between February 11 and April 12, 1968, black sanitation workers responded to years of dangerous working conditions, discrimination, and the work-related deaths of Echol Cole and Robert Walker by walking off the job. Throughout those sixty-four days, their efforts to join the American Federation of State, County, and

Municipal Employees (AFSME) Local 1733, to secure wage increases and end discrimination attracted national media attention, guaranteeing the widespread dissemination of photographs showing the black strikers and their supporters carrying posters emblazoned with the phrase and the verb "am" emphatically underscored. Among the supporters of the sanitation workers' strike were Roy Wilkins, James Lawson, Bayard Rustin, and the Reverend Dr. Martin Luther King, Jr., who would be killed in that city on April 4, before the strike was settled.

The 1988–89 cycle of paintings that Rollins and K.O.S. executed based on Franz Schubert's song cycle *Winterreise* made a profound impression when I first saw it in 1989 at Manhattan's Dia Center for the Arts, in an exhibition principally devoted to the entire suite of eleven monumental paintings based on Kafka's *Amerika*. Along a wall stretching almost sixty feet, the seventy panels composing this most extensive iteration of the *Winterreise* cycle receded in space. Each panel from the series consists of one page from Schubert's score laid down on linen and stretched over a wood panel. As the group has applied to each successive panel an increasing number of layers of white acrylic paint, containing suspended flecks of mica, the score becomes less and less legible as the viewer moves from left to right. The experience evokes the sensation of walking through a winter landscape as snow begins to fall until, eventually, whiteout occurs, an uncanny visual equivalent for Schubert's settings of Wilhelm Müller's twenty-

ANIMAL FARM '92 (AFTER GEORGE ORWELL), 1992
Acrylic on book pages mounted on canvas
109 7/8 x 541 3/8 inches
Courtesy of Galleria Raucci/Santamaria,
Naples and Galerie Eva Presenhuber, Zurich

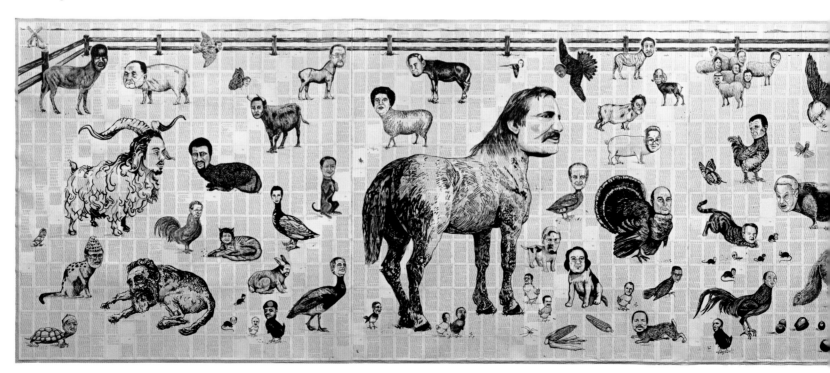

four poems addressing unrequited love and loneliness. *Winterreise*, displayed quite off to the side at Dia, provided this observer with a welcome respite from what Roberta Smith aptly called the "brassy, visual cacophony" that the *Amerika* series generated everywhere else on that floor of Dia's West 22nd Street building.[8]

Over the years, I've often thought back to that first mind-blowing experience of *Winterreise*, and its impression has lost none of its power. On the contrary, as I only realized upon a later encounter with another, truncated version of the work, I had come to mistake the size of the panels, greatly enlarging them in memory when in fact each panel measures an intimate twelve by nine inches—the size of a single page from the score. This retroactive enlargement attests to the power of quiet, especially in relation to even the most exquisite noise.

My own enthusiasm notwithstanding, other critics tended to overlook *Winterreise*, perhaps literally not seeing it amid the virtuoso visual cacophony at Dia; or perhaps their critical silence implied their disregard for a work they considered too clearly and exclusively related to Rollins's own taste for the European classics and too remote from the Kids, whose taste in music they may have presumed to begin and end with hip-hop. After all, Rollins's most hostile critics have voiced skepticism regarding the refinement and sophistication of the group's artistic output, which they reasonably attribute to Rollins. In discussions with some critical observers, such skepticism frequently joins with other, more toxic attitudes—namely, that while teaching the Kids, Rollins is also exploiting them.[9]

In the absence of any generative critical responses to *Winterreise*, and being so powerfully drawn to the piece, I determined to explore the work more closely and discussed Schubert's cycle with a music professor at Brown University. I asked whether *Winterreise* has figured in the tumultuous debate in musicological circles about Maynard Solomon's groundbreaking 1981 article, "Franz Schubert and the Peacocks of Benvenuto Cellini." Solomon had argued that Schubert, who never married and conducted no known romantic liaisons with women, but who did maintain passionate friendships within a circle of men, may have been homosexual. The response came that, no, *Winterreise* had not figured in that controversy. But the professor then directed me to song number XX, *Die Wegweiser* (the sign post). He suspected that its text, of all Müller's poems, would be the most suggestive as evidence of Schubert's alleged queer sexuality. After reading the poem and detecting a possible pattern in the group's project, I decided to write Tim, resulting in the following email exchange:

DD: The title page of the song called *Wegweiser* (sign post) appears more than once in various sets of the *Winterreise* paintings—for example, the opening panel of the set that currently figures in the Tang retrospective. Does/did that song/poem have special meaning for you? For the kids?

TR: The sign post is a metaphor for what we believe true artists use to, first, locate themselves in history and then make the decision to get lost in the wilderness of some new creation. This is so corny, but we've known it to be true.

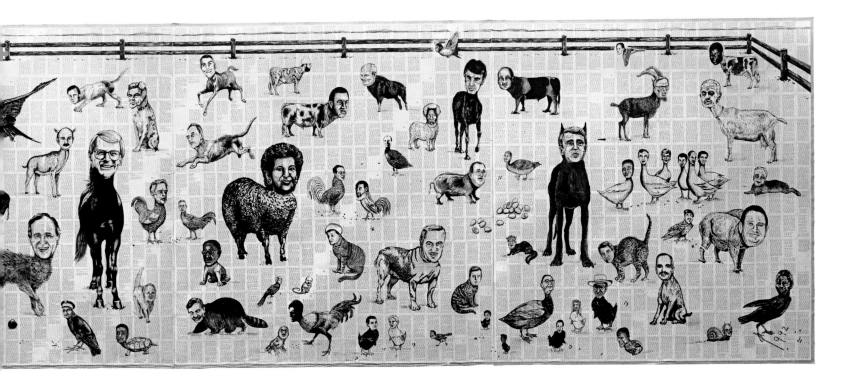

Corny? Hardly. But *Wegweiser* also has significance beyond its pedagogical utility as a means of teaching young artists about the importance of situating one's work historically, and then of pushing beyond such historical correspondence, which defines but thereby risks confining both artists and their works, and of the equal importance of moving on to "get lost" in the "wilderness" of uncharted territory.

Like any poem *The Sign Post* invites multiple interpretations, which are contingent on the reader in all of his or her complexity. Here, then, the poem translated into English:

Why do I avoid the highways
that other travelers take
and seek hidden paths
among snow-clad rocky heights?

Yet I have done no wrong
That I should shun mankind.
What senseless craving
drives me into the wilderness?

Signposts stand on the roads,
pointing towards the towns;
and I wander on ceaselessly,
restless, yet seeking rest.

I see a signpost standing there
Immovably before my eyes;
I must travel a road
from which no man has ever returned.[10]

Within the context of Rollins's project, there is no discernible reason to question his pedagogically oriented appreciation for the poem. But from the more private, or anyway personal,

perspective of the gay or bisexual man or woman, the poem also assumes other, no less important meanings, since as it so beautifully evokes the situation of the outcast or outsider who, confronted by social directives, is compelled to go his or her own way, which is the other way; that way of the Other. As such, *The Sign Post* expresses the pain of the exile to which homosexuals have been consigned by societies and cultures still dominated by the ideological state apparatuses of the Church, the family and the law—in short, compulsory heterosexuality.

Having said all that, I choose to finesse rather than pretend not to notice, two verses that seem to contradict this view: "Yet I have done no wrong/that I should shun mankind." Wouldn't the homosexual feel, on the contrary, that he or she *has* done a great deal wrong? I can resolve that apparent contradiction by recourse to the historical-constructionist understanding that in the early nineteenth century, when Müller composed his poems and Schubert set them to such achingly beautiful music, "homosexual" did not yet exist either as a conceptualization of same-sex love or as a way of categorizing same-sexers.[11] For the queer to claim a composer of Schubert's stature as one of our own is one way imaginatively to transcend the solitary fate of the social outcast by finding evidence of an illustrious cultural past with which one can identify. The compulsion to lay claim to a partly positive historical legacy, especially as such legacies have institutionally been denied or discounted, also informed Isaac Julien's contemporaneous film, *Looking for Langston* (1989), which looked at Langston Hughes and the Harlem Renaissance from a queer perspective for just such a sense of cultural belonging and validation. That desire for a past parallels Rollins's own determination that the Kids must lay claim to vaunted cultural traditions and practices of which polite society had declared them unworthy; that they should, rather, not knock on the palace door but slip in through the back door, whether or not that entails impersonating servants, and "stay for a while."

1. Rollins in Danya Goldfine, Dan Geller, *Kids of Survival: The Art and Life of Tim Rollins and K.O.S.* (video documentary, New York: Geller/Goldfine Productions, 1996).
2. Rollins's characterization suggests the "*antropofagia*," or "cannibalization" of European modernism that Brazilian Surrealists advocated during the mid-1920s to make such modernism *their* own. See Paolo Herkenhoff, "Introduao geral," in *XXIV Bienal de São Paulo, Núcleo Historico : Antropofagia e Histórias de Canibalismos*, ed. Paolo Herkenhoff and Adriano Pedrosa (São Paulo: Fundacão Bienal de São Paulo, 1998).
3. Rollins quoted in "Tim Rollins Talks to David Deitcher," *Artforum* 41, no. 8 (April 2003): 238.
4. Rollins in *Kids of Survival: The Art and Life of Tim Rollins and K.O.S.*
5. Marko Daniel, "The Art and Knowledge Workshop:

A Study," in *Tim Rollins and K.O.S.*, exh. cat. (London: Riverside Studios, 1988).
6. Ibid.
7. Rollins has only acknowledged his bisexuality publicly in recent interviews, though his queer sexuality had been an open secret for years, at least to all who knew him.
8. Roberta Smith, "'Amerika' by Tim Rollins and K.O.S.," *New York Times* (November 3, 1989), C33.
9. Some respected friends are among those who view the refinement and sophistication of the group's output with such skepticism, but the toxicity that can accompany that outlook was given its fullest, most destructive and irresponsible expression in a purportedly muckraking article in *New York* magazine in 1991. See Mark Lasswell, "True Colors: Tim Rollins's Odd Life with the Kids of Survival," *New York* (29 July 1991): 30–8.

10. I have cobbled together this English translation from two sources: first, from a translation by William Mann (1985) from the liner notes accompanying a 1972 recording of *Winterreise* by Dietrich Fischer-Dieskau, accompanied on the piano by Gerald Moore, Deutsche Grammophon 4151872, 1985; second, from the subtitles for a performance by Fischer-Dieskau, accompanied on the piano by Alfred Brendel, posted on You Tube: http://vids.myspace.com/index.cfm?fuseaction=vids.individual&videoid=32980098.
11. See Michel Foucault, *The History of Sexuality, Volume I: An Introduction*, trans. Robert Hurley (New York: Vantage, 1980) and Jonathan Ned Katz, *The Invention of Heterosexuality* (New York: Dutton, 1995). Also see my *Dear Friends: American Photographs of Men Together, 1840–1918* (New York: Abrams, 2001).

WINTERREISE (AFTER FRANZ SCHUBERT), 1989 (detail)
Acrylic and mica on music pages mounted on linen
12 x 9 inches
Private Collection

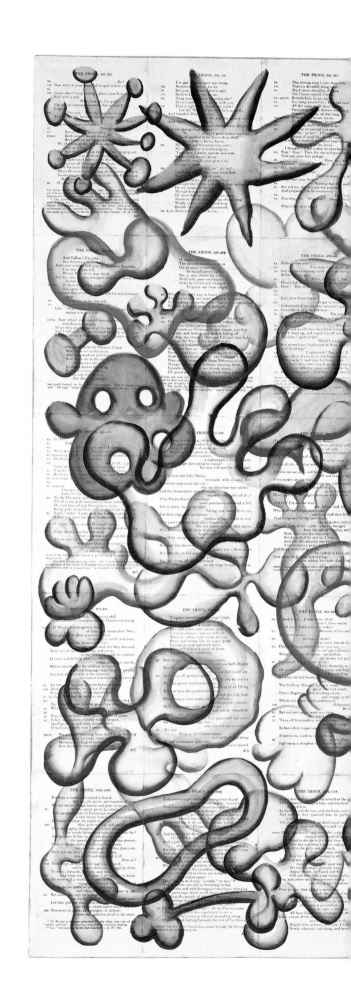

THE FROGS (AFTER ARISTOPHANES), 1993
Watercolor on book pages mounted on linen
31 x 40 inches
Private collection

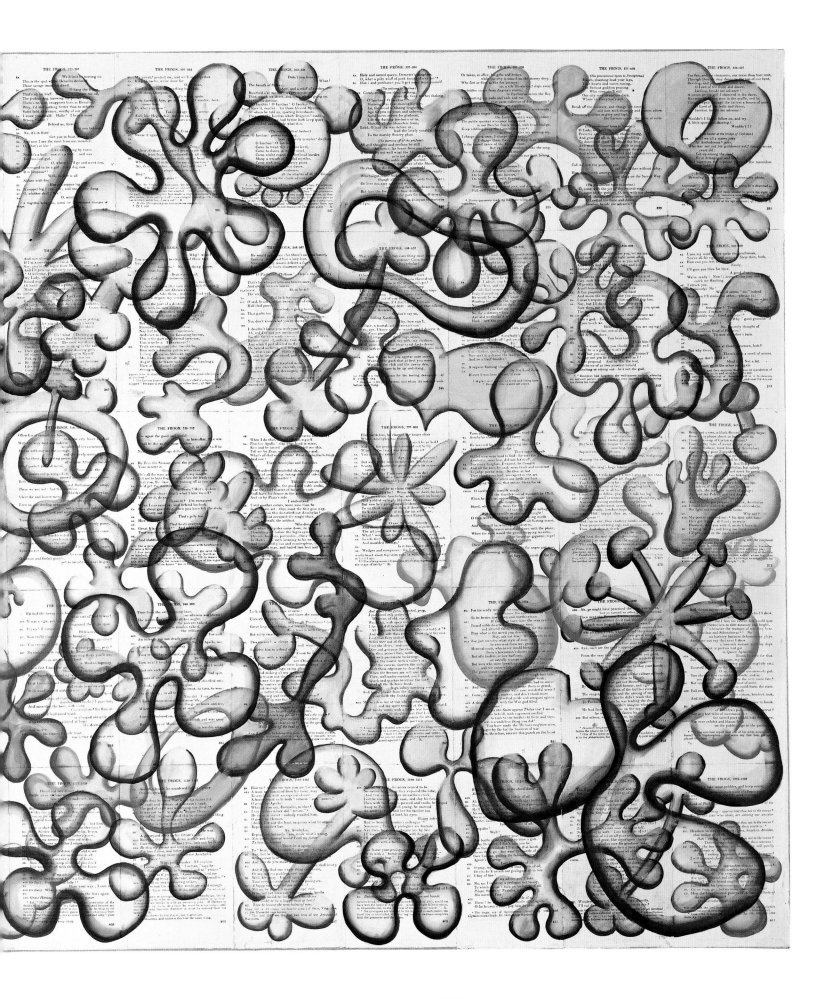

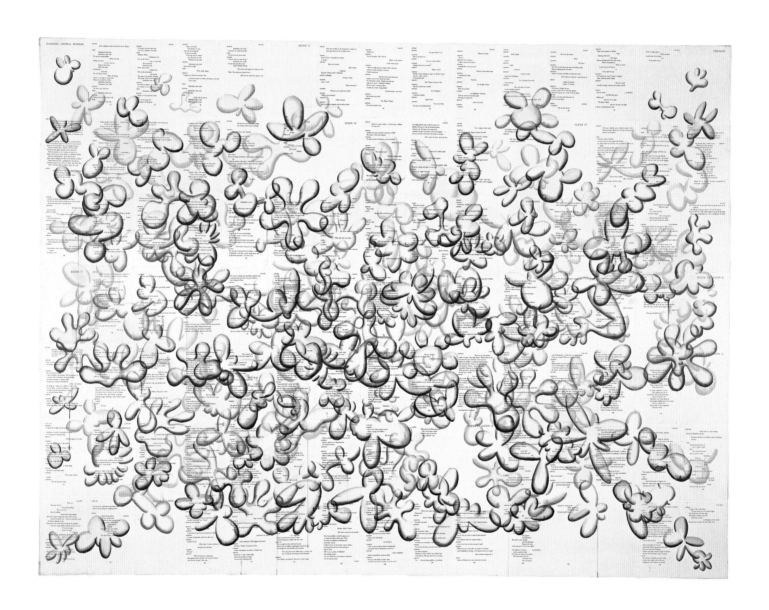

THE FROGS II (AFTER ARISTOPHANES), 1994
Watercolor and pencil on book pages mounted on linen
56 x 75 inches
Private Collection

Facing page:
Installation view, Mary Boone Gallery,
New York, 1995

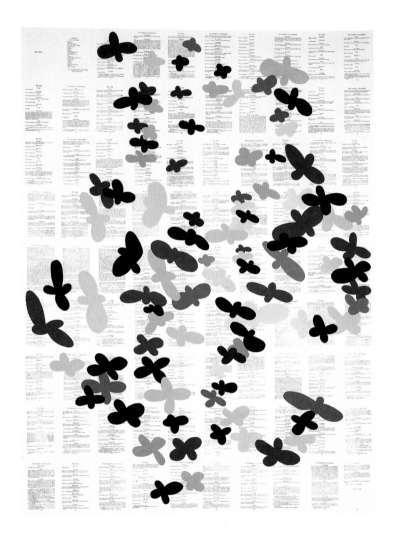

This page, left:
THE BIRDS II (AFTER ARISTOPHANES), 1994
Acrylic on book pages mounted on linen
72 x 54 inches
Collection of Ugo Rondinone, New York

This page, right:
THE BIRDS III (AFTER ARISTOPHANES), 1994
Acrylic on book pages mounted on linen
72 x 54 inches
Private Collection

Facing page:
THE BIRDS (AFTER ARISTOPHANES), 1994
Acrylic on book pages mounted on linen
72 x 54 inches
Private Collection

THE CLOUDS (AFTER ARISTOPHANES), 1994
Acrylic and oil on book pages mounted on linen
48 x 66 inches
Private Collection

THE CLOUDS II (AFTER ARISTOPHANES), 1994
Acrylic on book pages mounted on linen
48 x 66 inches
Private Collection

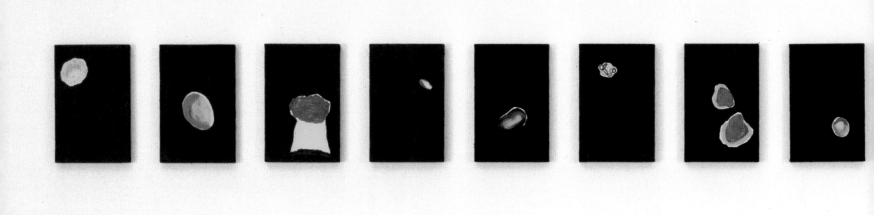

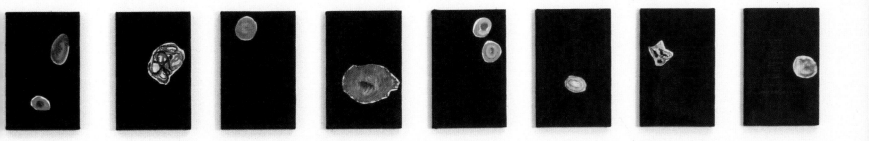

PROMETHEUS BOUND (AFTER AESCHYLUS), 1998
Oil pastel and india ink on xerograph on rag paper
mounted on wood panel
Sixteen works, 10 x 6 ¹/₂ inches each
Private Collection

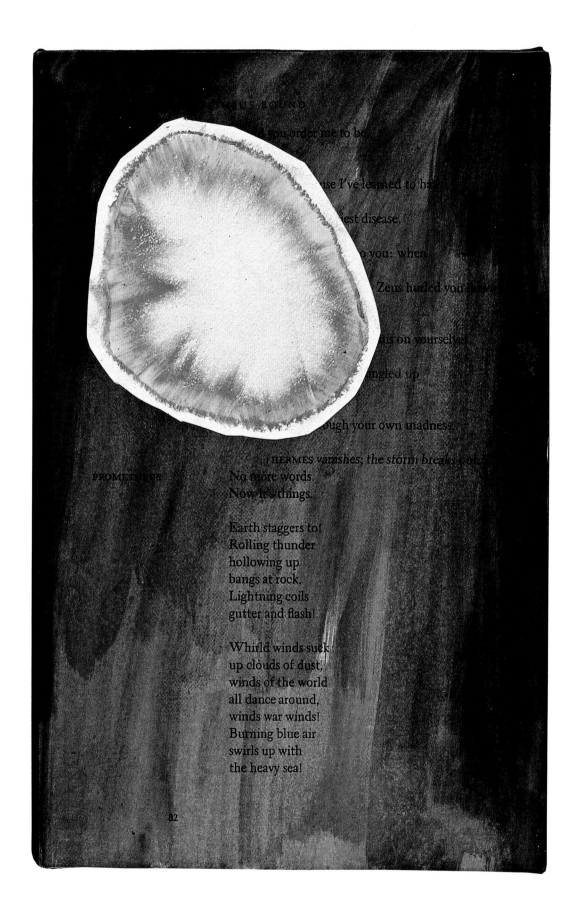

...you order me to be...

...se I've learned to ha...

...est disease.

...o you: when

...Zeus hurled you...

...is on yourself...

...angled up

...ough your own madness.

(HERMES vanishes; the storm breaks out...

PROMETHEUS No more words.
Now it's things.

Earth staggers to!
Rolling thunder
hollowing up
bangs at rock.
Lightning coils
gutter and flash!

Whirld winds suck
up clouds of dust,
winds of the world
all dance around,
winds war winds!
Burning blue air
swirls up with
the heavy sea!

82

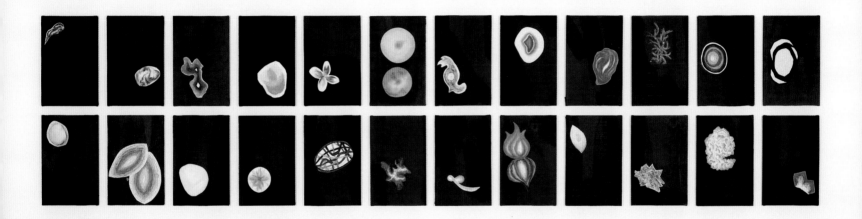

Facing page:
PROMETHEUS BOUND (AFTER AESCHYLUS), 1998–99
Oil pastel and india ink on xerograph on rag paper
on linen mounted on wood panel
10 x 6 ¹/₂ inches
Private Collection

This page:
PROMETHEUS BOUND (AFTER AESCHYLUS), 1998–99
Oil pastel on book page on inked canvas
mounted on wood panels
Twenty-four works, 9 x 6 inches each
Palmer Museum of Art, Pennsylvania State University,
University Park, Pennsylvania
Purchased with funds provided by the
Friends of the Palmer Museum of Art

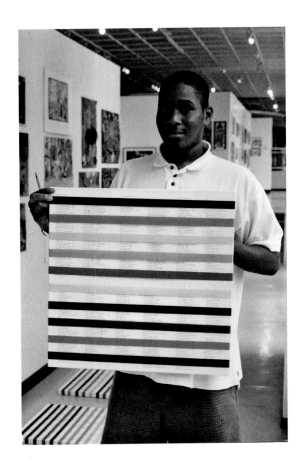
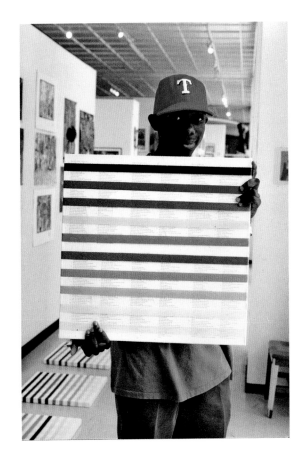
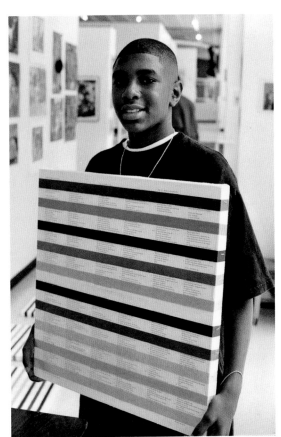
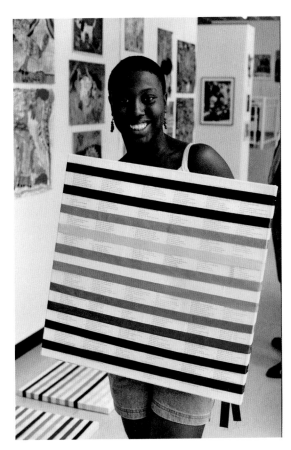

Workshop for THE PSALMS, Youth Art Connection,
Atlanta, Georgia, 1997

some fe-
the cause.
father has
youthful
re subject
hey exer-
f seen the
in shame;
d selected
of his first
nor even
the most
less fear
revenge
eeing the
him out

ever seen
he *father*,
d for the
t will be

I know.
testify,
curse to
rs cruel
ates the
colored
mity of

d moral
blighted

slavery,
. Then
gs that
mmortal

X

Perilous Passage
e Slave Girl's Life

away, Dr. Flint contrived a ne
that my fear of my mistress wa
t tones, he told me that he was g
in a secluded place, four miles av
I was constrained to listen, while
a home of my own, and to m
caped my dreaded fate, by being
other had already had high wo
had told him pretty plainly what
here was considerable gossip in t
to which the open-mouthed jeal
little. When my master said he
and that he could do it with little
es something would happen to
d that the house was actually beg
I would never enter it. I had rath
till dark; I had rather live and die
ay, through such a living death.
, whom I so hated and loathe
of my youth, and made my
long struggle with him, succe
nder his feet. I would do any
efeating him. What *could* I do? I
desperate, and made a plunge int
come to a period in my unhappy
I could. The remembrance fills
s me to tell you of it; but I have
I will do it honestly, let it cost

may. I will no
from a master
thoughtlessnes
lute my mind
inculcated by
hood. The inf
they had on
knowing, conc
and I did it wi
But, O, ye
childhood, wh
tion, whose h
desolate slave g
could have ma
shielded by the
of confessing
had been bligh
under the most
self-respect; but
demon Slavery;
I was forsaken
trated; and I be
I have told yo
had given rise to
chanced that a
knowledge of t
my grandmothe
interested for
answered in par
to aid me. He c
to me frequently
So much atte
ing; for human
sympathy, and
great thing to ha
crept into my h
too eloquent, al
course I saw wh
between us; but

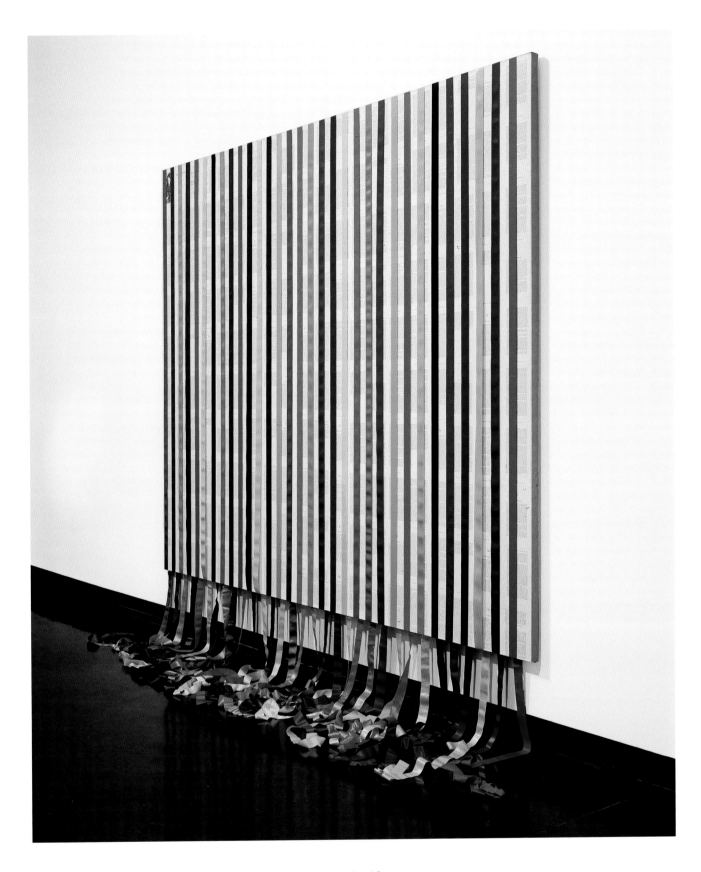

This page, detail facing:
INCIDENTS IN THE LIFE OF A SLAVE GIRL
(AFTER HARRIET JACOBS), 1998
Satin ribbons on book pages mounted on linen
87 x 110 inches, installation dimensions variable
The Bronx Museum of the Arts, New York
Gift of the artists, 1999.9.1

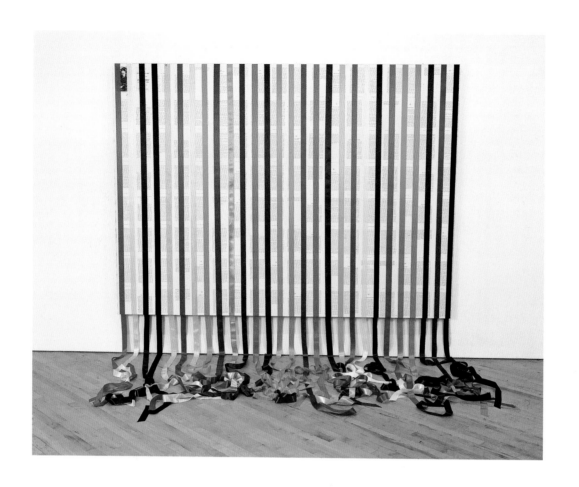

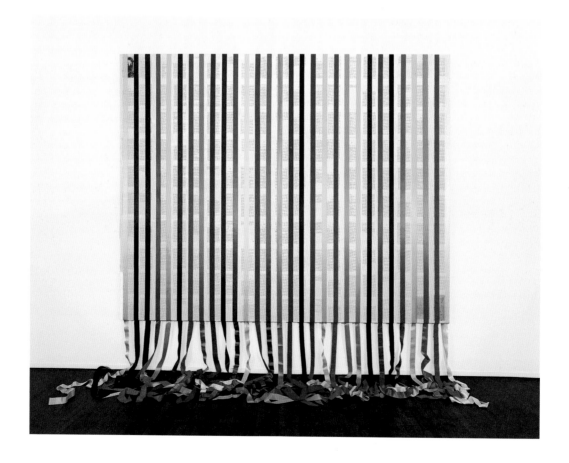

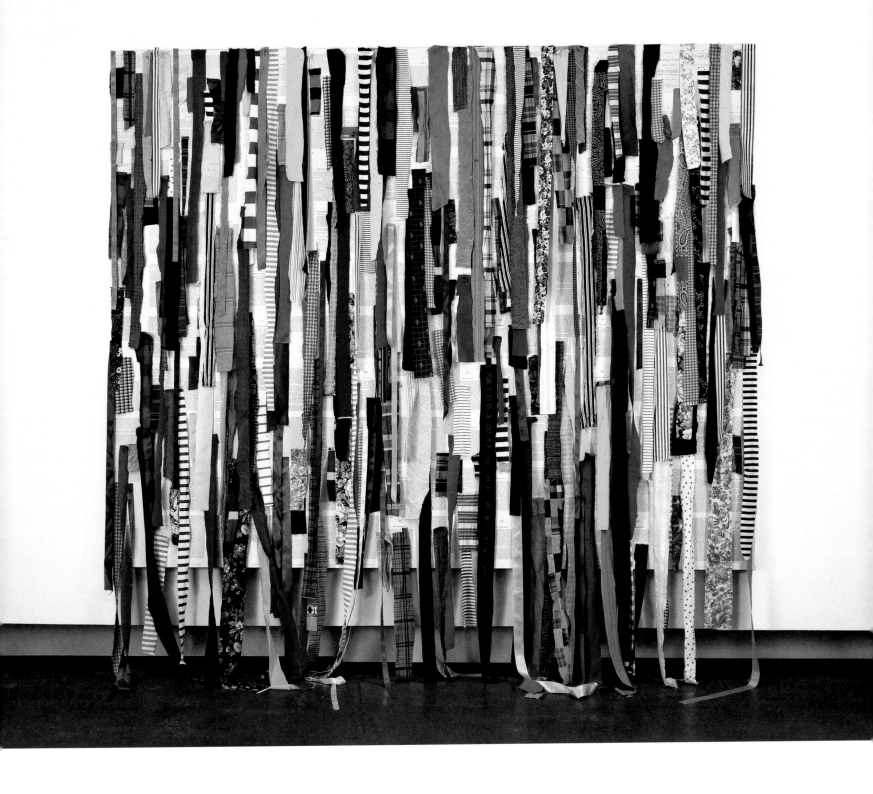

Facing page, top:
DIARY OF A SLAVE GIRL (AFTER HARRIET JACOBS), 1998
Satin ribbons on book pages mounted on linen
70 x 98 inches, installation dimensions variable
Williams College Museum of Art, Williamstown,
Massachusetts, Museum purchase, Kathryn Hurd Fund,
Miscellaneous Gifts Fund

Facing page, bottom:
INCIDENTS IN THE LIFE OF A SLAVE GIRL
(AFTER HARRIET JACOBS), 2000
Satin ribbons on book pages mounted on canvas
84 x 108 inches, installation dimensions variable
Courtesy of Galleria Raucci/Santamaria, Naples

This page:
INCIDENTS IN THE LIFE OF A SLAVE GIRL
(AFTER HARRIET JACOBS), 1998
Fabric on book pages mounted on linen
74 x 108 inches
Courtesy of Grand Arts, Kansas City, Missouri

toward the brick-red stretch of tennis courts. Far beyond, players in whites showed sharp against the red of the courts surrounded by grass, a gay vista washed by the sun. In the brief interval I heard a cheer arise. My predicament struck me like a stab. I had a sense of losing control of the car and slammed on the brakes in the middle of the road, then apologized and drove on. Here within this quiet greenness I possessed the only identity I had ever known, and I was losing it. In this brief moment of passage I became aware of the connection between these lawns and buildings and my hopes and dreams. I wanted to stop the car and talk with Mr. Norton, to beg his pardon for what he had seen; to plead and show him tears, unashamed tears like those of a child before his parent; to denounce all we'd seen and heard; to assure him that far from being like any of the people we had seen, I *hated* them, that I believed in the principles of the Founder with all my heart and soul, and that I believed in his own goodness and kindness in extending the hand of his benevolence to helping us poor, ignorant people out of the mire and darkness. I would do his bidding and teach others to rise up as he wished them to, teach them to be thrifty, decent, upright citizens, contributing to the welfare of all, shunning all but the straight and narrow path that he and the Founder had stretched before us. If only he were not angry with me! If only he would give me another chance!

Tears filled my eyes, and the walks and buildings flowed and froze for a moment in mist, glittering as in winter when rain froze on the grass and foliage and turned the campus into a world of whiteness, weighting and bending both trees and bushes with fruit of crystal. Then in the twinkling of my eyes, it was gone, and the here and now of heat and greatness returned. If only I could make Mr. Norton understand what the school meant to me.

"Shall I stop at your rooms, sir?" I said. "Or shall I take you to the administration building? Dr. Bledsoe might be worried."

"To my rooms, then bring Dr. Bledsoe to me," he answered tersely.

"Yes, sir."

In the mirror I saw him dabbing gingerly at his forehead with a crinkled handkerchief. "You'd better send the school physician to me also," he said.

I stopped the car in front of a small building with white pillars like those of an old plantation manor house, got out and opened the door.

"Mr. Norton, please, sir . . . I'm sorry . . . I—"

He looked at me sternly, his eyes narrowed, saying [nothing].

"I didn't know . . . please . . ."

"Send Dr. Bledsoe to me," he said, turning away and swinging up the graveled path to the building.

I got back into the car and drove slowly to the administration building. A girl waved gaily as I passed, a bunch of violets in her hand. Two teachers in dark suits walked decorously beside a broken fountain.

The building was quiet. Going upstairs I visualized Dr. Bledsoe, with his broad globular face that seemed to force its form from the fat pressing from the inside, which, as air pressing against the membrane of a balloon, gave it shape and buoyancy. "Old Bucket-head," one of the fellows called him. I never had. He had been good to me from the first, perhaps because of the letters which the school superintendent had sent to him when I arrived. But more than that, he was the example of everything I hoped to be: Influential with wealthy men all over the country; consulted in matters concerning the country; a leader of his people; the possessor of not one, but two Cadillacs, a good salary and a soft, good-looking and creamy-complexioned wife. What was more, while

pushed a wheelbarrow or performed some other act of determination and sacrifice to attest his eagerness for knowledge. I remembered the admiration and fear he inspired in everyone on the campus; the pictures in the Negro press captioned "EDUCATOR," in type that exploded like a rifle shot, his face looking out at you with utmost confidence. To us he was more than just a president of a college. He was a leader, a "statesman" who carried our problems to those above us, even unto the White House; and in days past he had conducted the President himself about the campus. He was our leader and our magic, who kept the endowment high, the funds for scholarships plentiful and publicity moving through the channels of the press. He was our coal-daddy of whom we were afraid.

As the organ voices died, I saw a thin brown girl rise noiselessly with the rigid control of a modern dancer, high in the upper rows of the choir, and begin to sing a cappella. She began softly, as though singing to herself of emotions of utmost privacy, a sound not addressed to the gathering, but which they overheard almost against her will. Gradually she increased its volume, until at times the voice seemed to become a disembodied force that sought to enter her, to violate her, shaking and bending her rhythmically, as though it had become the master of her being, rather than the fluid web of her creation.

I saw the guests on the platform turn to look at them, to see the thin brown girl in white who stood standing high against the organ pipes, and spun before our eyes a pipe of contained, controlled and animated anguish, a thin plain face transformed. I could not understand the words, but only the sorrowful, vague and ethereal, of the singing filled with nostalgia, regret and repentance, and a lump in my throat as she sank slowly down

controlled collapsing, as though she were balancing, sustaining the simmering bubble of her final tone by some delicate rhythm of her heart's blood, or by some secret concentration of her being, focused upon the life through the contained liquid of her large uplifted eyes.

There was no applause, only the appreciation of a profound silence. The white guests exchanged smiles of approval. I sat thinking of the dread possibility of having to leave all this, of being expelled; imagining the return home and the rebukes of my parents. I looked out at the scene now from far back in my despair, seeing the platform and its actors as through a reversed telescope; the doll-like figures moving through some meaningless ritual. Someone up there, above the alternating close-dry and grease-slick heads of the students rowed before me, was making announcements from a lectern upon which a dim light shone. Another figure rose and led a prayer. Someone spoke. Then around me everyone was singing *Lead me, lead me to a rock that is higher than I.* It was though the sound contained some force more pervious than the image of the scene of which it was a living connective tissue, I was pulled back to its image.

One of the guests had risen to speak. A man of striking ugliness; fat, with a bullet-head set on a short neck, a nose much too wide for its face, upon which he wore black-lensed glasses. He had been seated next to Dr. Bledsoe, but so concerned had I been with the president that I hadn't really seen him. My eyes had focused upon the white men and Dr. Bledsoe. So that now he arose and crossed slowly to the center of the platform I had the notion that part of Dr. Bledsoe had arisen and moved forward, leaving his other part smiling in the chair.

He stood before us relaxed, his white collar gleaming

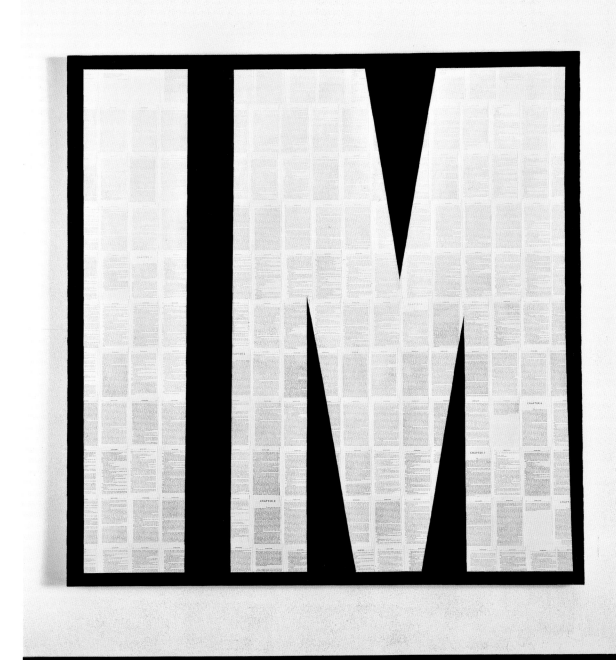

This page, detail facing:
INVISIBLE MAN (AFTER RALPH ELLISON), 1999
Matte acrylic on book pages mounted on canvas
60 x 60 inches
Collection of Dr. Rushton E. Patterson, Jr.

"We saw a newspaper headline that said VICTIM in very bold letters. We clipped off the I and M at the end of VICTIM, projected it, and said 'that's it,' it was exactly what we wanted."
NELSON RICARDO SAVINON

Workshop, Grand Arts, Kansas City, Missouri, 1998

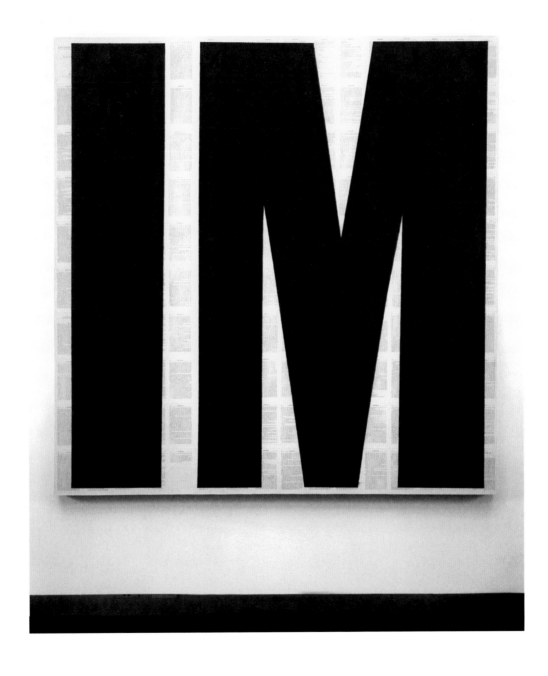

INVISIBLE MAN (AFTER RALPH ELLISON), 1998
Acrylic on book pages mounted on linen
72 x 72 inches
Private Collection

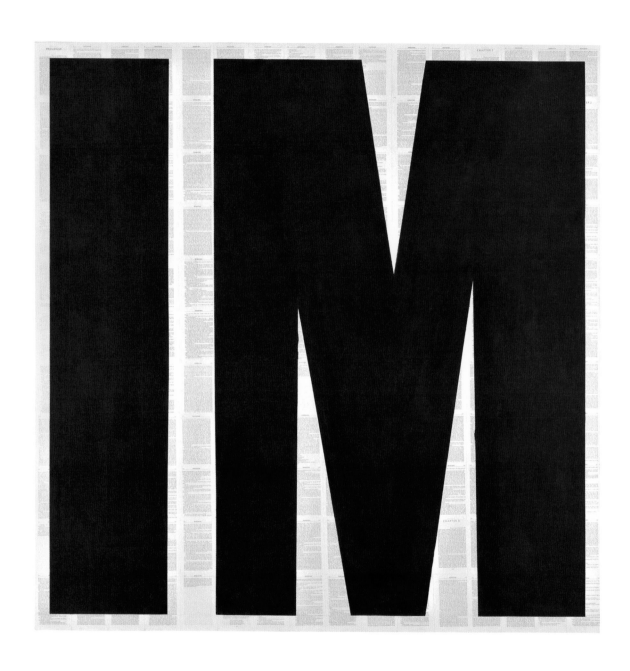

INVISIBLE MAN (AFTER RALPH ELLISON), 2007
Matte acrylic on book pages mounted on canvas
72 x 72 inches
Private Collection, Chicago, Illinois

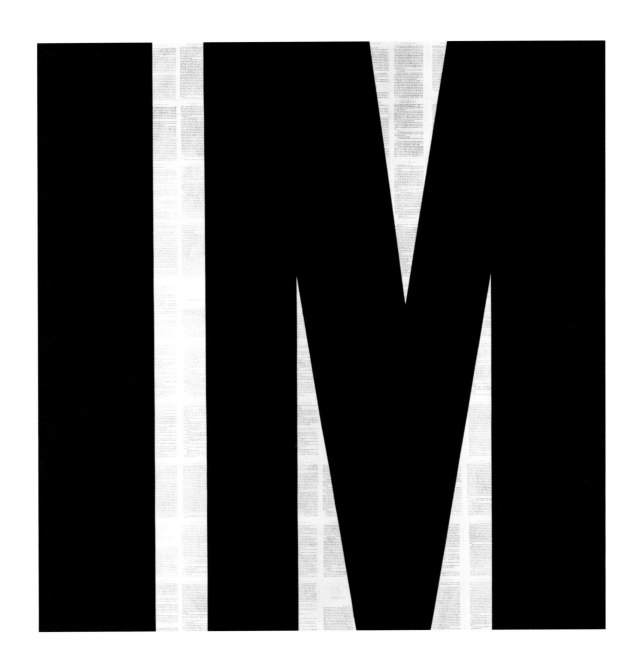

INVISIBLE MAN (AFTER RALPH ELLISON), 2008
Matte acrylic on book pages mounted on canvas
72 x 72 inches
Courtesy of the artists, Lehmann Maupin Gallery,
New York, and Galerie Eva Presenhuber, Zurich

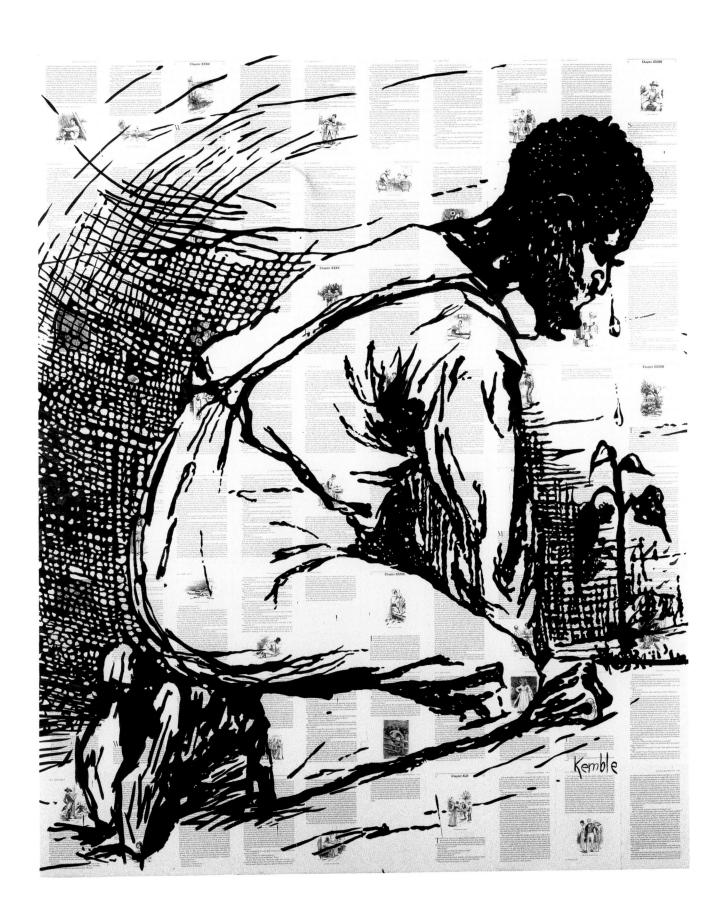

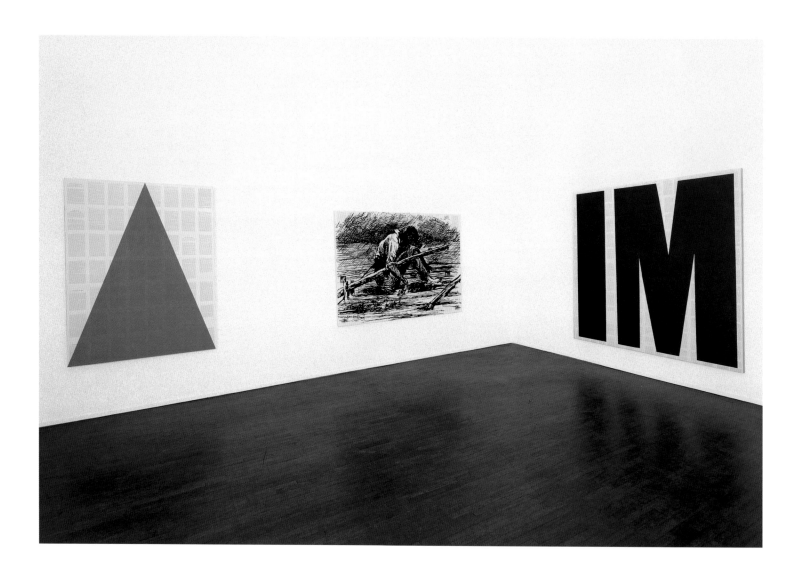

Installation view, Galleria Raucci/Santamaria,
Naples, 2001

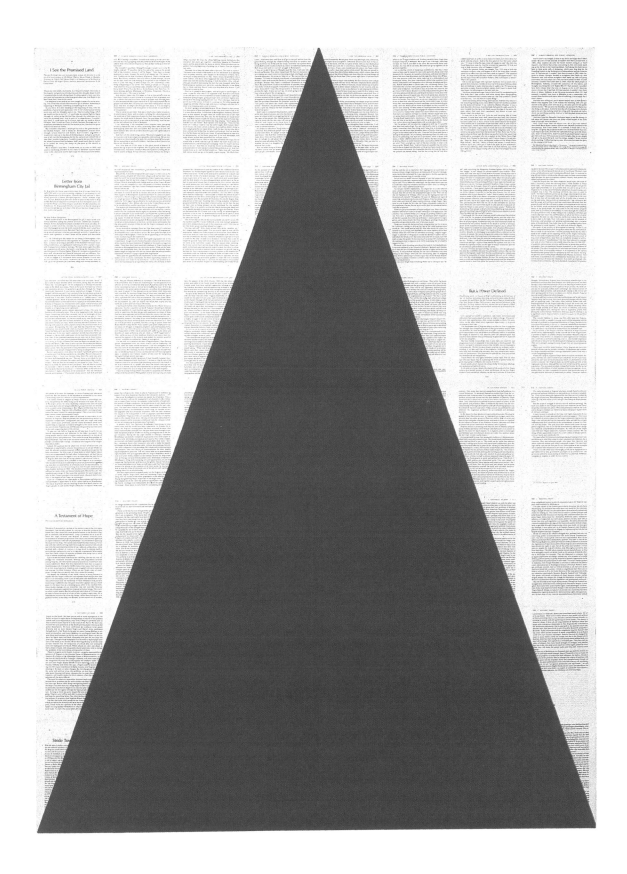

I SEE THE PROMISED LAND
(AFTER MARTIN LUTHER KING, JR.), 2000
Matte acrylic and pencil on book pages
mounted on canvas
62 x 45 ¹/₃ inches
Courtesy of Galleria Raucci/Santamaria, Naples

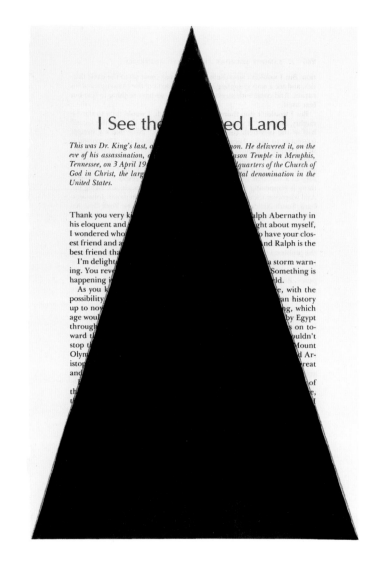

45

I See the Promised Land

This was Dr. King's last, and most apocalyptic, sermon. He delivered it, on the eve of his assassination, at [the Bishop Charles] Mason Temple in Memphis, Tennessee, on 3 April 1968. Mason Temple is the headquarters of the Church of God in Christ, the largest African American pentecostal denomination in the United States.

Thank you very kindly, my friends. As I listened to Ralph Abernathy in his eloquent and generous introduction and then thought about myself, I wondered who he was talking about. It's always good to have your closest friend and associate say something good about you. And Ralph is the best friend that I have in the world.

I'm delighted to see each of you here tonight in spite of a storm warning. You reveal that you are determined to go on anyhow. Something is happening in Memphis, something is happening in our world.

As you know, if I were standing at the beginning of time, with the possibility of general and panoramic view of the whole human history up to now, and the Almighty said to me, "Martin Luther King, which age would you like to live in?"—I would take my mental flight by Egypt through, or rather across the Red Sea, through the wilderness on toward the promised land. And in spite of its magnificence, I wouldn't stop there. I would move on by Greece, and take my mind to Mount Olympus. And I would see Plato, Aristotle, Socrates, Euripides and Aristophanes assembled around the Parthenon as they discussed the great and eternal issues of reality.

But I wouldn't stop there. I would go on, even to the great heyday of the Roman Empire. And I would see developments around there, through various emperors and leaders. But I wouldn't stop there. I would even come up to the day of the Renaissance, and get a quick picture of all that the Renaissance did for the cultural and esthetic life of man. But I wouldn't stop there. I would even go by the way that the man for whom I'm named had his habitat. And I would watch Martin Luther as he tacked his ninety-five theses on the door at the church in Wittenberg.

But I wouldn't stop there. I would come on up even to 1863, and watch a vacillating president by the name of Abraham Lincoln finally come to the conclusion that he had to sign the Emancipation Proclama-

279

Above, left:
I SEE THE PROMISED LAND
(AFTER MARTIN LUTHER KING, JR.), 1998
Acrylic on book page
9 x 7 inches
Private Collection

Right:
I SEE THE PROMISED LAND
(AFTER MARTIN LUTHER KING, JR.), 1998–99
Pen and acrylic on book page
9 x 7 inches
Private Collection

I SEE THE PROMISED LAND
(AFTER MARTIN LUTHER KING, JR.), 1999
10th Avenue and 26th Street, New York

10 And while they looked stedfastly
 toward heaven as he went up,
 behold,
 two men stood by them
 in white apparel;
11 Which also said,
 Ye men of Galilee,
 why stand ye gazing up into heaven?
 this same Jesus,
 which is taken up from you into heaven,
 shall so come
 in like manner as ye have seen him go
 into heaven.

12 Then returned they unto Jerusalem
 from the mount called Olivet,
 which is from Jerusalem
 a sabbath day's journey.
13 And when they were come in,
 they went up into an upper room,
 where abode
 both Peter, and James,
 and John, and Andrew,
 Philip, and Thomas,
 Bartholomew, and Matthew,
 James the son of Alphaeus,
 and Simon Zelotes,
 and Judas the brother of James.
14 These all continued with one accord
 in prayer and supplication,
 with the women,
 and Mary the mother of Jesus,
 and with his brethren.

15 And in those days
 Peter stood up in the midst of the disciples,
 and said,
 (the number of names together
 were about an hundred and twenty,)
16 Men and brethren,
 this scripture
 must needs have been fulfilled,
 which the Holy Ghost
 by the mouth of David
 spake before concerning Judas,
 which was guide to them that took Jesus.
17 For he was numbered with us,
 and had obtained part of this ministry.

18 Now this man purchased a field
 with the reward of iniquity;
 and falling headlong,
 he burst asunder in the midst,
 and all his bowels gushed out.
19 And it was known
 unto all the dwellers at Jerusalem;
 insomuch as that field is called
 in their proper tongue,
 Aceldama,
 that is to say,
 The field of blood.
20 For it is written in the book of Psalms,
 Let his habitation be desolate,
 and let no man dwell therein:
 and his bishoprick
 let another take.
21 Wherefore of these men
 which have companied with us
 all the time that the Lord Jesus
 went in and out among us,
22 Beginning from the baptism of John,
 unto that same day
 that he was taken up from us,
 must one be ordained
 to be a witness with us
 of his resurrection.
23 And they appointed two,
 Joseph called Barsabas,
 who was surnamed Justus,
 and Matthias.
24 And they prayed,
 and said,
 Thou, Lord,
 which knowest the hearts of all men,
 shew whether of these two
 thou hast chosen,
25 That he may take part
 of this ministry and apostleship,
 from which Judas by transgression fell,
 that he might go to his own place.
26 And they gave forth their lots;
 and the lot fell upon Matthias;
 and he was numbered
 with the eleven apostles.

2:1 And when the day of Pentecost
 was fully come,
 they were all with one accord
 in one place.

THE BOOK OF ACTS, 1998
Holy oil on book page
10 7/8 x 8 inches
Collection of the artists

ELEANOR HEARTNEY
ART AS FAITH

"IF YOU DON'T BELIEVE IN MIRACLES, YOU WON'T LIKE US"—Tim Rollins

On Sunday mornings at the Memorial Baptist Church in Harlem, busloads of tourists troop into the capacious sanctuary to get a little bit of that old time religion. They sway and nod their heads to the mesmerizing beat of the gospel choir and the rolling cadences of the sermon. After the collection they troop out again, leaving the remainder of the Sunday service to the church's regular members, who turn to the congregation's more private concerns. While the church membership is overwhelmingly African American, visitors frequently glimpse a lone white face in the choir stand. This belongs to the artist Tim Rollins, founder and director of the Art and Knowledge Workshop and the Kids of Survival.

Rollins has been a member of Memorial Baptist Church since 1994, a year of personal crises that propelled him back toward an engagement with religion that had been dormant since his childhood. One of the predominant liberation theology churches in the city, Memorial Baptist is known for its progressive philosophy and dedication to the Christian doctrine of social justice. The Church has been a second home for Rollins and augments the commitment and sense of community that he also brings to his practice of contemporary art.

The path that lead Rollins to Memorial Baptist Church is in many ways inseparable from the path that led him to found the Art and Knowledge Workshop. Both journeys are essentially tales of redemption, and both turn on his belief that creativity is an act of faith. Rollins's personal story draws on a strain of American life quite foreign to the conventional art world, which frequently regards religious faith as a form of superstition. Growing up in rural Maine, Rollins was deeply influenced by his great-grandmother, a spiritualist who occasionally whisked him off to revival meetings. Rollins recalls, "She had no running water, we'd go to revival tent meetings in that summer near Burnham, Maine..."[1]

Revival meetings are an American phenomenon. Originating in the late eighteenth century in response to westward expansion, these outdoor religious meetings, which may or may not take place beneath a tent, originally served a mobile population with a potent mix of religion and entertainment. Centered around a charismatic speaker, whose message was frequently underscored by rousing gospel music, revival meetings were and are highly emotional events that encourage participants to forge a personal relationship with Jesus and invite the faithful to testify to God's intervention in their lives, and non-believers to publicly come to God.

As a child, Rollins was immersed in this high-octane version of Christianity. He attended the Vacation Bible School where he was encouraged to make art, an activity little emphasized in his public school. He followed the preaching of the great evangelists, among them Blind Al Crocker, Oral Roberts, and the young Jimmy Swaggart. He started teaching Sunday school at thirteen, honing his own abilities as a public speaker. "I loved the performative passion of preaching," he notes. "It helped me become an educator".

At sixteen, Rollins moved on, letting his connection to organized religion grow dormant as he donned a hippie persona and put his passion instead into the social commentaries of Sartre and Marx. A more conventionally bohemian artistic existence followed, with art studies at the School of Visual Arts in New York and work towards an MA in Art Education from New York University. He followed his formal education with immersion in the New York art scene of the 1980s. From the beginning, however, Rollins was drawn to communal, socially engaged practices, beginning with the activist collective, Group Material, of which he was a founding member, and continuing in his creation of the Kids of Survival and the Art and Knowledge Workshop. Though he had put aside the active practice of religion, even during these years Rollins remained inspired by Gospel music and by the message of social justice preached by personal heroes like Martin Luther King and Malcolm X. The early book projects with K.O.S. include several that touch on themes of faith and redemption, among them works based on Franz Kafka's *Amerika*, Stephen Crane's *The Red Badge of Courage*, Gustave Flaubert's *The Temptation of Saint Antony* and Nathaniel Hawthorne's *The Scarlet Letter*.

The tumultuous year 1993–94, brought Rollins back to religion. It was a difficult time, marked by the death of one of the Kids in a gangland-style murder and accompanied by several professional and personal setbacks, which eventually left Rollins homeless and almost destitute. Curiously, he experienced the call

on New Year's Day, 1994, when, following a big yearend party, he felt compelled to go to church. After searching through the Yellow Pages for a suitable uptown institution, he found himself in the balcony of the Canaan Baptist Church of Christ in Harlem, where he unaccountably began to weep and was comforted by a child usher. In the ensuing months he explored other uptown Baptist Churches before settling finally into Memorial Baptist Church, where he drew inspiration from the preaching of its dynamic founder and pastor, the late Reverend Preston Washington.

Fifteen years later, Rollins remains deeply involved with the congregation and can be found there most Sunday mornings when he is in New York City. As to his religious philosophy, Rollins describes himself as "a red-letter Christian," a reference to versions of the Bible that highlight Christ's words in red, meaning one who focuses on Jesus's teachings about love and social justice, rather than on the often contradictory and confusing exegeses his words generate.

Rollins's engagement with religion, both as a child and as a mature adult, offers a perspective on his work with K.O.S. The Baptist experience centers upon the forging of a personal relationship with Christ as encountered through the inspired reading of scripture. This highly individualistic approach is moderated among black Baptists, whose worship draws on African American history from the days of slavery to the civil rights movement. The historical involvement of the black Baptist church in both these struggles has encouraged a more communitarian approach, stressing that freedom derives not from the individual action, but from the group.

While the Kids themselves tend to come from Catholic backgrounds, Rollins's Baptist experience has helped shape K.O.S. One can see this in the group's approach to literature, wherein artworks are sparked by passages in books that speak to the Kid's lives, a process akin to the practice of interpreting scripture through an inner light. In fact one can push the parallel even further, to the way that the group "reads" art. Rollins talks about introducing new K.O.S. members and students to the Museum of Modern Art in New York. "I take them on a tour of MoMA and then I ask, 'so what do you remember?' Their answers are amazing—kids see stuff. They says things like 'I remember the black painting about God,' meaning the Ad Reinhardt. They have an unedited attitude toward art."

The walls of MoMA and other museums operate as a kind of scripture to K.O.S., and religious iconography derived from art history often serves as inspiration for the group's imagery. This can be seen, for instance, in the oozing wounds that pepper the surface of the paintings based on *The Red Badge of Courage*. This motif was inspired by the scarified Christ of Grünewald's Isenheim Altarpiece. Similarly, the elaborate red letter A's that overlay the group's homage to *The Scarlet Letter* contain echoes

of illuminated manuscripts. Even a series based on Charles Darwin's *The Origin of Species*, a text often regarded by fundamentalist Christians as the ultimate repudiation of religion, uses a branching image of the tree of life based in part on Darwin's own drawings.

However, for K.O.S., faith is not simply a source of symbolism. The subjects the group explores and their working process also owe a debt to religion, for instance, in how the structure of K.O.S. echoes the communalism of the black Baptist experience. Here the the K.O.S. paintings based on Kafka's *Amerika* prove emblematic, inspired by the book's last chapter, which describes the Nature Theater of Oklahoma as a utopian place where "Everyone is welcome" and recruits are received with a cacophony of golden horns. The K.O.S. paintings, with their remarkable variety of horns, inspired by such diverse sources as Uccello's battle scenes, African masks, Hollywood horror films, and birds in flight, celebrate this inclusive, collective impulse. The horns, each designed by one of the Kids, all weave together into a single glorious composition. The works also echo certain traditional Baptist themes—here the horns serve as the trumpets calling the chosen to faith and recall the biblical tale of the Israelites' return from slavery in Egypt, when the blast of rams' horns brought down the walls of Jericho, a story that in the African American tradition became an allegory for the deliverance of the slaves from bondage. The image of horns also, for Rollins, supplies a metaphor for the power of music, one of the forces that brought him back to religion.

Like the *Amerika* paintings, all the works of K.O.S. operate on multiple levels—as meditations on education, on racial politics and prejudice, and on the nature of art and creativity. Looking at them through the prism of faith offers another set of perspectives. One frequent theme, the spiritual journey sparked by crises of faith, appears particularly powerfully in the works inspired by Flaubert's *The Temptation of Saint Antony*. This novel offers an extended dialogue between the devil and the hermit Antony, a lonely seeker of truth. In his prolonged struggle with Satan, Antony, overwhelmed by the possibility of a godless world, is forced to look into the face of evil. At one point he declares, "An icy cold grips my very soul. I'm past the point of pain! It's like a death deeper than death. I'm spinning in vast darkness. It's inside me. My conscious self shatters under this dilating void!"[2]

The paintings based on this work stress this sense of awe and dread. Washes of black and red paint and, in some of the works, thinned animal blood, cover pages of the book to create mysterious, biomorphic forms and atmospheric clouds that suggest the dissolution of matter and faith. But the imagery is double-edged—these unearthly forms also possess a sublime beauty, reinforcing that out of the destruction of our sense of self can come new life and new creations.

Similar issues come to the fore in the group's treatment of

Herman Melville's *Moby-Dick*, which focuses on a chapter titled "The Whiteness of the Whale," in which the narrator ruminates on the cultural and psychological meanings of the color white. These range from hopeful visions of purity and light to fearsome nightmares of obliteration and death. In the end, drawn to these more unsettling qualities, he sees in the whiteness of the whale so obsessively sought by his captain Ahab a metaphor for the possibility of a world without God and hence without meaning, reason, kindness, or solace. In words that echo Flaubert's Antony, he describes this whiteness as "a dumb blankness, full of meaning, in a wide landscape of snows—a colorless, all-color of atheism from which we shrink. . . ."[3]

To prepare for this work, Rollins took the Kids to the Museum of Fine Arts in Boston to see J.M.W. Turner's *Slave Ship*, which focuses on the dark turbulence of a raging sea beneath a sky rent with a blinding white light. Scattered among the roiling waters one sees arms and legs bobbing between sharks, evidence of the human ballast cast off to keep the distant ship afloat. In the hands of K.O.S., the pages of the book are rendered virtually unreadable by a layer of white paint, translating this apocalyptic scene into a vision of absolute purification and destruction.

Aeschylus's *Prometheus Bound* offers another tale of crisis, a chronicle of the terrible torments visited upon Prometheus, the Titan punished by Zeus for giving fire to humanity. Working with the Kids and with students at various art institutions, Rollins introduced his young artists to Peter Paul Rubens's 1611 painting of Prometheus, on display at the Philadelphia Museum of Art. In Rubens's hands Prometheus becomes a Christ figure whose wounds mime those of the crucified Jesus and whose sacrifice ensures the continuation of mankind. The K.O.S. response to this work focuses on the twofold aspect of fire as agent of destruction and creation, and on the responsibilities that accompany power. One of the Kids' felicitous description of Prometheus's gift of fire as "luminous petals" became the inspiration for paintings in which the book pages are covered with flower-like flames that affirm the inseparability of growth and destruction.

For K.O.S., these three works (*Moby-Dick*, *The Temptation of Saint Antony*, and *Prometheus Bound*) become springboards for an examination of the link between creativity and faith. As a potentially constructive and destructive force, human creativity has a Godlike potential to remake the world. This quality accords with George Steiner's idea in *Real Presences*, a book that has strongly influenced Rollins, that all artistic products contain a trace of the divine: "Be it in a specifically religious, for us Judaeo-Christian sense, or in the more general Platonic-mythological guise, the aesthetic is the making formal of epiphany. There is a 'shining through.'"[4]

This theme reaches its crescendo in the K.O.S. print portfolio *The Creation*, inspired by Franz Josef Haydn's sweeping oratorio. Following Genesis, the musical work evokes the emergence of the world from primordial chaos to the creation of man. For this work K.O.S. covered pages of the musical score with shifting, amorphous shapes and fields of black and gray that gradually become more concrete and distinct. The unfolding of the images suggests the separation of light and darkness and the emergence of the material world from the emptiness of the void. Here the focus is on the marvelous mystery of how something could suddenly exist in place of nothing.

These works deal with the notion of creativity as a sharing in God's work. Other series by K.O.S. explore the quest for redemption and the healing properties of hope, chief among them a set of works based on the words of Martin Luther King focusing on the struggle for social justice and King's belief in the ties that bind all humans together. As King noted in his famous 1963 *Letter from Birmingham Jail*, one of the texts used by K.O.S.,

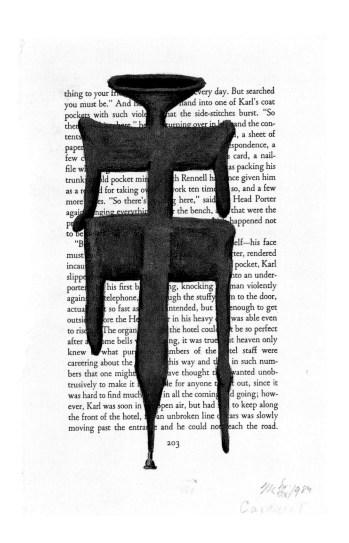

Study for AMERIKA (AFTER FRANZ KAFKA), 1984
Watercolor, ink, and graphite on book page
8 x 5 1/4 inches
Walker Art Center, Minneapolis
Gift of Richard Flood, 2005

"Moreover, I am cognizant of the interrelatedness of all communities and states. I cannot sit idly by in Atlanta and not be concerned about what happens in Birmingham. Injustice anywhere is a threat to justice everywhere. We are caught in an inescapable network of mutuality, tied in a single garment of destiny. Whatever affects one directly, affects all indirectly."[5]

In the works that pay homage to King, K.O.S. employs symbols that express different aspects of his ideas. Red and green triangles reflect King's beliefs about the three dimensions of a complete life, breadth, height, and depth. The triangle also suggests the image of the mountaintop from which King, echoing Moses, declared that he could see the Promised Land. Black stripes on other works recall his time in jail. These simple geometric forms, placed over the texts of King's letters and speeches, become symbols of the universal nature of the quest for freedom.

Something similar goes on in K.O.S. paintings derived from Ralph Ellison's *Invisible Man*. Here the assertive letters "IM" that K.O.S. places over pages of the book become another kind of universal symbol—a refusal to disappear. The image comes from several sources, first and foremost from the book's first sentence, in which the unnamed narrator declares, "I am an invisible man," and, by that assertion, ensures that he is not. When spoken, the two iconic letters, become a declaration of existence—I AM—and refer as well to the opening phrase of the First Commandment ("I am the Lord your God") and to Martin Luther King's rallying cry ("I am a Man").

A close reading of other series would yield similar connections with themes and imagery drawn from religion. But perhaps the most profound link between faith and the art of K.O.S. lies in the group's overarching conception of the meaning of art. For Rollins and the group, art constitutes a form of praise. This explains the group's emphasis on beauty. In the postmodern art world, beauty often raises suspicion as a capitulation to mass taste or a reactionary rejection of relativist standards of aesthetic quality. And indeed, K.O.S. has occasionally come under fire for creating works that appear too harmonious and cognizant of the masterpieces of Western art. Graffiti, these critics suggest, would be more appropriate to children of the ghetto.

But in insisting on beauty, Rollins also insists on the transformative power of art. He notes that, both in his own life and that of his Kids, art has provided a form of redemption. "Each work is a little miracle", he says. He adds, "Art, like faith, can move mountains." The lives of the Kids, touched by art and hope, provide an enduring testament to that belief.

1. All quotations from Rollins throughout this essay are from an interview between Rollins and the author, January 2009

2. Gustave Flaubert, *The Temptation of St. Antony* (New York: Viking Penguin, 1980): 212

3. Herman Melville, *Moby Dick* (New York: Modern Library, 1026): 194

4. George Steiner, *Real Presences* (Chicago: University of Chicago Press, 1989): 226

5. Martin Luther King, Jr. *Letter from a Birmingham Jail*, reprinted http://www.mlkonline.net/jail.html

DEATH AND TRANSFIGURATION
(AFTER RICHARD STRAUSS), 1994
Xerograph on music page
12 1/8 x 9 1/4 inches
Collection of the artists

 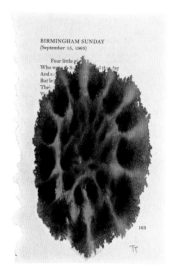 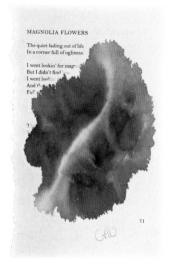 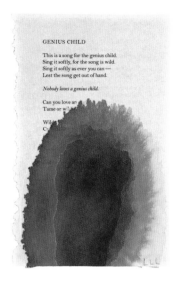

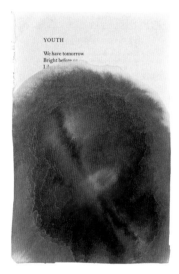 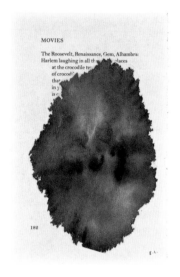 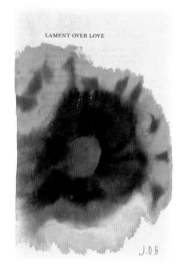 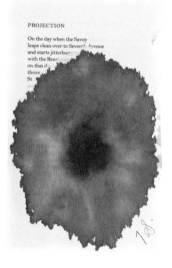

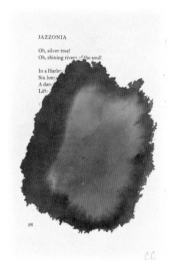 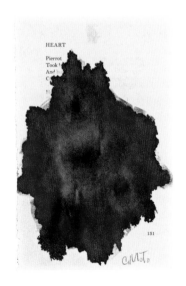 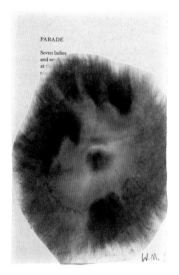 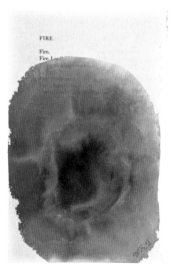

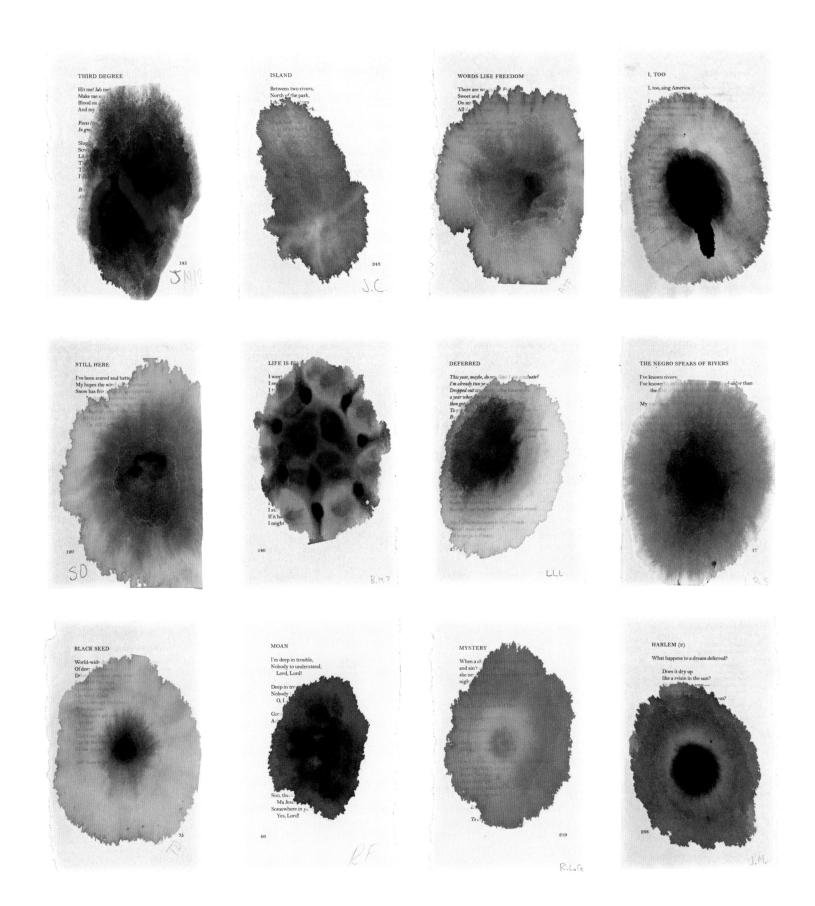

WHAT HAPPENS TO A DREAM DEFERRED/HARLEM 2
(AFTER LANGSTON HUGHES), 2002
Watercolor and aqaba paper on book pages
24 works, 6 ¹/₄ x 4 ¹/₁₆ inches each
Spencer Museum of Art, University of Kansas, Lawrence, Kansas
Gift of the artists

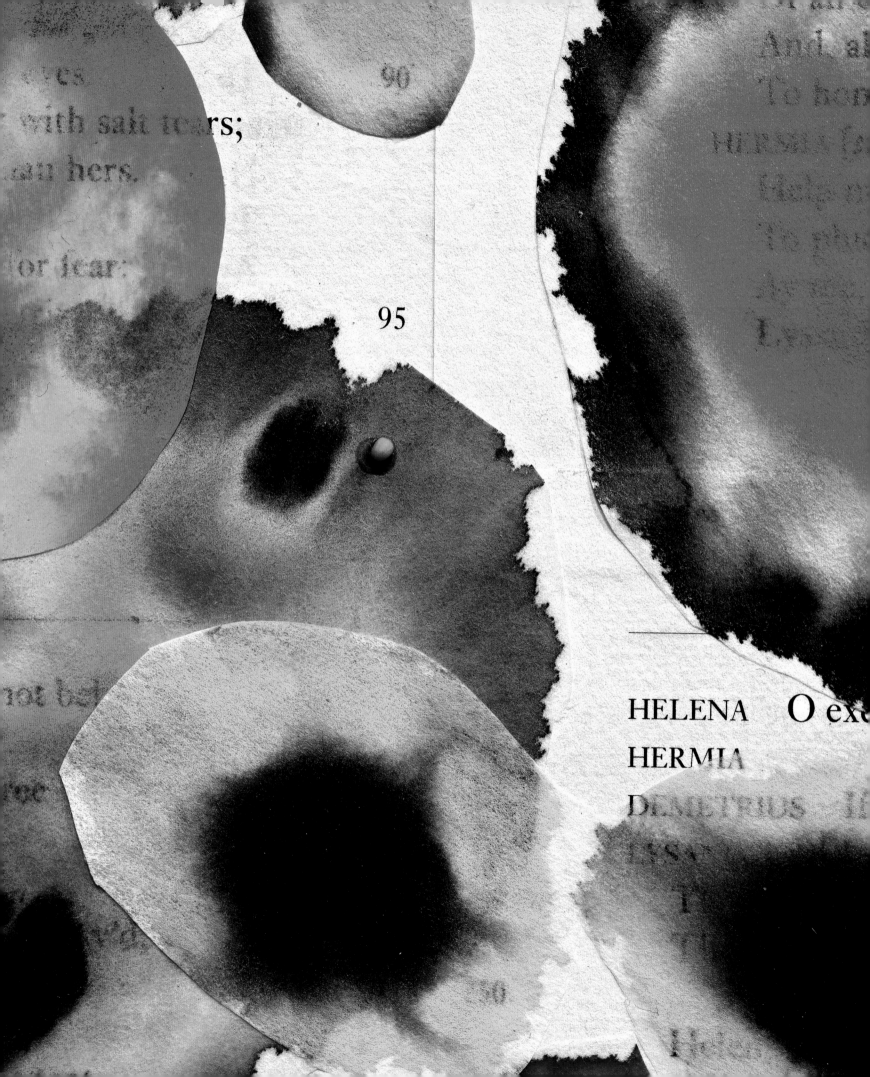

"The mustard seed is special. You can have faith that when you plant this little seed it will grow into one of the biggest trees in the world. Making an artwork is an article of faith. If you look closely enough art can spring from the tiniest inspirations, or the tiniest people in the case of this work. But it can loom large."

ROBERT BRANCH

This page, detail facing:
A MIDSUMMER NIGHT'S DREAM VI
(AFTER SHAKESPEARE), 2000
Watercolor, aqaba paper, fruit juices, and mustard seed
on book pages mounted on canvas
42 $^1/_4$ x 47 $^3/_4$ inches
The Hyde Collection, Glens Falls, New York
Purchased with funds donated by Jim Taylor and
Nan Guslander, and Feibes & Schmitt Architects,
Schenectady, New York

A MIDSUMMER NIGHT'S DREAM
(AFTER SHAKESPEARE), 1999
Watercolor, aqaba paper, fruit juices, and mustard seed
on book pages mounted on canvas
42 x 50 inches
Des Moines Art Center, Des Moines, Iowa
Gift of Lois and Louis Fingerman

A MIDSUMMER NIGHT'S DREAM (AFTER SHAKESPEARE
AND MENDELSSOHN), 2005–06
Watercolor, India ink, aqaba paper, and mustard seed
on music pages mounted on canvas
52 x 48 inches
Telfair Museum of Art, Savannah, Georgia

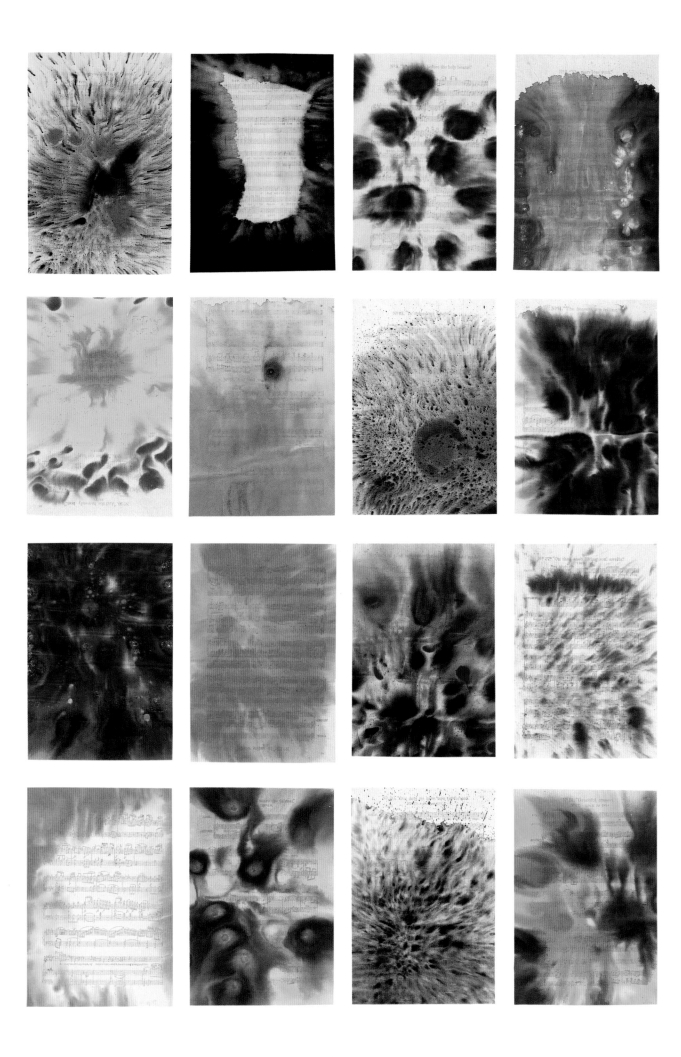

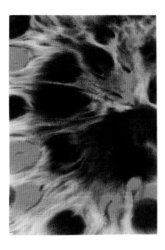

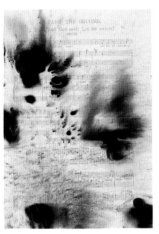

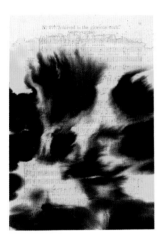

THE CREATION (AFTER FRANZ JOSEPH HAYDN), 2004
Watercolor and aqaba paper on music pages
Twenty works, 10 ³/₄ x 7 ¹/₈ inches each
Kalamazoo Institute of Arts, Kalamazoo, Michigan
Gift of Tim Rollins and K.O.S.

ON THE NATURE OF THE UNIVERSE
(AFTER LUCRETIUS), 2005
Watercolor, acrylic ink, India ink, and aqaba paper
on book pages on mounted on canvas
76 x 54 inches
Collaboration with Banneker High School,
Commissioned by Cultural Programs of the
National Academy of Sciences
Collection of the National Academy of Sciences,
Washington, D.C.

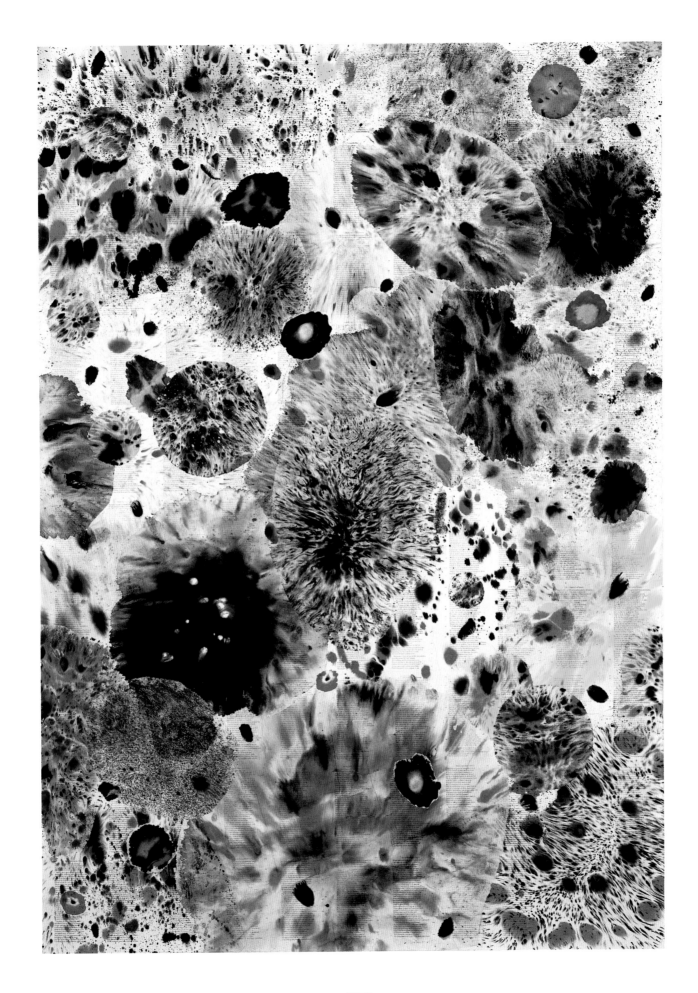

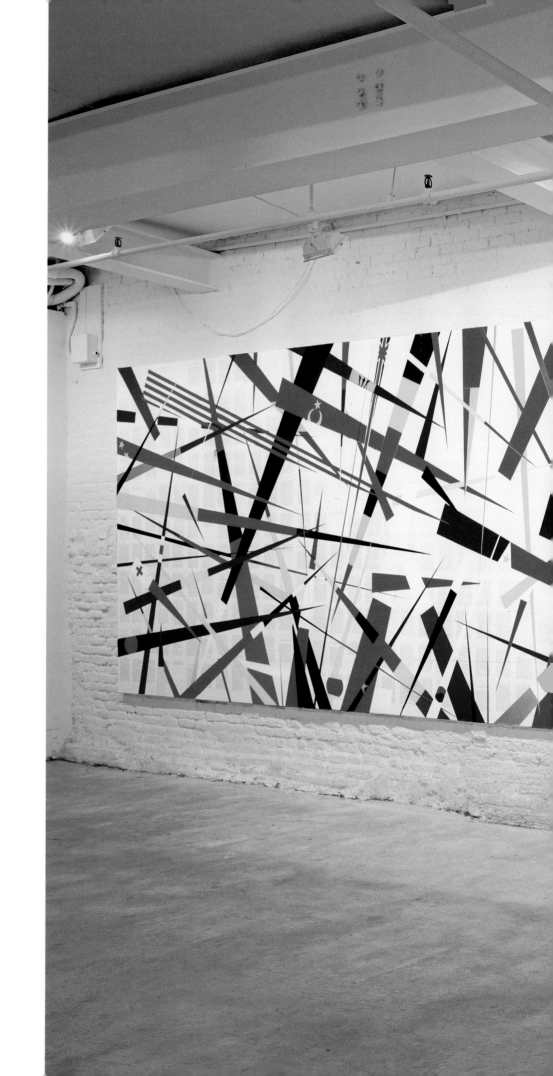

THE WAR OF THE WORLDS
(AFTER H. G. WELLS), 2004
Acrylic on book pages on canvas
12 x 35 feet
Courtesy of the artists, Lehmann Maupin Gallery,
New York, and Galerie Eva Presenhuber, Zurich
Installation view, White Box, New York

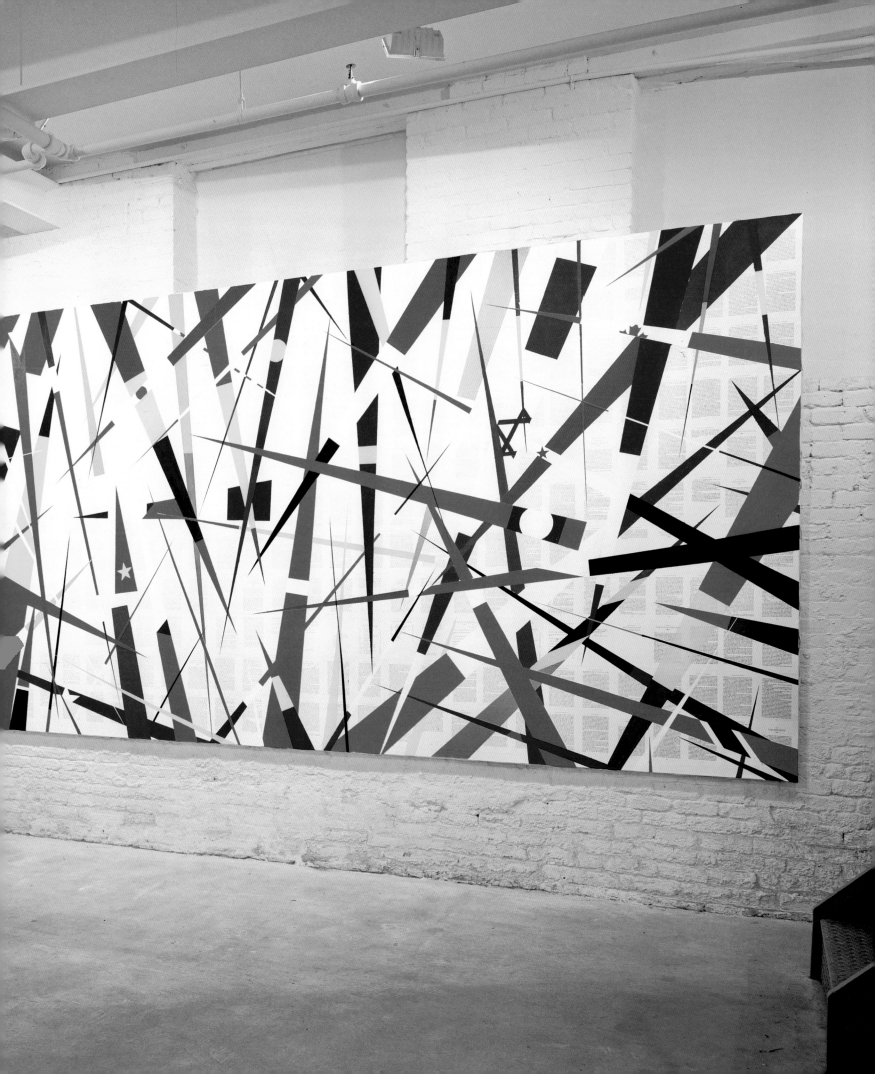

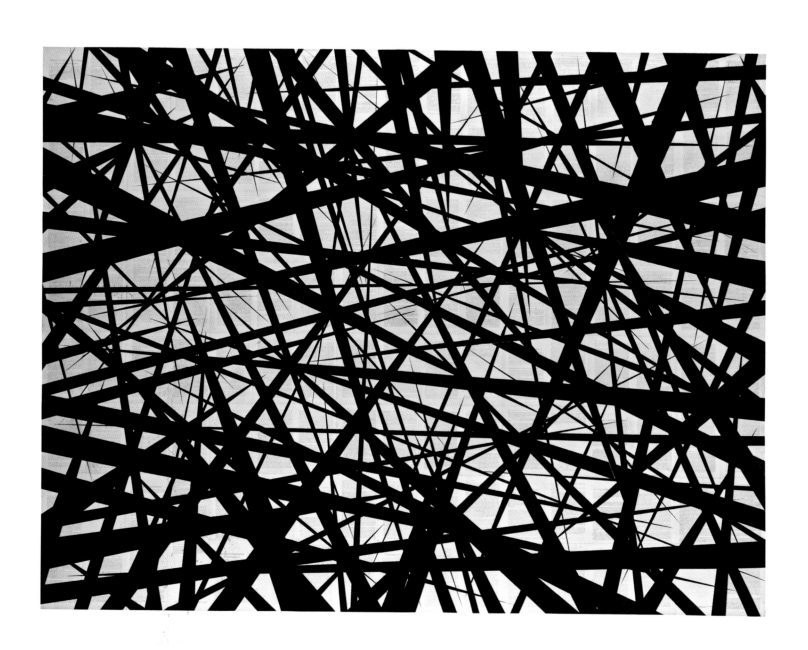

WHERE DO WE GO FROM HERE
(AFTER MARTIN LUTHER KING, JR.), 2008
Matte acrylic and book pages mounted on canvas
72 x 96 inches
Courtesy of the artists and
Lehmann Maupin Gallery, New York

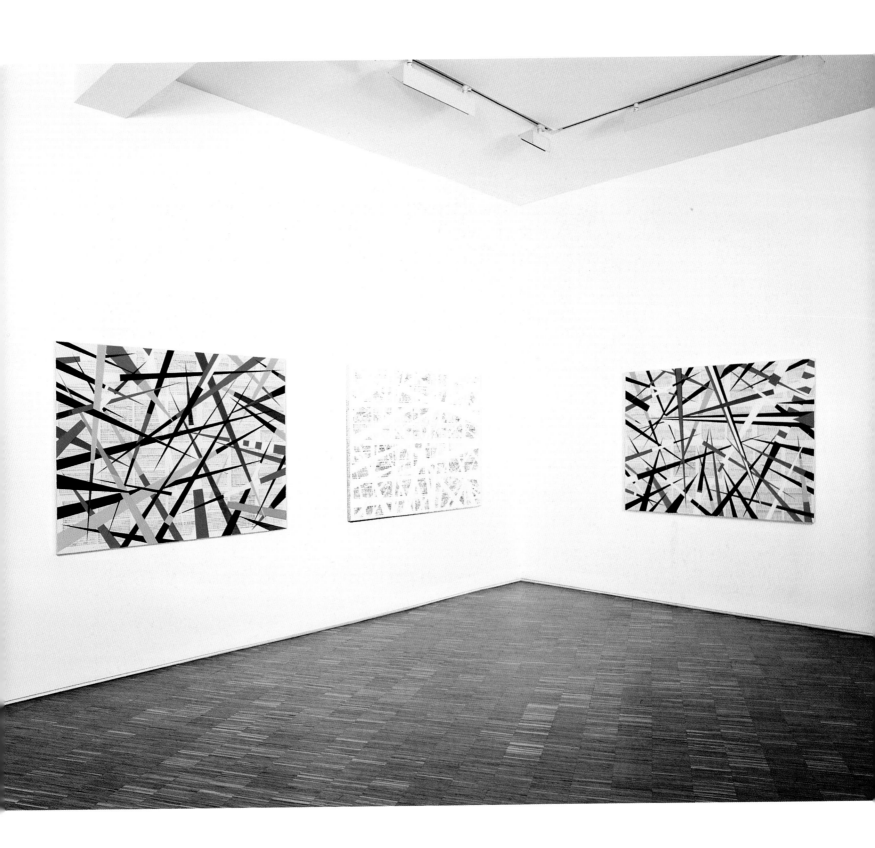

Works from MASS IN THE TIME OF WAR
(AFTER FRANZ JOSEPH HAYDN)
Installation view, Galleria Raucci/Santamaria,
Naples, 2006

METAMORPHOSEN II (AFTER RICHARD STRAUSS), 2008
India ink and shellac on music score mounted on canvas
48 x 120 inches
Dallas Museum of Art, DMA/amfAR
Benefit Auction Fund

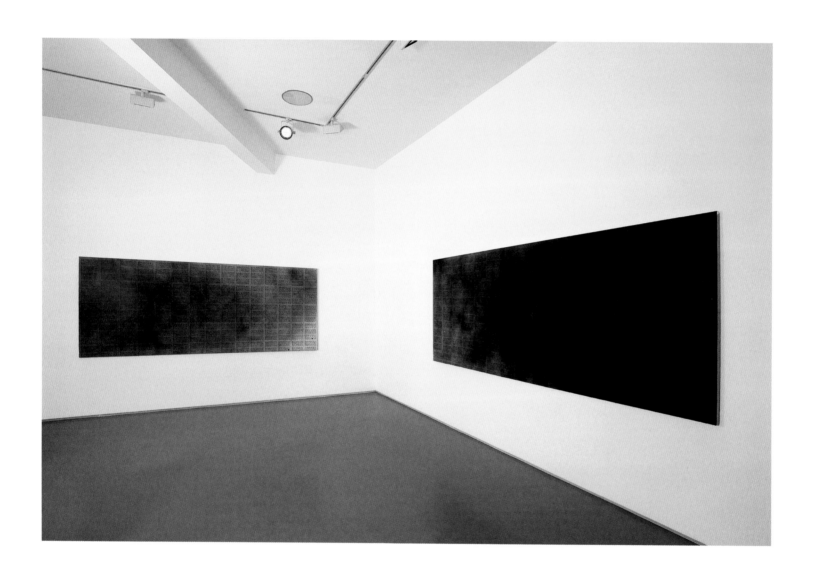

Installation view, Galleria Raucci/Santamaria,
Naples, 2008

Facing page:
STUDY FOR THE METAMORPHOSEN
(AFTER RICHARD STRAUSS), 2008
India ink on music page
11 3/4 x 9 inches
Courtesy of AMP Gallery, Athens

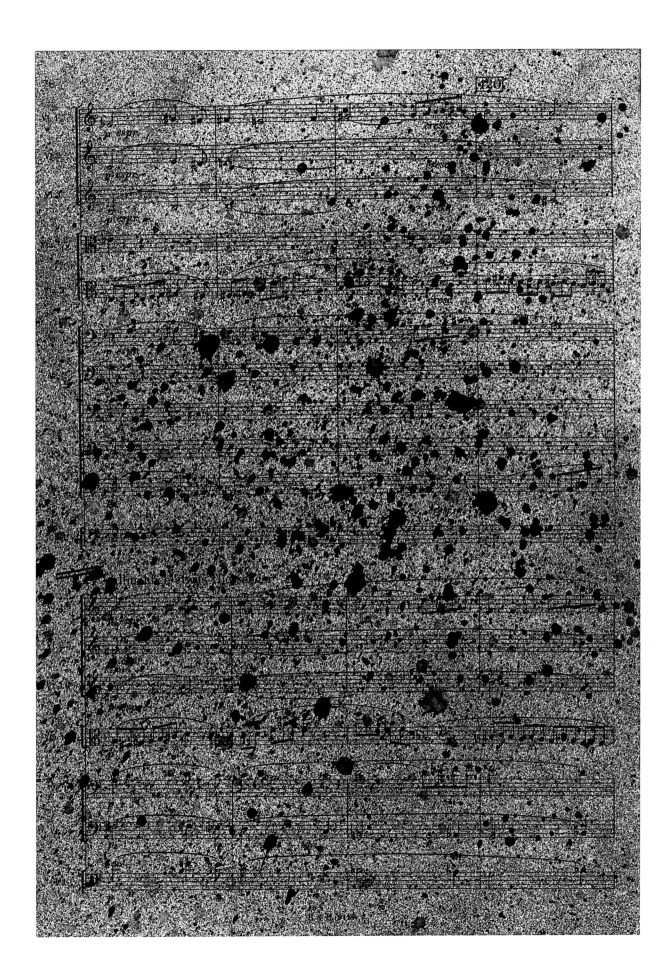

children or point them in the right direction. Ultimately, people shape their own characters. In addition, I face life with an extraordinary amount of courage. I feel so strong and capable of bearing burdens, so young and free! When I first _____ this, I was glad, because it means I can more easily withstand the blows life has in store.

But I've talked about these things so often. Now I'd like to turn to the _____ 'Father and Mother Don't Understand Me'. My parents _____ always spoiled me rotten, treated me kindly, defended me against _____ and done all that parents can. And yet for a long _____ felt extremely lonely, le_____ neglected and misunder_____. Father did everything he could to curb my rebellious spirit, but it was no use. I've _____ myself by holding my beha_____ up to the light and looking at what I was doing wrong.

Why didn't Father support me in my struggle? Why did he fall short when he tried to offer me a helping hand? The answer is: he used the wrong methods. He always talked to me as if I were a _____ going _____ difficult phase. It sound _____, sin _____ he's the only ____ who's given me a sense of con_____ and made me feel as if I'm a sensible person. But he _____ looked one thing he failed to see that this struggle _____ over my difficulties was more _____ ____ _____ than anything else. I didn't want to hear about _____ adolescent problems ____ 'other girls', or 'you'll ____ _____. I didn't _____ to be treated the same as all-the-other-girls, but as ____ _____ her-own-right, and Pim didn't _____ _____ that. Besides, I can't confide in anyone unless they tell _____ about themselves, and because I know very little about him, I can't _____ on a more intimate footing. Pim always acts like the elderly father who once had _____ fleeting impulses, but who can no longer relate to me as _____ no matter how hard he tries. As a result, I've never shared to see

though most of the time our solutions crumble when faced with the facts. It's difficult in times like these: ideals, dreams and cherished hopes rise within us, only to be crushed by grim reality. It's a wonder I _____ abandoned my ideals, they seem so absurd and _____ practical. Yet I cling to them because I still believe, in spite of everything, that people are truly good at heart.

It's utterly impossible for me to build my ____ on a foundation of chaos, suffering and death. I see the world being slowly transformed into a wilderness, I hear the approaching thunder that, one day, _____ destroy us too. I feel the suffering of mi_____. And yet, when I look up at the sky, I somehow feel that everything will change for the better, that this cruelty too will end, that peace and tranquility will return once more. In the meantime, I must hold on to my ideals. Perhaps the day will come when I'll be able to realize them!

Yours, Anne M. Frank

Dearest Kitty,
I'm finally getting _____ now _____ at last things are going well! ____ really good ____ news! An assassination attempt has been made on Hitler's life, and for once not by Jewish Communists or British _____ but by a German general who _____ not only a count, but young as well. The Füh_____ owe his life ____ to _____ luck, he escaped, unfortunately, with a few _____ and scratches. A _____ of _____ officers and _____ who were nearby were killed or wounded. The _____ who arranged has been shot _____

This is the _____ proof _____ many officers and generals are _____ ____ would like to see

_____ sin _____ but ____ will ____ they can establish a _____ militar_____ ____ _____ with the Allies, rearm _____ and, a_____ few dec_____ start a new war. Perhaps _____ brilg _____ time getting rid of _____ _____ cheaper for the Allies to _____ _____ ____ it all _____ _____ less work _____ _____ _____ it allow them to start _____ _____ targets, and I'd hate to anticipate the glorious event, since you'd probably noticed that I'm telling the truth, the _____ and nothing but the truth. For once, I'm not rattling on about high ideals.

Furthermore, Hitler has been so kind as to announce to his loyal, devoted people that as of today all military personnel are under orders of the Gestapo, and that any soldier who knows that one of his superiors was involved in this cowardly attempt on the Führer's life may shoot him on sight!

A fine _____, but _____ will _____ Little Johnny's ____ are sore after _____ g m _____ commanding officer yells at him. Johnny grabs _____ ____ you, you tried to kill the Führer. Take _____ _____ snooty officer who dared to re_____ _____ eternal _____ life (or is it eternal death?). E_____ _____ sees a soldier or gives an or_____ _____ we up his pants because the soldiers have authority, he does _____

Were you able to follow _____ or have I been jumping from one subject to another again? I can't help it, the prospect of going back to school in October ____ ____ me too happy to be logical! Oh dear, didn't I ____ ____ telling you I wanted to anticipate events? Forgive _____ that ____ call me a bundle of contradictions for nothing.

M. Frank

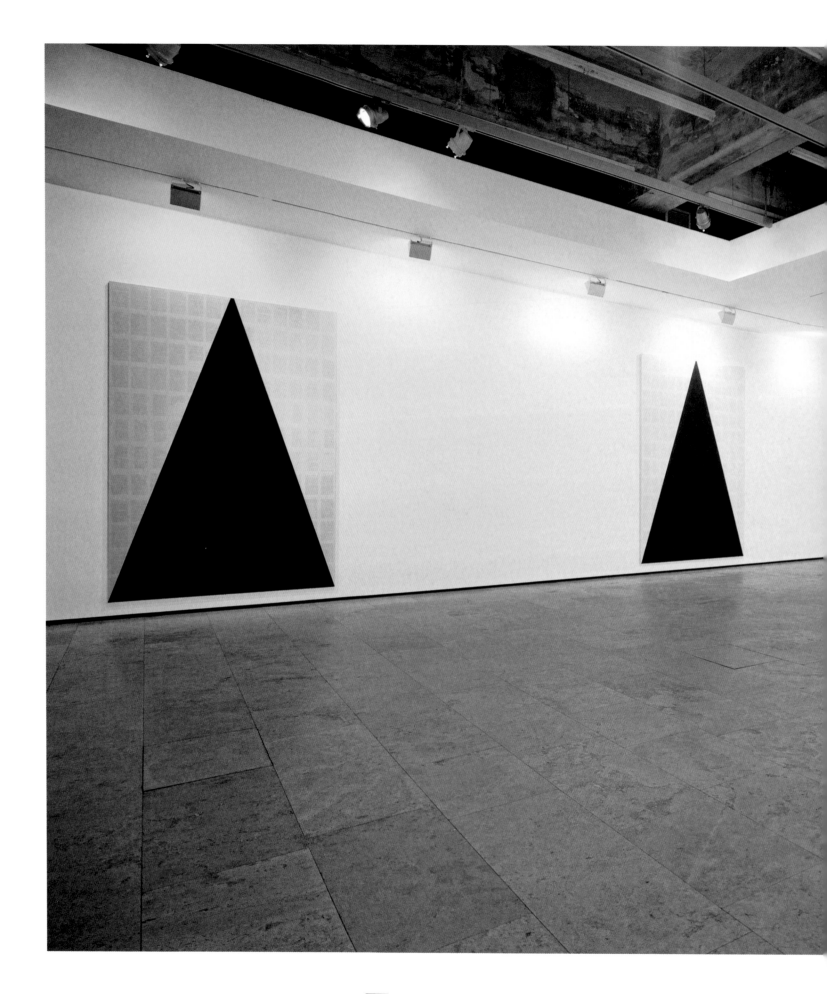

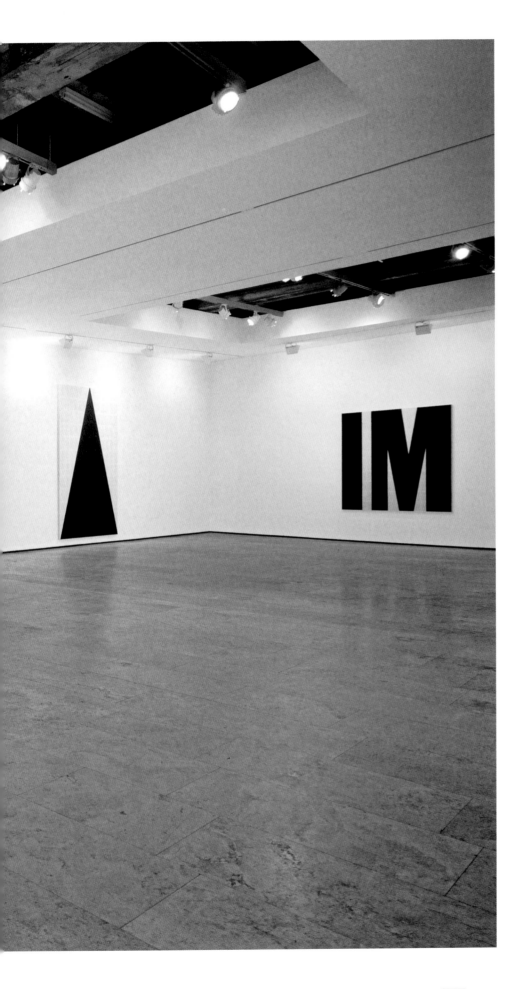

Installation view, Lehmann Maupin Gallery,
New York, 2008

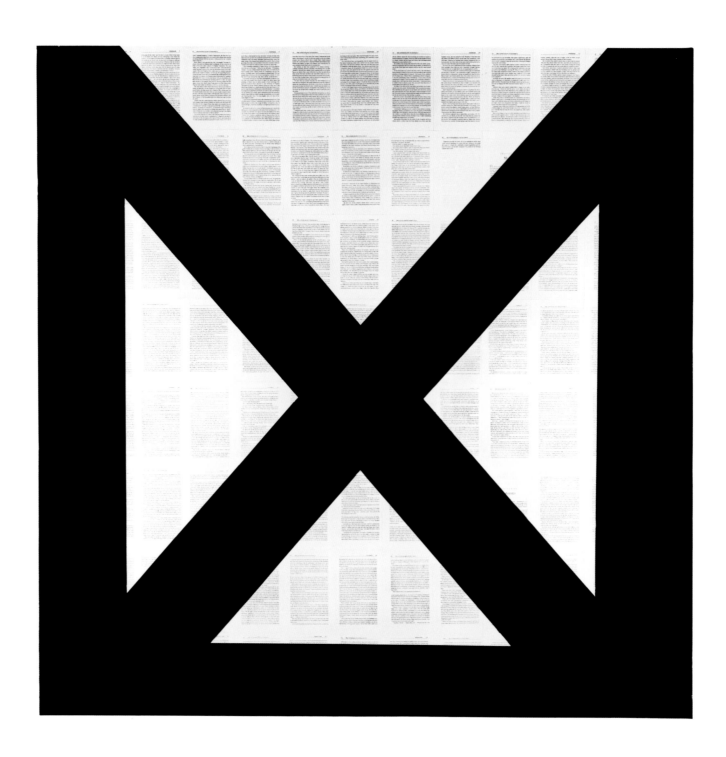

BY ANY MEANS NECESSARY (AFTER MALCOLM X), 2008
Matte acrylic on book pages mounted on canvas
72 x 72 inches
Courtesy of the artists and
Lehmann Maupin Gallery, New York

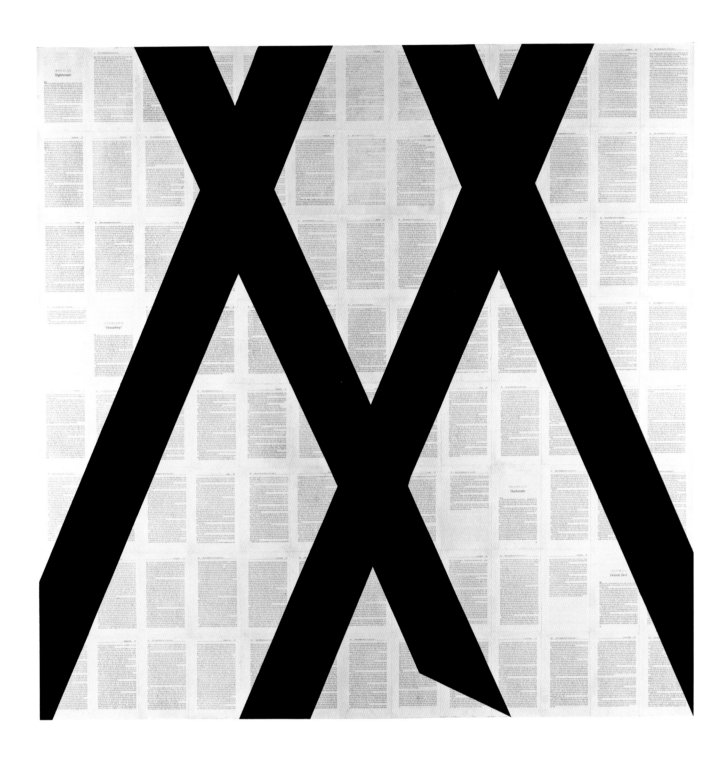

BY ANY MEANS NECESSARY (AFTER MALCOLM X), 2008
Matte acrylic on book pages mounted on canvas
72 x 72 inches
Courtesy of the artists and
Lehmann Maupin Gallery, New York

"As my sufferings mounted I soon realized that there were two ways that I could respond to my situation: either to react with bitterness or seek to transform the suffering into a creative force. I decided to follow the latter course."

MARTIN LUTHER KING, JR.

SUFFERING AND FAITH, 2008
Matte acrylic on book pages mounted on canvas
72 x 72 inches
Courtesy of the artists and
Lehmann Maupin Gallery, New York

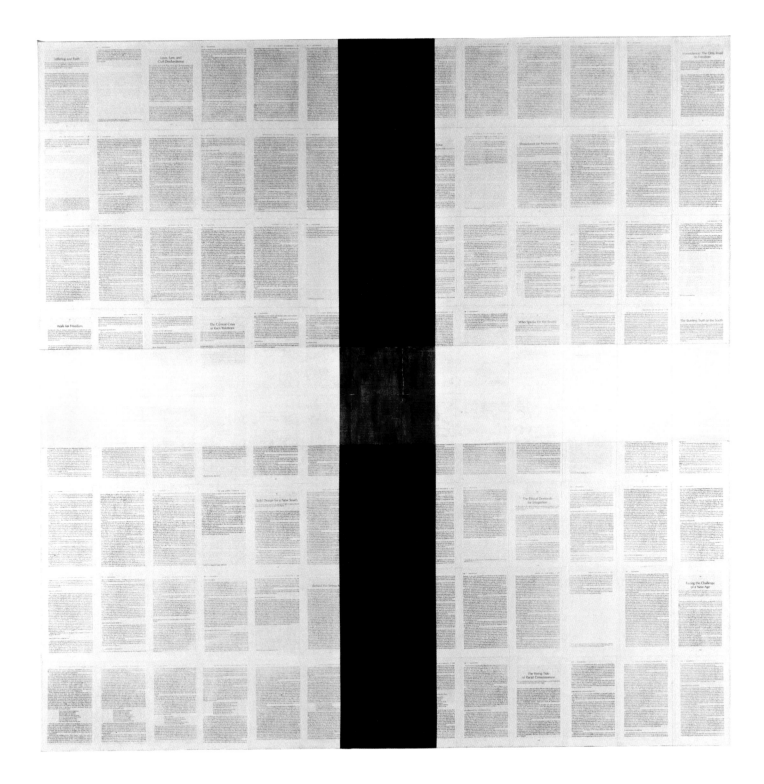

LETTER FROM BIRMINGHAM JAIL #2
(AFTER MARTIN LUTHER KING, JR.), 2008
Matte acrylic on book pages mounted on canvas
70 x 90 inches
Courtesy of the artists and
Lehmann Maupin Gallery, New York

I HAVE A DREAM #1 (AFTER MARTIN LUTHER KING, JR.), 2006
Matte acrylic on book page mounted on rag board
8 $^1/_2$ x 6 inches
Collection of the artists

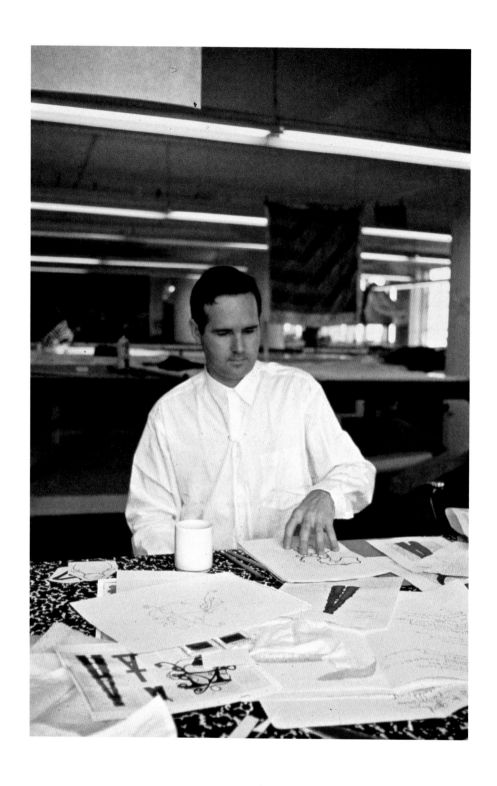

Tim Rollins at the Fabric Workshop and Museum,
Philadelphia, Pennsylvania, 1989

A DIALOGUE WITH TIM ROLLINS BY IAN BERRY

MAKE SOME MORE

IAN BERRY: When you were growing up in Maine, was art a part of your life?

TIM ROLLINS: Fine art was completely foreign to the culture I was brought up in—northern Appalachia, rural central Maine. We come from a very strong Protestant, puritanical anti-esthetic that is very utilitarian.

IB: No decorations.

TR: If you couldn't eat it, drink it, or smoke it, it ain't worth having. You had decor in the form of wallpaper. I remember a printed wallpaper everywhere, on the curtains and things like that. We had landscapes on pressed cardboard, Pity Puppy and Pity Kitty prints, and lots of bowling trophies on display. That was our visual pleasure.

IB: So you were a kid who drew and someone looked over your shoulder and said, "Hey, you're good at that."

TR: Right—it was something within. And even if I wasn't good at it, I imagine it's just something I had to do in order to be happy. Ever since I can remember, I wanted to be an artist, a teacher, and a scientist. I wanted to be a scientist because I was in love with horror movies—I loved the Mad Scientist! I was the school artist; I'd win all the art awards, make posters for the library, school proms, and dances. My favorite time of the week would be the last hour on Fridays. In school that was the only time we got to make art, and I lived for that. I remember my art teacher, Mrs. Springer, was my teacher in kindergarten and first grade and ended up being my art teacher my senior year in high school.

IB: Where did you see art? I imagine there weren't many artists in your town, but there was an art teacher at school, was there art at church?

TR: A little bit, not a whole lot. I'm from the First Baptist Church, which was in transition from the very staid original architecture with no color images, and hard wooden benches. It's alright to sing, dance, and play music to worship God, but there's something deeply suspicious about having a big, painted object on the wall and worshipping it. It's dangerously close to idolatry. In the '50s and '60s that changed. There was a giant painting of an angel in the front that I loved, and still love to visit when I go home to Pittsfield.

IB: How many people live in Pittsfield, Maine?

TR: About 1000 and declining.

IB: Why are people moving away?

TR: Because of the loss of the factory jobs.

IB: What was the factory?

TR: One was Northeast Shoe Company, where my daddy hand-sewed shoes. I come from a working class background and one thing I love about that is I can look at a pair of shoes and see the blood, sweat, and tears that went into making something we take for granted. Marx said it best, all commodities are essentially an ensemble of social relations. I can look at any object—this pen, this tape recorder—and imagine the labor and humanity of even the silliest, supposedly most basic commodity. Both mom and dad worked there for awhile before it closed down.

IB: This is the 1960s?

TR: Late 1960s. After a serious time of unemployment, daddy ended up working at Dexter Shoe Factory. Mom worked in a small twenty-bed rural hospital. When I was growing up, the major factories in town were big textile mills. There were also some tanning plants and a place called Edwards that made buzzers and doorbells, where all my aunts and uncles tended to work. That's about it. The rest was pretty rural.

IB: Did the kids in your high school think they were destined to work in the same types of places as their parents?

TR: There tended to be two groups: those that were going to go on to college and those that were going to stay home and continue in the factory. I was one of the former.

IB: You were going to college.

TR: I was going to college.

IB: Your choice or your parents?

TR: Totally my choice. I have a pretty strong personality and a strong will, so they knew to stay out of my way and didn't hinder me at all.

IB: You have brothers and sisters?

TR: I have a brother who followed me into teaching after being on the road for awhile, and two sisters. I grew up in a big country family with lots of aunts, uncles, cousins, and three grandmothers. My great-grandmother was a big influence on my life. My grandfather was a caboose conductor for the Maine Central Railroad, and my grandmother who recently passed worked in the commissary of Colby College in Waterville for forty or fifty years. Once we happened to be in the area and I wanted to see grammy in the commissary, so we stopped to visit

her. I think that was the first time I was ever on a college campus, and I thought it was an interesting place.

IB: Did you ever think about going to a college like Colby? Where did you end up?

TR: University of Maine at Augusta.

IB: Not too far away.

TR: About an hour or so, far enough to be free and to feel like you're on your own. When I was there from 1973 to 1975 they had a unique and progressive multimedia program. There was painting and sculpture, but also installation, modern dance, and performance. Electronic music was almost a requirement, so we'd be studying people like John Cage.

IB: This was a new world for you.

TR: Yes, it was a brand new program in these prefab trailers. They were desperate for students. In a funny way, I got paid to go to school there.

IB: Through scholarships?

TR: Because they wanted a startup and very strong students, and I was in the top of my class at Maine Central Institute.

IB: Did most of the students come from Maine or from other places?

TR: Most came from central Maine. In 1974, I found a book edited by Gregory Battock called *Idea Art*, and some issues of *Avalanche* magazine laying around in the library. I was looking at Barry Le Va and Vito Acconci and Jackie Winsor—it's amazing I teach with these folk now. I didn't know what it was all about, but thought if this is what you can give yourself permission to do as an artist, then I'm down with that. The real epiphany came while I was looking at an issue of *Art in America* and saw my first Andy Warhol tomato soup can and something just clicked. I remember thinking, "That's it, that's it, I got it." It was one of my favorite meals anyways.

IB: What do you think you got? What turned you on?

TR: The brashness of it, the sheer audacity of it, the strange compassion, the irony, but then the celebration and the critique all at once.

IB: You felt by just seeing those images that it was a big break?

TR: I never saw any art as a kid and my breakthrough came, I will never forget this, when I was thirteen on a field trip to Boston.

IB: A school trip?

TR: Yes—we went to the Museum of Fine Arts and the Isabella Stewart Gardner Museum, and I had the two most amazing experiences. The first experience occurred on our drive into Boston through Roxbury on the Massachusetts Turnpike. This was in the early '70s, and Roxbury was mad ghetto. I remember the visceral feeling of shock, sadness, and ultimately anger that anyone would have to live this way. I knew my family didn't have any money, but country poor and urban poor are two very different things— you had love, you had your church, you could run around the

backyard in your bare feet and catch frogs. That hit me. That was the first shock. The second shock came when we were in the Museum of Fine Arts and all the kids ran to see the mummies and I wanted to see the gigantic color field things. I think I saw my first Morris Louis. It was amazing just to see them and catch their aura. I remember one room had big cardboard boxes on the walls, some with a little bit of paint on them, in different configurations. As a country kid into art, my favorite thing was a giant refrigerator box because I could haul it into the backyard and turn it into a pirate ship or spaceship or Playboy Mansion depending on who lived next door, you know. And here on the wall in this big museum—Robert Rauschenberg's cardboards— was something I did all the time in my backyard. I remember getting so mad that my teacher and the kids were all laughing at it. I thought, "This is art! If this is what an artist will give himself permission to do, I am completely committed." It wasn't a decade later when I told the story to Bob himself, and he laughed and got all teared up. He said, "You got it right, Tim."

IB: How did it feel to be around your friends and teacher putting this work down?

TR: I felt sorry for them. I felt sorry for their lack of imagination and their closed-mindedness. I felt sorry that they couldn't feel what I was feeling.

IB: Did that make you weird?

TR: I knew I felt different.

IB: That can sometimes be an uneasy place to be.

TR: A lot of artists are lonely. I was lonely but also this art star in school so I didn't care. You know, trust thyself, and be not conformed to this world.

IB: It takes a lot of energy to be that way.

TR: Not for me.

IB: It takes some internal strength.

TR: Strength with a purpose, and I have that.

IB: You finished your degree at University of Maine?

TR: No, I got a two-year degree, I knew I couldn't afford art school. I have been working since I was fourteen years old.

IB: Doing what?

TR: Grocery stores were my thing. I was the master bagger, and would also do inventory, about the only thing things you could do at sixteen or seventeen. I had to have my album money, my art supply money, and my comic book money. I had to be independent because I didn't want anyone to tell me what to do or what not to do. That's who I am to this day, and I hope I instill that spirit of independence and self-reliance in the participants in K.O.S.

IB: So you were looking at other schools and knew you wanted to leave Maine, but school was too much money.

TR: Yes, to get back to the Gregory Battock book, I read an essay called "Art After Philosophy" by someone named Joseph Kosuth. Around this time I also encountered an amazing book,

probably the most influential book in my life—Germano Celant's first book on Arte Povera, the one that had grainy black and white photographs and hardly any text. I'm going through this, and there is Joseph Beuys, there is Mario Merz, there is Richard Ryman, and early Richard Serra, and I'm going, alright, I'm with it, yup, Gilberto Zorio, and then here comes Kosuth and there's just his picture of a dictionary definition. Then I saw the works where he put ads in newspapers and read his essay. It was like an awakening. His essay made total sense to me and I remember reading at the bottom, "Joseph Kosuth, School of Visual Arts, New York." So I got on the pay phone and called SVA, which I had kind of heard of but not really, and asked if Kosuth still taught there. Yes? Send me a catalog right away. That was it. I put together a portfolio—it was actually a duffel bag filled with conceptual artworks that I had been making in Maine. They are pretty hilarious. I drew the town line between Augusta and Gardiner, Maine. I found it on a topographical map, and actually drew the line through the woods and across the highway. I have pictures of it somewhere.

IB: You took photographs?

TR: Of course, like a good conceptual artist! So I got into SVA but was terrified because I had never been to New York, and the only time I had been to a city was maybe for a day or so in Boston. Some friends dropped me in front of the Chelsea Hotel, which was the only hotel I had ever heard of. I thought maybe Warhol still lived there—I was so green, I was picking pine needles out of my hair. The New York Dolls were there, which was great, because I was really into that. David Johansen and all those guys—I was thrilled.

IB: You stayed there?

TR: For about a month and then I ran out of money. I had saved up $1000 and thought I was rich, but even back then in New York, rent would be $500 a month.

IB: Did you get a scholarship? How did you pay for school?

TR: I got a good deal with SVA and borrowed a whole lot of student loan money. The vice president of the school at that time was David Rhodes. He looked at my essay and portfolio, and said, "I want to meet this country kid from Maine who knows everything about our fine arts faculty." I think he felt sorry for me or was nervous! A month later he was loaning me money to stay on. I was in the Student Counseling Office every other day trying to keep it together.

IB: So where were you living after the Chelsea?

TR: After the Chelsea I was bouncing around little boarding rooms, and spare rooms of alcoholic professors in the upper West Side who were desperate for any money they could get. I would walk to school many days, from 85th and Broadway to 23rd and Lexington.

IB: What were you making?

TR: The first day Joseph was running a seminar based on some of his drawings and brought in someone like Stanley Diamond. At that time he was working with a new collective coming out of Art and Language and writing and publishing a journal called *The Fox*. I remember sitting there, thinking, "This is space talk"— I had no idea what they were talking about. I thought something was really wrong with me. So I went to the library, got out the dictionary, and found that half of the words from the essays weren't in the dictionary—they were made up! It was my introduction to pseudo-academic discourse. I'm not making fun of the ideas; they were great and I teach them all the time. Joseph is actually very lucid too. It was just the vibe that made it seem like a foreign language. After that I felt more confident about going in there. I told Joseph that I came all the way from Pittsfield, Maine, to study with him and started talking about his early shows and this or that. He said, "You know more about me than I know about myself," and asked if I wanted to be his assistant. I know he felt sorry for me. I think he still feels sorry for me because of what I decided to do and being in the Bronx. So I became his assistant and learned a lot. I went to Castelli Gallery and in walked Roy Lichtenstein. Joseph asked me once to drop off a painting at Warhol's Factory—he was making a trade. "But don't stay," he said. Of course I did stay, but you know, I had to for a little while.

IB: So through that studio you got to really see what the art world was; how galleries worked and how other artists set their studios.

TR: Yes, but Joseph is different too because he is such an intellectual presence. I mean Roland Barthes would come over for dinner. I got the best job because I got to organize his library.

IB: Perfect for you.

TR: At this time I also had a work-study job at the School of Visual Arts Library. I shelved the books, which is better than any art history survey course on earth. I read everything and they'd get mad because I was so slow. But, you know, two dollars an hour, I'm going to do what I want to do. I also repaired the books that were broken. So I used to make money putting books together, and now I make money tearing them apart. At least I know my material.

IB: How long did you work for Kosuth?

TR: About three years. We decided that we didn't want to do a boring graduate school seminar, but wanted to do something activist. So we called our group F383 after the name of our course and formed a little posse. We essentially terrorized the SVA administration and critiqued everything, such as the making of objects conforming to a bourgeois notion of art solely as property, and discrete objects that you hang on the wall. We got involved with the youngest members of artists meeting for cultural change and those meetings I will never forget. They were on Sunday nights at Paula Cooper's Gallery on Wooster Street before Soho became Soho, and it would be Lucy Lippard, Leon Golub, Nancy

Spero, May Stevens, Carl Andre, Joseph Kosuth, all these people, the Art and Language and *The Fox* people…

IB: And anybody could go, so you were welcome?

TR: Yeah, I think they enjoyed us and wanted some young participants. It was so unorganized it was like herding cats. To see these artists go at each other, to see them tear into each other with such violence was an amazing lesson for me. I appreciated the passion, but deep down my old New England pragmatism said alot of these folks don't want to change anything, they just want to fight.

IB: So these were like salons where one person would present something and then …

TR: …and then everyone would go at 'em. One of the most interesting things we did was a publication, a pretty well-known publication, called the *Anti-Catalog*. It was a critique of the Whitney Museum's big show about the history of American Art, which Robert Venturi designed. The show was so exclusionary and elitist—it included hardly any artists of color and hardly a ny politically oriented artists. It was a very limited survey that neglected the history of the Whitney, and many different histories. Joseph designed it and I assisted him.

IB: Tell me more about your early political ideas.

TR: I was dissatisfied with elite, closed interactions and the lack of genuine political effect. Lenin said that without revolutionary theory, there can be no revolutionary practice, and I think John Dewey would say that without revolutionary practice, there can be no revolutionary theory. I have always gotten my theory out of what I did and what worked and what didn't. My hero Reverend Martin Luther King, Jr. called it the paralysis of analysis, where you are so afraid to do the wrong thing that you do no thing. You are just stuck. He wrote this in response to Civil Rights organizers who said he was too impatient and needed to be more moderate. They didn't want to march—they were afraid.

IB: Did you know about Martin Luther King at this time?

TR: King was my hero growing up as a child.

IB: In Maine? How did you know about him?

TR: Thank God for T.V.

IB: You did not have a racially diverse community in Maine?

TR: Oh no. Not to be cynical, but one of the great things about Maine Central Institute is that they imported a lot of black folk to be athletes, especially for basketball. So there were kids from Chicago and New York, and we bonded with each other because they were so shocked that I knew who James Brown was, let alone Reverend James Cleveland or Shirley Ceasar. That was the music I loved, to the horror of my daddy. I had a lot of black friends, which was very unusual in my community. There were very few black kids, hardly any Jews. Mr. Weinberger was the one Jew who came to our church because the synagogue was all the way in Waterville, and he was elderly, and sometimes, especially during the winter, he didn't feel like going. You know, the Baptist

Church where I'm from comes from the progressive abolitionist libertarian American Baptist conventions, which is very different from the southern Baptist conventions. I can't agree with the Southern Baptists.

IB: They're very different?

TR: The thing about the Baptist Church is that every church is different. It's a self-governing body. So you are not answering to anyone except your congregation. If the pastor starts acting crazy or doing stupid stuff, you fire them. It's a company, which is great if you can keep it alive financially. That's always the hard part, that and keeping people coming because they enjoy being there as a family.

IB: When you were first in New York working with Kosuth, and figuring out how to live in a city were you going to church?

TR: That was actually at a point when you start reading Marx and Sartre and start questioning everything. You say, "Okay, I've had enough with this, I'd rather do something else." So, no, I wasn't actively involved in church.

IB: Let's talk more about New York and that desire to get out and do something rather than just talk about it. You and Julie Ault got together with some other students?

TR: And Patrick, who was a classmate of mine at NYU—I was there for graduate studies in Art Education. We became real close, and actually became lovers, which was a nice breakthrough for me as well.

IB: Was he your first boyfriend?

TR: Boyfriend, yes, but not my first gay encounter. I had several girlfriends in Maine, and then went back and forth for a bit. Patrick had an apartment in the East Village at the time, and Julie and I had a beat up old loft on 26th and Lexington just above a big kung fu studio. I remember every time they would kick and bang the whole place would shake, and my books would fall down; it was like a movie. It used to be an old whorehouse, so when we came to clean it out, we were picking up condom wrappers, whips, and all this stuff. It took a week to clean that stuff out and then every night at 3 a.m. some Japanese businessman would buzz and bang on the door, and I'd always have to be the one who'd come out because Julie and Yolanda Hawkins, who was sharing it with us, didn't want to go to tell him it wasn't, because he wouldn't believe them. It was a horrible neighborhood, just Hookerville. I knew all the hookers, Ebony, Snowflake, and Juicy. I remember Juicy made me buy them snowcones once.

IB: Where was this?

TR: 26th and Lexington. Now I'm sure the loft is $5000 a month.

IB: You were all SVA students?

TR: No, Julie didn't go to school. She was from Winthrop, Maine, and was my best friend. She also went to the University of Maine at Augusta for just two years, and then ended up in New York. That was an amazing time to be in New York, a lot

of cross-pollination. Before there was talk of interdisciplinary, we just had that sort of life. Your average day would be amazing. While we are at NYU we decided to start a group and a gallery and called it Group Material.

IB: You wrote manifestos?

TR: You bet. I drafted several essays, including a small one called "Caution, Alternative Space," where we criticized Artists Space. We were pretty radical. We said it was mainly just a showcase for when you get into the galleries, which in many ways it was. I was criticized for that, but I look back and most of it was true, so I feel better. We had a space on 13th Street and started putting together shows based on social themes. We got about ten of us together, chose not to sell anything, and for $50 a month, we got a storefront. All these crazy artists are going to open up this space in this little abandoned bodega. We painted all the walls red.

IB: Red for action? Red for conflict?

TR: It comes from Russian constructivism, use the red wedge to beat the whites.

IB: Did you really wear all red clothes?

TR: Yes—I had a red jumpsuit and red boots that I wore all the time. I had two jumpsuits that I washed in the sink, no laundry bills.

IB: You were a living performance.

TR: Kind of. Staying alive. So we started organizing these shows and I'll never forget the first opening night. It was a total mob scene. The energy was amazing because we were on the heels of the Times Square Show, and Colab had just opened.

IB: That was Jenny Holzer and Mike Glier.

TR: Tom Otterness, Kiki Smith, I can see them all, John Ahearn…

IB: Christy Rupp, Marilyn Minter.

TR: We were on this amazing block, so the dynamic was fascinating. That lasted for about a year.

IB: You had exhibitions, events…

TR: …symposiums, and lectures. Lucy Lippard was a really big help. Bertell Ollman, who was my professor, came in to give a lecture on the theory of alienation. Everyone did this stuff for free, because they thought we had something going. I'm very grateful for their extraordinary generosity.

IB: After that year, what did you decide to do?

TR: We decided that in a funny way we were becoming victims of our own success. We hated being in the space—such an albatross—and the rent burden, so we started doing public projects. I think the first one was called M-5. We got a grant from the National Endowment for the Arts and commissioned artists to make MTA transit posters. It was on the M-5 bus because it travels the length of Manhattan on 5th Avenue from Harlem, uptown, midtown, downtown, all the way down. We started working on projects like that from our loft on 26th Street

because we knew we needed new headquarters. At that point Julie had met Andres Serrano, and they got married and moved in together in this twelve-by-ten foot room [*laughing*] on 13th Street.

IB: He was making photographs?

TR: Yes, storing them under the bed, and Julie was framing them because she worked at Chelsea Framers and Baskin-Robbins. At that point I was still at the SVA Library, and working with Kosuth. I also did go-go dancing on Saturday nights at Club Taboo. I did '60s dancing with a girl named Wendy Wild.

IB: How did you learn to dance?

TR: I watched *Hullabaloo* when I was growing up in Maine. I got really into it because there was nothing else to do. I got all the dance books out from the library. I won dance contests in junior high school—I was fierce. *Shindig*, *Hullabaloo*, and then *Soul Train* and it was over. That was fun. That's how you survived, and it was such an amazing time.

Then I started teaching in a program called Learning to Read Through the Arts. There were a lot of cynical teachers there who were teaching because it was the only job they could get and no one else wanted it. I wanted it because I came all the way from Maine and all of my friends thought New York stretched from Houston Street to 14th, and that was it. Uptown, Harlem, South Bronx, the so-called "outer boroughs"—they didn't exist. No one even knew a thing about Staten Island.

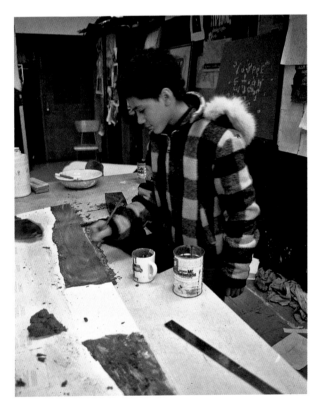

Carlos Rivera at I.S. 52, South Bronx, ca. 1982

I was studying at NYU for my MA in teaching when I got invited on a special artist trip to China through artists meeting for cultural change. I went to China with Kosuth, Susan Cohen, my classmate Hannah Aldefer, Sarah Charlesworth, Jene Highstein, Suzanne Harris, Jackie Winsor, and Keith Sonnier; little old me and a few sprinkling of academics. My student loan was supposed to be for my last semester at NYU, but I couldn't borrow anymore, so I took the loan and went to China instead.

IB: What did you do in China?

TR: We toured several cities. This was right after the Gang of Four had been deposed and before any cultural exchange. We went to museums, looked at what the authorities considered art, and froze to death. I couldn't drink tea for ten years after that trip. Our guide, Chang, was the same age as me and we really hit it off. He had to do the party line big time, but when we were in private on the bus we could talk and it was fantastic. I was fascinated by the schools and especially the social clubs, because they were almost like an advanced Boys and Girls Club, but for everyone. You felt like something amazing was happening and something amazing still is happening.

IB: Were these clubs for kids or adults?

TR: For whole communities, teenagers, elders, anyone.

IB: Like at Town Square?

TR: Exactly, it's like a Grange Hall. When I was young and before everyone got their T.V.s and stopped talking to each other, people would meet at these Grange Halls for big Saturday night dinners, country dancing, square dancing, and all this stuff. When I returned from China was really when the idea to do Group Material started—I was very influenced by that experience.

IB: When you got back, you began working with Julie?

TR: Yes, and everyone in Group Material.

IB: And after a year of having the space, you decided to make projects as Group Material?

TR: Yes, public projects.

IB: How long did that last?

TR: It never really stopped. We started to be invited to these mega shows like Documenta. We showed in the Whitney Biennial twice. P. S. 1 wanted us to do an installation. Then we moved from that and we started doing installations.

IB: And you were a fairly tight group?

TR: Pretty tight. It's a situation where you start out with twelve and then there are four, and it got to the point where if we're doing all the work in the group and if you're not you're not. It's the same thing with K.O.S. now—take a break and come back when you want to fully participate. The last thing I helped organize was *Democracy* for the Dia Center for the Arts.

IB: That period is how long?

TR: Two or three years. And then we started K.O.S. I started working with the kids in 1981 and then was at I.S. 52 in 1982.

IB: Which started out as a teaching job?

TR: Yes—it was a full-time teaching job. But it wasn't just that. I was deeply compelled by the situation, the stress of the neighborhood, and the beauty and intelligence of the kids who were supposedly emotionally handicapped and dyslexic. Again my old Yankee common sense told me there was something wrong and that I could do something about it. I'm not a missionary, but I was on a mission. If you can do it, you should do it. It's service. Once I started getting involved with the kids, especially when we opened the studio in 1984, it was amazing. I was operating in the public school.

IB: Were you an art teacher?

TR: I was the art teacher for Special Ed. I was so good with the kids that I was soon working six to seven periods a day, forty-five minutes a period with mostly handicapped, academically at risk at kids. We had a Truant Clinic with a lot of dyslexic kids, and a lot that just were knuckleheads and misbehavers.

IB: How did you learn about all of the problems they were going through?

TR: The graduate studies in teaching at NYU were certainly not there to prepare me for that sort of experience. I had been through something as a kid that helped me understand. They hated school but loved art and made the tragic mistake of equating education with schooling. We used art as a means to knowledge. That's how we became the Art and Knowledge Workshop.

IB: In I.S. 52?

TR: It all started in that school.

IB: Who at school supported your projects?

TR: George Gallego, a very dynamic Puerto Rican American principal from the neighborhood, hired me. He had moved out, but came back, again with that sense of wanting, needing to give back. I was in the school at least six or seven years. You can't imagine what the Bronx looked like and felt like in the early 1980s; you can see it in early works like *Dracula* and *Frankenstein*. The problem with these paintings, though, is that they are too realistic. Marx says it's one thing to describe reality, but another thing to try to change it. Soon we got out of that cathartic descriptive phase, but it was a trip.

IB: What did people see that was happening in your classroom that they wanted more of?

TR: The kids were breaking out of their regular classes and banging on my big metal door in my beat-up classroom with no windows, rusty pipes, and a sink that didn't work because they wanted to be in there; it was blasting with hip-hop and had great energy. We made art, we made music, we did fashion, we did spoken word. Not to be cute, and not to get the cover of *ArtForum*, but to literally survive. The kids came up with the name K.O.S. during a twenty-dollar contest. We had to call ourselves something, because it was happening—we were becoming a group or a team. I love the notion of art as a means to survive. To affirm you have a voice, you have something to say. It doesn't

matter if you live in the poorest congressional district in the U.S., it doesn't matter if your daddy's dead or abandoned you when you were three, it doesn't matter if every expert in the school is getting paid tens of thousands of dollars in federal funding to put you in Special Ed and to tell you what you cannot do.

IB: I can imagine that school administrators wouldn't appreciate your saying that.

TR: Some did and some didn't. And I didn't get invited to a lot of education conferences. There was this perception that, "Oh, you can't do this with the kids, they have Attention Deficit Disorder." I'd just say, "Here's a kid who can play Nintendo for eight hours straight without taking a bathroom break, he doesn't have A.D.D., he has T.D.D, Teacher's Deficit Disorder." If you can't say Amen, say Ouch! No, that did not go over so well. But in the classroom, we made *Dracula*, we made *Frankenstein*, we made Dante's *Inferno*, and then that wonderful period when we made *Absalom, Absalom!*

IB: When did you decide to quit school and start your own studio?

Tim Rollins and K.O.S., c. 1983–84
Art and Knowledge Workshop, Longwood
Avenue studio

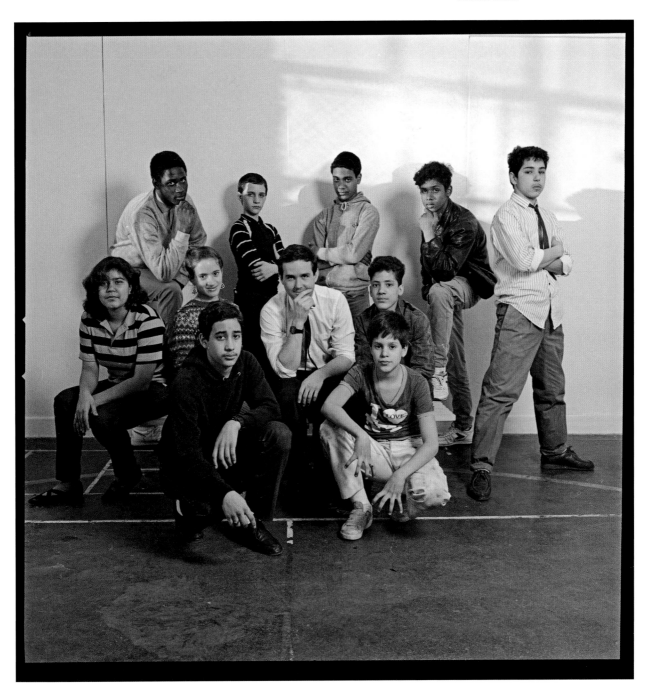

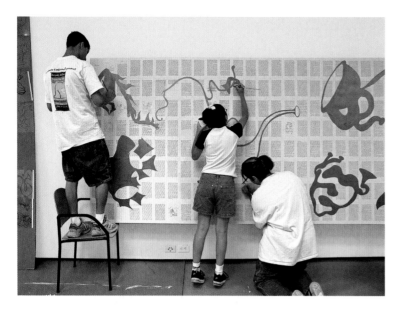

Workshop, Grand Arts, Kansas City, Missouri, 1998

TR: We knew we needed our own space. Our big battle was not with the negative teachers or the clueless administrators that replaced George, but with the custodians. It sounds so silly, but they ran that school; they were a gang. This was at a point when their union had nothing to do with the teacher's union. They would change the locks on the principal if they didn't like what he was doing. I think a lot of them just loved to go get high or something, because I would stay after school and they would be cursing me out on the intercom. I'm not going to repeat what they said, but it wasn't nice. Our materials would go missing; we'd lock the room and come in the next day and there was paint poured all over the sink. It wasn't the students. We had to get out of there. The Longwood Neighborhood Community Center was a few blocks away, in an old school, P.S. 32. It had been taken over by the community because the Board of Ed abandoned it and when you abandon a building in that neighborhood it becomes a big crack house. They would be dragging girls in there, and the police were not helpful. So a group called the Mid-Bronx Desperados first took it over, and then Banana Kelly, a community-based group. Then the city government was shamed into taking the building over and providing space for community groups. The Bronx Council in New York was there, and Fred Wilson's first Longwood Art Gallery, he was on my floor. There was a white elephant in the space that no one wanted, a gymnasium. It wasn't a colossal gymnasium, but it was pretty terrific. I said, "I want that gym, how much is it? $700 a month. Okay, good." We got non-profit status and I filled out an application to the National Endowment for the Arts.

You had to be in business for three years in order to apply for the grant and I thought, "Well, I have been teaching here for three years, so I guess I have been in business, right?" They wanted an after-school program. So we made a deal, and a truce with the custodians. This was in 1983, George was there, all the teachers, and parents, and we told them to show up at this place at three

o'clock for our after-school program. We had *Absalom, Absalom!* and other paintings there, and when the site visitor came everybody was just on. It was a total act, a brilliant performance piece. The kids were showing him the paintings, and the parents were saying, "This is the greatest teacher we've ever had." It was great and the kids were so slick. The guy was totally blown away. Of course, there was an issue with the custodians, who said we could meet at 3:30, but had to be out by 4:30. So, I said listen, we're going to cut this short today because I want to take you over to the space that we really need this money for. When we got to the space and opened the door, all the kids were going *ooh* and *aah* because they had not actually seen it yet. This guy was almost in tears. So we got the grant, $8,000. He told me, "Your story was good, but it was the work that blew everyone on the panel away, work that you had thirteen, fourteen, fifteen year-olds making."

IB: That's a great story.

TR: Isn't it? We finally had a home and here are kids that are supposedly unteachable working in their regular school from eight in the morning until three in the afternoon. And when the final three o'clock bell rang, my kids and I would march straight to the school. We would be there from three to six, seven, eight, nine o'clock at night. The rule was that you had to have your homework done and if you don't have homework, I was going to give you some. All the teachers didn't give them homework because the kids wouldn't ever do it. Then the parents would yell at the teachers, "How come you are not giving my kid homework?" No one knew what the battle was. So we did homework, checked it, and if it wasn't right, you did it again. All that had to be done before you made art. That was the incentive.

IB: So they would hang out at your place doing homework first?

TR: Yes. There was a big homework table with books and resources. I'm a good teacher, and led them to everything. Then we would start collaborating on the works. A lot of the kids really couldn't read. All these experts were saying, "Carlos can't read and you're doing Dante's *Inferno* and Kafka?" I said, "Well, how come he can memorize an entire rap album?" At that time it was a tape, side A and B, and he could rap the entire thing without missing one beat, not one. So I started doing books on tape. I had a tape recorder and at night with a couple of Heinekins, my cat, and rocking chair, I would read to myself and make my own books on tape. In between blasting Treacherous 3, Tanya Whitley, and Afrika Bambaataa—all that great classic stuff—we listened to me reading Kafka's *America* and the kids would just draw and draw and draw until we'd come up with something that seemed to make sense. Then we'd get the books, prepare it on the canvas, and just work.

IB: So you had a dozen or so kids?

TR: It would vary because it depended on your behavior that day. If you acted up you were out.

IB: All boys?

TR: Mainly. We had three or four girls, but the boys created an environment that was sometimes hard for the girls. This is not the Brady Bunch and in that particular machismo culture, it was sometimes rough for them. Their parents also put more constraints on the girls that the boys didn't have.

IB: These are black kids, Latino kids?

TR: Mainly Latino kids. At that point they were mostly Puerto Rican, now it's mostly Dominican. Now we're starting to get Jewish and Puerto Rican Jewish members; it's the Obama generation!

IB: So they are listening to these tapes of you reading this stuff that sounds crazy, and are you saying to them…

TR: …but it doesn't sound crazy.

IB: …are you saying, "Wait a minute, do you know what that word means?"

TR: Yes, we'd break it down all the time. I was just with a bunch of fifth graders doing *A Midsummer Night's Dream* at P.S. 50 in East Harlem, and they would tell me, "Break it down Professor Tim," and I would break it down. I'd tell the story first, and then we'd go to the videotape. Then we'd break it—"You got it, you're with me"—and they get it. I didn't know this stuff either until I was trapped in a situation at the University of Albany Museum where they wanted to do a Shakespeare semester. This was a really rough time for me; I was starving, mainly homeless, and we had no money. So when they said they were going to give us $2,000 for a weeklong workshop, I jumped on it. Two weeks before the workshop was to start, I still had no idea what we were going to do, and just told the museum it was going to be a surprise. To be honest, I didn't know much about Shakespeare. I had seen a few plays, and read them in high school because it was required, but I wasn't feeling it. Then I found this quote from Theseus's monologue in *A Midsummer Night's Dream* —it is the best definition of art I have found in the English language. So we started thinking about the motif, and it soon became obvious that it had to include the flower; this flower has magic nectar with the power to make you fall in love with the next living thing you see upon awakening. So, I went to the SVA Library and researched the history of the flower in Western Art and other parts of the world. We got together about twenty-four slides, studied them, and memorized the names. It was perfect for these junior high knuckleheads I was going to work with, because it's a little bit scary and sinister, and a little bit funny. Puck is such a great character too—they're all Puck! This was at the University, so there were faculty on the balcony watching, and we have an audience during the whole time. And if I have an audience, they're going to get a show. It went great and the kids were totally into it. Nothing is more inspirational than a deadline and the fear of looking really stupid; through that pressure we created a whole new series.

IB: At the initial stages, when you are deciding to choose these books, why choose one over another?

TR: Intuition. It's often a book I don't know myself.

IB: So it's always up to you?

TR: Aside from the interaction with the kids, my favorite part of the project is the research and development. It's fun for me to think about what might work, and what everyone might respond to. I've got to respond to it too, and if I'm not feeling it, they're not going to be either. As they get older, they are bringing texts to the table like *War of the Worlds* and *The Origin of Species*, which everyone has wanted to nail for years. It's about what feels right, what's in the air. Even though we're a collective, we're still like any other artist; you intuit what you need to say right now, and how you can say it with mystery and power.

IB: Tell me a little bit more about how the collective of K.O.S. works. In collaborative teams there is usually some back and forth, some struggle at times, and there's always—I know you have felt this from time to time—some questioning from the outside.

TR: We are met with a lot of cynicism. Actually even I'm skeptical. Everyday I go in asking, "Is this real?" But when you have been making art with young folk and now adults, full-blown adults, for thirty years you have to believe it's real and get going.

IB: But how? You were definitely the boss in the studio because you had kids, and rules.

TR: We don't use the word boss—they call me maestro. Maestro does not mean master, so people need to get over that paradigm. Maestro in our neighborhood is a term of honor—a conductor, a master teacher. I'm not a boss, a jefe, or a chief; I am the conductor of our choir. Certain people have certain abilities, some are great and haven't gotten there yet, some have been there for awhile and are soloists, but nothing is more beautiful than when we all get together on the same page with a common song.

If this did not work, you would not have people. This is self-selecting, voluntary. It's especially telling during difficult periods when we don't get paid—the long dry period was a big test. Looking back it was a horrible struggle, but I'm glad we had the test. The storm is passing over.

IB: You mean the mid-'90s?

TR: Yes, when everything crashed in 1992 and Chris was murdered. I call it the wilderness days. That was a test as to whether this was real or not. Now older K.O.S. members are following me into teaching and want to start their own groups within the schools. We have little satellite programs all over the place now.

IB: Tell me more about the specific process of one of the projects in the '80s and early '90s—from the research and development to execution.

TR: Sure. I can lead you specifically through any one of the projects, because they all have different stories.

IB: How about Kafka's *Amerika*?

TR: At that time I was a big fan of a lot of avant-garde filmmaking and I saw a film called *History Lessons* by Jean-Marie Straub

and Danièle Huillet, incredibly difficult filmmakers. It was a story about this kid in Oklahoma. I immediately ran to St. Mark's and got *Amerika* and read the last chapter, "The Nature Theatre of Oklahoma." I had no idea what it would be as a painting, but knew that it was perfect for us. There's an amazing scene where Karl, the protagonist, goes to this stadium to join a commune called The Nature Theatre of Oklahoma. The commune has two rules: everyone is welcome; and everyone is an artist. It sounded just like our group. And Karl says something like, "I think this is probably a fraud, but it's the most beautiful fraud I have ever heard of in my life." When he reaches the stadium, Kafka has hundreds of women dressed as angels, blowing whatever they want to on long golden horns. For months the kids drew these long, boring golden horns. We tried the angel wings, but that didn't work. I was home one night still trying to figure it out when I stumbled across a PBS show about Dizzy Gillespie—and he was playing a horn with the bell that goes up at this radical angle. Why didn't I think of that—how he bent up the horn? So I got a videotape of it and brought it in. As a kid growing up in Maine, believe it or not, I loved people like Miles Davis and Coltrane, so I got some of my jazz tapes and brought them in. Then I pulled out Dr. Seuss's *Horton Hears a Who* from our big pile of books, because the microscopic community of Whos have to blow and make so much noise to register their presence and visibility on the thistle they live on, so they don't get dropped into the pot of boiling oil. So the kids started competing for who could do the most bugged-out horn.

IB: The craziest!

TR: It looked great, but we still didn't know exactly where it was going. Then there was the idea of gold, so I went to find gold paint, and it all looked crappy. Luckily I finally found Pelikan makes this amazing warm gold that looks stunningly beautiful. We started making studies on Xerox paper that I liberated from the English teacher and used an overhead projector. We had no money for transparencies so the librarian gave us some, because they always give the art teacher their trash. She gave us old library book covers too. Remember the old ones that they'd glue onto the books, the cellophanes? We would cut the cellophane off and buy some sharpie markers, so you could trace your horn. Then with an overhead projector on a rolling cart that we liberated from a burnt-out science teacher, we started putting them on the wall. After laying out the grid of pages, we would start working. And we worked on it for six or seven months, one horn at a time. Kids first learned how to render on the table. It is a completely organic process and when it was done it screamed, "I'm done."

IB: All the kids are involved? Everybody's hands are on the finished product?

TR: Not necessarily—you have to show me you have the technical skill on the table before you get on the canvas. You have to perform in the dress rehearsal before you get on the stage. Most everyone wants to be on the stage, which means you want to get it together. And you are not doing this for a grade, you are doing it because you want to get into the real action.

IB: So, it's you that's making the decision about who's good enough to get on the canvas?

TR: Everyone does. I'll say, "Oh give them a chance," and they'll say, "Tim, no, no, no!"

IB: Everyone does that together?

TR: Yes, and it works. It isn't just me being boss man—that would never work. If I did that, they would just walk out.

IB: What about the kids that don't make it—do they just fade away?

TR: That, or they become satisfied with just doing drawings and don't want to be up there anyway. The labor distributes itself pretty naturally. We work against that horrible, patronizing, lowest common denominator mentality. Our kids can do anything any other kid can do, but you have to push them and convince them. You've got to psych them into excellence.

IB: Did any of the community—the kids themselves or the community of the Bronx around you—ever say, "Hey, what are you doing here?"

TR: Not really. Maybe if they didn't know anything about the project, but most knew I was Tim, the art teacher. I was a daily presence. I walked the neighborhood.

IB: So you were never thought of as "not from here."

TR: No, I never get that or the racial thing. Some stupid macho dudes and drug dealers on the street weren't happy with me. They just don't know what you're doing. It's like taking a pencil and putting it in a spider's web—the spider doesn't know what the pencil is, but they know something is happening. There was overwhelming support from the parents and the positive teachers. A lot of the brothers and sisters who were not doing the right thing would see their little brother or sister in this workshop and traveling to Spain, so we got a lot of family support. Also several of those drug dealers were my former students in 1981, '82, so three or four years later, they would say, "Hey, you leave him alone."

IB: Was being gay a problem?

TR: At the time I was with Kate Pierson (from the B-52's), so everyone was a little bit confused. But the culture is kind of confused as well. When they were old enough to ask if it was true, I would say, "Yeah, but you still love me, and I love you. You don't have to worry about me." I lost some kids because of their very conservative Catholic parents who were fueled by fear and sheer homophobia. There was white phobia too.

IB: What's that?

TR: You suspect white folk and how they perceive you; you think they are going to look down at you. A lot of people that look like us have a false sense of superiority, and a lot of folk

that look like my kids have a false sense of inferiority. Art is so important because it creates a communicative bridge. It eliminates the mythology and lessens the preconceptions.

IB: When did you first decide that you wanted to show this work to the art world outside of the Bronx?

TR: I thought we had something really important to say. We showed the first works, like *Who's Killing the Kids?* even before we were K.O.S. at Group Material. Thank God we had Group Material because I was getting a lot of responses like "Tim, I'm sorry, we just don't do children's art." And these are pretty serious works that had nothing to do with children's art. Alternative Spaces said no. I'll never forget when Leon Golub and Nancy Spero came to the show at Group Material—this was when the headquarters were at my loft on 26th Street and Lexington Avenue—and they got it big time. Two giants of art. I remember Nancy looking and smiling, and Leon saying, "You are really onto something kid. You better keep going with this. Only you can do this."

Another break came when the dealer Ronald Feldman called about an exhibition he was organizing with Carrie Rickey called *Atomic Salon.* They were going to show Warhol and Philip Guston and wanted to know if I knew any young artists that would fit the theme. I remember I was in the phone booth during my half-hour lunch break, which always ended up being fifteen minutes. I told him I knew a group of really young artists making tremendous work, my junior high Special Ed class here at I.S. 52. I could hear the silence on the other end, this polite silence, and knew exactly what was going through his mind: those corny posters, "War is unhealthy for children and other living things" with hand prints and mosaics out of construction paper. I told him that he should see it and that it was pretty amazing. He said, "What about Friday afternoon?" I said, "Fine," and hung up. This was like a Tuesday and I had nothing. Baby, I was at the library right after looking up information on Hiroshima and Nagasaki—this was before we got our studio, before the web—and found this amazing book called *Unforgettable Fire.* St. Mark's Books helped create our career at that point. Do you know this book? It's drawings by survivors of Hiroshima. I completely changed the lesson plan and the next day I explained the idea of hypocenter, and showed them the pictures. Most didn't even know what it was—they had to find Japan on the map, they thought Hitler was Russian. Prospect Avenue was the hypocenter of the Bronx. The kids were going through Leonardo's war notebooks and made tons of drawings. We edited them down to about eighteen and laid them out in a grid that turned into a big T-grid. I went into Feldman's, watching some of my artist friends leaving with dejected faces, and laid it out on the floor. I remember Ronald saying, "Oh my God, what is this?" That's the best thing you can hear as an artist. We got the space right between Guston and Warhol. I was in shock. We were not Guston, or Warhol, but we

were not getting blown off the wall. All the kids came down for the opening; it was just amazing. It was the real thing. It wasn't in a bank lobby or in the back room of some museum where they keep kids' work so that they can get education funding once in awhile.

At this time we also began work on *1984,* because Ronald was organizing a show next year with that title. By then we developed a way of working where you'd draw images and put them on transparencies. There's a lot of urban mythology about this, but the book pages did come in when one of the kids drew in the book. It triggered something in me, which I'm sure was influenced by Joseph's work with language. These books are completely denied for the kids. Yet we don't appropriate them, we take them back. There's a little Baptist song that says, "I went to the enemy's camp and took back what he stole from me, and literature is written for us." Living in the South Bronx in 1983, we could definitely relate to *1984.*

At that point, I spent every penny I had on the project. I would spend money getting a big frame to make it look as much like fine art as possible even if it was made out of donated or scrap materials. But Ronald still came up to me and said that there was no way he could sell them, and that while he would like to represent me, he just couldn't take the emotional consequences of the project. I had no idea what he was talking about. He's a good Jewish uncle, because he was prophesying. Maybe if I had known the consequences, I would never have done it either. But then we started to get invited to group exhibitions, where we showed *Dracula* and *Frankenstein.* And then Richard Flood, who was a Group Material fan, told us about a show he was doing called *Social Studies,* at Barbara Gladstone Gallery—this is 1985. There were great artists in that show. We finally finished *Amerika I* and we now had a place to show it. We knew we had to blow people out of the water, and that this was the time to do it. So we rolled up *Amerika I* because we couldn't even afford to ship it, and took it on the 6 train during rush hour, holding it above everyone's heads. When we finally got to Richard, he goes, "What hath God wrought?" I remember when we were leaving all the kids saying, "Do we have to go home? We like this." It was something new, something off your block.

The school didn't even know we were doing this. And things just started happening. We got a nice mention by Grace Glueck in a review of a group show in *The New York Times.* And then Chase Manhattan Bank bought *Amerika I* for $5000. When we got paid, I showed the kids the check for $2500. One of the kids said, "Damn, white folk will buy anything! Let's make some more." So we did.

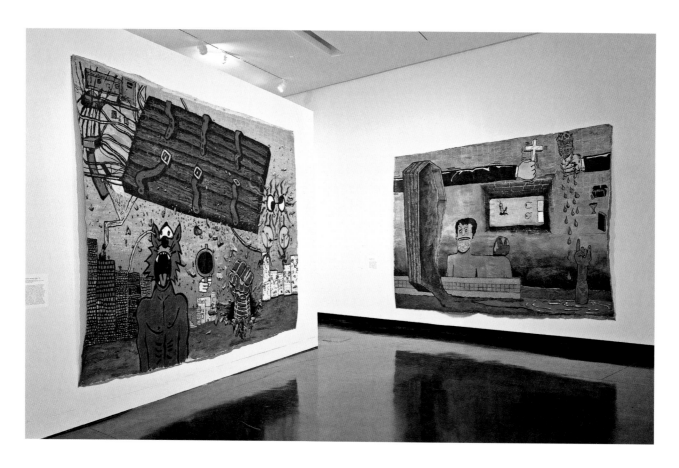

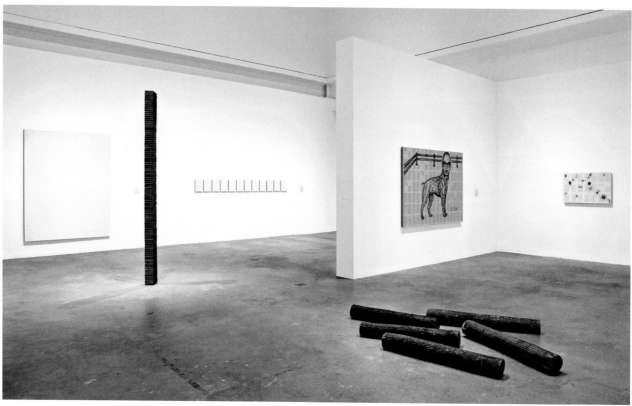

Top:
Installation view, The Frances Young Tang Teaching
Museum and Art Gallery at Skidmore College,
Saratoga Springs, New York, 2009

Bottom:
Installation view, ICA Philadelphia, Pennsylvania, 2009

WORKS IN THE EXHIBITION

All works by Tim Rollins and K.O.S.
Dimensions listed in inches: height x width x depth

1. UNTITLED (BRICKS), 1982–83
Tempera and acrylic on found brick
Six bricks, approx. 8 x 3 1/$_2$ x 2 1/$_2$ inches each
Collection of Peter Stern, courtesy of the artists
and Lehmann Maupin Gallery, New York;
Courtesy of Brooke Alexander; Collection of
David Deitcher; Collection of the artists

2. JESUS RETURNS TO THE SOUTH BRONX, 1983
Woodcut and watercolor on kraft paper
20 x 17 inches
Collection of the artists

3. ANGRY FATHER AND MOTHER, 1982–84
Watercolor on anti-abortion legislation
21 5/$_8$ x 16 7/$_8$ inches
Collection of Alice Zoloto-Kosmin

4. HOUSE OF THE ANGEL, 1982–84
Watercolor on anti-abortion legislation
21 5/$_8$ x 16 7/$_8$ inches
Collection of Alice Zoloto-Kosmin

5. DRACULA (AFTER BRAM STOKER), 1983
Acrylic on book pages mounted on canvas
Irregular, approx. 108 x 144 inches
Collection of the artists

6. FRANKENSTEIN (AFTER MARY SHELLEY), 1983
Acrylic on book pages mounted on canvas
Irregular, approx. 113 3/$_4$ x 158 1/$_4$ inches
Courtesy of the artists, Galerie Eva Presenhuber,
Zürich, Galleria Raucci / Santamaria, Naples

7. AMERIKA I (AFTER FRANZ KAFKA), 1984–85
Oil paint stick, acrylic, china marker, and pencil
on book pages on rag paper mounted on linen
71 1/$_2$ x 177 inches
The JPMorgan Chase Art Collection

8. BY ANY MEANS NECESSARY: NIGHTMARE
(AFTER MALCOLM X), 1986
Black gesso on book pages mounted on canvas
21 x 28 inches
Whitney Museum of American Art, New York
Gift of Barbara and Eugene Schwartz, 93.148

9. THE RED BADGE OF COURAGE IV (AFTER
STEPHEN CRANE), 1986
Oil on book pages mounted on linen
21 x 36 inches
The Carol and Arthur Goldberg Collection

10. FROM THE ANIMAL FARM: JESSE HELMS
(AFTER GEORGE ORWELL), 1987
Graphite and acrylic on book pages mounted
on canvas
55 7/$_8$ x 80 1/$_8$ inches
Courtesy of the artists and Galerie Eva
Presenhuber, Zürich

11. WHITE ALICE (AFTER LEWIS CARROLL),
1984–87
Acrylic on book pages mounted on canvas
72 x 128 inches
Collection of Jane and Leonard Korman

12. THE HOLY BIBLE, 1987
Books, steel
114 1/$_2$ x 8 x 5 5/$_8$ inches
Private Collection, courtesy of
Thomas Ammann Fine Art, Zürich

13. WINTERREISE (SONGS XX–XXIV)
(AFTER FRANZ SCHUBERT), 1988
Acrylic and mica on music pages mounted
on linen
Twelve works, 12 x 9 inches each;
12 x 119 inches overall
Collection of Ruth and William Ehrlich,
New York

14. THE TEMPTATION OF SAINT ANTONY—THE
NICOLAITANS (AFTER GUSTAVE FLAUBERT), 1990
Blood, water, and isopropyl alcohol on xerograph
mounted on rag paper
Twelve works, 11 1/$_4$ x 8 inches each
Straus Family Collection

15. X-MEN 1968 (AFTER MARVEL COMICS), 1990
Comic book pages and acrylic mounted on linen
76 1/$_4$ x 194 inches
Straus Family Collection

16. PINOCCHIO #3, 9, 27, 35, 42
(AFTER CARLO COLLODI), 1991
Wood, plastic, wax, and tung oil
Five irregular logs, approx. 43 x 6 x 6 inches each
Collection of the artists

17. THE WHITENESS OF THE WHALE II
(AFTER HERMAN MEVILLE), 1991
Acrylic on book pages mounted on linen
90 x 68 inches
Fisher Landau Center for Art,
Long Island City, New York

18. THE SCARLET LETTER—THE PRISON DOOR
(AFTER NATHANIEL HAWTHORNE), 1992–93
Acrylic on book pages mounted on linen
54 1/$_8$ x 77 1/$_4$ inches
Mildred Lane Kemper Art Museum,
Washington University in St. Louis
University Purchase, Bixby Fund, 1993

19. DEATH AND TRANSFIGURATION (AFTER
RICHARD STRAUSS), 1994
Xerograph on music page
12 1/$_8$ x 9 1/$_4$ inches
Collection of the artists

20. INCIDENTS IN THE LIFE OF A SLAVE GIRL
(AFTER HARRIET JACOBS), 1998
Satin ribbons and book pages mounted on linen
Canvas: 87 x 110 inches;
installation dimensions variable
The Bronx Museum of the Arts
Gift of the artists, 1999.9.1

21. INVISIBLE MAN (AFTER RALPH ELLISON), 1999
Matte acrylic on book pages mounted on canvas
60 x 60 inches
Collection of Dr. Rushton E. Patterson, Jr.

22. A MIDSUMMER NIGHT'S DREAM VI
(AFTER WILLIAM SHAKESPEARE), 2000
Watercolor, aqaba paper, fruit juices, and
mustard seed on book pages mounted on canvas
42 1/$_4$ x 47 3/$_4$ inches
The Hyde Collection, Glens Falls, New York
Purchased with funds donated by Jim Taylor and
Nan Guslander, and Feibes & Schmitt Architects,
Schenectady, New York

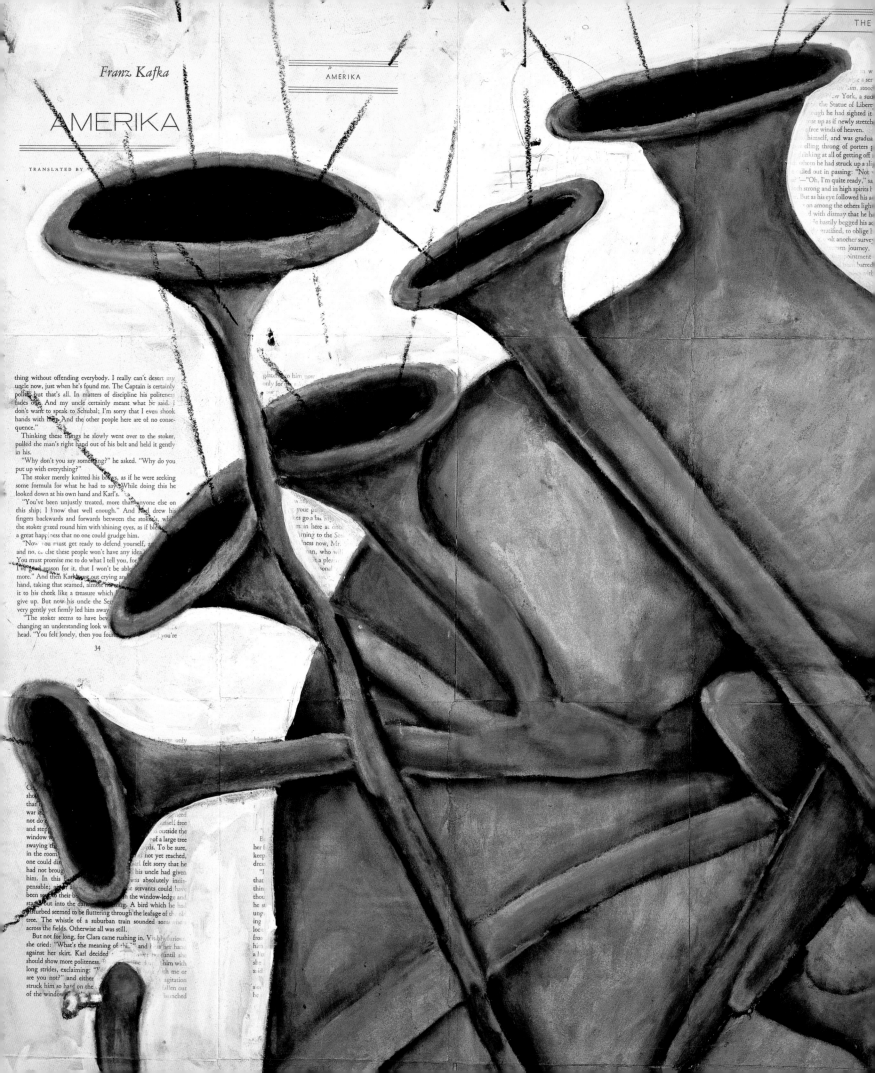

CONTRIBUTORS

Julie Ault is an artist and author who independently and collaboratively makes exhibitions, publications, and diversiform projects. Recent projects include *Installation*, Vienna Secession, 2006, in collaboration with Martin Beck, and *Points of Entry*, a permanent art project for Queens College, City University of New York, 2004. Ault is the editor of *Felix Gonzalez-Torres* (steidl/dangin, 2006), and *Alternative Art New York, 1965–1985* (University of Minnesota Press, 2002), and the author of *Come Alive! The Spirited Art of Sister Corita* (Four Corners Books, 2006). She is currently organizing the book *Show and Tell: A Chronicle of Group Material* (Four Corners Books, 2010) about the New York City-based collaborative she co-founded in 1979. Ault is a Ph.D. candidate in Visual Art at Malmö Art Academy, Lund University, where she teaches on a visiting basis.

Susan Cahan is an art historian, educator, and curator who specializes in contemporary art and the history of museums. She is currently Associate Dean for the Arts at Yale College, New Haven. From 2003 to 2009 Cahan was the Des Lee Professor in Contemporary Art at the University of Missouri–St. Louis and Associate Dean in the College of Fine Arts and Communication. From 1996 to 2001 Cahan served as senior curator for the private collection of Eileen and Peter Norton and director of arts programs for the Peter Norton Family Foundation and from 1987 to 1996 she worked at the New Museum of Contemporary Art in New York as Deputy Director and Curator of Education. Her publications include "Performing Identity and Persuading a Public: The Harlem On My Mind Controversy" published in *Social Identities* (2007); *I Remember Heaven: Jim Hodges and Andy Warhol* (Contemporary Art Museum St. Louis, 2007); "Regarding Andrea Fraser's Untitled" in *Social Semiotics* (2006); and *Contemporary Art and Multicultural Education* (Routledge, 1996). Cahan received her M.A. in Art History at Hunter College and her Ph.D. at the Graduate Center of the City University of New York.

Ian Berry is Associate Director and The Susan Rabinowitz Malloy '45 Curator of The Frances Young Tang Teaching Museum and Art Gallery at Skidmore College. A specialist in contemporary art, Berry has organized several interdisciplinary exhibitions that bring together diverse objects from a wide variety of fields with new works of international contemporary art. In addition to large-scale surveys of recent drawing, painting, and appropriation art, Berry has produced monographic exhibitions and catalogues in collaboration with artists such as Nayland Blake, Kathy Butterly, Joseph Grigely, Jim Hodges, Nina Katchadourian, Martin Kersels, Alyson Shotz, Shahzia Sikander, and Amy Sillman. Berry received his M.A. from the Center for Curatorial Studies at Bard College and previously served as Assistant Curator at the Williams College Museum of Art. Recent publications include *Kara Wallker: Narratives of A Negress* (MIT Press, 2003; Rizzoli, 2008), *America Starts Here: Kate Ericson and Mel Ziegler* (MIT Press, 2006), *Dario Robleto: Alloy of Love* (University of Washington Press, 2008), and *Fred Tomaselli* (Prestel, 2009).

David Deitcher is an independent curator, art historian, and critic whose essays have appeared in periodicals such as *Artforum*, *Art in America*, *Parkett*, and the *Village Voice*, as well as numerous anthologies and monographs on such artists as Felix Gonzalez-Torres, Isaac Julien, Roy Lichtenstein, and Wolfgang Tillmans. Deitcher is the editor of *The Question of Equality: Lesbian and Gay Politics in America Since Stonewall* (Scribner, 1995), and the author of *Dear Friends: American Photographs of Men Together, 1840–1918* (Abrams, 2001), which won a Lambda Literary Foundation book award in 2001. In 2001, he organized the latter into an exhibition of the same name at New York's International Center of Photography. Deitcher received his M.A. from New York University and Ph.D. from the Graduate Center of the City University of New York. He teaches art and critical theory at the International Center of Photography/Bard College Program for Advanced Photographic Studies.

Felix Gonzalez-Torres (1957–1996) is an artist known for work that combined conceptual and minimalist forms with personal and socio-political content. Born in Guàimaro, Cuba, Gonzalez-Torres moved to New York City in 1979, where he received his B.F.A from Pratt Institute, Brooklyn, New York and M.F.A. from the International Center of Photography/New York University. In 1983 he participated in the Independent Study Program at the Whitney Museum of American Art and in 1987 he joined the New York City-based collaborative Group Material. His work has been featured in numerous solo exhibitions, including shows at the New Museum of Contemporary Art, New York (1988); Brooklyn Museum of Art, New York (1989); Museum of Modern Art, New York (1992); Museum of Contemporary Art, Los Angeles, Hirshhorn Museum and Sculpture Garden, Washington, D.C., and Renaissance Society at the University of Chicago (1994); and Solomon R. Guggenheim Museum, New York (1995). His work has been included in numerous posthumous exhibitions; and in 2007 a survey of his work represented the United States at the Venice Biennale.

Lawrence Rinder is an art historian, curator, writer, and Director of the Berkeley Art Museum and Pacific Film Archive, University of California, Berkeley. Rinder has served as the MATRIX Curator and Curator for Twentieth Century Art at BAM/PFA (1988–1998); Founding Director of the CCA Wattis Institute for Contemporary Arts (1998–2000); the Anne & Joel Ehrenkranz Curator of Contemporary Art at the Whitney Museum of American Art (2000–2004); and Dean of the College at California College of the Arts (2004–2008). He has organized or co-organized over 100 exhibitions at museums and galleries across the country, including solo shows on Louise Bourgeois, Tim Hawkinson, Suzan Frecon, Rudolf Steiner, Richard Tuttle, and Felix Gonzalez-Torres, and group shows, including *The American Effect* (2003), *2002 Whitney Biennial*, *Searchlight: Consciousness at the Millennium* (2000), and *In a Different Light* (1995), co-organized with Nayland Blake. Rinder received his B.A. in art from Reed College, Portland, Oregon, and M.A. in art history from Hunter College, New York. He has held teaching positions at Columbia University, New York; the University of California, Berkeley; and Deep Springs College, Deep Springs, California.

Dr. James Romaine is a New York City-based historian of contemporary art. He received his Ph.D. in art history from the Graduate Center of the City University of New York with a dissertation entitled *Constructing a Beloved Community: The Methodological Development of Tim Rollins and K.O.S.* He is the co-founder of the New York Center for Arts and Media Studies, a program of Bethel University, where he is an assistant professor of art history. He has published articles on Vincent van Gogh, Robert Gober, Mark Wallinger, Eric Fischl, Andy Goldsworthy, Tim Rollins and K.O.S., Richard Serra, and Vija Celmins in *Art Journal of the College Art Association*, *American Arts Quarterly*, and *Image Journal*.

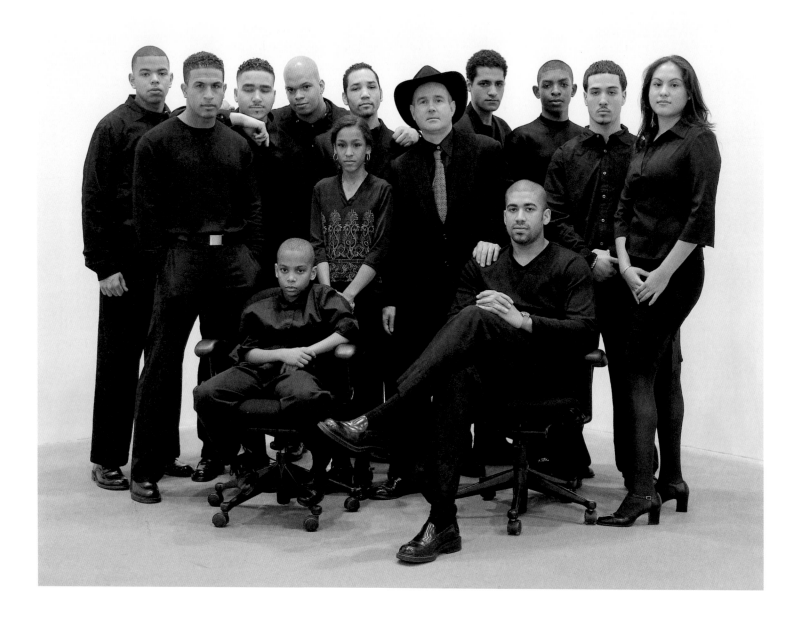

Tim Rollins and K.O.S., 2000

TIM ROLLINS AND K.O.S. 1981–PRESENT

Initially exhibited as "Tim Rollins and 15 kids from the South Bronx" or "Twenty Kids from the South Bronx with Tim Rollins," the group adopted the name "Tim Rollins and Kids of Survival" in 1985. Over three decades of collaboration, the group itself has changed, as members moved away, went on to college, pursued other avenues, and new members joined.

This list includes Rollins's first collaborators at Intermediate School #52 to K.O.S. members currently working today.

Tim Rollins (b. 1955, Pittsfield, ME)

Angel Abreu (b. 1973, Philadelphia, PA)

Jorge Abreu (b. 1979, New York, NY)

Wilson Acosta (b. 1971, New York, NY)

Che Addison (b. 1984, New York, NY)

Christina Argulla (b. 1971, New York, NY)

Adalberto Badillo (b. 1970, New York, NY)

Aracelis Batista (b. 1974, New York, NY)

Wesley Martin Berg (b. 1984, Minneapolis, MN)

Daniel Bocatto (b. 1991, Campinas, Brazil)

Robert Branch (b. 1977, New York, NY)

Howard Britton (b. 1974)

Jose Burgos (b. 1971, New York, NY)

Brenda Carlo (b. 1974, New York, NY)

Jose Carlos (b. 1970, New York, NY)

Emanuel Carvajal (b. 1981, New York, NY)

Daniel Castillo (b. 1982, New York, NY)

Felix Cepero (b. 1971)

Ivania Cordero (b. 1983)

Richard Cruz (b. 1970, New York, NY)

Adam DeCroix (b. 1973, Chicago, IL)

Robert Delgado (b. 1971, New York, NY)

Joshua Drayzen (b. 1984, Long Island, NY)

Ala Ebtekar (b. 1978, Berkeley, CA)

Luis Feliciano (b. 1972, New York, NY)

George Garces (b. 1972, New York, NY)

James Gillian (b. 1972)

Michael John Gonzalez (b. 1971)

Anel Hernandez (b. 1972)

Christopher Hernandez (1978–1993)

Pedro Herrera (b. 1990, Bronx, NY)

Ivor Jones (b. 1971)

Victor Llanos (b. 1976, New York, NY)

William Lugo (b. 1972)

Richard Lulo (1971–1988)

John Mendoza (b. 1971)

Nelson Montes (b. 1972, New York, NY)

Jorge Luis Muniz (b. 1971)

Joel Nieves (b. 1970, New York, NY)

Jose Padilla (b. 1971, New York, NY)

Jose Parissi (b. 1968, New York, NY)

Roberto Ramirez (b. 1970, New York, NY)

Nelson Ricardo Savinon (b. 1971, New York, NY)

Alberto Rivera (b. 1971)

Carlos Rivera (b. 1971, New York, NY)

Marcus Roberts (b. 1983, San Francisco, CA)

Hector Rodriguez (b. New York, NY)

Roy Rogers (b. 1971, Saint Thomas, U.S. Virgin Islands)

Annette Rosado (b. 1972, New York, NY)

Jesus Ruiz (b. 1971, New York, NY)

Jose Ruiz (b. 1971, New York, NY)

Darnell Smith (b. 1971)

Lenin Tejada (b. 1979)

Henry Tilo (b. 1971)

Gregorio Torres (b. 1971)

Lissette Torres (b. 1970)

Miguel A. Valentin (b. 1986)

Steven Vega (b. 1986, Middletown, NY)

Yesenia Velez (b. 1972)

Benjamin Volta (b. 1979 Abington, PA)

James Wells (b. 1984, Memphis, TN)

Bryce Zackery (b. 1984, Rochester, MN)

Tim Rollins (b. 1955, Pittsfield, ME)
Rollins received an A.S. from the University of Maine in Augusta in 1976, a B.F.A. from the School of Visual Arts in New York in 1978, and pursued graduate studies in art education and philosophy at New York University. 2011 will mark the 30th year of the group's collaboration.

Angel Abreu (b. 1973, Philadelphia, PA)
Angel Abreu joined K.O.S. in 1985 from I.S. 52. He graduated from Deerfield Academy, and attended the University of Pennsylvania and New York University. He is currently a painter and active in K.O.S.

Jorge Abreu (b. 1979, New York, NY)
Younger brother of Angel Abreu, Jorge Abreu joined K.O.S. in 1990. He graduated from Landmark Academy, High School of Graphic Arts, and attended Bard College. He is currently a writer and active in K.O.S.

Wesley Martin Berg (b. 1984, Minneapolis, MN)
Berg joined K.O.S. in 2007 and remains active in the group. He received his BFA from the School of Visual Arts. He is currently an artist and artist assistant in New York.

Daniel Bocatto (b. 1991, Campinas, Brazil)
Bocatto joined K.O.S. in 2007 and remains active in the group. He recently graduated with honors from Yonkers High School and is a student at Cooper Union in New York.

Robert Branch (b. 1977, New York, NY)
Branch joined K.O.S. in 1993. He graduated from Kennedy High School, received an undergraduate degree from Cooper Union in New York, and graduate degree from Teachers College at Columbia University. He currently works in the department of Educational Technology at the Teachers College and is active in K.O.S.

Jose Carlos (b. 1970, New York, NY)
Carlos was a student of Rollins's at I.S. 52 from 1981 to 1984. After I.S. 52, he attended Kennedy High School.

Emanuel Carvajal (b. 1981, New York, NY)
Carvajal joined K.O.S. in 1993 though his friend Jorge Abreu. After graduating from Landmark High School, he attended the State University of New York, Purchase. He left K.O.S. in 2002 and currently lives in New York.

Daniel Castillo (b. 1982, New York, NY)
Castillo joined K.O.S. in 1993 through his friend Jorge Abreu. He graduated from Landmark High School, Bard College, and Lehman College. He is currently a teacher in New York and active in K.O.S.

Richard Cruz (b. 1970, New York, NY)
Cruz joined K.O.S. in 1985 from I.S. 52 and remained active through 1991. He attended LaGuardia High School.

Robert Branch, South Bronx,
New York, 1994

Victor Llanos, South Bronx,
New York, 1993

Adam DeCroix (b. 1973, Chicago, IL) DeCroix joined K.O.S. in 2003 through his Cooper Union classmate Robert Branch. He graduated from Cooper Union, the Whitney Independent Study Program, and the State University of New York, Purchase. He is currently active in K.O.S.

Joshua Drayzen (b. 1984, Long Island, NY) Drayzen joined K.O.S. in 2006. He received a B.F.A. from the School of Visual Arts and is currently an art teacher in public schools.

Ala Ebtekar (b. 1978, Berkeley, CA) Ebtekar joined K.O.S. in 1997 in San Francisco. He graduated from Richmond High School, and received a B.F.A. from the San Francisco Art Institute and M.F.A. from Stanford University. He currently teaches at the University of California, Berkeley and exhibits widely. He is active in K.O.S.

George Garces (b. 1972, New York, NY) Garces joined K.O.S. in 1985 from a summer program at Lehman College and remained active through 1990. He attended LaGuardia High School and is a musician.

Christopher Hernandez (1978–1993) Hernandez joined K.O.S. in 1988 when he was in the third grade. He was the driving force behind *From the Earth To The Moon (after Jules Verne)*. Inspired by a dream, he gathered found glass off the street to create a constellation-like pattern on the canvas. He was murdered in 1993.

Victor Llanos (b. 1976, New York, NY) Llanos joined K.O.S. in 1990 from I.S. 52 and remained active through 1994. He graduated from Monroe High School.

Nelson Montes (b. 1972, New York, NY) Montes joined K.O.S. in 1985 from I.S. 52 and remained active through 1990. He graduated from Monroe High School and attended Monroe College.

Jose Parissi (b. 1968, New York, NY) Parissi joined K.O.S. in 1984 from I.S. 52 and remained active through 1990. He graduated from Monroe High School and attended LaGuardia Community College.

Carlos Rivera (b. 1971, New York, NY) Rivera joined K.O.S. in 1985 from I.S. 52 and remained active through 1994. He graduated from the High School of Art and Design and attended the State University of New York, Purchase.

Annette Rosado (b. 1972, New York, NY) Rosado joined K.O.S. in 1985 from I.S. 52, and remained active through 1990. She graduated from Monroe High School.

Nelson Ricardo Savinon (b. 1971, New York, NY) Savinon joined K.O.S. in 1985 from a summer program at Lehman College. He studied for two years at the School of Visual Arts in New York and is an artist and graphic designer.

Steven Vega (b. 1986, Middletown, NY) Vega joined K.O.S. in 2008 and remains active in the group. He recently received his B.F.A. with honors from the School of Visual Arts in New York.

Benjamin Volta (b. 1979 Abington, PA) Volta joined K.O.S. in 2004 in Philadelphia and remains active in the group. He graduated from the Pennsylvania Academy of Art and the University of Pennsylvania. He currently teaches art in the Philadelphia public school system.

Carlos Rivera, South Bronx, New York, 1993

EXHIBITION AND WORKSHOP HISTORY

In 1979, Tim Rollins co-founded the artist collaborative, Group Material, where he remained an active member until 1987. He exhibited his work once outside of Group Material at New York University's Education Building Gallery in 1980.

In 1981, Rollins began teaching art at Intermediate School #52 in the South Bronx and after 1982 all of his exhibited work involved his collaborations with his students. The following exhibition history begins with Group Material projects from their first shows in 1980 until 1987 when Tim left the group to focus on his work with Kids of Survival.

GROUP MATERIAL

1980

Inaugural Exhibition, Group Material, E. 13th St., New York, September
The Salon of Election '80, Group Material, E. 13th St., New York, November
Alienation, Group Material, E. 13th St., New York, December

1981

The People's Choice, Group Material, E. 13th St., New York, January
It's A Gender Show, Group Material, E. 13th St., New York, February
Consumption: Metaphor, Pastime, Necessity, Group Material, E. 13th St., New York, March
Facere/Fascis, Group Material, E. 13th St., New York, April
Atlanta, An Emergency Exhibition, Group Material, E. 13th St., New York, June
Enthusiasm!, Group Material Headquarters, New York, October
M-5, 5th Avenue buses, New York, December

1982

DA ZI BAOS, Democracy wall on Union Square, New York, March
Works on Newspaper, Group Material Headquarters, New York, March
Primer (for Raymond Williams), Artists Space, New York, May 29–July 17
Luchar, An Exhibition for the People of Central America, Taller Latino Americano, New York, June

1983

Revolutionary Fine Arts, Taller Latino Americano, New York, April
Subculture, IRT subway trains, New York, September

1984

Artists Call, P.S.1 Contemporary Art Center, Long Island City, New York, January

1985

A.D., Christian Influence in Contemporary Culture, Work Gallery, New York, January
Whitney Biennial 1985, Whitney Museum of American Art, New York, March 13–June 9
Democracy Wall, Chapter Arts Centre, Cardiff, Wales, May
MASS, traveled to: Hallwalls, Buffalo, New York; Spaces, Cleveland, Ohio; New Museum of Contemporary Art, New York; Studio Museum of Harlem, New York, 1985–86
Messages to Washington, Washington Project for the Arts, Washington D.C., September
The Other America, Festival Hall, London, England, November

1986

Liberty and Justice, co-organized with Alternative Museum, New York, February 22–March 22
Group Material: Jessica Diamond, Connie Hatch, Doug Ashford, Julie Ault, Mundy McLaughlin, Tim Rollins, New Museum of Contemporary Art, New York, April 12
Arts and Leisure, Kitchen, New York, May 24–June 14

1987

Documenta 8: Museum of 100 Days, Museum Fridericianum, Kassel, Germany, June 12–September 20
Constitution, Temple University Gallery, Philadelphia, Pennsylvania, October 1–November 14
Resistance (Anti-Baudrillard), White Columns, New York, February

TIM ROLLINS AND K.O.S.

The list that follows combines exhibitions and workshops by Tim Rollins and K.O.S. from their first show in 1982 at Ronald Feldman Gallery through the publication of this catalogue. Workshops are listed throughout and are noted when associated with an exhibition. Exhibitions are followed by dates when available. Traveling exhibitions are listed under initial date and venue.

Selected Solo Exhibitions

1985

Prayers to Broken Stone: Five Years of Art Against Arson, Hostos Art Gallery, Hostos Community College, Bronx, New York

1986

Tim Rollins and K.O.S., 1983–1985, Fashion Moda, South Bronx, New York, January 25–March 26
By Any Means Necessary: Tim Rollins and K.O.S., Amelie A. Wallace Gallery, State University of New York, Old Westbury, New York, March 3–March 28
Tim Rollins and K.O.S., Jay Gorney Modern Art, New York, October–November 30

1987

Tim Rollins and K.O.S., Lawrence Oliver Gallery, Philadelphia, Pennsylvania, April (Workshop)
Tim Rollins and K.O.S., Rhona Hoffman Gallery, Chicago, Illinois, October 16–November 14
Amerika IX, Knight Gallery at Spirit Square Arts Center, Charlotte, North Carolina (Workshop)
Everyone Is Welcome: Messages to the Public, Workshop with Public Art Fund, Spectacular Light Board, Times Square, New York

1988

Viewpoints—Tim Rollins and K.O.S., Walker Art Center, Minneapolis, Minnesota, February 14–April 24 (Workshop)
Tim Rollins and K.O.S., Jay Gorney Modern Art, New York, March 5–April 2
Tim Rollins and K.O.S. (Kids of Survival), Institute of Contemporary Art, Boston, Massachusetts, April 14–June 12 (Workshop for *Amerika—For Thoreau*)
Tim Rollins and K.O.S., Riverside Studios, London, England, July 27–August 21; traveled to: Ikon Gallery, Birmingham, England, September 3–October 3; Orchard Gallery, Derry, Northern

Ireland, October 6–October 29 (Workshop for *The Red Badge of Courage* with Riverside Studios and Orchard Gallery)

Amerika—For the People of Bathgate Community, Workshop with Elementary School No. 4, Mural on Bathgate Avenue, Bronx, New York, Sponsored by Public Art Fund, Port Authority of the City of New York, and Board of Education of the City, completed October 6

Tim Rollins and K.O.S., Barbara Krakow Gallery, Boston, Massachusetts, November 12–December 7

Tim Rollins and K.O.S., Galería La Máquina Española, Madrid, Spain

1989

Tim Rollins and K.O.S., Jay Gorney Modern Art, New York, May 6–June 3

Tim Rollins and K.O.S., Galerie Johnen & Schöttle, Cologne, Germany, June 16–July 22

Tim Rollins and K.O.S.: Amerika, Dia Art Foundation, New York, October 13–June 17, 1990; traveled to: Museum of Contemporary Art, Los Angeles, California, July 8–September 9, 1990

Tim Rollins and K.O.S., Interim Art [now Maureen Paley], London, England, December–January 1990

1990

Tim Rollins and K.O.S./Matrix 109, Wadsworth Atheneum Museum of Art, Hartford, Connecticut, January 14–April 22

Tim Rollins and K.O.S.: Temptation of Saint Antony 1987–1990, Museum für Gegenwartskunst, Basel, Switzerland, May 20–August 20

Tim Rollins and K.O.S. (Kids of Survival): The Temptation of St. Antony and Winterreise, State University of New York, Cortland, New York, October 30–December 7

Amerika—For the Authors of Chicago, Workshop with Columbus College and Harold Washington Public Library, Chicago, Illinois

Tim Rollins and K.O.S., Württembergischer Kunstverein, Stuttgart, Germany

1992

Tim Rollins and K.O.S., Mary Boone Gallery, New York, May 2–June 27

Directions—Tim Rollins and K.O.S.: Animal Farm, Hirshhorn Museum and Sculpture Garden, Smithsonian Institution, Washington, D.C., September 17–December 6 (Workshop for *From the Animal Farm* with Hirshhorn Museum and Sculpture Garden and Duke Ellington School of the Arts)

1993

Tim Rollins and K.O.S., Fundación para el Arte Contemporáneo, Mexico City, Mexico, May 25–July 31 (Workshop for *The Scarlet Letter*)

Tim Rollins and K.O.S.: The Scarlet Letter, Rhona Hoffman Gallery, Chicago, Illinois, May 28–July 2

Tim Rollins and K.O.S.: The Scarlet Letter VI, Barbara Krakow Gallery, Boston, Massachusetts, September 18–October 13

1994

Tim Rollins and K.O.S.: The Red Badge of Courage, Southeastern Center for Contemporary Art, Winston-Salem, North Carolina, April 23–July 17 (Workshop for *The Red Badge of Courage—Winston-Salem* with Petree Middle School and Independence High School)

Animal Farm, Grand Central Station, New York, October 3–October 23

1995

Tim Rollins and K.O.S., Mary Boone Gallery, New York, January 7–February 25

A Celebration of the Spirit, Workshop for *The Red Badge of Courage* with Quartz Mountain Art Gallery, Oklahoma Arts Institute, Oklahoma City, Oklahoma

The Frogs, Workshop with Kaleidoscope Program for Children, Philadelphia, Pennsylvania

The Iliad and *The Odyssey*, Workshop with Bronx Juvenile Detention Center, South Bronx, New York, Sponsored by City of New York Department of Juvenile Justice, Department of Design and Construction and Department of Cultural Affairs Percent for Art Program

1996

Kommos, Olin Art Gallery, Kenyon College, Gambier, Ohio, January 19–February 29

The Frogs and *Amerika*, Workshop with Department of Public Art, University of South Florida, Tampa, Florida

1997

Tim Rollins and K.O.S.: Beyond The Veil: Fifteen Years of Art and Teaching, The Fabric Workshop and Museum, Philadelphia, Pennsylvania, May 15–July 5

Prometheus Bound, Academie Galerie, Workshop with K.O.S. member Robert Branch and Utrecht School of the Arts, Utrecht, the Netherlands, September 11–September 12

Tim Rollins and K.O.S.: The Psalms, Workshop with Youth Art Connection, Atlanta, Georgia, September 22–September 27, October 14–15, November 19, December 17–19, January 24–February 2, 1998

The Nature Theatre of Oklahoma, Workshop with Young Lives and Oklahoma City Public Schools, Oklahoma City, Oklahoma, Sponsored by Young Lives, Inc. and the Kirkpatrick Foundation

Installation views, State University of New York, Old Westbury, New York, 1986

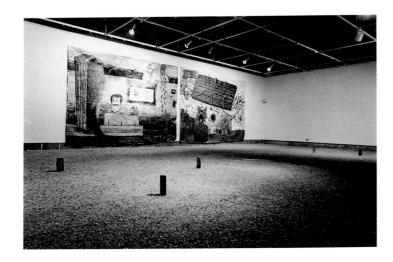
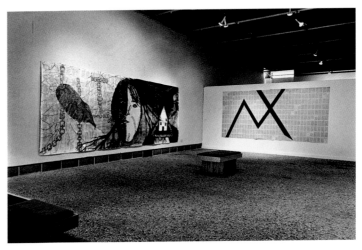

1998

Tim Rollins and K.O.S.: Fifteen Years of Art and Teaching, Ohio University Art Gallery, Athens, Ohio, January 16–February 7

Tim Rollins and K.O.S.: Kids Across Amerika, University of South Florida Contemporary Art Museum, Tampa, Florida, January 16–March 3

Tim Rollins and K.O.S.: The Strength to Love, Greenville College Art Gallery, Greenville, Illinois, March–April

Tim Rollins and K.O.S.: Fifteen Years of Art and Teaching, University Art Museum at the State University of New York, Albany, New York, March 28–April 19 (Workshop for *A Midsummer Night's Dream* with University Art Museum at the State University of New York, Albany, New York, March 24–March 27)

Tim Rollins and K.O.S.: A Paper Retrospective, Palmer Museum of Art, Pennsylvania State University, University Park, Pennsylvania, July 7–December 20

In Collaboration with Tim Rollins and K.O.S., Paule Anglim Gallery, San Francisco, California, September 2–September 26

Tim Rollins and K.O.S., Grand Arts, Kansas City, Missouri, September 11–October 24 (Workshop with Education studios of Nelson-Atkins Art Museum)

In Collaboration with Tim Rollins and K.O.S., Zeum, San Francisco, California (Workshop)

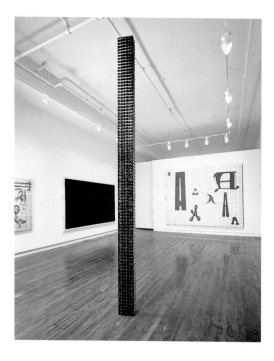

Installation view, Jay Gorney Modern Art, New York, 1988

1999

Tim Rollins and K.O.S., Theater Gallery at Berkeley Art Museum, University of California, Berkeley, California, January 16–March 14

Tim Rollins and K.O.S.: Collaboration with Studio Air Chicago, Rhona Hoffman Gallery, Chicago, Illinois, January 22–February 20 (Workshop)

I See the Promised Land, Workshop with Museum Club and Discovery Squad Students, New York State Museum, Albany, New York, January 27–January 29

Tim Rollins and K.O.S.: Fifteen Years of Art and Teaching, Hatton Gallery at Colorado State University, March 22–April 30 (Workshop for *The Frogs* during the program *It's a Gas!*)

Tim Rollins and K.O.S., Trinity Christian College, Palos Heights, Illinois, October 7–November 5

Jay Etkin Gallery, Memphis, Tennessee (Workshop for *Invisible Man* and *I See the Promised Land* with Memphis Public Schools and the Echoes of Truth Arts Program)

Workshop at Robert Livingston Junior High Magnet School, Albany, New York

2000

Tim Rollins and K.O.S., Baumgartner Gallery, New York, February 26–April 15

Tim Rollins and K.O.S.: Survey, 1981–2000, Wood Street Galleries, Pittsburgh, Pennsylvania, March 31–May 13 (Workshop with Pittsburgh Public Schools, Liberty Magnet School, Pittsburgh Cultural Trust)

Tim Rollins: And As Imagination Bodies Forth, The Hyde Collection, Glens Falls, New York, April 30–July 30 (Workshop with Education Department for *A Midsummer Night's Dream*)

A Midsummer Night's Dream, Workshop with Artist's Studio Program and ArtSeed, M.H. de Young Memorial Art Museum, San Francisco, California, June

Crow's Shadow Institute of the Arts, Pendleton, Oregon (Workshop for *A Midsummer Night's Dream*)

2001

Tim Rollins and K.O.S.: Superheroes, Des Moines Art Center, Des Moines, Iowa, January 19–April 29

Tim Rollins and K.O.S., Galleria Raucci/Santamaria, Naples, Italy, April 1–May 31

Tim Rollins and K.O.S.: The Evidence of Things Not Seen, Workshop at Cathedral Church of St. John the Divine, New York

2002

Tim Rollins and K.O.S.: The Langston Hughes Project, Spencer Museum of Art, University of Kansas, Lawrence, Kansas, February 9–May 26

Tim Rollins and K.O.S.: New Work, Baumgartner Gallery, New York, April

2003

Tim Rollins and KOS: The Virginia Avenue Park Project: A Midsummer Night's Dream, Santa Monica Museum of Art, Los Angeles, California, April 2–April 12 (Workshop for *A Midsummer Night's Dream* with Virginia Avenue Project and Santa Monica Museum of Art)

New Paintings, Galleria Raucci/Santamaria, Naples, Italy, October 11–November 30

Tim Rollins and K.O.S.: Twenty Years of Art and Teaching, Jay Etkin Gallery, Memphis, Tennessee

Tim Rollins and K.O.S.: Works on Paper, Mills Gallery, Central College, Pella, Iowa

2003

Tim Rollins and K.O.S.: Amerika Agape, Leonard Pearlstein Gallery, Drexel University, Philadelphia, Pennsylvania, April 21–May 9

Tim Rollins and K.O.S.—Purple with Love's Wound, University of Virginia Art Museum, Charlottesville, Virginia, September 19–November 9 (Workshop for *A Midsummer Night's Dream* with University of Virginia Art Museum's Early Visions and Summer Arts programs)

Tim Rollins and K.O.S.: Works on Paper 1983–2003, Art Resources Transfer, New York, October 15–November 15

A Midsummer Night's Dream, Lamar Dodd School of Art Main Gallery, University of Georgia, Athens, Georgia, October 21–November 7

2004

Tim Rollins and K.O.S. (Kids of Survival), Kalamazoo Institute of Art, Kalamazoo, Michigan, January 17–March 7 (Workshop for *The Creation* with middle school students at Kalamazoo)

Creation Mythologies, Leonard Pearlstein Gallery, Drexel University, Philadelphia, Pennsylvania, February 4–February 27

The Creation (After Haydn), Workshop with Maine Seacoast Mission "EdGE" Youth Program and Millbridge Elementary School, Maine College of Art, Portland, Maine, March 5–March 7

Tim Rollins and K.O.S.: Large Scale Works, Carrie Secrist Gallery, Chicago, Illinois, June 4–July 2

Let There Be Light, Linda Schwartz Gallery, Cincinnati, Ohio, June 5–July 31

Tim Rollins and K.O.S.: War of the Worlds, White Box, New York, November 1–November 22

2005

Tim Rollins and K.O.S.: The Creation, Center for Maine Contemporary Art, Rockport, Maine, February 26–April 10

The Creation Project, Pyramid Atlantic Arts Center, Silver Springs, Maryland, March 29–May 24 (Workshop *Discoveries Through Reading as Process: Art as Content* with Pyramid Atlantic Arts Center, 2003–2004)

The Creation Folio, Edison Gallery, Washington, D.C., March 30–June 24; traveled to: Maryland Art Place, Baltimore, Maryland, January 10– March 4, 2006

On Music: Tim Rollins and K.O.S., Kreeger Museum, Washington, D.C., April 8–July 30

On the Nature of the Universe, Workshop with Benjamin Banneker High School at National Academy of Sciences, Washington, D.C., April 13–April 15

Freedomworks: Paintings by Tim Rollins and K.O.S., Fusebox Gallery, Washington, D.C., April 16– May 21

Celebrate the Future, Haydon Art Center, Lincoln, Nebraska, September 1–September 30

The Creation: Tim Rollins and K.O.S., Contemporary Art Center of Virginia, Virginia Beach, Virginia, September 15–October 30

Everyone is Welcome—For the People of Fargo, Federal Building and Post Office Mural, Workshop with Fargo youths, Fargo, North Dakota, October 4–October 8

Building the Beloved Community, Youth Art Connection Gallery, Atlanta, Georgia, November 3–December 16

2006

We See the Promised Land: Tim Rollins and K.O.S. with the Youth of Atlanta, Museum of Contemporary Art, Atlanta, Georgia, February 2–April 22

The Creation (after Haydn), New York Center for Arts and Media Studies, New York, February 10–March 10

New Works on Music, Galleria Raucci/Santamaria, Naples, Italy, February 24–March 31

2007

Tim Rollins and K.O.S.: 25 Years, Galerie Eva Presenhuber, Zürich, Switzerland, October 20–December 22

2008

King and Courage, Warehouse Gallery, Syracuse University, Syracuse, New York, February 19– April 5 (Workshop with Fowler and Nottingham High Schools, February 11– February 14)

Let There be Light: After the Creation by Franz Joseph Haydn, Clifford Art Gallery, Colgate University, Hamilton, New York, February 25– April 6

Metamorphosen, Galleria Raucci/Santamaria, Naples, Italy, October 3–December 19

Tim Rollins and K.O.S., Lehmann Maupin Gallery, New York, October 23–December 2

Tim Rollins and K.O.S., AMP, Athens, Greece, November 13–December 11

2009

On the Origin of the Species (after Darwin), National Academy of Sciences, Washington, D.C., February 2–June 15

Tim Rollins and K.O.S.: A History, The Frances Young Tang Teaching Museum and Art Gallery at Skidmore College, Saratoga Springs, New York, February 28–August 23; traveled to: Institute of Contemporary Art, University of Pennsylvania, Philadelphia, Pennsylvania, September 10–December 13, 2009; Frye Art Museum, Seattle, Washington, January 23– May 31, 2010

Selected Group Exhibitions

1982

The Atomic Salon, Ronald Feldman Fine Arts, New York, June 9–July 2

LA/NY Urban Activist Art, S.P.A.R.C., Los Angeles, California, June

1983

The 1984 Show, Ronald Feldman Fine Arts, New York, January 26–March 12

The War Show, University Art Gallery, State University of New York, Stony Brook, New York, March 22–April 29

Hundreds of Drawings, Artists Space, New York, December 10–January 14, 1984

Ansatzpunkte Kritischer Kunst Heute, Bonner Kunstverein, Bonn, Germany, December 10– January 29, 1984; traveled to: Neue Gesellschaft für Bildende Kunst, Berlin, Germany, February 7–March 11, 1984

Artists' Call, Brooke Alexander Gallery, New York

The State of the Art: The New Social Commentary, Gladstone Gallery, New York

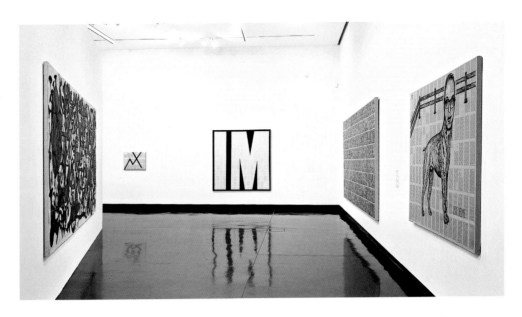

Installation view, The Frances Young Tang Teaching Museum and Art Gallery at Skidmore College, Saratoga Springs, New York, 2009

1984

Timeline: The Chronicle of U.S. Intervention in Central and Latin America, P.S.1 Contemporary Art Center, Long Island City, New York

A Decade of New Art, Artists Space, New York, May 31–June 30

Real Politik, Fashion Moda, South Bronx, New York, October 29–November 6

Art: For and Against, Thorpe Intermedia Gallery, Sparkill, New York

Identity and Illusion, Monika A. and Charles A. Heimbold, Jr. Visual Arts Center, Sarah Lawrence College, Bronxville, New York

Olympiad, Kantor Gallery, Los Angeles, California

1985

Disinformation: The Manufacture of Consent, Alternative Museum, New York, March 2– March 30

Public Art, Nexus Art Center, Atlanta, Georgia, November 22–December 21; traveled to: C.W. Woods Gallery, University of Southern Mississippi, Hattiesburg, Mississippi; McKissick Museum, University of South Carolina, Columbia, South Carolina; Trahern Gallery, Austin Peay State University, Clarksville, Tennessee; Valencia Community College, Orlando, Florida; North Carolina Museum of Art, Raleigh, North Carolina, August 16–October 19, 1986; University of the South Art Gallery, Sewanee, Tennessee

Social Studies, Gladstone Gallery, New York

1986

Lawrence Oliver Gallery, Philadelphia, Pennsylvania, May–June 30

Art And Its Double: A New York Perspective, Fundació la Caixa, Barcelona, Spain,

November 27–January 11, 1987; traveled to: Fundació la Caixa, Madrid, Spain, February 1987

Text and Image: The Wording of American Art, Holly Solomon Gallery, New York, December 11–January 3, 1987

for encima Del Bloqueo, Centro de Arte Contemporáneo Wilfredo Lam, Havana, Cuba

1987

Out of the Studio: Art with Community, P.S.1, Institute for Art and Urban Resources, Long Island City, New York, January 25–March 22

Perverted by Language, Hillwood Gallery, Long Island University, Greenvale, New York, February 11–March 6

A Different Corner, Definition and Redefinition— Painting in America, I Bienal Internacional de Pintura, Museo de Arte Moderno, Cuenca, Ecuador, April 24–July 24

Similia/Dissimilia: Modes of Abstraction in Painting, Sculpture, and Photography, Städtische Kunsthalle, Düsseldorf, Germany, August 29–September 25; traveled to: Sonnabend Gallery, New York; Leo Castelli Gallery, New York, December 5–December 22; Miriam & Ira D. Wallach Art Gallery, Columbia University, New York, December 4–January 30, 1988

Recent Tendencies in Black and White, Sidney Janis Gallery, New York, December 3–December 24

1988

NY Art Now, Saatchi Gallery, London, England, January–February

Committed to Print, Museum of Modern Art, New York, January 31–April 19

Aperto '88, La Biennale di Venezia, Venice, Italy, June 26–September 25

ROSC '88, Guinness Hop Store, St. James Gate and Royal Hospital Kilmainham, Dublin, Ireland, August 19–October 15

The BiNational: American Art of the late 80s, German Art of the Late 80s, Institute of Contemporary Art, Boston, Massachusetts, September 20–November 27; traveled to: Museum of Fine Arts, Boston Massachusetts, September 23–November 27; Kunstsammlung Nordrhein-Westfalen, Düsseldorf, Germany, September 24–November 27; Kunstverein für die Rheinlande und Westfalen, Düsseldorf, Germany, December 10–January 22, 1989

Constitution: Exhibit by New York Artists' Collective, Group Material, Temple University Art Gallery, Philadelphia, Pennsylvania, October 2– November 28

Art Against AIDS, Jay Gorney Modern Art, New York

The Beauty of Circumstance, Josh Baer Gallery, New York

Longwood Art Gallery, Bronx Council of the Arts, South Bronx, New York

1989

Horn of Plenty, Stedelijk Museum, Amsterdam, the Netherlands, January 14–February 19

The Bronx Celebrates: Word and Image, Lehman College Art Gallery, Bronx, New York, March 30–May 6

Oberlin Alumni Collect: Modern and Contemporary Art, Allen Memorial Art Museum, Oberlin College, Oberlin, Ohio, May 9–June 14

A Decade of American Drawing, 1980–1989, Daniel Weinberg Gallery, Los Angeles, California, July 15–August 26

Color and/or Monochrome: A Perspective on Contemporary Art, Tokyo Kokuritsu Kindai

Bijutsukan, Tokyo, Japan, September 30– November 26; traveled to: Kyoto Kokuritsu Kindai Bijutsukan, Kyoto, Japan, January 5– February 12, 1990

For 20 Years: Editions Schellmann, Museum of Modern Art, New York, November 13– March 13, 1990

A Good Read: The Book as a Metaphor, Barbara Toll Fine Arts, New York

1990

John Cage—Tim Rollins and K.O.S.: New Releases, Crown Point Press, New York, January 27– March 10

Price of Power, Museum of Contemporary Art, Cleveland, Ohio, February 1–April 21

Stripes, Barbara Krakow Gallery, Boston, Massachusetts, March 10–April 4

Insect Politics: Body Horror/Social Order, Hallwalls Contemporary Arts Center, Buffalo, New York, March 17–April 13

Mike Kelley, Tim Rollins and K.O.S., and Meyer Vaisman, Jay Gorney Modern Art, New York, May 12–June 2

The Decade Show: Frameworks of Identity in the 1980s, Studio Museum in Harlem, Museum of Contemporary Hispanic Art, and New Museum of Contemporary Art, New York, May 18–August 19

Word As Image: American Art 1960–1990, Milwaukee Art Museum, Milwaukee, Wisconsin, June 15–August 26; traveled to: Oklahoma Art Center, Oklahoma City, Oklahoma, November 17–February 2, 1991; Contemporary Arts Museum, Houston, Texas, February 23–March 12

Pharmakon '90, Nippon Convention Center, Makuhari Messe International Exhibition Hall, Tokyo, Japan, July 27–August 21

Art Meets Science and Spirituality in a Changing Economy, Museum Fodor, Amsterdam, the Netherlands, September–October

Aldo Rossi, Tim Rollins and K.O.S., Rhona Hoffman Gallery, Chicago, Illinois, October 4– November 2

Oh, Those Four White Walls!: The Gallery as Context, Atlanta College of Art, Atlanta, Georgia, October 8–November 14

Team Spirit, Neuberger Museum, State University of New York, Purchase, New York, October 14–January 6, 1991; traveled to: Cleveland Center for Contemporary Art, Cleveland, Ohio, February 1–March 29, 1991; Vancouver Art Gallery, Vancouver, British Columbia, Canada, May 25–July 28, 1991; Art Museum at Florida International University, Miami, Florida, September 13–October 11, 1991; Spirit Square Center for the Arts, Charlotte, North Carolina, March 6–May 3, 1992; Davenport Art Museum, Davenport, Iowa, June 7–July 26, 1992; Laumier Sculpture Park, St. Louis,

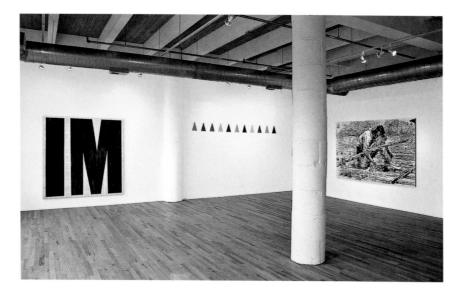

Installation view, Rhona Hoffman Gallery, Chicago, Illinois, 1999

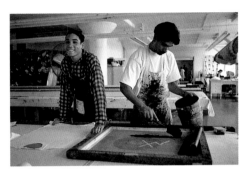

Fabric Workshop and Museum, Philadelphia, Pennsylvania, 1989

Missouri, August 29–October 24, 1992
Felix Gonzalez-Torres, Michael Jenkins, Tim Rollins and K.O.S, Jay Gorney Modern Art, New York, October 20–November 20
Language in Art, Aldrich Contemporary Art Museum, Ridgefield, Connecticut, October 20–January 7, 1991
3 Tage Umhausen, Umhausen, Austria
First Tyne International Exhibition of Contemporary Art, Hatton Gallery, Newcastle upon Tyne, England
Lawrence Oliver Gallery, Philadelphia, Pennsylvania
Sophie Calle, Tim Rollins and K.O.S., Stephen Prina, Trans Avant-Garde Gallery, San Francisco, California

1991
Reimaging America, Momenta Art, Philadelphia, Pennsylvania, January 3–February 2
Whitney Biennial 1991, Whitney Museum of American Art, New York, April 2–June 30
The Library of Babel: Books to Infinity, Hallwalls Contemporary Arts Center, Buffalo, New York, April 6–May 31
Words and Numbers, Robert and Elaine Stein Galleries at Wright State University, Dayton, Ohio, April 7–May 14
Trans-positions, University of South Florida Art Museum, Tampa, Florida, September 23–October 19
Burning in Hell, Franklin Furnace, New York, September 27–December 14
Devil on the Stairs: Looking Back on the Eighties, Institute of Contemporary Art, University of Pennsylvania, Philadelphia, Pennsylvania, October 4–January 5, 1992; traveled to: Newport Harbor Museum, Newport Beach, California, April 16–June 21, 1992
1991 Carnegie International, Carnegie Museum of Art, Pittsburgh, Pennsylvania, October 19–February 16, 1992 (Workshop for *The Temptation of Saint Antony—The Forms* with

Department of Education, Carnegie Museum of Art)
American Art of the 80s, Palazzo delle Albere, Trento, Italy, December 18–March 1, 1992

1992
Doubletake: Collective Memory and Current Art, Hayward Gallery, London, England, February 20–April 20; traveled to Kunsthalle Wien, Vienna, Austria, January 8–February 28, 1993
Quotations: The Second History of Art, Aldrich Contemporary Art Museum, Ridgefield, Connecticut, May 16–September 20; traveled to: Dayton Art Institute, Museum of Contemporary Art at Wright State University, Dayton, Ohio, October 18–November 25
The Power of the City/The City of Power, Whitney Museum of American Art Downtown at Federal Reserve Plaza, New York, May 19–July 10
Malcolm X: Man, Ideal, Icon, Walker Art Center, Minneapolis, Minnesota, December 12–April 4, 1993; traveled to: Institute of Contemporary Art, Boston, Massachusetts, July 14–October 17, 1993; Detroit Institute of Arts, Detroit, Michigan, December 5, 1993–February 27, 1994; Anacostia Museum, Washington, D.C., April 1–June 1, 1994; Nexus Contemporary Art Center, Atlanta, Georgia, June 26–August 15, 1994; Yerba Buena Center for Contemporary Art, San Francisco, California, September 4– October 15, 1994

1993
Die Sprache der Kunst [The Language of Art], Kunsthalle Wien, Vienna, Austria, September 3–October 17

1994
Public Interventions, Institute of Contemporary Art, Boston, Massachusetts, April 24–July 17
Black Male: Representations of Masculinity in Contemporary American Art, Whitney Museum of American Art, New York, November 10–March 5, 1995; traveled to: Armand Hammer Museum of Art and Culture, University of California, Los Angeles, California, April 25–June 18, 1995
Gewalt/Geschäfte [Violence/Business], Neue Gesellschaft für BBildende Kunst, Berlin, Germany, December 10–February 17, 1995

1995
Zeichen & Wunder [Signs & Wonders], Kunsthaus Zürich, Zürich, Switzerland, March 31–June 18; traveled to: Centro Galego de Arte Contemporánea, Santiago de Compostela, Spain, July 20–October 20
Word for Word, Beaver Collage Art Gallery [now Arcadia University Art Gallery], Glenside, Pennsylvania, September 14–October 25

1996
Imagined Communities, Oldham Art Gallery, Oldham, England, January 27–March 24; traveled to: John Hansard Gallery, University of Southampton, Southampton, England, April 9–May 18; Firstsite at the Minories, Colchester, England, May 25–July 3; Walsall Museum and Art Gallery, Walsall, England, July 10–August 25; Royal Festival Hall, London, England, September 7–October 27; Gallery of Modern Art, Glasgow, Scotland, December 6–February 16, 1997

Installation view, Galleria Raucci/Santamaria, Naples, 2002

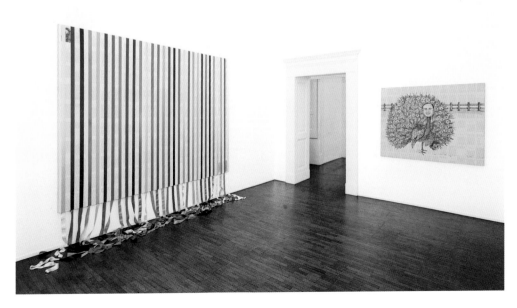

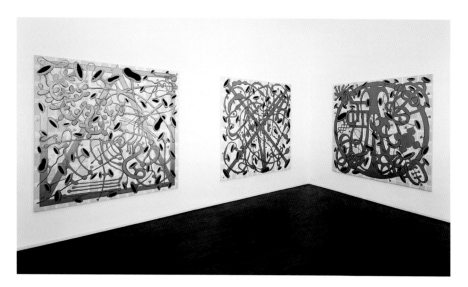

Installation view, Galleria Raucci/Santamaria, Naples, 2002

Deformations: Aspects of the Modern Grotesque, Museum of Modern Art, New York, February 10–May 21

Cultural Economies: Histories from the Alternative Arts Movement, Drawing Center, New York, February 24–April 6

Bronx Spaces, Longwood Arts Project/Bronx Council on the Arts, Bronx Museum of the Arts, Bronx, New York, March 8–June 23

Youth Matters, Castellani Art Museum, Niagara University, Niagara, New York, April 21–June 9; traveled to: Centre Gallery, Miami-Dade Community College, Miami, Florida, August–October 25

Thinking Print, Museum of Modern Art, New York, June 20–September 10

1997

More Than One: Twentieth Century Print Portfolios, Museum of Modern Art, New York, May 16–September 2

The Hirshhorn Collects: Recent Acquisitions 1992–1996, Hirshhorn Museum and Sculpture Garden, Smithsonian Institution, Washington, D.C., June 4–September 9

Coming Home Again, School of Visual Arts Gallery, New York, November 6–November 29

The Dual Muse: The Writer as Artist, the Artist as Writer, Washington University Gallery of Art [now Mildred Lane Kemper Art Museum], St. Louis, Missouri, November 7–December 21

1998

The Rights of Spring, PPOW, New York, May 2–May 30

Beyond Borders: Two Portfolios by Robert Ryman and Tim Rollins and K.O.S., Williams College Museum of Art, Williamstown, Massachusetts, July 18–January 3, 1999

Points of Departure: Art on the Line, Main Line Art Center, Haverford, Pennsylvania, 1998–June 2001 (Workshop)

1999

Fast Forward—Borderline, Kunstverein, Hamburg, Germany, January 28–March 28

Art at Work: Forty Years of the Chase Manhattan Collection, Contemporary Arts Museum, Houston, Texas, March 3–May 2; traveled to: Queens Museum of Art, Queens, New York, May 16–October 1, 2000

Dream City, Kunstraum, Kunstverein, Museum Villa Stück, Munich, Germany, March 25–June 20 (Workshop for *I See the Promised Land* with Munich public schools, Siemens Kulturprogram and the Munich Kunstverein)

Urban Mythologies, Bronx Museum of the Arts, Bronx, New York, April 7–September 5

Almost Warm and Fuzzy: Childhood and Contemporary Art, Des Moines Art Center, Des Moines, Iowa, September 12–November 21 (Workshop with Des Moines Art Center, PACE Youth Program); traveled to: Tacoma Art Museum, Tacoma, Washington, July 7–September 17, 2000; Scottsdale Museum of Contemporary Art, Scottsdale, Arizona, October 6, 2000–January 14, 2001; P.S.1 Contemporary Art Center, Long Island City, New York, February 4–April 8, 2001; Fundació la Caixa, Barcelona, Spain, April 26–July 8, 2001; Crocker Art Museum, Sacramento, California, August 30–November 4, 2001; Art Gallery of Hamilton, Ontario, Canada, November 24, 2001–January 20, 2002; Memphis Brooks Museum of Art, Memphis, Tennessee, June 2–July 28, 2002; Cleveland Center for Contemporary Art, Cleveland, Ohio, September 13–November 17, 2002

The American Century: Art & Culture 1900–2000, Part II: 1950–2000, Whitney Museum of American Art, New York, September 26–February 13, 2000

MCM-Y2K: A Century of Art on Paper, Des Moines Art Center, Des Moines, Iowa, December 11–February 13, 2000

Recent Acquisitions, Tate Gallery, London, England

Installation view, Galerie Eva Presenhuber, Zurich, 2007

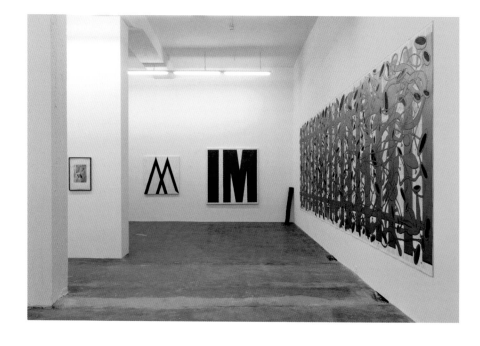

2000

Collection in Context, Studio Museum in Harlem, New York, March 1–May

Collective Art Practice, Les Abattoirs: Musée d'art moderne et contemporain, Toulouse, France, June 24–October 15 (Workshop for *I See the Promised Land*)

Tetrasomia, Dia Art Foundation, New York, September 14–November 9

Celebrating 75 Years—Permanent Change: Contemporary Works from the Collection, Williams College Museum of Art, Williamstown, Massachusetts, December 11–April 22, 2001

2001

Real Time, Salina Art Center, Salina, Kansas, January 29–April 21 (Workshop March 5–March 10)

Art as prayer, Cooper Union Gallery, New York, March

Collaborations with Parkett: 1984 to Now, Museum of Modern Art, New York, April 5–June 5

Le Tribu' Dell'Arte, Galleria d'Arte Moderna e Contemporanea, Rome, Italy, April 24–October 7

2002

In the Spirit of Martin: The Living Legacy of Dr. Martin Luther King, Jr., Charles H. Wright Museum of African American History, Detroit, Michigan, January 12–August 4; traveled to: Bass Museum of Art, Miami Beach, Florida, September 7–November 9; Frederick R. Weisman Art Museum, Minneapolis, Minnesota, January 4–April 6, 2003; International Gallery, Smithsonian Institution, Washington, D.C., May 15–July 27, 2003; Memphis Brooks Museum of Art, Memphis, Tennessee, August 30–November 9, 2003; Montgomery Museum of Fine Arts, Montgomery, Alabama, December 20, 2003–March 28, 2004

Material World: From Lichtenstein to Viola 25 Years of The Fabric Workshop and Museum, Museum of Contemporary Art, Sydney, Australia, February 28–April 28

Collecting Contemporary Art—A Community Dialogue, Ackland Art Museum, Chapel Hill, North Carolina, March 10–April 7

Large Scale, Baumgartner Gallery, New York, June–July 29

Fast Forward II, Berkeley Art Museum, University of California, Berkley, California, June 19–February 9, 2003

Plotting, Carrie Secrist Gallery, Chicago, Illinois, September 13–October 12

2003

Il Quarto Sesso. Il Territorio Estremo Dell'Adolescenza, Stazione Leopolda, Florence, Italy, January 9–February 9

Representing Slavery, Williams College Museum of Art, Williamstown, Massachusetts, September 13–December 21

Crimes and Misdemeanors, Contemporary Arts Center, Cincinnati, Ohio, November 22–November 21, 2004

2004

Media Comm(unity)/Comm.medium: Divenire Comunità Oltre il Mezzo: l'Opera Diffusa [Becoming Community Over Half: The Work Widespread], Museo Masedu, Sassari, Italy, February 28–May 28

Revelation: A Fresh Look at Contemporary Collections, Mint Museum of Art, Charlotte, North Carolina, May 29–September 19

Werke, die wir immer schon (wieder) gerne sehen wollten [Work that We Always (Again) Like to See Wanted], Elisabeth Kaufmann, Zürich, Switzerland, December 4–January 8, 2005

Monument, Tate Gallery, London, England

2005

Collection Remixed, Bronx Museum of the Arts, Bronx, New York, February 3–May 29

Magic Gardens, Kidspace at MASS MoCA, North Adams, Massachusetts, March 31–September 5 (Workshop with 4-8 grade students at North Berkshire School Union, March)

25 Years Baumgartner Gallery: Selected Solo Exhibitions, Part Two, Baumgartner Gallery, New York, September 9–October 12

Beautiful Dreamer, Spaces, Cleveland, Ohio, September 9–October 23

In Private Hands: 200 Years of American Painting, Pennsylvania Academy of Fine Arts Museum, Philadelphia, Pennsylvania, October 1–January 8, 2006

Flashback: Revisiting the Art of the Eighties, Museum für Gegenwartskunst, Basel, Switzerland, October 29–February 11, 2006

Looking at Words, Andrea Rosen Gallery, New York, November 2–December 31

2006

Collaboration as a Medium: 25 Years of Pyramid Atlantic, Maryland Art Place, Baltimore, Maryland, January 10–March 4

The Downtown Show: The NY Arts Scene 1974–1984, Grey Art Gallery, New York University, New York, January 10–April 1; traveled to: Andy Warhol Museum of Art, Pittsburgh, Pennsylvania, May 20–September 3

Whitney Biennial 2006: Day for Night (included in "Down By Law" curated by the Wrong Gallery), Whitney Museum of American Art, New York, March 2–May 28

reverence, Hudson Valley Center for Contemporary Art, Peekskill, New York, May 20–September 21

The Gold Standard, P.S.1 Contemporary Art Center, Long Island City, New York, October 29–January 15, 2007

MECA Prints: Master Editions and Public Actions, Institute of Contemporary Art at Maine College of Art, Portland, Maine, November 22–February 4, 2007

Notations: Out of Words, Philadelphia Museum of Art, Philadelphia, Pennsylvania, November 24–June 24, 2007

2007

Commemorating 30 Years Part II: 1980–1990, Rhona Hoffman Gallery, Chicago, Illinois, April 13–May 12

Commemorating 30 Years Part III: 1991–2007, Rhona Hoffman Gallery, Chicago, Illinois, May 18–June 22

Repicturing the Past/Picturing the Present, Museum of Modern Art, New York, June 13–November 5

What is Painting? Contemporary Art from the Collection, Museum of Modern Art, New York, July 7–September 17

Stripes, The Frances Young Tang Teaching Museum and Art Gallery at Skidmore College, Saratoga Springs, New York, August 4–December 30

Exhibitionism: An Exhibition of Exhibitions of Works from the Marieluise Hessel Collection, Hessel Museum of Art, Center for Curatorial Studies and Art in Contemporary Culture, Bard College, Annandale-on-Hudson, New York, October 20–February 17, 2008

2008

You & Me, Sometimes, Lehmann Maupin Gallery, New York, March 20–May 3

As Láthair/Off Site, Irish Museum of Modern Art, Dublin, Ireland, May 1–May 11

Contemporary Collaborations: Artist and Master Printer, Portland Museum of Art, Portland, Maine, May 24–August 10

2009

Chelsea Visits Havana, Museo Nacional de Bellas Artes, Havana, Cuba, March 27–April 20

SELECTED BIBLIOGRAPHY

Books, Exhibition Catalogues, and Brochures

Aperto '88: XLIII Esposizione Internazionale d'Arte. Exh. cat. Venice: La Biennale di Venezia, 1988.

Art and Its Double: A New York Perspective. Exh. cat. Barcelona: Fundació Caixa de Pensions, 1986.

Atkinson, Dennis, and Paul Dash. *Social and Critical Practices in Art Education.* Stoke-on-Trent, England: Trentham, 2005. Essay by Tim Rollins.

Barnes, Lucinda. *Between Artists: Twelve Contemporary American Artists Interview Twelve Contemporary American Artists.* Los Angeles: A.R.T. Press, 1996. Félix González-Torres interviewed by Tim Rollins.

Belli, Gabriella, and Jerry Saltz. *American Art of the 80's.* Exh. cat. Milan: Electa, 1991.

Berry, Ian, ed. *Tim Rollins and K.O.S.: A History.* Exh. cat. Cambridge, Massachusetts: The Frances Young Tang Teaching Museum and Art Gallery at Skidmore College and MIT Press, 2009. Essays by Julie Ault, Susan Cahan, David Deitcher, Eleanor Heartney, Lawrence Rinder, and James Romaine. Interview with Tim Rollins by Ian Berry.

Bonito Oliva, Achille. *Art Tribes.* Exh. cat. Milan: Skira Editore, 2002. Essay by Alessandra Galletta.

Bowman, Russell, and Dean Sobel. *Word As Image: American Art, 1960–1990.* Exh. cat. Milwaukee, Wisconsin: Milwaukee Art Museum, 1990.

Brown, Kathan. *Ink, Paper, Metal, Wood: Painters and Sculptors at Crown Point Press.* Exh. cat. San Francisco: Chronicle Books, 1996.

Cahan, Susan, Felix Gonzalez-Torres, Tim Rollins, and Jan Avgikos. *Felix Gonzalez-Torres.* Los Angeles: A.R.T. Press, 1993.

Cameron, Dan. *NY Art Now: The Saatchi Collection.* Exh. cat. Milan: Giancarlo Politi Editore, 1987.

Catalogue Raisonné: Collection of Contemporary Art Fundación "La Caixa." Exh. cat. Barcelona: Fundación "La Caixa," 2002.

Cathcart, Linda L. *Artists Space: A Decade of New Art.* Exh. cat. New York: Committee for the Visual Arts, 1984.

A Celebration of the Spirit. Exh. cat. Oklahoma City: Oklahoma Arts Institute, 1997.

Chassman, Gary Miles. *In the Spirit of Martin: The Living Legacy of Dr. Martin Luther King, Jr.* Exh. cat. Atlanta, Georgia: Tinwood Books, 2002.

Collection Remixed. Exh. cat. Bronx, New York: Bronx Museum of the Arts, 2005. Essays by Marysol Nieves, Lydia Yee, Amy Rosenblum Martín, Antonio Sergio Bessa, Olivia Georgia, and Erin Salazar.

Cooke, Lynne, Bice Curiger, and Greg Hilty. *Doubletake: Collective Memory & Current Art.* Exh. cat. London: South Bank Centre and Parkett, 1992.

Cooke, Lynne, and Mark Francis. *Carnegie International 1991.* Exh. cat. Pittsburgh, Pennsylvania: Carnegie Museum of Art, 1991.

Courtney, Julie. *Points of Departure: Art on the Line.* Exh. cat. Haverford, Pennsylvania: Main Line Art Center, 2001.

The Creation: Tim Rollins and K.O.S. at Pyramid Atlantic. Exh. cat. Silver Spring, Maryland: Pyramid Atlantic Arts Center, 2005.

Crone, Rainer, ed. *Similia/Dissimilia.* Exh. cat. New York: Rizzoli, 1988.

Cruz, Amada, and Tim Rollins. *Tim Rollins and K.O.S.: Animal Farm.* Exh. brochure. Washington, D.C.: Hirshhorn Museum and Sculpture Garden, Smithsonian Institution, 1992.

Curiger, Bice, ed. *Zeichen & Wunder: Niko Pirosmani (1862–1918) und die Kunst der Gegenwart* [Signs & Wonders: Niko Pirosmani (1862–1918) and Recent Art]. Küsnacht, Switzerland: Cantz Verlag, 1995.

Danto, Arthur Coleman. *Embodied Meanings: Critical Essays & Aesthetic Meditations.* New York: Farrar, Straus & Giroux, 1994.

Documents. 01–06. Dublin: City Arts Centre, 2003.

Doss, Erika Lee. *Twentieth-Century American Art.* Oxford: Oxford University Press, 2002.

Dream City: Ein Münchner Gemeinschaftsprojekt. Exh. cat. Berlin: Vice Versa, 1999.

Drucker, Johanna, and William H. Gass. *Dual Muse: The Writer as Artist, the Artist as Writer.* Exh. cat. St. Louis: Gallery of Art and International Writers Center, Washington University; Philadelphia: John Benjamins Pub., 1997.

Elwood, Sean, ed. *The 1984 Show.* Exh. cat. New York: Ronald Feldman Fine Arts and Village Voice, 1984.

Ferguson, Russell, ed. *Discourses: Conversations in Postmodern Art and Culture.* New York: New Museum of Contemporary Art; Cambridge, Massachusetts: MIT Press, 1990.

Il Foro Internacional de Teoría Sobre Arte Contemporáneo. Guadalajara, Mexico: Fomento Arte Contemporáneo, 1994.

Foster, Tonya, and Kristin Prevallet, eds. *Third Mind: Creative Writing through Visual Art.*

Installation view, Galerie Eva Presenhuber, Zurich, 2007

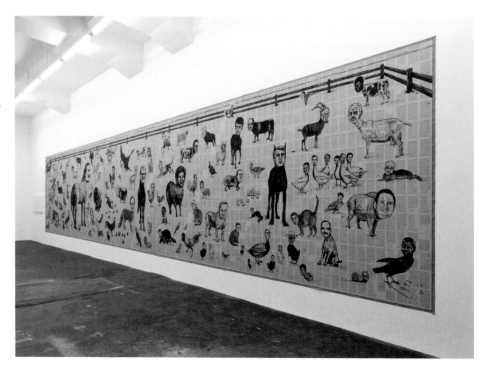

ACHILLES AND ODYSSEUS (AFTER HOMER), 2001
Bronze, marble, granite
Horizon Juvenile Center, 560 Brooke Avenue,
Bronx, New York
Commissioned by the City of New York Department
of Juvenile Justice, the Department of Design and
Construction and the Department of Cultural Affairs
Percent for Art Program

New York: Teachers & Writers Collaborative, 2002. Essay by Michele Wallace.

Garrels, Gary, ed. *Amerika: Tim Rollins and K.O.S.* Exh. cat. New York: Dia Art Foundation, 1989. Essays by Gary Garrels, Michele Wallace, and Arthur Coleman Danto.

Gewalt/Geschafte [Violence/Business]. Exh. cat. Berlin: Neue Gesellschaft für Bildende Kunst, 1994.

Goodman, Robin F., and Andrea Henderson. *The Day Our World Changed: Children's Art of 9/11.* Exh. cat. New York: New York University Child Study Center, Museum of the City of New York, 2002.

Götz, Stephan, Craigen W. Bowen, and Katherine Oliver. *American Artists in Their New York Studios: Conversations About the Creation of Contemporary Art.* Cambridge, Massachusetts: Center for Conservation and Technical Studies, Harvard University Art Museums; Stuttgart, Germany: Daco-Verlag Günter Bläse, 1992.

Grant, Daniel. *Selling Art Without Galleries: Toward Making a Living from Your Art.* New York: Allworth Press, 2006.

Heartney, Eleanor. *Art & Today.* London: Phaidon Press, 2008.

———. *City Art: New York's Percent for Art Program.* London: Merrell, 2005.

Heartney, Eleanor, Aldo Rossi, and Tim Rollins. *Aldo Rossi, Tim Rollins and K.O.S.* Exh. cat. Chicago: Rhona Hoffman Gallery, 1991.

Herman, Edward S., and Noam Chomsky.

Disinformation: The Manufacture of Consent. Exh. cat. New York: Alternative Museum, 1984.

Hylton, Richard, ed. *Imagined Communities.* Exh. cat. London: Hayward Gallery, 1995. Essay by Kobena Mercer.

Jochimsen, Margarethe. *Ansatzpunkte Kritischer Kunst Heute* [Points of Departure of Critical Art Today]. Exh. cat. Bonn, Germany: Der Kunstverein, 1983.

Joselit, David. *Currents: Tim Rollins and K.O.S.* Exh. brochure. Boston: Institute of Contemporary Art, 1988.

Kaiser, Philipp. *Flashback: Eine Revision der Kunst der 80er Jahre* [Revisiting the Art of the 80s]. Basel: Kunstmuseum Basel, Museum für Gegenwartskunst; Ostfildern-Ruit, Germany: Hatje Cantz, 2005.

Leigh, Christian, ed. *A Different Corner: Definition and Redefinition, Painting in America.* Exh. cat. Cuenca, Ecuador: Museo de Arte Moderno, 1987.

Lewallen, Constance. *Tim Rollins and K.O.S.* San Francisco: Point Publications, 1990.

Linenthal, Edward Tabor. *The Unfinished Bombing: Oklahoma City in American Memory.* Oxford: Oxford University Press, 2001.

Lippard, Lucy. *Get the Message?: A Decade of Art for Social Change.* New York: E.P. Dutton, 1984.

Malchiodi, Cathy A. *The Art Therapy Sourcebook.* Los Angeles: Lowell House, 1998.

Mapplethorpe, Robert. *Splash: Isabella Rossellini, Robert Mapplethorpe, Vito Acconci, Tim Rollins and K.O.S., Ross Bleckner.* New York: Crandall Enterprises, 1988.

Margolis, Nancy H, ed. *Tim Rollins and K.O.S.: The Red Badge of Courage.* Exh. cat. Winston-Salem, North Carolina: Southeastern Center for Contemporary Art, 1994. Essays by Susan Lubowsky, Bruce Lineker, Terri Dowell-Dennis, and Tim Rollins.

McGrady, Patrick. *Tim Rollins and K.O.S.: A Paper Retrospective.* Exh. cat. University Park, Pennsylvania: Palmer Museum of Art, Pennsylvania State University, 1998.

Nickas, Robert. *The Art of the Real.* Exh. cat. Geneva: Galerie Pierre Huber, 1987.

———. *Perverted by Language.* Exh. cat. Greenvale, New York: Hillwood Art Gallery, Long Island University, 1987.

Oeri, Maja, and Theodora Vischer. *Emanuel Hoffmann-Stiftung Basel.* Basel: Wiese Verlag, 1991.

Osaki, Hitoshi, and Tadao Ogura. *Shikisai to monokuromu: gendai bijutsu e no shiten* [Color and/or Monochrome: A Perspective on Contemporary Art]. Exh. cat. Tokyo: Tokyo Kokuritsu Kindai Bijutsukan, 1989.

Osman, Jena, and Juliana Spahr, eds. *Chain 9: Dialogue.* New York: 'A 'A Arts, 2002. Essay by Tim Rollins and K.O.S.

The Other America. Exh. cat. London: Royal Festival Hall, 1985.

Paley, Nicholas. *Finding Art's Place: Experiments in Contemporary Education and Culture.* New York: Routledge, 1995.

Papastergiadis, Nikos, ed. *Annotations 1: Mixed Belongings and Unspecified Destinations.* London: Institute of International Visual Arts and John Hansard Gallery, 1996.

Patterson, Vivian, and Mark Reinhardt. *Representing Slavery.* Exh. brochure. Williamstown, Massachusetts: Williams College Museum of Art, 2003.

Perretta, Gabriele. *Media Comm(unity)/Comm. medium: Divenire Comunità Oltre il Mezzo: l'Opera Diffusa.* Exh. cat. Milan: Mimesis, 2004. Interview by Antonio Caronia and essay by Walter Benjamin.

Plotting: A Survey Exhibition of Artists' Studies. Exh. cat. Chicago: Carrie Secrist Gallery, 2002.

Retorno al País de las Maravillas: El Arte Contemporáneo y La Infancia. Exh. cat. Barcelona: Fundació Caixa d'Estalvis I Pensions, 2001.

Rinder, Lawrence. *Viewpoints: Tim Rollins and K.O.S.* Exh. cat. Minneapolis: Walker Art Center, 1988.

Rollins, Tim and K.O.S. *Prometheus Bound: A Work of Art for the Web,* <http://www.diacenter. org/kos>. Dia Center for the Arts, New York, September 18, 1997.

———. *The Temptation of Saint Antony, XV–XXXIV: The Solitaires.* San Francisco: Crown Point Press, 1990. Essay by Kitty Mrosovsky and text by Gustave Flaubert.

———. *Tim Rollins and K.O.S.: The Temptation of Saint Antony, 1987–1990.* Exh. cat. Basel: Museum für Gegenwartskunst, 1990. Essay by Dieter Koepplin. Dialogue with Tim Rollins and K.O.S.

Romaine, James. *Art as Prayer.* Exh. brochure. New York: International Arts Movement and the Center of Faith and Art, 2001.

———. *Objects of Grace: Conversations on Creativity and Faith.* Baltimore: Square Halo Books, 2002.

ROSC '88. Exh. cat. Dublin, Ireland: ROSC '88, 1998.

Ross, David, Jürgen Harten, Trevor Fairbrother, David Joselit, and Elisabeth Sussman. *The BiNational: American Art of the Late 80s, German Art of the Late 80s.* Exh. cat. Boston: Institute of Contemporary Art and Museum of Fine Arts; Cologne, Germany: DuMont Buchverlag, 1988.

Saltz, Jerry. *Recent Tendencies in Black and White.* Exh. cat. New York: Sidney Janis Gallery, 1987.

———, ed. *Beyond Boundaries: New York's New Art.* New York: Alfred van der Marck Editions, 1986. Essays by Peter Halley and Roberta Smith.

Sandler, Irving. *Art of the Postmodern Era: From the Late 1960s to the Early 1990s.* New York: IconEditions, 1996.

Siegel, Jeanne. *Coming Home Again.* Exh. cat. New York: School of Visual Arts Gallery, 1997.

Sollins, Susan, and Nina Sundell. *Team Spirit.* Exh. cat. New York: Independent Curators Inc., 1990.

Storr, Robert, and Judith Tannenbaum. *Devil on the Stairs: Looking Back at the Eighties.* Exh. cat. Philadelphia: Institute of Contemporary Art, University of Pennsylvania, 1991.

Talbott, Susan Lubowsky, and Lea Rosson DeLong. *Almost Warm and Fuzzy: Childhood and Contemporary Art: Activity Book for Kids.* Des Moines, Iowa: Des Moines Art Center, 1999.

Tejada, Roberto. *Tim Rollins and K.O.S.* Exh. cat. Mexico City: Fundación para el Arte Contemporáneo, 1993.

Tim Rollins and K.O.S. Exh. cat. Hartford, Connecticut: Wadsworth Atheneum Museum of Art, 1990.

Tim Rollins and K.O.S. Exh. cat. London: Riverside Studios, 1988.

Tim Rollins and K.O.S.: Purple with Love's Wound. Exh. cat. Charlottesville, Virginia: University of Virginia Art Museum, 2003.

Wakabayashi, Isamu. *Tokyo Kokuritsu Kindai Bijutsukan Shozohin Mokuroku* [Catalogue of Collections, the National Museum of Modern Art, Tokyo]. Tokyo: Tokyo Kokuritsu Kinda Bijutsukan, 1994.

Wright, Esther. *Kids of Survival: The Life and Art of Tim Rollins and K.O.S.: A Facilitator's Guide to the Video Series.* Bloomington, Indiana: National Education Service, 1997.

Articles and Reviews

Abbe-Martin, Mary. "Bronx Artist Directs Local Student Effort." *Star and Tribune* (8 January 1988).

Adams, Brooks. "Kids at Work." *Interview* (December 1989).

Artman, Deborah. "The Beauty of Survival: Tim Rollins and K.O.S." *Lincoln Center Theater Review,* no. 8 (Summer 2004): 18.

Artner, Alan G. "Kids' Artistic View of Books a Noble Effort." *Chicago Tribune* (13 November 1987).

Auping, M., P. Morrin, D. E. Brookhardt, M. Kahan, and R. Jones. "(Untitled)." *Art Papers* 7, no. 4 (July/August 1983): 2–23.

Ayers, Robert. "Tim Rollins and K.O.S.: Lehmann Maupin." *ARTnews* 108, no. 1 (January 2009): 117.

Baker, Kenneth. "Inner-City Kids in Explosive Collaboration." *San Francisco Chronicle* (4 February 1990): 14.

———. "Temptation." *Artforum* (October 1990): 125–132.

Barrio-Garay, Jose Luis. "Tim Rollins y K.O.S." *Goya* (July 1992): 105.

Bass, Ruth. "Tim Rollins and K.O.S." *ARTnews* 91 (October 1992): 128.

Beard, Steve. "Proust in Five Minutes." *Artscribe* (March 1990).

Berman, Marshall. "Can These Ruins Live?" *Parkett,* no. 20 (June 1989): 42–55.

Biles, Jan. "Artistic Explosion." *Lawrence Journal-World* (19 February 2002).

Bolin, Paul E. "We Are What We Ask." *Art Education* 49, no. 5 (September 1996): 6–10.

Bracewell, Michael. "Beyond These Four Walls." *London* (13 February 1996): 9.

Bradt, George. "Kids to Work with Artist." *Bridgton News* (20 April 2006).

———. "They're on Fire Today!" *Bridgton News* (4 May 2006).

Bredin, Lucinda. "A Touch of Art Class." *London Evening Standard* (28 July 1988).

Brenson, Michael. "Art: Out of the Studio, Community Settings." *New York Times* (6 February 1987): C23.

———. "Reviews/Art; Tim Rollins and K.O.S. at Jay Gorney Modern Art." *New York Times* (12 May 1989): C28.

Brooks, Rosetta. "Tim Rollins and K.O.S. (Kids of Survival)." *Artscribe International,* no. 63 (May 1987): 40–47.

Buck, Louise. "Survival Art." *Arena* (December 1989).

Burchard, Hank. "Political Animals on Parade." *Washington Post* (18 September 1992): Weekend Section, 61.

Cameron, Dan. "Against Collaboration." *Arts Magazine* 58, no. 7 (March 1984): 83–87.

———. "Art and Its Double – A New York Perspective." *Flash Art,* no. 134 (May 1987): 57–72.

———. "The Art of Survival: A Conversation with Tim Rollins and K.O.S." *Arts Magazine* 62, no. 10 (June 1988): 80–83.

———. "Group Material Talks to Dan Cameron." *Artforum* 41, no. 8 (April 2003): 198–199.

Campitelli, Maria. "Tim Rollins and K.O.S." *Juliet Art Magazine* (June 1989).

Cano Carreton, Vicente. "Tim Rollins y K.O.S.: El Arte a Frente a la Marginacion Social." *Vogue España* (December 1988).

Colsman-Freyberger, Heidi. "Tim Rollins and K.O.S." *Rokugatsu No Kaze* (August 1992): 20–23.

Cullum, Jerry. "Literary Agents." *Access Atlanta* (2 March 2006).

Cyphers, Peggy. "Tim Rollins and K.O.S." *Arts Magazine* (January 1990): 94.

Danto, Arthur. "Art: Tim Rollins and K.O.S." *Nation* 250, no. 3 (22 January 1990): 100–105.

Dawson, Jessica. "Tim Rollins and K.O.S., Scoring with Teamwork." *Washington Post* (5 May 2005): C05.

Decker, Andrew. "The 1991 Whitney Biennial: Provocation and Beauty." *Vis a Vis* (May 1991): 22.

Decter, Joshua. "Tim Rollins and K.O.S.: The Workshop has Survived Because We Love Each Other." *Flash Art,* no. 150 (January/February 1990): 89–93.

Deitcher, David, and Tim Rollins. "Tim Rollins Talks to David Deitcher." *Artforum* 41, no. 8 (April 2003): 78–79, 237.

Di Mattia, Joseph. "Tim Rollins' Survival Course." *Art Papers* 7, no. 6 (February 1988): 11.

Dominguez, Robert. "His 'Art' Is in Right Place." *Daily News* (6 September 1996): 66.

Donohoe, Victoria. "A Palette of Four Fresh Talents." *Philadelphia Enquirer* (30 May 1986).

Doss, Erika. "Witnessing the Beloved Community: Tim Rollins and K.O.S." *College Art Association* (25 February 2000).

Fairbrother, Trevor. "We Make Art in the Future Tense." *Parkett,* no. 20 (June 1989): 74–91.

Faust, Gretchen. "Tim Rollins and K.O.S." *Arts Magazine* (September 1989): 94.

Fisher, Jean. "Tim Rollins and Kids of Survival." *Artforum* 25, no. 5 (January 1987): 111.

Gablik, Suzi. "Making Art As If the World Mattered: Some Models of Creative Partnership." *Utne Reader* (July 1989).

Galdieri, Francesco. "Tim Rollins and K.O.S." *Tema Celeste* (July/September 2001).

Ganahl, Jane. "Helping Kids Find a Life through Creating Art." *San Francisco Examiner* (12 April 1996): D3.

———. "Opening Young Minds to Art." *San Francisco Examiner* (13 January 1998): C1.

Gayford, Martin. "Good News from the Battlefield." *London Sunday Telegraph* (15 August 1998).

Giovanni, Joseph. "Beacon of Hope." *Harper's Bazaar,* no. 3383 (October 1993): 183.

Glueck, Grace. "Art and Survival in the South Bronx." *San Francisco Chronicle* (27 November 1988): 5.

———. "Social Studies." *New York Times* (28 June 1985).

———. "Survival Kids Transform Classics to Murals." *New York Times* (13 November 1988): 1, 42.

Golub, Adrienne M. "Layers: Between Science and Imagination; Tim Rollins and K.O.S.: Kids Across America: Contemporary Art Museum, University of South Florida, Tampa." *Art Papers* 22, no. 4 (July/August 1998): 36.

Gookin, Kirby. "Tim Rollins and K.O.S." *Artforum* 28, no. 2 (October 1989): 170–171.

Gragg, Randy. "The Art of Learning." *Seattle Times* (22 August 2000).

Graham-Dixon, Andrew. "From the Bronx to Hammersmith: Tim Rollins and K.O.S. Beyond Child's Play." *London Independent* (26 July 1988): 15.

Hall, David. "Memphis, Tennessee." *Art Papers* 27, no. 1 (January/February 2003): 36.

———. "Rollins' Band." *Memphis Flyer* (23–29 November 2000).

Hambright, Christy. "Healing Art." *Winston-Salem Journal* (28 March 1994): 8–9.

Heartney, Eleanor. "Alternative America." *Art in America* 84, no. 6 (June 1996): 34–37.

———. "Public Discourse, Private Interests and the Public Street." *Art Papers* 16, no. 2 (March/April 1992): 14–17.

———. "The Treacherous Library: Recent Book Art." *Sculpture* 10, no. 5 (September/October 1991): 46–51.

Helfand, Glen. "AIDS Reality Enters Art: Group Material Stages AIDS Timeline at Berkeley." *Artweek* (30 November 1989).

———. "Radical Art Survives the Bronx in Style." *San Francisco Weekly* (17 October 1990): 1, 13–14.

Hershkovits, David. "The Kids Are Alright." *Paper* (September 1991): 18–19.

Hess, Elizabeth. "Burning Issues." *Village Voice* (29 March 1988).

———. "Class Conscious." *Village Voice* (25 November 1986): 92.

———. "Graffiti R.I.P." *Village Voice* (22 December 1987).

Heymer, Kay. "Tim Rollins and K.O.S." *Tema Celeste* (October 1989): 74.

Hilton, Tim. "Holding Up a Mirror." *London Guardian* (27 July 1988).

———. "Kid's Stuff." *London Guardian* (3 August 1988).

Hixson, Kathryn. "Tim Rollins and K.O.S." *Arts Magazine* (January 1992): 89–90.

Howard, Melanie. "Museum to Show Youths' Work; D.C. Students Paint Mural." *Washington Times* (10 July 1992): B1.

Howe, Katherine. "The Atomic Salon." *Images and Issues* (September/October 1982).

Indiana, Gary. "Tim Rollins and K.O.S. at Jay Gorney Modern Art." *Art in America* 75, no. 3 (March 1987): 137–138.

Israel, Nico. "Almost Warm and Fuzzy/Disasters of War." *Artforum* 39, no. 9 (May 2001): 171.

Januszczak, Waldemar. "Artful Dodge in the Bronx." *London Guardian* (22 September 1987).

Jarque, Fietta. "Los K.O.S., un Grupo de Muchachos del Bronx Que Irrumpe en el Mercado del Arte Neoyorquino." *El Pais* (11 February 1987).

Jensen, Lars. "Die Kunst des Überlebens." *Monopol*, no. 12 (December 2007): 28–37.

Jinkner-Lloyd, Amy. "Report from Pittsburgh: Musing on Museology." *Art in America* (June 1997): 44–51.

Johnson, J. "Art Educator Shares Vision and Dream During Lecture." *Daily Sentinel Nacogdoches* (23 October 2001).

Johnson, Ken. "Art in Review: Tim Rollins and K.O.S." *New York Times* (17 March 2000).

Jolles, Claudia. "Tim Rollins and K.O.S." *Das Kunst-Bulletin* (November 1990): 38–47.

Jones, Ronald. "Tim Rollins and K.O.S." *Flash Art*, no. 132 (March 1987): 107.

Kaplan, Cheryl. "By the People and for the People: Tim Rollins and His Youth Project K.O.S.: A Conversation with Tim Rollins and Cheryl Kaplan." *DB-Art Magazine* (April 2008).

Karmel, Pepe. "For K.O.S., the Play's the Thing." *New York Times* (13 January 1995): C25.

Kastor, Elizabeth. "Kids with the Art of Survival: New York's Tim Rollins, Teaching with a Bold Stroke." *Washington Post* (26 September 1992): D1.

Kent, Sarah. "Bronx Break." *Time Out London* (23–30 September 1987): 20–21.

Kessler, Jane. "Kids of Survival: Tim Rollins and K.O.S." *Art Papers* 12, no. 2 (March/April 1988): 25–26.

Koslow, Francine A. "Tim Rollins and K.O.S.: The Art of Survival." *Print Collector's Newsletter* 19, no. 4 (September/October 1988): 139–142.

Kramer, Hilton. "South Bronx Children's Art at Dia: Buoyant, Cheerful, Well Executed." *New York Observer* (6 November 1989).

Lane, Ingrid Groller. "Barnyard Full of Big Shots." *Washington Post* (24 September 1992): DC5.

Larson, Kay. "Coming to Amerika…" *New York Magazine* (20 November 1989).

Lasswell, Mark. "True Colors." *New York Magazine* (29 July 1991): 30–38.

Lee, David. "Classics from the Street." *London Times* (27 July 1988).

Leggewie, Claus. "Bilder der Kids aus dem Getto." *Merian* (December 1993): 122–123.

Levin, Kim. "Out of the Studio: Art with Community." *Village Voice* (10 March 1987): 86.

———. "Studio Visits." *Mirabella* (September 1989): 96.

———. "Tim Rollins and K.O.S. at Jay Gorney Modern Art." *Village Voice* (23 May 1989): 94.

Lewallen, Constance. "Rollins and K.O.S., A Survey of Works on Paper." *Berkeley Art Museum Newsletter* (January 1999): 5.

———. "Tim Rollins and K.O.S.: Interview." *View* (January 1990).

Lipson, Karin. "America, Amerika: Art Against the Odds." *Z Magazine* (December 1989).

———. "Creativity with the Public's Blessing." *Newsday* (2 February 1987).

———. "Works of Art By Any Means Necessary." *Newsday* (18 March 1986).

Lloyd, Ann Wilson. "Malcolm X: The Artists' View." *Art in America* (May 1994): 45–47.

Mah, S. L. "Kids Creations." *Kalamazoo Gazette* (21 January 2004).

Mahoney, Robert. "Reading Art: Tim Rollins and K.O.S." *New York Press* (April 1988).

Mansfield, Susan. "Painting the Pain." *Scotsman* (16 October 2001): 8.

McKenna, Kristine. "Art from the Heart of Amerika Straight Out of the South Bronx, Tim Rollins Brings His K.O.S. (Kids of Survival) and Their Art, 'Amerika I–XII.'" *Los Angeles Times* (8 July 1990): 3.

McNally, Owen. "High Art Meets the Streets." *Hartford Courant* (14 January 1990).

Meinhardt, Johannes. "The Temptation of Saint Antony in Basel and Stuttgart." *Kunstforum International* (November 1990).

Morgan, Judy. "Imaginations Bloom Under Artist's Tutelage." *Daily Sentinel Nacogdoches* (26 October 2001).

———. "Rollins' Program Inspires Students Through the Arts." *Daily Sentinel Nacogdoches* (19 October 2001).

Morris, S. "A 'Dream' Fulfilled." *Albany Times Union* (13 July 2000).

Myers, Terry R. "Tim Rollins and K.O.S." *Flash Art*, no. 148 (October 1989): 132.

Myoda, Paul. "Tim Rollins and K.O.S." *Frieze* (May 1995): 64–65.

Neill, Michael, and Elizabeth McNeil. "Escape Route." *People* 46, no. 22 (25 November 1996): 119–121.

Nesbitt, Lois. "Drawn from the South Bronx." *New York Woman* (November 1989).

Nickas, Robert, and Kevin Power. "Art and Its Double." *Flash Art (International Edition)*, no. 132 (February/March 1987): 113–114.

Nilson, Lisbet. "From Dead End to Avant-Garde." *ARTnews* 87, no. 10 (December 1988): 132–137.

Norman, Tony. "Disciple of Art." *Pittsburgh Post-Gazette* (31 March 2000).

O'Sullivan, Michael. "Tim Rollins' Creative Streak." *Washington Post* (15 April 2005): T54.

Paley, Nicholas. "Kids of Survival: Experiments in the Study of Literature." *English Journal* 77, no. 5 (September 1988): 54–58.

Parks, Andrew. "Big Bang Theorist." *Philadelphia City Paper* (5–11 February 2004).

Pass, Louise. "Tim Rollins and His Kids of Survival." *Arts Journal* (December 1987): 4–5.

Patterson, Tom. "Tim Rollins Helps Students Find Identities in Art." *Winston-Salem Journal* (12 June 1994): C2.

Pedulla, Albert. "Fulfilled in your Seeing: The Life and Work of Tim Rollins and K.O.S." *Image*, no. 45 (Spring 2005).

Perree, Rob. "20 Jaar Tim Rollins and K.O.S." *Kunstbeeld* (September 2000).

Pincus-Witten, Robert. "Electrostatic Cling or the Massacre of Innocence." *Artscribe*, no. 64 (July 1987): 36–41.

Placky, Robert. "On Site: A Residency with Tim Rollins and K.O.S." *Art Education* (July 2000): 50–54.

R., Laine M. "Tim Rollins Helps Youth Create their Masterpiece." *Beacon* (6 November 2005).

Rankin-Reid, Jane. "Tim Rollins and K.O.S." *Tema Celeste*, no. 17/18 (October 1988): 64.

Renton, Andrew. "Tim Rollins and K.O.S.: An Open Book." *Art & Design/New Art International* (September 1990): 78–81.

Risatti, Howard. "The Eighties Reviewed." *Art Criticism* 6, no. 1 (1989): 66–74.

Robinson, Walter, and Carlo McCormick. "Slouching Towards Avenue D, Report from the East Village." *Art in America* 72, no. 6 (Summer 1984): 134–161.

Rollins, Tim. "Art as Social Action: An Interview with Conrad Atkinson." *Art in America* 68, no. 2 (February 1980): 118–123.

———. "Collaboration: Tim Rollins and K.O.S." *Parkett*, no. 20 (June 1989): 34–41.

———. "Five Big Problems for Artists" and "Art and Guns." *Poetry East* (Winter 1982/Spring 1983): 148–152.

———. "Foreword: The Arts, Urban Education…" *Education and Urban Society* (August 2001).

———. "Helping Kids Grow Through Art." *Parent and Preschooler Newsletter* (January 2002).

———. "The Making of 'Amerika.' " *Figura*, no. 6 (Summer 1985): 17–19.

———. "An Open Letter to Conrad Atkinson." In *Picturing the System*, 80–83. London: Institute of Contemporary Art, 1981.

Rollins, Tim, and Arlene Raven. "Closing the Gap: Impacting the Culture." *Art Papers* 15, no. 2 (March/April 1991): 20–28.

Rollins, Tim and K.O.S. (Richard Cruz, George Garces, Jose Parissi, Carlos Rivera, Annette Rosado, Nelson Savinon). "Dialogue February 2, 1990 W. 19 St. Studio." *New Observations*, no. 78 (30 September 1990): 8–11.

Rollins, Tim and K.O.S. (Richard Cruz, Nelson Montes, George Garces, Nelson Savinon, Christopher Hernandez, Aracelis Batista, Annette Rosado, Carlos Rivera). "Dialogue 5, April 19, 1989: The Art and Knowledge Workshop Studio." *Parkett*, no. 20 (June 1989): 56–71.

Romaine, James. "Constructing a Beloved Community: the Methodological Development of Tim Rollins and K.O.S." Ph.D. diss., City University of New York, 2007.

———. "On a Clear Night I Can See the Sun: Tim Rollins and K.O.S. Test Faith's Possibilities." *Image*, no. 45 (Spring 2005).

———. "The Promised Land: An Interview with Tom Rollins and K.O.S." *CIVA Seen 1* (April 2001).

Ruble, Casey. "Tim Rollins and K.O.S.: Lehmann Maupin." *Art in America* 97, no. 4 (April 2009): 140–141.

Saint Louis, Catherine. "What They Were Thinking about Race; The Gospel According to Tim." *New York Times* (16 July 2000).

Scanlan, Joseph. "Tim Rollins and K.O.S. at Rhona Hoffman." *Dialogue* (March 1988).

Schambelan, Elizabeth. "Tim Rollins and K.O.S. at Baumgartner." *Art in America* 90, no. 4 (April 2002): 147.

Shaw-Eagle, Joanna. "A Transformative Joy; Student Works Probe 'Creation.' " *Washington Times* (30 April 2005).

Shearing, Graham. "Rollins Submerges Egos in a Shared Canvas." *Pittsburgh Post-Gazette* (31 March 2000).

Sherman, Betsy. "Out of the Streets and into the Galleries." *Boston Globe* (3 April 1997): E3.

Smith, G. "An Interview with Tim Rollins." *Three Point Seven* (2002).

Smith, Roberta. "Amerika, by Tim Rollins and K.O.S." *New York Times* (3 November 1989).

———. "Art: A Collaboration, Tim Rollins and K.O.S." *New York Times* (21 November 1986): C28.

———. "Tim Rollins and K.O.S." *New York Times* (19 June 1990): C16.

Sola, Michael. "Just Take It Step By Step: An Interview with Tim Rollins and the Kids of Survival Crew." *Radical Teacher Magazine*, no. 33 (January 1988).

Sozanski, Edward. "Sophisticated Work from 'At-Risk' Students." *Philadelphia Inquirer* (6 June 1997).

———. "Using Art's Values to Enrich Students." *Philadelphia Inquirer* (23 April 1987): D4.

Stack, Peter. "The Key to Survival in the Bronx Is Art." *San Francisco Chronicle/Datebook* (10 April 1996).

Stapen, Nancy. "The Medium Has a Message." *Elle Magazine* (March 1989).

———. "Tim Rollins and K.O.S." *Art News* 93 (January 1994): 169.

Storr, Robert, Feliz Gonzalez-Torres, Lucy R. Lippard, Franz Meyer, Kellie Jones, William Allen, Jay Gorney, Dan Cameron, Dieter Koepplin, Pura Cruz, Jean Fisher, Jovita Nedd, Declan McGonagle, and Wilfried Dickhoff. "Statements." *Parkett*, no. 20 (June 1989): 92–115.

Sturman, John. "Tim Rollins and K.O.S. at Jay Gorney Modern Art." *ARTnews* 84, no. 6 (Summer 1985): 190.

Sundell, Margaret. "Tim Rollins and K.O.S. at Dia Art Foundation." *Seven Days* (15 November 1989).

Talasek, J.D. "On the Nature of the Universe." *Issues in Science and Technology* (Spring 2006).

Tallman, Susan. "Cultural Literacy." *Arts Magazine* 64, no. 7 (March 1990): 17–18.

Taylor, Paul. "Bronx Revival." *Vogue* (January 1990): 114–117.

AMERIKA (AFTER FRANZ KAFKA) and THE FROGS—FOR THE CHILDREN OF TAMPA (AFTER ARISTOPHANES), 1997
Acrylic on linen panels
Indoor public murals made in workshop with 40 K–12 grade students from Tampa area public schools for the Anchin Center and Education II Building at University of South Florida, Tampa
AMERIKA: 48 feet and 8 inches x 5 feet
THE FROGS: 144 feet and 8 inches x 5 feet

Temin, Christine. "Tim Rollins and K.O.S." *Boston Sunday Globe* (17 April 1988).

Thomas, Kevin. "Powerful 'Kids' Portrays Art as a Teacher of Survival." *Los Angeles Times* (28 February 1997).

Thomas, Mary. "Tim Rollins Guides Students From 'Survival' to Success." *Pittsburgh Post-Gazette* (29 April 2000).

Thompson, Carmen R. "Kids Give Ghetto the Brush-Off!" *New York Daily News* (3 March 1996): 13.

Veltman, Chloe. "Kids on Canvas." *London Telegraph Magazine* (30 September 2000).

Wallach, Amei. "Survival Art, 101." *New York Newsday* (30 October 1989).

Watson, Petra. "Art, Pedagogy, Utopia." *C Magazine*, no. 28 (Winter 1991): 33–38.

White, Pat. "Show of Children's Art Tells Tale of Two Cities." *Charlotte Observer* (21 December 1987).

Wildberger, Sara. "It's All in the Paper at Pyramid Atlantic." *Washington Post* (18 January 2001): T25.

Wolfe, Kristin L., and James S. Harrison. "Survival Guide." *Visual Art Journal: School of Visual Arts Magazine* 11, no. 1 (Spring 2003): 24–26.

Wollheim, Richard. "Tim Rollins and the Kids of Survival: The Art of Hope in the South Bronx." *Modern Painters* 11, no. 1 (March 1998): 93–97.

Woodruff, Mark. "Tim Rollins and K.O.S." *Taxi Magazine* (October 1989): 96.

Video

Brown, Kathan, and Bruce Schmeichen. *Ink, Paper, Metal, Wood: 35 Years at Crown Point Press*. VHS. San Francisco: Crown Point Press in association with Fine Arts Museums of San Francisco, 1998.

Fleming, Anne Taylor, and Tim Rollins. *Art Treasures*. VHS. Alexandria, Virginia: PBS Video, 1990.

Goldfine, Dayna, Tim Rollins, and Daniel Geller. *Kids of Survival: The Art and Life of Tim Rollins and K.O.S.* VHS. Re-released on DVD in 2006. San Francisco: Geller/Goldfine Productions; Bloomington, Indiana: National Educational Service, 1996.

Iwamasa, Ken. *Tim Rollins and K.O.S (Kids of Survival)*. VHS. Boulder, Colorado: University of Colorado, 1993.

Rosso, Franco. *The Art of Survival: The Story of Tim Rollins and K.O.S.* VHS. London: BBC, 1989.

Zwicky, Calder, and Hatuey Ramos Fermin. *Tim Rollins and K.O.S. Interview*. DVD. Bronx, New York: Bronx Museum of the Arts, 2009.

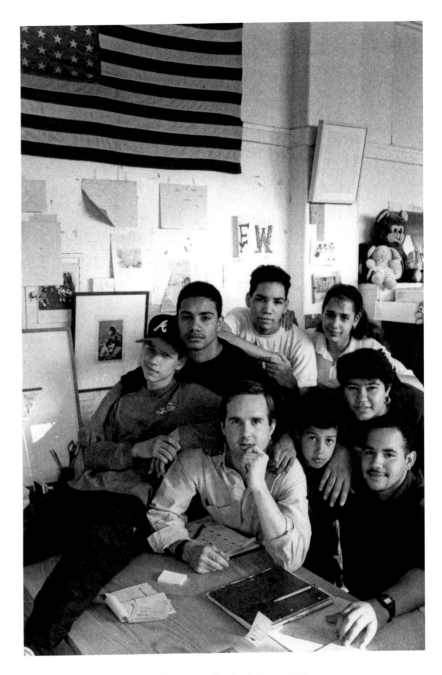

Tim Rollins and K.O.S., Longwood Avenue studio, South Bronx, 1988
Clockwise from bottom left: George Garces, Nelson Montes, Nelson Ricardo Savinon, Aracelis Batista, Annette Rosado, Richard Cruz, Christopher Hernandez, Tim Rollins

ACKNOWLEDGMENTS

This book is the first to survey the work of Tim Rollins and the Kids of Survival. It is a celebration and a critical assessment of what they have produced in thirty years as a collective. I was first introduced to Tim Rollins by then Director of the Williams College Museum of Art Linda Shearer who suggested that we invite him to speak at the museum. His presentation was something unlike anything I had heard before and his words that day changed my way of thinking about how art can function in society. I stayed in touch with Tim and had the pleasure of seeing works by the group over the years in exhibitions and collections across the country. At the Tang Museum I was encouraged by Director John Weber to pursue a more in depth history of the group and that research has led to this volume. My sincere thanks to Tim for his confidence and trust in letting me tell this history of K.O.S. and for his hours recording interviews, talking with students, and offering advice and connections along the way. It is my hope that this is the first of many histories of K.O.S. and that those who open this book will feel the same spark from reading about his vision for a life in art that I did.

As much as this project tells the story of K.O.S., it revolves around the artworks they created. We are grateful to the many collectors and museums who lent us their works for the exhibition: Alyson and Angel Abreu; Brooke Alexander, New York; The Bronx Museum of the Arts, New York; David Deitcher; Ruth and William Ehrlich; Galerie Eva Presenhuber, Zurich; Fisher Landau Center for Art, Long Island City, New York; Carol and Arthur Goldberg; The Hyde Collection, Glens Falls, New York; The JPMorgan Chase Art Collection; Jane and Leonard Korman; Lehmann Maupin Gallery, New York; Mildred Lane Kemper Art Museum, Washington University, St. Louis; Dr. Rushton E. Patterson, Jr.; Galleria Raucci/Santamaria, Naples; Nelson Ricardo Savinon; Peter Stern; Straus Family; Thomas Ammann Fine Art AG, Zurich; Whitney Museum of American Art, New York; and Alice Zoloto-Kosmin.

Creating this catalogue involved compiling an extensive archive of images and information from a wide range of sources. The following people and institutions generously assisted with images, collection information, and memories of K.O.S. workshops and exhibitions that helped us form this history. Thanks to: Amy Adams, Fleisher/Ollman Gallery, Philadelphia, Pennsylvania; John Ahearn; Doris Ammann, Thomas Ammann Fine Art, Zurich; Sasha Baguskas, Crown Point Press, San Francisco, California; Bill Arning; Beverly Balger Sutley, Palmer Museum of Art, Pennsylvania State University, University Park, Pennsylvania; Aileen Bastos, Wadsworth Atheneum Museum of Art, Hartford, Connecticut; Jennifer Belt and Robin Stolfi, Art Resource Inc., New York; Carol Borgmann, Korman Family Office; Pamela Caserta, Walker Art Center, Minneapolis, Minnesota; Olga Chatzidaki, AMP Gallery, Athens, Greece; Lynda Clark and Lucie Strnadova, Tate Images, London; Jean Collier, University of Virginia Art Museum, Charlottesville, Virginia; Andrea Collins, Mint Museum of Art, Charlotte, North Carolina; Genevieve Cottraux, University of California, Berkeley Art Museum and Pacific Film Archive; Alison Day, Brooklyn Museum of Art, New York; Amy Densford and Emily Newton, Hirshhorn Museum and Sculpture Garden, Smithsonian Institution, Washington, D.C.; Jeanne Dreskin, Dia Art Foundation, New York; Jay Etkin, Jay Etkin Gallery, Memphis, Tennessee; Alessia Evangelista, Fondazione Morra Greco, Naples; Kelsi Evans, Fales Library and Special Collections, New York University, New York; Motrja P. Fedorko, Jersey City Museum, New Jersey; Alison and Marc Feldman; Holly Frisbee, Philadelphia Museum of Art, Philadelphia, Pennsylvania; Robin Goodman, Kalamazoo Institute of Arts, Kalamazoo, Michigan; Jay Gorney; Lisa Haegele and Stacy Park, Mildred Lane Kemper Art Museum, Washington University, St. Louis, Missouri; Dana Hanmer and Jeffrey Bussman, Fabric Workshop and Museum, Philadelphia, Pennsylvania; Rhona Hoffman and Charlotte Marra, Rhona Hoffman Gallery, Chicago, Illinois; Owen Houhoulis, Brooke Alexander, New York; Hsu-Han Shang, JP Morgan Chase Bank; Elizabeth Jabar, Printmaking Chair, Maine College of Art, Portland, Maine; JoAnn L. Jackson and Rebecca DesMarais, Youth Art Connection, Atlanta, Georgia; Frank Janzen, Crow's Shadow Institute of the Arts, Pendleton, Oregon; Thomas Jarek, Eva Presenhuber, and Silja Wiederkehr, Galerie Eva Presenhuber; Brianne Johnson, Writers House, LLC, New York; Jayme Johnson, Spencer Museum of Art, Lawrence, Kansas; David Kim, Public Art Fund, New York; Mickey Koch, Des Moines Art Center, Des Moines, Iowa; Linda Lambertson, Institute of Contemporary Art, Maine College of Art, Portland, Maine; Larry Mangel; Marilyn Masler, Memphis Brooks Museum of Art, Memphis, Tennessee; Denise Mattia, The Carol and Arthur Goldberg Collection; Jackie McAllister, Fisher Landau Center for Art, Long Island City, New York; Melissa Mercurio, Birmingham Museum of Art, Birmingham, Alabama; Beth Moore, Telfair Museum of Art, Savannah, Georgia; Timothy Allen Motz, Toledo Museum of Art, Toledo, Ohio; Hannah Munger, Percent for Art Program, City of New York Department of Cultural Affairs; Marguerite O'Molloy, Irish Museum of Modern Art, Dublin; Andrew Ong; Berit Potter, Whitney Museum of American Art, New York; Elaine M.S. Quick, Warehouse Gallery, Syracuse University, Syracuse, New York;

Barbara Rathburn, The Hyde Collection, Glens Falls, New York; Umberto Raucci, Giorgio Salzano, and Carlo Santamaria, Galleria Raucci/Santamaria, Naples; John Rexine, MIT List Visual Arts Center, Cambridge, Massachusetts; Ruth V. Roberts, Indianapolis Museum of Art, Indianapolis, Indiana; Clay Rolader; Sarina Rousso, Georgia Museum of Art, Athens, Georgia; Mark Rubenstein; Erin M.A. Schleigh, Museum of Fine Arts, Boston, Massachusetts; Amanda Schneider, Lehmann Maupin Gallery, New York; Cathy Serrano, Ronald Feldman Fine Arts, New York; Tobias Sirtl, Phillips de Pury & Company; Susan Sosnick and Karen Sosnick Schoenberg; Mary Spielberger, Kantor Art, Beverly Hills, California; Nicole Stotzer, Parkett; Linda Szoldatits, Tishman Speyer, JD Talasek, National Academy of Sciences, Washington, D.C.; Rachel Tassone, Williams College Museum of Art, Williamstown, Massachusetts; Lisa Thrower, Museum of Contemporary Art Georgia, Atlanta, Georgia; Shelley Wilson, Studio Museum in Harlem, New York; Barbara C.G. Wood, National Gallery of Art, Washington, D.C.; Lacey Wozny, Grand Arts, Kansas City, Missouri; and Valerie Wright, Rose Art Museum of Brandeis University, Waltham, Massachusetts.

This project is a special one in the history of the Tang Museum and all of the staff helped make it happen—thanks to Curatorial Project Assistant Kristen Carbone, Educator Ginger Ertz, Senior Preparator Torrance Fish, Events Coordinator Lori Geraghty, Senior Museum Educator Susi Kerr, Associate Director for Administration and Public Programs Gayle King, Head of Installations and Building Manager Chris Kobuskie, Assistant Registrar Ryan Lynch, Graphic Designer Patrick O'Rourke, Community Relations Manager and Store Manager Barbara Schrade, and Administrative Assistant Kelly Ward for their unflagging support. Thanks to the Tang's installation crew, including Sam Coe, Rob Goodall, Sean O'Connell, and Jay Tiernan, and to former staff members Ginny Kollak, Katrina Dumas, and Anna Zofia Valenzuela '08 who provided critical early support. Thanks also to the many Skidmore students who helped along the way: Alexandra Citrin '09; Sophie Cohen '10; Rachel Downes '09; Jessie Edelman '08; Francesca Fanelli '09; Kengo Ikeda-Iyeki '12; Morgan Levey '08; Erika Sabel '07; and Brooke Williams '11.

Special thanks to Tang Curatorial Assistant Megan Hyde for keeping a steady watch over this project and to Registrar and Collection Manager Elizabeth Karp for managing the exhibition's tour.

The exhibition had wonderful hosts in Claudia Gould, Ingrid Schaffner, Jenelle Porter, Jill Katz, Robert Chaney, Shannon Bowser, and especially Kate Kraczon at the Institute of Contemporary Art, University of Pennsylvania in Philadelphia, and Midge Bowman, Laura Landau, Donna Kovalenko, Jill Rullkoetter, and especially Robin Held at the Frye Art Museum in Seattle.

This magnificent book is the result of great design by Bethany Johns and careful printing by Roberto Conti, Laura Cuccoli, and Ann Faughender at Conti Tipocolor with new photography by Arthur Evans. Also thanks to Aaron Igler and the many other photographers whose images are included here, especially Lisa Kahane and Tom Warren whose early photographs of the group provide an important record of their history. Thank you not only for your photographs but also for sharing the stories that went along with them.

I am grateful to the essayists who not only crafted new writings for this book but also offered anecdotes, questions, and ideas along the way – thanks to Julie Ault, Susan Cahan, David Deitcher, Eleanor Heartney, Larry Rinder, and Dr. James Romaine. Special thanks to James for offering his dissertation research, which helped us form the list of K.O.S. members and their biographies. Thanks to Parkett for their permission to reproduce the statement by Felix Gonzalez-Torres and to the estate of Martin Luther King for their permission to reproduce his writings. Special thanks to Megan Hyde and Jay Rogoff for their thoughtful editing of the essays in this book.

We are privileged to have the partnership of MIT Press to distribute this book, and thank Anar Badalov, Kate Caldwell, Erin Hasley, and Janet Rossi for their trust and patience throughout the process of making this volume. Special thanks to Roger Conover for his early support—it is great to have you in our corner.

My most loving thanks to Tim and the many members of K.O.S. both past and present who throughout the last three decades have shown us all what hard work, brave spirit, and unrestrained creativity can produce. Your work together continues to inspire many and most certainly has changed the world.

IAN BERRY
Associate Director and Susan Rabinowitz Malloy '45 Curator
The Frances Young Tang Teaching Museum and Art Gallery
Skidmore College

CREDITS